THE CULTURE OF DIAGRAM

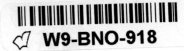

THE CULTURE

JOHN BENDER

Stanford University Press

OF DIAGRAM

MICHAEL MARRINAN

Stanford, California

Stanford University Press
Stanford, California

This book has been published with assistance from the Halperin Fund of the Department of Art & Art History, the Department of English, and the School of Humanities and Sciences at Stanford University.

Printed in the United States of America on acid-free, archival-quality paper

Library of Congress Cataloging-in-Publication Data
Bender, John B.
 The culture of diagram / John Bender and Michael Marrinan.
 p. cm.
 Includes bibliographical references and index.
 ISBN 978-0-8047-4504-8 (cloth : alk. paper) — ISBN 978-0-8047-4505-5 (pbk. : alk. paper)
 1. Visualization. 2. Visual perception. 3. Art and science. 4. Art, Modern—History. 5. Scientific literature—History. 6. Encyclopédie—Criticism and interpretation. 7. Diderot, Denis, 1713-1784. I. Marrinan, Michael. II. Title.
 BF367.B46 2010
 121'.35—dc22

 2009021940

Designed by Bruce Lundquist
Typeset at Stanford University Press in 11/16 Sabon with Optima display

CONTENTS

ILLUSTRATIONS

PLATES

FIGURES

ACKNOWLEDGMENTS

This book touches upon many fields of knowledge and has been under way for many years. During this time, we have been helped by countless friends, colleagues, students, librarians, and curators, as well as by commentary from auditors at lectures and seminars. Even though we cannot name everyone, we truly appreciate the good-natured interest that has greeted our ideas. Michael Marrinan would also like to express his gratitude to Davey Hubay, who has propped up his resolve to keep working with long conversations and many hundreds of sandwiches. For his part, John Bender is grateful to Ann Bender for more than ten years of empathetic engagement with the project.

Among the referees employed by the Stanford University Press, Daniel Brewer, James Elkins, and Timothy Lenoir offered commentary that was central to our reconception of the manuscript as we brought it to final form. Other colleagues read an early version and had considerable impact on our thinking: they were Ann Bermingham, Bliss Carnochan, Jay Fliegleman, Sepp Gumbrecht, Mary Poovey, and David Wellbery.

Simon Goldhill and Peter de Bolla occasioned a turning point in our thinking about diagram by inviting us to offer a series of seminars and a

lecture at King's College, Cambridge, during a week in winter of 2002. Their commentaries, and those of John Forrester, Stefan Hoesel-Uhlig, and Simon Schaffer, guided us through a labyrinth of new ideas. Six years later, we found ourselves back at Cambridge thanks to Mary Jacobus, director of the Center for Research in the Arts, Social Sciences and Humanities, to present the refined version of our thinking about diagram.

We were fortunate to try out our ideas at several universities, where our hosts and their colleagues offered rich commentary. Among them number John Frow, who organized the comprehensive "Visual Knowledges" conference in Edinburgh in 2003; Laura Runge of the DeBartolo Conference at the University of South Florida; Daniel Horowitz, director of the Institute for the Humanities at the University of Michigan; Deidre Lynch and Dror Wahrman of the Center for Eighteenth-Century Studies at Indiana University, Bloomington; David Bates of the Department of Rhetoric, University of California, Berkeley; and Béatrice Fraenkel of the École des Hautes Études, coordinator of the 2008 International Word and Image Conference in Paris.

Other colleagues who helped us advance this project include: Keith Michael Baker, Marta Braun, Lorraine Daston, Daniel Edelstein, John Etchemendy, Peter Galison, Thomas Hankins, Roger Hahn, Marian Hobson, Peter Reill, Jessica Riskin, Clifford Siskin, J. B. Shank, Joanna Stalnaker, James Grantham Turner, and Jason Weems.

We have been fortunate that several tolerant and able students have assisted with the research and checking: Alexandra Arch, Joann Kleinneiur, Maia Kraus, Christy Pichichero, and James Wood.

No research is possible without the help of librarians and curators. While we have benefited from the generosity of all the institutions listed in the captions, we are especially grateful to the Stanford University Libraries, and to Michael Keller, John Mustain, and Roberto Trujillo. Ian W. Hunter and Serge Lafontaine of MIT supplied the crucial color images of robotic eye surgery that adorn the cover of this volume and with which we begin our argument.

Stanford University Press has offered patient encouragement over the years. For this, we are much indebted to Geoffrey Burn, Emily-Jane Cohen, Alan Harvey, and Norris Pope, as well as our excellent copy editor, Richard Gunde. The finished book owes much to the expert attention

of Judith Hibbard, Bruce Lundquist, and David Luljak. At Stanford, this project has been supported financially by the Department of English, the Department of Art and Art History, and the Dean of the School of Humanities and Sciences.

Many readers and auditors have inquired about our working method. We outlined this book together in 1997 on the rue de Seine in Paris, when circumstances brought us together for a few days of undistracted brainstorming. At first we tried composing parts of the text separately but, in tandem with the evolution of our thinking, we eventually found ourselves working jointly on the manuscript face to face at the same desk.

Our translations, and much of the special photography in the book, are the work of Michael Marrinan. In the end, though, this book stands as a testament to the somewhat willful ambition of both authors to write a book that can be called truly collaborative and thoroughly interdisciplinary. That we have pulled it off is also a testament to an unusual academic friendship.

—*Stanford University, October 2009*

THE CULTURE OF DIAGRAM

SCENARIO

A surgeon enters the bright, even light of an operating room where the patient, prepared for surgery, occupies a table surrounded by the expected array of monitors, respirators, and sterilized tools. But rather than taking his usual place near the patient, the surgeon seats himself at a nearby console where an assistant places over his head a helmet that completely covers his eyes and most of his face. The helmet is plugged into a computer and the doctor grasps two wands shaped to resemble microsurgical scalpels. He signals to a technician at a computer terminal that he is ready: a delicate surgical procedure on one of the patient's eyes is about to begin.[1]

What is happening here? Without ever physically touching the patient, nor even seeing him directly, the doctor is directing a delicate procedure inside the eye itself. The "helmet" he wears is a head-mounted display (HMD) that positions before his own eyes two small color television monitors connected to a stereo imaging device. What the doctor "sees" is a real-time, stereoscopic image of the movement and position of his microsurgical tools (FIGURE 1 / PLATE 1 and FIGURE 2 / PLATE 2). Moving his head changes the position of the miniature camera so that the doctor

seems to be inside the eye itself, able to see at close range the movements and effects of the scalpel's actions.

Those movements are controlled by a sophisticated robot, which responds to the surgeon's manipulation of the scalpel-like wand held in each hand, but executed with a greater precision and stability than the doctor could ever perform by himself. The computer driving the robot automatically reduces his movements by a factor of 100, and it removes nearly all the physiological tremor of his hands. It also continuously monitors the surgeon's actions by comparing them to the structure of a mathematically defined virtual eye stored within its data banks, so that if he should try to proceed too quickly among delicate tissues of the actual eye, the computer will impede or correct the gesture. Sensors within the scalpel mechanism register the amount of resistance produced by its

FIGURE 1
"Surgical virtual environment showing virtual surgical instruments, 3-D guidance information, surgeon's tremor power spectrum (top left) and patient's vital signs (left-hand side)." Computer-driven interface from Ian W. Hunter et al., "Ophthalmic Microsurgical Robot and Associated Virtual Environment," *Computers in Biology and Medicine*, vol. 25 (1995). © 1995, with permission from Elsevier.

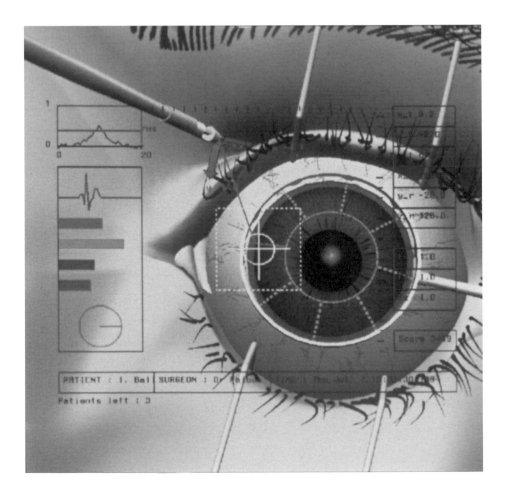

cutting action and pass the data to the controlling computer, where it is magnified by a factor of 100 and sent to the wands held by the doctor: in this way, the surgeon "feels" the effect of his actions within the patient's eyeball.

In a comparison probably inspired by the layered meanings of the German word *Operateur* [surgeon/projectionist], Walter Benjamin drew an analogy between the work of a surgeon and that of a cameraman. "The surgeon," he wrote, "greatly diminishes the distance between himself and the patient by penetrating into the patient's body . . . at the decisive moment [he] abstains from facing the patient man to man; rather, it is through the operation that he penetrates into him." Benjamin is describing a familiar scenario, an early version of which is pictured in Denis Diderot and Jean Le Rond d'Alembert's *Encyclopedia* (FIGURE 3).

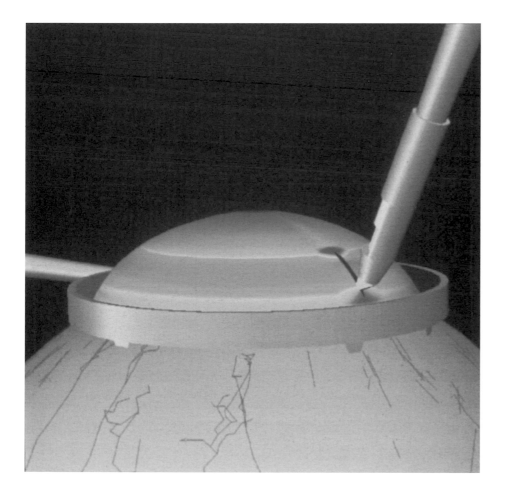

FIGURE 2
"Stress contours calculated on an incised human cornea during a radial keratotomy simulation." Computer-driven interface from Ian W. Hunter et al., "Ophthalmic Microsurgical Robot and Associated Virtual Environment," *Computers in Biology and Medicine*, vol. 25 (1995). © 1995, with permission from Elsevier.

FIGURE 3
"Chirurgie," pl. XXIV. Engraving
by Robert Bénard after a design
by Louis-Jacques Goussier for
Diderot and d'Alembert, *Recueil
des Planches*, vol. 3. Courtesy
Department of Special Collections,
Stanford University Libraries.
Photo: Marrinan.

He goes on to say that a cameraman's relationship to the world—like a surgeon's instrumentalized relationship to his patient—is both depersonalized by the cinematic apparatus and "penetrates deeply into its web."[2] What Benjamin could not imagine in 1936 was that advances in microrobotics, electronic imaging, and computing power would transform his metaphor into reality: our ophthalmologist, who neither touches his patient nor sees him directly, is literally a surgeon-cameraman, completely immersed in a world of electronically produced images yet guiding a scalpel through the living tissue of his patient's eye.

The machinery of a modern operating room seems to challenge many of the everyday, commonsense notions that Benjamin took as givens: the integrity of a physical body; its opacity to others; and a rather uncomplicated relationship between what John Locke called "the primary qualities of things, which are discovered by our senses" and our complex ideas of "corporeal substances" that derive from sensible secondary qualities.[3] Indeed, some predictions of what an operating room of the future will be like include scenarios where entire procedures are performed by computer-controlled robots, attached to advanced imaging devices (such as MRI machines) and working with digitally stored models of the patient (obtained from CAT scanners), whose motions are guided by artificial intelligence programs.[4] For the moment, the physical limitations of robot mechanisms, the lack of adequate mathematical definitions of complex tissues (needed to program a robot), the massive computational demands such systems would place on computer processors, and the high costs of research and development keep such radical scenarios on the distant horizon of medical technology.[5] Commercially available surgical robots, such as the da Vinci, have been approved for laparoscopic, minimally invasive surgery under the guidance of an attending physician, but completely autonomous robots have yet to be developed.[6]

Alongside these practical reasons related to surgical safety and affordability, surgeons worry that they would no longer directly control the situation. Sophisticated computer-guided robots require their own specialist operators, which means that surgeons must pass commands to technicians rather than working directly on the physical body of the patient.[7] As one medical team has written, doctors generally prefer to have a robot pre-programmed for a procedure under active control of

the surgeon, because in this case "from both the surgeon's and the patient's point of view, the robot is merely a 'tool'. It is evident that the surgeon carries out the operation and not the robot."[8] This suggests a lingering suspicion about the reliability of transferring data directly from electronic sensors to robotic actors, and implies that both sides of the surgical experience prefer an expert human to inhabit—or at least physically monitor—the circuit of information and action. There seems to be a reluctance to accept penetration of our bodies by a fully autonomous "apparatus" (Benjamin's term) of medical technology, regardless of its sophistication.

We open this book with an almost science-fiction account of modern medicine because it stages the experience of virtual reality in a markedly graphic manner, by placing a physical body under an actual scalpel guided through a fictive space of computer simulation. Underlying this unusual meeting of surgeon and patient, mediated almost exclusively by mechanical sensors, digital sampling, and algorithmic instruction sets, is an implicit confidence in the information delivered to the surgeon, in his ability to form a clear and accurate idea of the physical corrections to be made to the affected eye. Anyone would hope the surgeon has an accurate picture of the patient's condition so that the operation might be successful. Yet this raises a simple but profound question: is the helmet's stream of real-time data a description of the eye?

Proponents of a copy theory of representation would probably say "no." The paradox is that advocates of a non-mimetic theory of description, such as Nelson Goodman, would be hard-pressed to answer "yes." Goodman distinguishes description from depiction on the grounds that the former is syntactically "articulated" rather than "dense." By this he means that the components of descriptions are disjointed and measurably discontinuous from one another, whereas those of depictions appear indivisible—even though they may be infinitely subdivided to achieve higher resolution. The digitized sampling of data and its numeric displays in the surgeon's helmet surely qualify as articulate systems, while the real-time video image he views simultaneously provides a visual spectrum every bit as "dense" as would a conventional depiction.[9]

What is unusual about the surgery example is the convergence of dissimilar data—a kind of willful grafting of Goodman's two syntactic

schemes—in which both the surgeon and the patient have placed their trust. This trust does not develop because they are convinced that one sees the visual organ more completely in the helmet than with the naked eye, but because—for the highly specialized encounter of surgery—this is the most functional way of seeing it. The surgeon cares little if the patient has green or blue eyes, for example, and the helmet display ignores those qualities, yet it reports with great accuracy every minute change in the scalpel's position. So we will answer with a term employed by Goodman, but not used in his sense, that the digital data-stream is not a description of the eye but a *diagram*. A diagram is a proliferation of manifestly selective packets of dissimilar data correlated in an explicitly process-oriented array that has some of the attributes of a representation but is situated in the world like an object. Diagrams are closer in kind to a Jackson Pollock than to a Rembrandt.

Diagrams have existed for centuries. Our ambition is neither to write that long history nor to devise an all-inclusive, trans-historical definition.[10] Nevertheless, we may enumerate some of their formal characteristics: they tend to be reductive renderings, usually executed as drawings, using few if any colors; they are generally supplemented with notations keyed to explanatory captions, with parts correlated by means of a geometric notational system. The *Oxford English Dictionary*'s (*OED*) etymology of the word is somewhat broader, indicating that musical notations and written registers were part of its early usage. By the mid-nineteenth century, the *OED* reports that "diagram" was being used to "represent symbolically the course or results of any action or process, or the variations that characterize it." This emerging ability to concretize process forms the center of our book. The modern history of the word masks something implicit about the nature of diagrams that can be recovered by recalling the Greek use of *diagramma* in mathematical proofs. "The perceived diagram does not exhaust the geometrical object," writes Reviel Netz. "This object is partly defined by the text. . . . But the properties of the perceived diagram form a true subset of the real properties of the mathematical object. This is why diagrams are good to think with."[11] It is significant that d'Alembert's short entry for "Diagramme" in the *Encyclopedia* elides the ancient and modern meanings: "It is a figure or construction of lines intended to explain or to demonstrate an assertion."[12]

Between the early seventeenth century and the middle of the nineteenth century, diagrams were increasingly adapted to represent complex processes uncovered by scientific investigations or instantiated by mechanical inventions. Was this an accident? We argue that the hybrid visual attributes of diagrams facilitate their migration to these complex tasks of representation. The proliferation of discrete packets of dissimilar data, which characterizes diagrams, allows them to be apprehended in series or, paradoxically, from several vantage points. Their disunified field of presentation—ruptured by shifts in scale, focus, or resolution—provokes seriated cognitive processes demanding an active correlation of information. Our general approach in this book is to emphasize this potential for process—both cognitive process and historical process—implicit in the types of visual configurations usually called diagrams. Our earlier and later citations from the *OED* frame the eighteenth-century point of departure for this book—and the publication of Diderot and d'Alembert's *Encyclopedia*. The diagrammatic premises of their approach to visualizing knowledge are explored in Chapter 2.

Our view of Diderot and d'Alembert's intellectual project in the *Encyclopedia* is intertwined with our process-oriented concept of diagram, and more akin to the analysis of Jean Starobinski than that of Michel Foucault. For Foucault, the *Encyclopedia* is a table—an array for nearly unfettered inspection. For Starobinski, it is an arena of knowledge rife with internal discontinuities barely concealed by its "imposing facade, baroque in style and markedly stoic," behind which "spreads the completely modern activity of discontinuous appropriation that is quick to forget the outmoded constraints of organic unity."[13] Starobinski suggests that the arbitrary alphabetic order of the *Encyclopedia* actually sows disorder by breaking with the closed loop of knowledge implicit in the form's history. Especially germane to Starobinski's account is his attention to the complex system of cross-references that work against the alphabetic arrangement and produce a secondary order—a proliferation of readings instituted by the cross-references but animated by the reader/user's individual penchant to know. In the words of Annie Becq, at the heart of the *Encyclopedia* lies a paradox "that values continuity while recognizing in fact that discontinuity is necessary."[14] This same paradox structures and animates what we call diagram.

We emphasize the *Encyclopedia*'s proliferation of knowledge rather than focusing upon its disciplinary compartmentalization. We take our cue from the inclusionary mood of a familiar passage in Diderot's *Prospectus*:

That is what we had to explain to the public about the arts and sciences. The section on the industrial arts required no less detail and no less care. Never, perhaps, have so many difficulties been brought together with so few means of vanquishing them. Too much has been written about the sciences. Less has been written about most of the liberal arts. Almost nothing has been written about the industrial arts.[15]

Diderot's ambition was to produce not only the great "interlinking of the sciences" that constitutes an encyclopedia, but also a catalogue of the bewildering diversity and density of activities that comprise human life.[16] To make it possible for readers to find their way through this labyrinth, the authors adopted the alphabetic ordering of a dictionary which, as many writers have noted, established a tension between encyclopedic closure and a serialized accumulation of knowledge.[17] Diderot himself was aware of the problem:

If one raises the objection that the alphabetical order will ruin the coherence of our system of human knowledge, we will reply: since that coherence depends less on the arrangement of topics than on their interconnections, nothing can destroy it; we will be careful to clarify it by the ordering of subjects within each article and by the accuracy and frequency of cross-references.[18]

What Diderot describes here, notably in his attention to "interconnections" and the "frequency of the cross-references," is a process of learning and discovery that cuts across the dictionary order in complex and unpredictable ways. The aim of this process—which we take to be the essence of diagram—was:

to point out the indirect and direct links amongst natural creatures that have interested mankind; to demonstrate that the intertwining of both roots and branches makes it impossible to know well a few parts of this whole without going up or down many others.[19]

The implication here, as Starobinski and Herbert Dieckmann suggest, is not that knowledge for Diderot entails absolute inclusiveness, but

rather emerges from a process of *enchaînement* [linking] guided by cross-references; that is, from the user's active exercise of relational judgment.

Most critical readings of the *Encyclopedia* align its mode of presentation with a rationalist enterprise of analytic subdivision in which large and complex subjects are broken down—or fragmented—into small units of study. Our view, informed by Diderot's understanding of the relationship of parts to whole, is not to treat the entries or illustrations as fragments of an idealized entity, but as a proliferation of independent elements that, when interconnected, produce knowledge of the whole. The distinction is worth making, for it asks whether the *Encyclopedia* is written from the vantage point of absolute knowledge able to disassemble complex objects at will (Foucault's table) or is a collection of working objects—devised ad hoc in the manner of *bricolage*—that evoke the world's density from a finite number of material soundings.[20]

Working objects are both the tools and products of research processes that in practice correlate familiar oppositions: word and image; representation and the real world; physical mechanics of vision and its processing in the mind; or Goodman's articulate and dense syntactic systems.[21] Here, too, we recover the place of diagrams in Greek mathematical reasoning in which, according to Netz, "the diagram is not a representation of something else; it is the thing itself."[22] Diagrams are things to work with. By framing our concept of diagram as a flexible tool of research, we link it to Diderot's idea that the *Encyclopedia* makes knowledge visible by its system of correlations [rapports] rather than its arrangement of materials. The *Encyclopedia* fails as a compendium, but establishes the matrix of diagrammatic knowledge.[23]

The *Encyclopedia* seemed a new organization and presentation of knowledge. And so it is. At the same time, the authors reached freely into the encyclopedias, dictionaries, manuals, and compendia of imagery that formed the modern tradition within which they lived intellectually. They were inspired by Francis Bacon and guided by figures like Pierre Bayle, Antoine Furetière, John Harris, and, above all, Ephraim Chambers, whose two-volume *Cyclopaedia* of 1728 they intended initially to translate.[24] Diderot and d'Alembert acknowledged their debt to Chambers's vision of an encyclopedia as "the chain by which one can descend without interruption from the first principles of an art or science all the way down to its

remotest consequences . . . back up to its first principles."[25] They recognized the cross-references as his great innovation, although they believed he had failed to exploit fully their potential. They also note that Chambers "had read books but he scarcely saw any artisans," so that his work does not contain "many things that one learns only in the workshops." In an *Encyclopedia*, they argue, these omissions break the "enchainement and [are] harmful to both the form and the substance" of the work.[26] A telling phrase in Diderot's *Prospectus* about their intellectual debt to Chambers was deliberately deleted from the published version of the *Preliminary Discourse*: "the general arrangement is the only point in common between our work and his."[27] By contrast, Diderot and d'Alembert distinguished their project from the *Cyclopaedia* by the sheer scale of their ambitions: against Chambers' two-volume work they propose multiple folio volumes of text that would eventually number seventeen. From this immense increase of scale followed the need for multiple authorship, and with this a multiplicity of diverse perspectives that ultimately were to be adjudicated through the judgment of readers following cross-references. Full implementation of the technique of cross-references both implied and enabled the increase of scale that characterizes the *Encyclopedia*.

More to our purposes, Diderot and d'Alembert explicitly imagined their system of cross-references to be extended to the huge reserve of visual material proposed for the plates. They fully subscribed to the notion that a picture is worth a thousand words:

But the general lack of experience, both in writing about the arts and in reading things written about them, makes it difficult to explain these things in an intelligible manner. From that problem is born the need for figures. One could demonstrate by a thousand examples that a simple dictionary of definitions, however well it is done, cannot omit illustrations without falling into obscure or vague descriptions; how much more compelling for us, then, was the need for this aid! A glance at the object or at its picture tells more about it than a page of text.[28]

Their original plan was to include no fewer than 600 plates in two volumes.[29] The final product was vastly more visual: 2,569 plates distributed over eleven volumes whose scope and diversity dwarfed the 30 plates of Chambers's *Cyclopaedia*.[30] Equally significant is the imagined role of this storehouse of imagery in the everyday use of the *Encyclopedia*. Diderot

and d'Alembert do not propose to illustrate every detail of a machine or every step of a process, but "have restricted them to the important movements of the worker and to only those phases of the operation that are very easy to portray and very difficult to explain."[31] They admit that an experienced artisan will probably not discover much that is new in the plates, except for some novel points of view and some observations that only become apparent after years of work. A studious reader, by contrast, will find "what he would have learned by watching an artisan operate." Moreover, each plate will be linked to an explanation "with references to the places in the rest of the Dictionary relating to each figure."[32] Here is the process of discovery through correlation imagined by D'Alembert and Diderot:

The reader opens a volume of the plates; he sees a machine that whets his curiosity; it is, for example, a powder mill or a paper mill, a sugar mill or a silk mill, etc. Opposite it he will read: figure 50, 51, or 60, etc., powder mill, sugar mill, paper mill, silk mill, etc. Following that he will find a succinct explanation of these machines with references to the articles "Powder," "Paper," "Silk," etc.[33]

There can be no more eloquent description of correlation among image, dictionary definitions, and textual explications than this scenario of an ideal user actually working with the materials of the *Encyclopedia*. Our claim is not that the *Encyclopedia* invents specific formal devices, but by foregrounding the process of discovery, and encouraging its operation, the volumes set new standards for the cognitive activity of readers able to glean from the editors' selection of plates "knowledge of the other circumstances which one does not see."[34]

The need to correlate dense and articulate systems became pressing at the historical conjuncture when they no longer could be indexed to a fixed and stable world. The *Encyclopedia*'s article on description brings this issue to the fore. Where Gotthold Ephraim Lessing and others stepped forward to debunk the system of *ut pictura poesis* that postulates an identity between word and image, the authors of the *Encyclopedia* devised a system of correlation that adopted the linear order of a dictionary but cross-cut and doubled back upon that linearity with diagram-like gestures of attention that link texts, plates, and legends in a process predicted by the *Prospectus*.[35] Our example of eye surgery suggests that

Goodman's distinction between articulate systems and dense systems no longer accounts for the complex correlations of computer-generated environments, but we do not want our point to rest solely upon contemporary advances in high-speed calculation. Rather, this book sketches from the time of the *Encyclopedia* a genealogy of visual correlation as a form of knowledge—a process aided and abetted by advances in mathematics as much as optics—that constitutes what we call the culture of diagram.

What kind of observer animates this process? What is the physical role and ontological status of this observer? What kind of observer is a surgeon who wears a head-mounted display while performing a delicate procedure? Clearly, the surgeon is not a creature alienated from his body by the scepticism of Descartes, for his gestures become scalpel cuts upon another person. Although enmeshed in machinery, the surgeon replicates neither Locke's isolation from the world in the camera obscura of understanding nor Jonathan Crary's disempowered subject of technological manipulation. Facing a complex of real-time visual displays and the digital readout of instruments, the surgeon deploys an active process of cognition that cuts across Peter Galison's distinction between picturing (image) and counting (logic). What the surgeon sees is not a mirror-like rendering of the eye. In fact, questions about visual reality or visual truth are obviated by the faith that both surgeon and patient bring to the operation. Why is this? Because the system works. Our surgeon, above all, is a user and a practitioner whose métier surely would have fascinated Diderot.

Users and métiers return us to the physical world of people and things and to the endless exchanges among them in everyday life. Things do not privilege a single vantage point, but are viewed or handled or manipulated in many different ways. People and animals—even some machines—can focus perceptual attention: objects cannot. To focus attention implies a capacity to shape the way others see the world and, by extension, the potential to shape collective views of the world by convention and education. Pictorial representation in Europe since the Renaissance is a history of possessing the world and objects in it by presenting them again (re-presenting) under controlled conditions that specify visual focus, resolution, and spatial context, among other variables. Systems of perspective—be they Alberti's one-point construct, the distance-point

method attributed by Svetlana Alpers to Dutch artists, or alternatives discussed by James Elkins—are, in our account, ways of formalizing relationships in the world. Moreover, all are diagrammatic. This shared diagrammatic basis is more trenchant than one system's positioning of a physical viewer at the center (Alberti), or another's erasure of that viewer to foster the illusion that things describe themselves (Alpers). Historically, as Samuel Edgerton shows, diagrams based on Alberti's model quickly dominated others in Renaissance Italy because his *costruzione legittima* gave "depicted scenes a sense of harmony with natural law, thereby underscoring man's moral responsibility within God's geometrically ordered universe." According to Peter de Bolla, this model continued to dominate eighteenth-century practice as a means of controlling the growing awareness of contingency attached to physical acts of viewing and the social spaces of spectating—cracks in the structure opened by the imagination. But all such perspective diagrams are functionally identical in their attempts to fill the spatial voids among people or things with an orderly intelligibility.[36]

Some diagrams are simply representational—things, processes, even people splayed open to view (FIGURE 4)—and that may or may not situate an implicit observer as spectator. Certain kinds of diagrams—from Alberti's *costruzione legittima* to Foucault's reading of Jeremy Bentham's panopticon—do dictate a dominant point of view. The diagrams that interest us, however, differ from these hierarchical models because they are situated in the world like objects: they foster many potential points of view, from several different angles, with a mixed sense of scale that implies nearness alongside distance. Scientific practice, and the perfection of instruments like the telescope and microscope, required specialized diagrams functionally more useful than perspective. Data-recording instruments might shrink the need for visual representation to a minimum, yet recorded changes in barometric pressure still must be correlated with the visual experience of cloud formations if we hope to present an adequate description of the weather. Today, meteorologists constantly refer to satellite photographs to supplement the numerical data of their instruments.

The last half of eighteenth century, as we show, witnessed a kind of warfare among systems of diagram for explanatory power. The nature of this combat becomes clear in the columns of the *Encyclopedia* article on

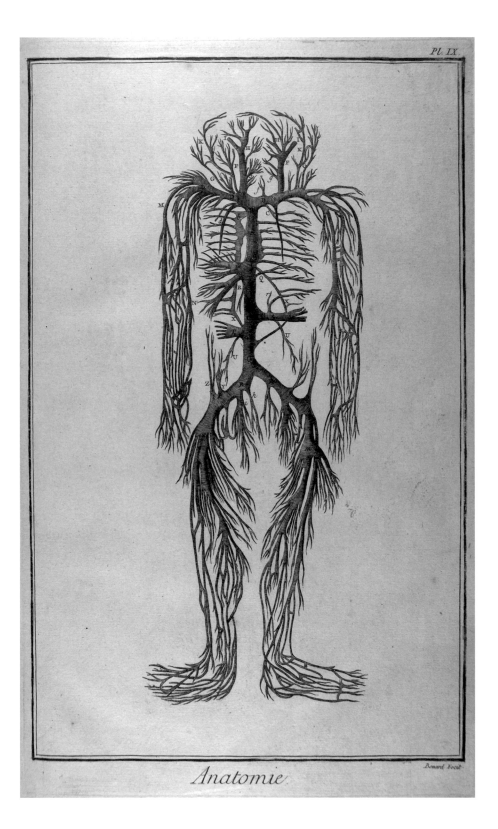

Pl. IX.

Anatomie.

FIGURE 4
"Anatomie," pl. IX. Engraving by
Robert Bénard for Diderot and
d'Alembert, *Recueil des Planches*,
vol. 1. Courtesy Department of
Special Collections, Stanford
University Libraries.
Photo: Marrinan.

description of 1754, discussed fully in Chapter 3. The article was written by four authors who posit four distinct points of view; in effect, four diagrams for describing things and their relationships to one another.[37] Louis-Jean-Marie Daubenton calls for differential analyses based on the complexity of the object under study. Edmé-François Mallet steadfastly adheres to the unities of time and place consonant with rhetoric's legislation of emotional control. Louis de Jaucourt counters with a model that privileges the emotional response (the secret emotion) that might be elicited within a viewer and escapes all such legislation. Finally, Jean Le Rond d'Alembert registers a parallel debate among contemporary mathematicians: on the surface, he endorses the accepted description of curves as figures drawn literally with the instruments of geometry, yet a cross-reference to the long article on "curves" indexes his own fascination with the prospect of purely computational descriptions using the calculus. Twenty years later, in his supplement to the original article, Jean-François Marmontel revisits the efficacy of one-point perspective by invoking the emotional impact of staged performances, which he calls *tableaux*, that unfold within a theatrical space rigorously organized by lines of sight. Marmontel's rewrite, and its context of contemporary theater and painting, is the focus of Chapter 4.

The incommensurability of these separate analyses betrays a fundamental tension within the *Encyclopedia*'s concept of description. The article performs an historical snapshot of the emerging culture of diagram that crystallizes domains of knowledge and maps the areas where descriptive representation reaches its disciplinary limits. The *Encyclopedia*'s innovation lay in the ambition to bridge those limits, in both its texts and plates, with a new emphasis upon a correlation [rapport] of data. Its ability to achieve this goal was limited to the media resources of print culture. Barbara Stafford recognizes Diderot's "concrete habit of putting all sensory and intellectual domains in imaginative and dialogical communication with one another," yet she insists upon a "trivialization, denigration, and phantomization of images" that led to their "theoretical marginalization."[38] Although Stafford acknowledges the complexity and nascent modernity of the *Encyclopedia*'s visual arrays, she underscores the "hygienic severity and emotional restraint" of their settings as arenas for "a choreography of tidy gestures."[39] This austere version

of the science of the *philosophes*, which Stafford contrasts to the sensuous variety and tantalizing magic effects of popular pseudo-science demonstrations, diverges from our reading of the plates as richly textured pictorial and diagrammatic objects.[40] The plates materialize the sensuous feel of engraved printing while mapping correlations among people, places, and things to produce a fulsome, extra-optical understanding of the practices, métiers, and products of contemporary life.

In our view, the intellectual project of the *Encyclopedia* is not ensnared in the word–image opposition that preoccupied so many mid-eighteenth-century thinkers, memorably summarized by Lessing. We believe it transcends what Stafford calls a "continuing pictorial impotence" in the face of a "linguistic hegemony."[41] The *Encyclopedia* sidesteps a simple word–image dualism by invoking the power of mathematics to open a conceptual space for correlations neither rooted in direct experience nor verifiable by the senses. This conceptual opening, which is crucial to our account, is mentioned only briefly in d'Alembert's contribution to the article on description. He gestures to a future mathematics of transcendental curves—objects of knowledge not occurring in nature—that might allow non-visual correlations among experiential phenomena. The post-d'Alembert history of mathematics as a tool of description is one of increasing attention to and reliance upon non-experiential modes of understanding: models of correlation extrapolated from verifiable data are replaced, albeit with intense disagreement among scientists, by predictive models based on probabilities. Such procedures challenge fundamentally the mechanistic and causal view of the world that prevailed in Newton's wake. Predictive models, in turn, laid the groundwork for quantum mechanics and the study of phenomena that are visible—if at all—for only a few millionths of a second in specialized viewing chambers. Although existing at the limits of visibility, the reality of such phenomena can be apprehended only by mathematical formulas. The unfolding of the culture of diagram, as discussed in Chapter 5, hinges upon the emergence of mathematics as the single most powerful tool for the correlation of dissimilar forms of data.

Correlation is a search for relationships among variables, and its success is measured when a convergence of data is recognized. Such a convergence might be actual, as when pressing a doorbell brings your

friend to a third-floor window and elicits a cry of salutation. It might be graphical, as when the curve of measured humidity crosses the plot of ambient temperature. It might be purely mathematical, as when several equations intersect to define a set of shared variables, or practical, as when an architect uses a CAD program to define the possible undulations of a load-bearing wall. Today, correlations can also be virtual, as when computer-driven systems of imaging, data collection, and mathematically drawn vectors plot digitally a non-existent space to create the experience of flying an airplane or performing eye surgery.

High speed mathematical correlations in real time are the motors of virtual reality environments, and they underpin our surgeon's voyage to the center of his patient's eye. Importantly, the surgeon does not master the situation—the computer forbids any false move—but rather exercises a métier from within a fully integrated diagrammatic matrix. The surgeon's ability to correlate the complex flow of data appearing in the headset depends upon his active participation in a process that suspends human will to the extent that it is driven by instruments. Immersion in a virtual environment is not a form of advanced perspective domination— not the ultimate mimetic representation—but simply the performance of an assigned role within a complex convergence of words, images, numerical data, and synthesized touch. We might say that virtual environments take seriously the objectness of diagram by producing an experience that cannot be reduced to a single point of view—in the high-speed correlations of virtual reality, Diderot's *rapports* become homologous with the world itself.[42]

DIAGRAM

<div style="text-align: right">2</div>

How do diagrams work as objects? How can diagrams be objects to think with? These are large questions and difficult to broach in the abstract. To approach them means attending to the perceptual skills and habits with which we apprehend and understand representations in general. Treating diagrams as things in themselves means giving up the notion that they are simply abstractions of reality, stripped down versions of the world of experience. In this chapter we want to situate diagrams within experience and to map the chain of thoughts and gestures of attention that give them meaning.

We begin with an information-rich painting by François Desportes (FIGURE 5 / PLATE 3). Desportes sets before our eyes a richly carved silver dish with fruit reflected panoramically in two highly polished silver platters. A luxurious, marble-topped commode visible at the lower right forms a table of presentation. A thick velvet curtain disguises most of the table and rises behind the arrangement to merge with the vertical planes of the spatial container. The slightly chipped stones of a wall suggest an architectural opening toward the right, but three dead partridges discourage us from penetrating this space. An elaborate ewer backed by a platter further

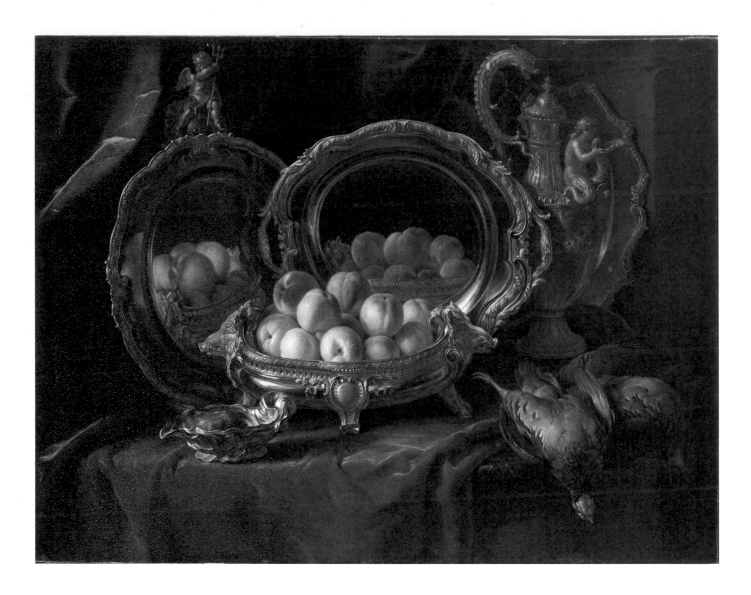

FIGURE 5

François Desportes, *Silver Tureen with Peaches*, n.d. Oil on canvas. Stockholm, Nationalmuseum, inv. NM 800 (91 × 118 cm). Photo: © The National Museum of Fine Arts, Stockholm.

DIAGRAM

21

limits our exploration of the surrounding context. Desportes completely fills the spatial box of the picture with an intelligible arrangement of things: his presentation of the peaches is staged with an artifice quite unlike everyday appearance. The still-life—a delicious object in itself—orchestrates a wealth of visual information. Yet every element is returned to a single point of view from which we could choose a peach at the back of the dish without changing position. This implied facility of movement only obscures the absolute fixity of our placement before the picture. By contrast, a real bowl of peaches can be approached from literally hundreds of directions.

Most visual diagrams are ranged upon a flat planar surface similar to Desportes's canvas, but they multiply points of view by presenting arrays rather than legislating the single view of a replete spatial environment. Diagrams incite a correlation of sensory data with the mental schema of lived experience that emulates the way we explore objects in the world. They are closer to being things than to being representations of things. Consider the *Encyclopedia*'s plate of a pastry-maker's shop (FIGURE 6) alongside the aestheticized and sealed world of Desportes's peaches.[1] The upper part offers a view of the workroom in which many objects and ingredients—including game birds and a wild hare—are arranged on tables, displayed on shelves, and hung on the walls of a clearly articulated spatial box. The sheer number of things produces an orderly clutter, but there are very many spatial voids: the empty foreground; the implied openings both left and right; and the measurable distances among work stations where each figure performs a specialized task. Desportes's still-life closely links a cohort of adjoining objects to produce a claustrophobic space. The components of the pastry shop are isolated spatially and functionally from one another; they offer themselves to multiple regards and users, and they generate an emptiness that invites movement.

In the lower part of the pastry plate one re-encounters up close, and from several different angles, some implements visible in the workroom's overall view. The kneading station, nearly hidden in the general tableau, appears below in a three-quarters view that clarifies its size and features of use. The kneading station is seen in perspective, but its relationship to the spatial box of the upper tableau must be extrapolated. Conventions of rendering appear to capture the object's three-dimensionality, but without displacing any measurable volume: there is

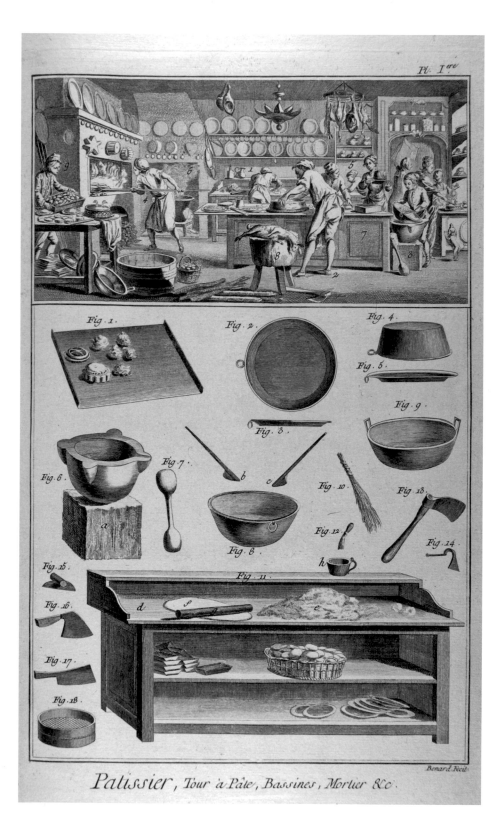

FIGURE 6
"Patissier, Tour à Pâte, Bassines,
Mortier, &c," pl. I. Engraving by
Robert Bénard for Diderot and
d'Alembert, *Recueil des Planches*,
vol. 8. Courtesy Department of
Special Collections, Stanford
University Libraries.
Photo: Marrinan.

DIAGRAM

23

no place to stand before the kneading station and it casts no shadows onto the surrounding white surface. This paradoxical notation signals to an attentive viewer that the white of the page is neither a void nor a space but simply a material whiteness.[2] This whiteness is an arena of potentiality that fosters connections without fixing them or foreclosing thought experiments. Numbers near objects lie on the white surface and index explanations in the accompanying legend. Volumetric renderings perforate the whiteness with the materiality of things in space and promote visual correlations with their appearance in the general view.[3] This whiteness permeates the plates of the *Encyclopedia* and characterizes their mode of description. It serves as the medium for mimetic simulations inside perspective tableaux, and as a neutral field of presentation for the floating world of visual catalogues that makes up the other sectors of the plates. This whiteness is the field of Diderot's *rapport* that we call correlation. We take it be a virtual space whose material presence—which joins together the disparate parts of the *Encyclopedia* plates—provides support for the composite play of imagery and cognition that is the motor-energy of diagram.

The *Encyclopedia*'s preoccupation with technique privileges an imagined, tactile manipulation of things as a powerful mode of correlation. The plate on pastry-making specifies correct practical applications of its tools, and we do track the kneading stand and other objects in use as specified in the legend. At the same time, correlation permits flexibility, both in our passage through the white field of display to the space of use and in our awareness of the creative misuse of tools. The heavy stone mortar on its wood block, for instance, becomes in the image of the shop a perfect support for the copper basin in which a young man beats egg whites. The white field of display below and the white space of work above are conceptually discontinuous, yet the whiteness joining them supports projections and correlations that would otherwise escape the habits of normal use.

The spaces of work depicted in the plates of the *Encyclopedia* recall mimetic representations in genre painting, alongside objects catalogued in white fields of display. We do not naturalize the plates in this way. Rather, we underscore the separateness of their visual compartments to keep alive the idea that diagrams de-naturalize things in order to open

DIAGRAM

24

up spaces for creative misuse. A picture like Jean-Baptiste-Siméon Chardin's *The Copper Fountain* (FIGURE 7 / PLATE 4) shares accidental affinities with the plates, for it also sets objects on a simple table of presentation against a nearly flat, undifferentiated field of color. Nonetheless, contrasts between the plate and the Chardin can sharpen our argument about diagram. Color is the most salient difference, but closely associated is the play of light and shade, which shapes Chardin's intimate cor-

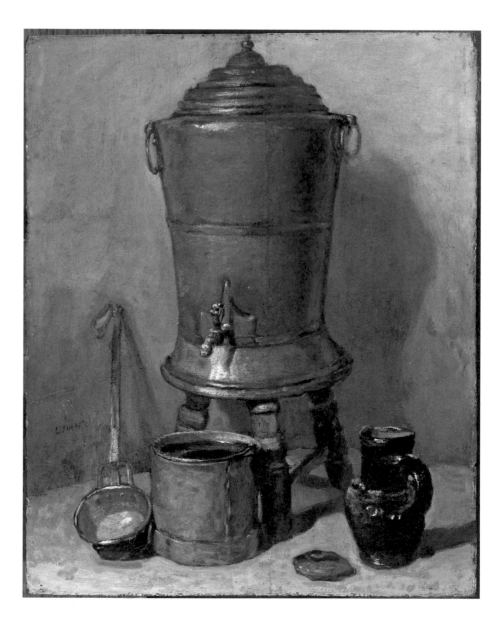

FIGURE 7

Jean-Baptiste-Siméon Chardin, *The Copper Fountain*, n.d. Oil on wood. Paris, Musée du Louvre, inv. MI 1037 (25.8 × 23 cm). Photo: © Réunion des Musées Nationaux / Art Resource, NY / © Gérard Blot / Hervé Lewandowski.

DIAGRAM

25

ner of the world more subtly than strict geometric perspective. Chardin's light falls evenly across everything, casting shadows that relate objects to one another and to their shared space before the background wall. Light in the pastry plate diffuses differentially. It enters strongly from the right and casts a pattern of commonsense shadows throughout the workshop, but no such regularity prevails in the section of whiteness below, where each tool receives its own light and casts no shadows. Chardin's objects live within a fixed formal order where the cistern and its attendant objects describe an obvious pyramid of shapes. They also imply a story of everyday use. As we scan from the dipper at the left, to the bucket under the spigot, and onto the pitcher and its cover at the right, the activity comes to mind of filling a water pitcher for use at table.

Chardin's pointed rendering of a dull sheen on the surfaces and edges of each object suggests the patina of wear produced by repeated enactments of such ritual gestures over many years. The picture is a still-life [nature morte], but its visual markers activate the objects with an aura of past history and distant times. The pastry plate (FIGURE 6) actually depicts the use of objects, yet its several activities are not choreographed into a coherent narrative thread. The workers perform their separate tasks with such great attention that they are almost oblivious to one another's presence—an effect of isolation broken only at the far right where an attendant cuts a pâté for a customer. The plate freezes several discrete actions as if in an instant, denying the passage of time and the physical contingencies of production.[4] Unlike Chardin's objects, those of the *Encyclopedia* plate show not the least sign of wear. This lack of patina is a striking erasure within the *Encyclopedia*'s plates, an absence that suggests these images do not index a past time but activate the here and now of present encounter. To imagine dipping water from Chardin's bucket to fill the pitcher associates us with the history of those who have done so before or will come after. By contrast, the plate engages us with techniques stripped of a visible history, practices that start afresh each time and remain perpetually new.

II

Dislocating the plates from the task of representation to an existence akin to objects places them in a visual culture of print media not circumscribed

DIAGRAM

26

by the demands of technical illustration, not dominated by the structure of language, and not isolated as aesthetic objects. The distinctive gain of this approach becomes clear if we consider Roland Barthes's discussion of the pastry-making plate.[5] In the lower part of this image he finds "the ensemble of various instruments necessary to the profession," each "inert, frozen in its essence . . . analogous to the quasi-academic form of a verbal or nominal paradigm." By contrast, the vignettes present the object and its varieties "in a lively scene . . . linked to other objects within a real situation: here we rediscover the syntagmatic dimension of the message."[6] Barthes's view of the plates is built upon a structuralist theory that maps language along two axes: a paradigmatic axis that allows for substitutions and metaphors; a syntagmatic axis that makes possible the expression of time and action. "The *Encyclopedic* image," he writes, "is human not only because man is represented in it but also because it constitutes a structure of *information*. This structure, though iconographic, is articulated in most instances like real language (the one which, in fact, we call *articulate*), whose two dimensions as revealed by structural linguistics it reproduces."[7] Barthes's linguistic model of the *Encyclopedia* plates effaces their problematic visual fissures. In his account, they display neither more nor less discontinuity than everyday language, despite a later declaration about their monstrous poetics.

Barthes never sacrifices the "progress of reason." The plates retain a "logical character" in which "the image analyzes, first enumerating the scattered elements of the object or of the operation and flinging them as on a table before the reader's eyes, then recomposing them, even adding to them the density of the scene, i.e., of life." Barthes begins by asserting, in the tradition of Lessing, that the plates differ from the texts of the *Encyclopedia*. The plates mobilize reading without the single logical vector that the linearity of language requires.[8] He claims for the plates "a precious circularity: we can read them starting from the experiential or, on the contrary, from the intelligible: the real world is not reduced, it is suspended between two great orders of reality, in truth, irreducible orders."[9] Although the plates are visual forms, they are suspended—like language—between the two great orders of experience and intelligibility. This is why Barthes breaks them down into paradigmatic and syntagmatic components. His homology betrays a deep-seated bias for *reading*

DIAGRAM

27

the plates, regardless of the order in which they are perceived. Readability—indeed, *narrativity*—is, for him, the essential component of their value as information.

Barthes eventually develops a "poetics" for the plates, by which he means "the sphere of the infinite vibrations of meaning, at the center of which is placed the literal object." The images repeatedly animate a vibration of astonishment in viewers, an effect he characterizes with a specific example:

Consider the astonishing image of man reduced to his network of veins; here anatomical boldness unites with the great poetic and philosophic interrogation: *What is it?* What name to give it? How give a name? A thousand names rise up, dislodging each other: a tree, a bear, a monster, a hair shirt, a fabric, everything which overflows the human silhouette, distends it, draws it towards regions remote from itself, makes it overstep the divisions of Nature; yet, just as in the sketch of a master, the swarm of pencil strokes finally resolves into a pure and exact form, perfectly signifying, so here all the vibrations of meaning concur to impose upon us a certain idea of the object.[10]

Barthes's question "what is it?" before the *Encyclopedia*'s rendering of the human venous system (FIGURE 4) quickly becomes a problem of *describing* the graphic image: "What name to give it? How give a name?" Faced with a set of bewildering marks on the page, Barthes recognizes that many names are possible, but he avoids open-ended reading by adopting a vocabulary of connoisseurship —"just as in the sketch of a master." After a moment's hesitation he accedes "to that great undifferentiated substance of which verbal or pictural poetry is the mode of knowledge," and he concludes, "the iconography of the *Encyclopedia* is poetic."[11] In the end, Barthes's appreciation is aesthetic.

Despite his best efforts to locate and to name an underlying unity in the plates of the *Encyclopedia*, Barthes often lingers on their peculiar discontinuities. He notes that the plates transgress nature by offering monstrosities in the guise of explanations, yet he de-radicalizes the implications of monstrosity: "all these transgressions of Nature make us understand that the poetic (for the monstrous can only be the poetic) is never established except by a displacement of the level of perception." Paradoxically, Barthes brackets these variations with normalizing

DIAGRAM

28

aesthetic categories, even while recognizing "it is one of the *Encyclopedia*'s great gifts to *vary* (in the musical sense of the term) the level on which one and the same object can be perceived, thereby liberating the very secrets of form." He is fascinated by the shifting scale and points of view within the plates, such as the monstrous flea or labyrinthine snowflake, but he confines his responses to the closely guarded enclave of the aesthetic: "is poetry not a certain power of *disproportion*, as Baudelaire saw so well, describing the effects of reduction and focusing that hashish induces?"[12] Many plates do juxtapose sensibilia—as if recorded by instruments or from synthesized points of view—to data of a human scale and range. These visual arrays of new and sometimes surprising forms of knowledge need not be perceptual, much less aesthetic.

Barthes does acknowledge the disruptive epistemology of the plates:

It is the *Encyclopedia*'s wager (in its plates) to be both a didactic work, based consequently on a severe demand for objectivity (for "reality"), and a poetic work in which the real is constantly overcome by *some other thing* (the *other* is the sign of all mysteries). By purely graphic means, which never resort to the noble alibi of *art*, Encyclopedic drawing explodes the exact world it takes as its subject. . . . In its very order (described here in the form of the syntagm and the paradigm, the vignette and the bottom of the page), the Encyclopedic plate accomplishes this *risk* of reason.[13]

For Barthes, the two-part visual structure of many plates produces a transcendent "opening up" of Nature and generates "a kind of wild surrealism" at the heart of an ostensibly didactic program. Yet their disruptive, mixed-up world, their fascination with the "*wrong side* of things," never escapes intelligibility, because Barthes frames their two-part visual arrays—the vignettes and the analytic images—as simply mirroring the double articulation of language.[14]

A lens of astonishment, wonderment, and violence is one device to understand a plate like the anatomized hand and foot (FIGURE 8). A linguistic paradigm might also work here because of the need to decipher the nearly unintelligible view of a foot's underside. The letters and numbers keying individual parts to the printed legend also imply decipherment. Surely, paradigmatic and syntagmatic dimensions are at work, though not in Barthes's favored configuration with a tableau at the top and a visual

DIAGRAM

29

catalogue below. Our understanding of diagram expands Barthes's ability to read across a variety of plates. We do not focus on individual images or localized groupings, but emphasize improvised visual comparisons among them. Such correlations, which leap across categories and break out of the discrete parcels of plates in related groupings, test the limits of Barthes's treatment.

The plates on "Dessein" are examples that fit neither with Barthes's system of astonishment and violence nor with his linguistic paradigm. He is little interested in such plates. Our visual theory of diagram attends to the nearly invisible internal ruptures in the plate showing legs and feet (FIGURE 9). Two separate renderings of legs in space merge imperceptibly as if they formed one tableau, while front and profile views of a foot are presented above in annotated drawings. The scaled measurements under the pair of feet at the top of the page imply a realm analogous to the visual catalogue of more overtly divided plates, but this domain bleeds across the whiteness to merge with the highlighted mass of a three-dimensional leg. Just as in the pastry-making plate, a material whiteness posits diagrammatic potential and permits a leap from the plate of legs and feet to that of hands (FIGURE 10). In this plate, four disembodied hands caught in different gestures are rendered in localized spaces: truncated shadows situate the fragment and shape physical volumes modeled by light. But the shadows dissolve almost immediately into white and are linked across the blank field, both to one another and to a fifth hand modeled in light, annotated with letters, yet casting no external shadows. The whiteness provokes an almost imperceptible switching between tableau and visual catalogue—Diderot's *rapport* in action. It also enables an even greater leap—back a full two volumes of plates—from the "Dessein" rendering of hands (FIGURE 10) to that of "Anatomie" (FIGURE 8). When diagrams are treated as material objects, their entire surface plays a role and whiteness is never a void. Switching between disciplines like drawing and anatomy becomes standard procedure in a process of correlation that produces new forms of knowledge and understanding. When anatomy's insider view of the hand is put against the surface we live with in daily life, the user is reminded of his or her physical being and cognitive activity: this awareness is located in neither of the images separately, but only comes alive in the activity of correlation.

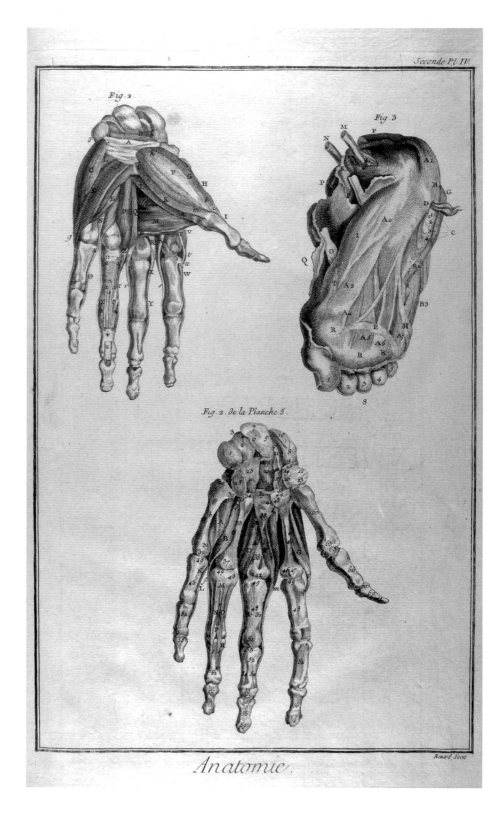

FIGURE 8
"Anatomie," pl. Seconde IV.
Engraving by Robert Bénard for
Diderot and d'Alembert, *Recueil
des Planches*, vol. 1. Courtesy
Department of Special Collections,
Stanford University Libraries.
Photo: Marrinan.

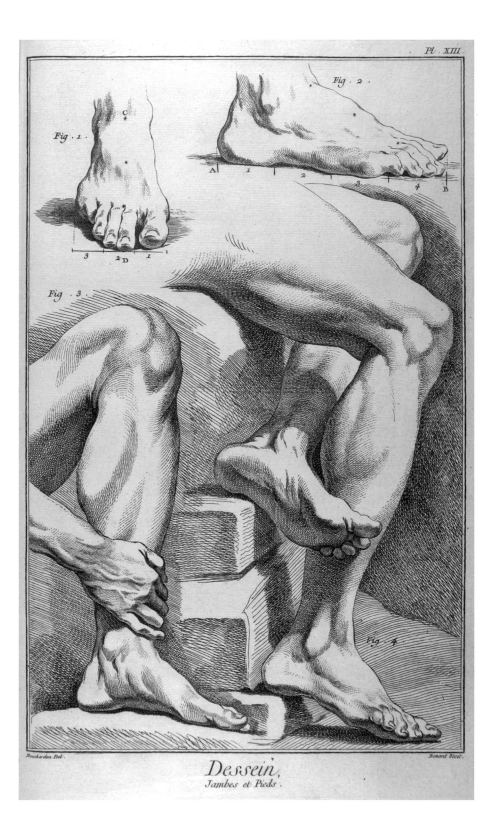

FIGURE 9

"Dessein, Jambes et Pieds,"
pl. XIII. Engraving by Robert
Bénard after a design by Edmé
Bouchardon for Diderot and
d'Alembert, *Recueil des Planches*,
vol. 3. Courtesy Department of
Special Collections, Stanford
University Libraries.
Photo: Marrinan.

DIAGRAM

32

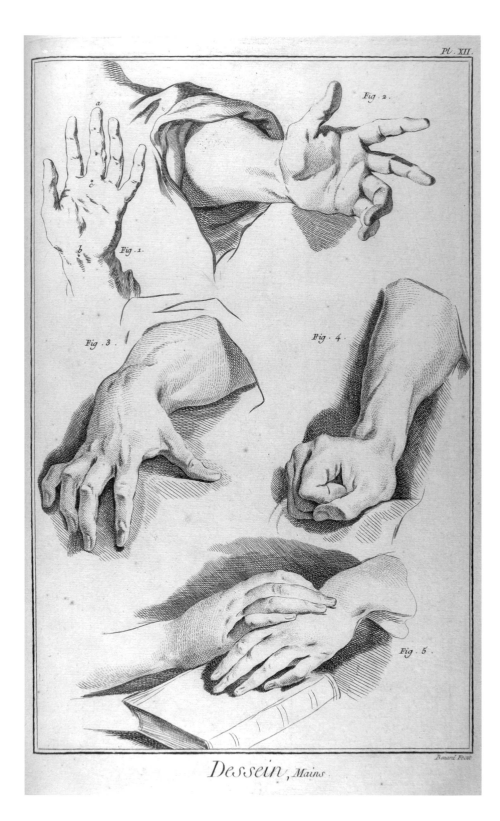

DIAGRAM

33

Barthes asked, confronting the plate of the human venous system, "How give a name?" We want to name such images *diagrams*, an ordinary term that offers a powerful tool for articulating the radical nature of description within the pages of the *Encyclopedia*. We take diagrams to be visual forms of description that make few concessions to imitation, meaning by "imitation" a staging of content as if belonging to a world both contiguous with and similar to our own. Our view of diagrams aligns them functionally with the "working objects" of late-eighteenth-century atlases discussed by Lorraine Daston and Peter Galison. "If working objects are not raw nature," they write, "they are not yet concepts, much less conjectures or theories; they are the materials from which concepts are formed and to which they are applied."[15] Daston and Galison are concerned with the specific genre of scientific atlases as part of a larger project to "chart the emergence and nature of new conceptions of objectivity and subjectivity" across the nineteenth and early twentieth centuries. Their account underscores the period's attempts to achieve the balance between individual and type that was deemed essential for an effect of "objectivity." Eighteenth-century atlas-makers short-circuited the idealization and aesthetic interpretation of artists by enlisting grids, measurements, and devices like the camera obscura. Daston and Galison suggest that atlases "be seen as a hybrid of the idealizing and naturalizing modes: although an individual object (rather than an imagined composite or corrected ideal) is depicted, it is made to stand for a whole class of similar objects." The hybrid of "idealizing" and "naturalizing" seen by Daston and Galison in atlases corresponds historically to the productive discontinuity established by the use of visual catalogues and tableaux in the diagrams of the *Encyclopedia*. This point will become clear after we explain the stakes involved in these terms.

III

Both visual catalogues and tableaux present information in iconic form. Both organize their information according to some internal hierarchy of importance. Both establish a sense of scale relative to other things in the world. And both assume some kind of viewer or perceiver of the information presented. Tableaux, as in the example of Chardin's *Copper Fountain*, characteristically locate this information in a fictive world that

DIAGRAM

34

resembles in space and scale the world of human experience. Tableaux assume that viewers are human beings endowed with normal perceptual skills. More important, tableaux maintain a fixed and stable relationship among hierarchies of importance, scalar references, and assumed viewers. Visual catalogues, in contrast, vary the constituent elements of hierarchy, scale, and subjective orientation independent of one another. They provide information about things that lie outside the range of normal human perception, draw parallels among things that vary widely in size or function, and report data indifferently, like instruments.

Diagrams align, juxtapose, and contrast two kinds of information: on the one hand, the autonomous bursts of data that characterize visual catalogues; on the other, the uniform flux of homogenous information provided by tableaux. Explanatory texts keyed to the imagery may attempt to stabilize this flux of information and may be an integral element of diagrams. But language cannot fully specify all of the ways in which users employ diagrammatic material. This unspecified interaction of varied components generates kinds of knowledge impossible to infer from any one element: the pastry-making plate as a whole is a *diagram* of the trade, not simply a genre-like rendering of its practice nor an inventory of its specialized implements.

Our scheme, which places visual catalogue and tableau under the aegis of diagram, establishes a new context for the idea of tableau. The illusionist "spatial box" of post-Renaissance Western European painting has been the dominant form of visual organization in Europe since the late Middle Ages, and remains a preferred model for presenting visual information.[16] To chart the affinities between visual catalogues and tableaux is to recognize that the geometric armature of one-point perspective theorized by Leone-Battista Alberti, along with the distant-point perspective systems favored by Dutch artists, are themselves diagrams. Alberti's theory synchronizes assumptions of hierarchy, scale, and the coherence of a viewer's perceptions of the world to promote a humanist subject for whom visual information is organized.[17] The Albertian diagram of vision was peculiar, for it closed down rather than opened up the possibilities of correlation by replacing the plenitude of the world with a geometry of sight, a conic field of vision imprisoned before a peep-hole: the user of his diagram has but one choice.[18] The distance-point system of perspective

DIAGRAM

35

dispensed with the absolutism of Alberti's conic scheme to offer a wider range of descriptive possibilities that attends to individual objects rather than ordering empty space. It does not refer the world to a single point of vision, but assumes that the world is ordered and offers users several avenues of correlating and understanding that order. By contrast, the diagrams deployed in the *Encyclopedia* present phenomena of everyday life without foreclosing the potential for many views, thus leaving open numerous opportunities for users to make personalized correlations.

The complexity of diagram in the *Encyclopedia* unfolds in the images on "Agriculture" that launch the entire collection of plates with the fundamental life activity of plowing and sowing. The series opens with a tableau much larger than the vignettes typical of the métier plates (FIGURE 11). This image vacillates between a distance-point rendering of space in the manner of Dutch landscapes and a visual catalogue, grounded on whiteness, where two stages in the development of agricultural technology are presented. At first glance, the landscape seems to unfold from near to far with a conventional foreground, middle ground, and background. Ruins of a fortress on the hill establish an historical past as well as the horizon. The village nestled beneath signals contemporary habitation. But this smooth progression of historical time is interrupted by another chronology: in the middle ground appears a cluster of figures far too large for their placement in perspectival space. Legends help us to understand these anomalies of scale, but they interject a present time of reading that collapses temporal distance. Here, men plant crops in three independent operations: one casts the seed by hand, one guides a harrow, and a third compacts the ground with a roller. A row of bushes and a dilapidated fence separate the middle from the immediate foreground. In this sector, two even larger figures appear in profile across the plate and, as the legend declares, practice a new form of planting. The woman guides a device designed by the abbé Soumille that drops seeds at regular intervals in a straight line. A man with a modern plow traces the same line to cover the seeds immediately.

The picturesque inhabitants of the plate appear to domesticate a natural environment that is coherent in time and space, like a painting by Ruisdael (FIGURE 12 / PLATE 5). But such a comparison underscores how Ruisdael's corner of the world is knit together as an organic whole that

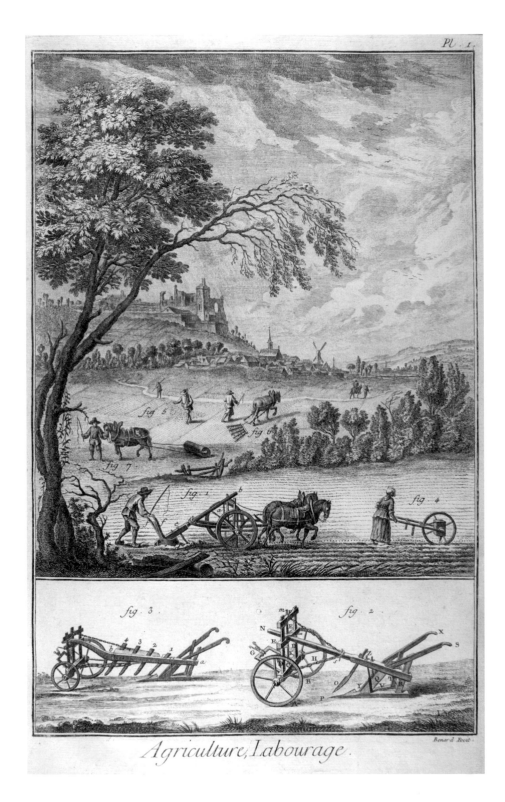

FIGURE 11
"Agriculture, Labourage," pl. I.
Engraving by Robert Bénard for
Diderot and d'Alembert, *Recueil
des Planches*, vol. 1. Courtesy
Department of Special Collections,
Stanford University Libraries.
Photo: Marrinan.

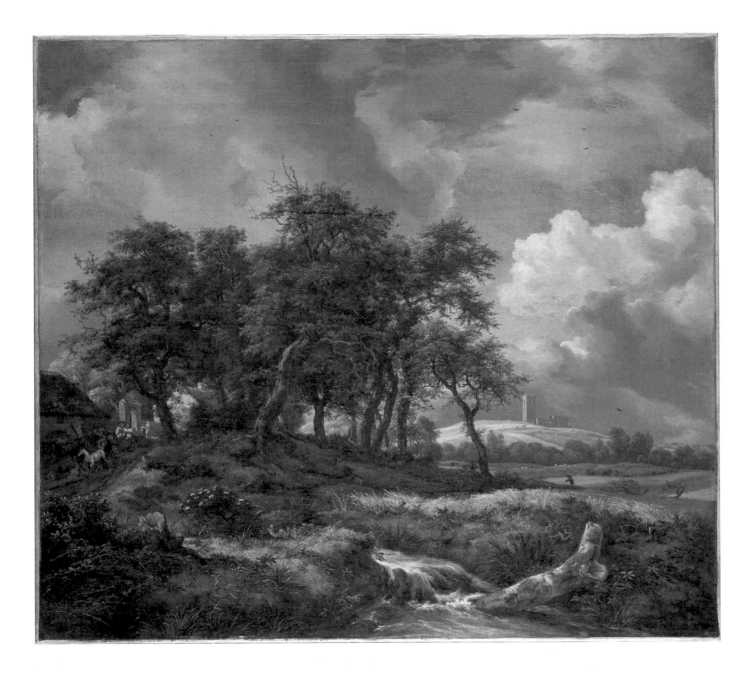

FIGURE 12

Jacob van Ruisdael, *Landscape near Muiderberg*, ca. 1652. Oil on canvas. Oxford,
Ashmolean Museum, inv. A875 (66 × 75 cm). Photo: Ashmolean Museum, Oxford.

DIAGRAM

38

resists analytic parsing: his picture offers a complex play of light and shade animated by the natural forces of wind and water. By contrast, the pastoral unity of the plate fractures visually into two zones of bright light—separated in time and space—where the progress of agricultural technology is catalogued and demonstrated. Here, in the first image among the *Encyclopedia*'s thousands, the framing devices and visual unities of landscape representation yield to the formal requirements of a correlation designed to explain. This upper segment achieves at a stroke the double optic united by whiteness of the bi-partite pastry-maker's plate (FIGURE 6).

The lower section of the first "Agriculture" plate both reveals and extends the complications implicit in the upper part. Two examples of plows—an "ordinary" type and an "improved" version designed by Monsieur Tull—are situated on a ground plane marked by tufts of grass upon which they cast shadows. In this part of the plate the whiteness hovers in a state of suspended reference: are we to connect it to the areas of pure white in the image above and read it as infinite space, or should we relate it to the pervasive whiteness of plate II (FIGURE 13) and understand it as the virtual space of a visual catalogue? The choice is left open. We can read the *dédoublement* of signification in either direction, but doing so relativizes our physical relationship to the objects: passing from the upper section of the first plate to the scaled images of plate II, by way of the lower section of plate I, carries us across a continuum of whiteness that releases us from a single point of view. In the second plate the space-making effects of directed light and shadow are almost eliminated, leaving only a few odd and schematic shadows to erupt sporadically from beneath the plows. As we move through plates II, III, and IV (FIGURES 13, 14, 15), the equipment demonstrated in the first loses its context of use. In plate IV (FIGURE 15) it is disaggregated into component parts and revealed in multiple points of view upon the whiteness of a page conceptually resized by scales of reference. Here, the physicality of objects and their use is leached away and natural light struggles to cast token instances of shadow. We, however, are allowed to see with a clarity and precision not part of everyday life. Whiteness, the catalyst that binds tableau to visual catalogue, enables a trenchant knowledge that is the descriptive gain of the graphic economy of diagram.

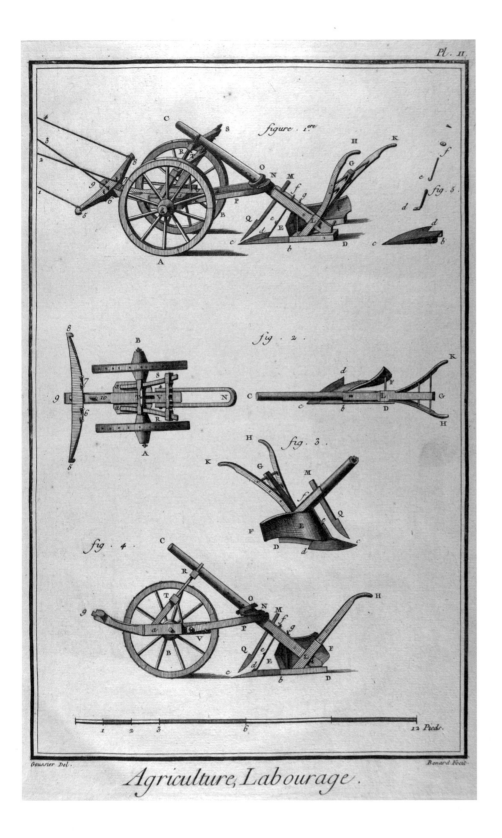

FIGURE 13

"Agriculture, Labourage," pl. II.
Engraving by Robert Bénard after
a design by Louis-Jacques Goussier
for Diderot and d'Alembert,
Recueil des Planches, vol. 1.
Courtesy Department of Special
Collections, Stanford University
Libraries. Photo: Marrinan.

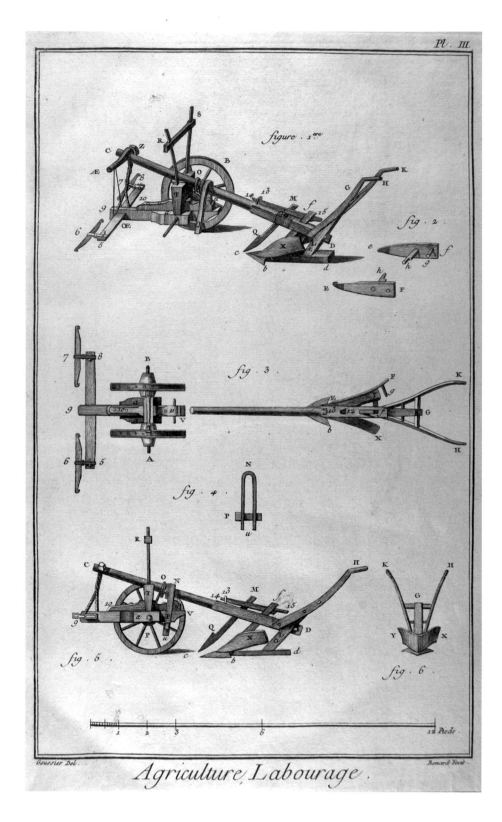

FIGURE 14
"Agriculture, Labourage," pl. III.
Engraving by Robert Bénard after
a design by Louis-Jacques Goussier
for Diderot and d'Alembert,
Recueil des Planches, vol. 1.
Courtesy Department of Special
Collections, Stanford University
Libraries. Photo: Marrinan.

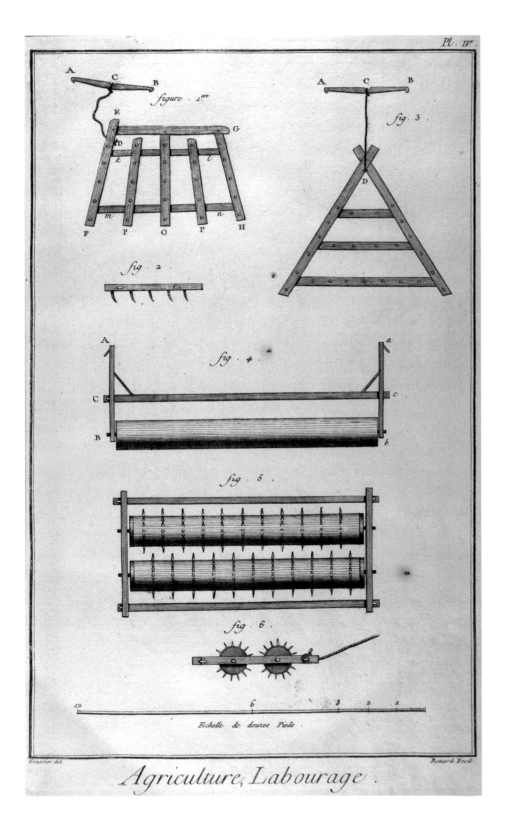

FIGURE 15
"Agriculture, Labourage," pl. IV.
Engraving by Robert Bénard after
a design by Louis-Jacques Goussier
for Diderot and d'Alembert,
Recueil des Planches, vol. 1.
Courtesy Department of Special
Collections, Stanford University
Libraries. Photo: Marrinan.

DIAGRAM

42

Although it is commonplace to dwell on the plates rendering métiers such as pastry-making, the *Encyclopedia*'s diagrammatic strategies appear most vividly in hybrid examples such as those dedicated to hunting, choreography, and military maneuvers. The plates of "Chasse, Venerie" (FIGURES 16, 17, 18) mark a clear-cut departure from the word–image dichotomy usually associated with annotated illustrations.[19] The descriptive density of these plates links vignette, writing, and notation into a web that demands intricate, highly interactive decipherment, pushing the graphical medium to its diagrammatic limits. Each plate consists of a conventional tableau at the top, strongly marked off from the rest of the image by an inner frame. The conceptual insularity of these vignettes is underscored by the absence of annotations keyed to texts or legends. Crossing the internal frame of these plates is akin to moving from a realm of visual illusion to a domain of indexical allusion and pure notation. Unlike the isolated kitchen tools or dismantled farm implements displayed in plates about pastry-making or plowing, the largest areas of the hunting plates record signs: antlers and piles of dung dropped in the forest by stags of different ages; the graphic evidence of hoof prints left in the forest by their passage; the engraved musical scores of notes sounded at different stages of the pursuit. Sentence fragments above the musical staves indicate when the various tones should be played, but taken as a whole the hunting plates offer few clues for reading their complex hybrid of imagery and notations as an ensemble. In this case, diagrammatic whiteness cannot mediate the conceptual discontinuity of the parts. As if signaling this failure, the three plates of stag hunting are accompanied by a long expository account that requires nearly ten pages of printed text. The *Encyclopedia*'s treatment of stag hunting is extraordinary for mobilizing a full range of written language, abstract and arbitrary notations, indexical icons, and pictorial tableaux in an attempt to diagram the highly ritualized, courtly craft of tracking animals under the Ancien Régime.

Surprisingly, the long narrative attached to the hunting plates hardly mentions the musical scores that figure so prominently in the images. In contrast, the hoof prints, feces, and antlers are subject to detailed analyses with instructions about how to read the age and health of the animals from these indexical signs. Why are the scores so visually important and so narratively neglected? One possible answer is to see them as attempts to

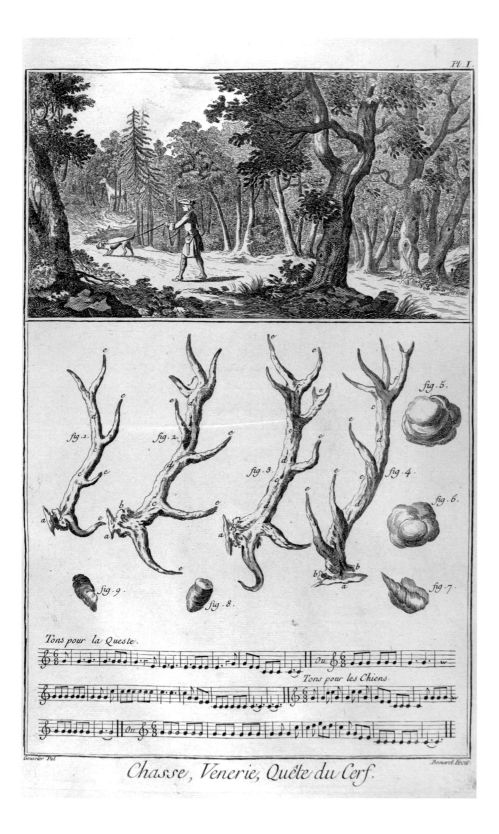

FIGURE 16
"Chasse, Venerie, Quête du Cerf," pl. I. Engraving by Robert Bénard after a design by Louis-Jacques Goussier for Diderot and d'Alembert, *Recueil des Planches*, vol. 3. Courtesy Department of Special Collections, Stanford University Libraries. Photo: Marrinan.

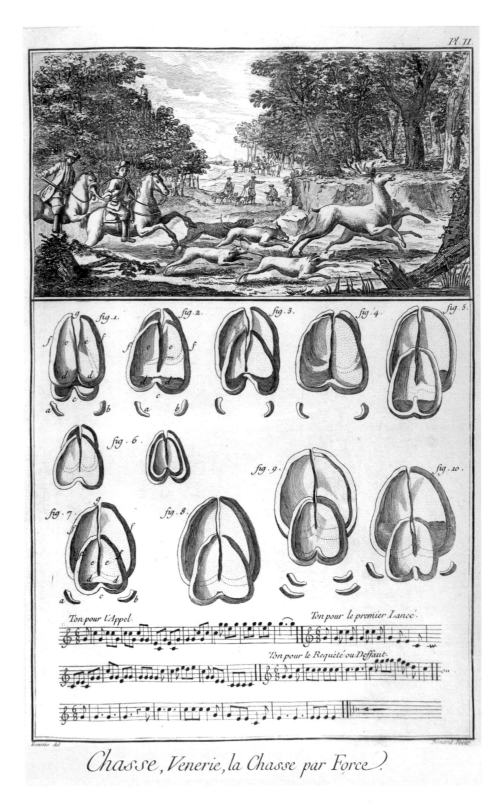

FIGURE 17
"Chasse, Venerie, la Chasse par Force," pl. II. Engraving by Robert Bénard after a design by Louis-Jacques Goussier for Diderot and d'Alembert, *Recueil des Planches*, vol. 3. Courtesy Department of Special Collections, Stanford University Libraries. Photo: Marrinan.

FIGURE 18
"Chasse, Venerie, la Curée,"
pl. III. Engraving by Robert
Bénard after a design by Louis-
Jacques Goussier for Diderot and
d'Alembert, *Recueil des Planches*,
vol. 3. Courtesy Department of
Special Collections, Stanford
University Libraries.
Photo: Marrinan.

DIAGRAM

46

invest the static, graphic image with two essential elements of narrative—episode and duration—without completely succumbing to the power of language. Words are used above the staves to mark off parts of the musical score according to the formal sequence of the hunt. The musical notes add a dimension of time's passing that is rigorously non-narrative and non-linguistic. The musical score implies an auditory—even haptic—physical experience different from the optics of vision. Descriptive labels on the staves connect pure musical notation to specific elements of the upper tableaux: they refer to dogs, and several figures in the plates actually sound horns. Music invests these plates with episode, duration, and an aural resonance to secure for their visual presence the right to narrate before the overwhelming, non-visual textual weight of the extensive legends.

The musical staves with their non-narrative representation of time and process offer a clue to understanding the emergence of a powerful type of correlation only partially exploited by the *Encyclopedia*'s plates: the ability of notation to describe time in abstract terms. Operating at the outer limit of diagram in a print culture, the hunting plates push, in their insistence on the indexical and notational, toward mathematics. The overflow of explanatory text suggests a breakdown of graphic intelligibility in complex diagrams. We find a parallel development in more technical spheres, where the informational yield of notational schemes begins to take precedence as evolving standards of adequacy force description to shift from text-based expositions of observable events to mathematical functions and graphic notations. Predictive formulas and repeatable patterns augment the density and variability of everyday experience: diagram allows verbal, graphic, and mathematic commentaries to coexist.

The plates devoted to military exercises reveal this shift of description to a non-linguistic register in their treatment of drill formations. The paucity of explanatory texts relative to the lengthy narratives accompanying the hunting plates is a sign of the weight borne here by notation. Three kinds of images make up this section. The first group of five plates depicts soldiers in specific formal postures, including presenting arms, firing their weapons, and tearing open a cartridge with the teeth (FIGURE 19). These are fully trained soldiers who demonstrate positions as discrete gestures rendered in stop-action, but arranged on the sheet sequentially as notations. Summary ground lines and shadows are the

DIAGRAM

47

token relics of a spatial world, while the rigorous arrangement of the figures in three registers—analogous to musical scoring—dictates lateral comprehension. Yet reading these first plates as illustrating bodily discipline in the manner of Foucault oversimplifies their role in the matrix of images that diagrams the military arts.

The second group of plates halts our attention, for they are stark images of purely graphic notation with no reference to a world of experience (FIGURE 20). They dispense with individual, idiosyncratic bodies for reasons explained by a note at the head of the accompanying text:

In this and the following plates, soldiers are noted by black dots designating the center of the space they occupy. Since one assumes that the soldiers touch one another, there should be no space between the points; but, in that case, the illustrations would be too confusing and the movements the plates ought to represent too difficult to study.[20]

Soldiers are reduced to points, with a small line indicating the direction of their attention. White dots indicate recently vacated spaces and dotted lines the trajectories followed when taking up the positions marked in black. This recourse to a graphic notation makes visible both time (prior placement versus new placement) and movement (dotted lines), and it holds the two together with an underlying geometry of implied gridlines and regular curves mapping the white field of visual presentation. The notations are not easy to read: even having mastered the visual code, one needs to consult short texts keyed to each plate in order to interpret the arcane patterns of marks. The process is like a shuttle, for the texts can obscure more than clarify. The user is quickly involved in back-and-forth comparisons between the words and the images when attempting to correlate the two. Even more dramatically than the hunting plates discussed above, these works mobilize our attention across the word–image divide, and reward us with a comprehension that is not ordained, but is actively produced. When effecting this passage of correlation between word and image—or between soldiers in formal postures standing on the ground and soldiers rendered as dots—the user is forced to change frames of reference. The *Encyclopedia* invented a material structure to manage these transitions surreptitiously, by taking the white space of diagram as a constituent element.

FIGURE 19

"Art Militaire, Exercice," pl. III.

Engraving by Robert Bénard for

Diderot and d'Alembert, *Recueil*

des Planches, vol. 1. Courtesy

Department of Special Collections,

Stanford University Libraries.

Photo: Marrinan.

FIGURE 20
"Art Militaire, Evolutions," pl. VII.
Engraving by Robert Bénard for
Diderot and d'Alembert, *Recueil
des Planches*, vol. 1. Courtesy
Department of Special Collections,
Stanford University Libraries.
Photo: Marrinan.

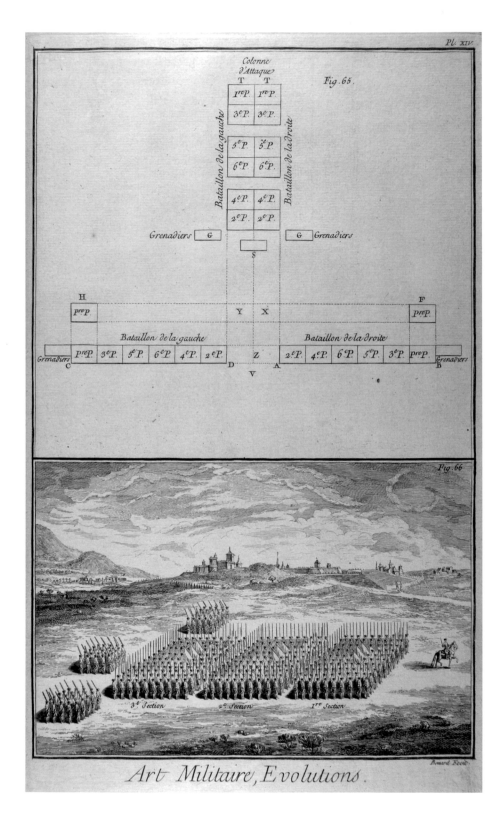

FIGURE 21
"Art Militaire, Evolutions,"
pl. XIV. Engraving by
Robert Bénard for Diderot and
d'Alembert, *Recueil des Planches*,
vol. 1. Courtesy Department of
Special Collections, Stanford
University Libraries.
Photo: Marrinan.

DIAGRAM

51

The last plate on tactical exercises for infantry demonstrates the yield of correlation when diagrams become working objects (FIGURE 21). Here the double structure affords the user two distinct views that emulate how a commander sees his troops: reviewing them in abstract upon a table covered with charts, and observing them in the field from an overlook. The text explains how troops are to fall out in ranks from a defensive line into a tight, triple formation designed to spearhead an attack. The whiteness dominating the upper sector of the page is both a leaf in a military portfolio and a non-representational *champ* or field of action. Crossing the frame of the plate, the graphic whiteness of the chart becomes the ground plane of the battlefield below. The vignette's seemingly unified perspective, with its tight blocks of troops arranged like the paving stones of a city square in a Renaissance painter's manual, actually is delusional, because the soldiers are far too large for the spatial recession implied by the foreground details or buildings of the hill town in the distance. The vignette subverts strict perspective to align itself graphically with the notations of the chart, and subordinates imitation to analysis. The tableau-like presentation of troops in the vignette approaches the character and function of a visual catalogue from which one could derive the chart above. But the move from one to the other would be almost impossible to grasp were it not for the preceding plates in which the physical bodies of soldiers had become points in space, their trajectories marked by dotted lines. Between the soldiers presenting arms of the opening plates and the attack column of the final image, a graphical rendering has evaporated physical presence into mathematical plots—ideal bodies moving through time along geometrically determined paths. The conceptual re-framing is profound, and its efficacy depends entirely upon a material ground of whiteness that unites the plates to one another.

The amalgam of information staged by the *Encyclopedia*'s diagram of infantry exercises would probably be of little value or interest to professional soldiers or field commanders. By contrast, curious users of Diderot's compendium would learn from the to-and-fro of attention among images and legends something of the complexity and discipline of modern warfare. The same might be said about professional hunters relative to the hunting plates, or about farmers and the plates on agriculture. What is at stake here is not farming, pastry-making, hunting,

DIAGRAM

52

or soldiering: the diagrams of the *Encyclopedia* are not manuals. The descriptions they produce are new objects. They do not merely catalogue individual parts, but generate understanding by eliciting a study of those parts in new and unpredictable re-formations shaped to a large extent by the user's orientation and expertise. Curiosity, the hunger to know, is the motor force that brings to life the *Encyclopedia*'s inert materials of ink and paper. Correlation was a powerful tool for exploring new ideas that challenged established categories and expectations. In the next chapter we sketch the historical moment of its emergence from the energy released when dynamic processes of analysis encounter prior, static models of understanding. How does the *Encyclopedia* deal with the challenge of describing the world?

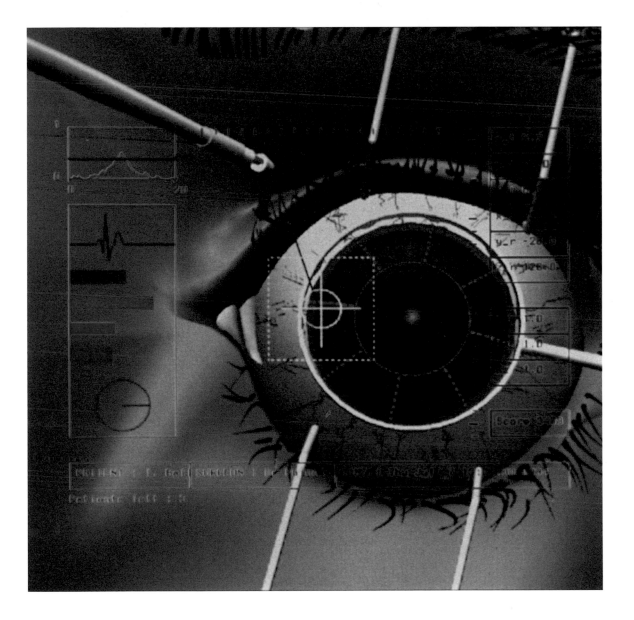

PLATE 1

"Surgical virtual environment showing virtual surgical instruments, 3-D guidance information, surgeon's tremor power spectrum (top left) and patient's vital signs (left-hand side)." Computer-driven interface from Ian W. Hunter et al., "Ophthalmic Microsurgical Robot and Associated Virtual Environment," *Computers in Biology and Medicine*, vol. 25 (1995). © 1995, with permission from Elsevier.

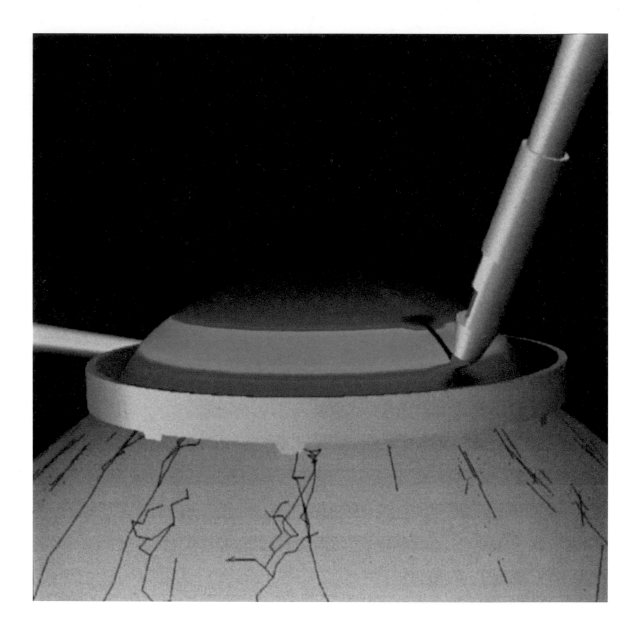

PLATE 2

"Stress contours calculated on an incised human cornea during a radial keratotomy simulation." Computer-driven interface from Ian W. Hunter et al., "Ophthalmic Microsurgical Robot and Associated Virtual Environment," *Computers in Biology and Medicine*, vol. 25 (1995). © 1995, with permission from Elsevier.

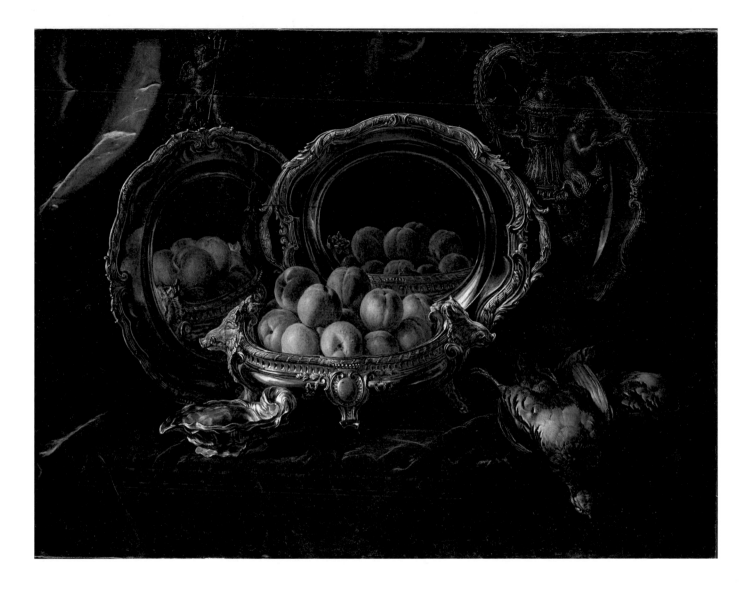

PLATE 3

François Desportes, *Silver Tureen with Peaches*, n.d. Oil on canvas. Stockholm, Nationalmuseum, inv. NM 800 (91 × 118 cm). Photo: © The National Museum of Fine Arts, Stockholm.

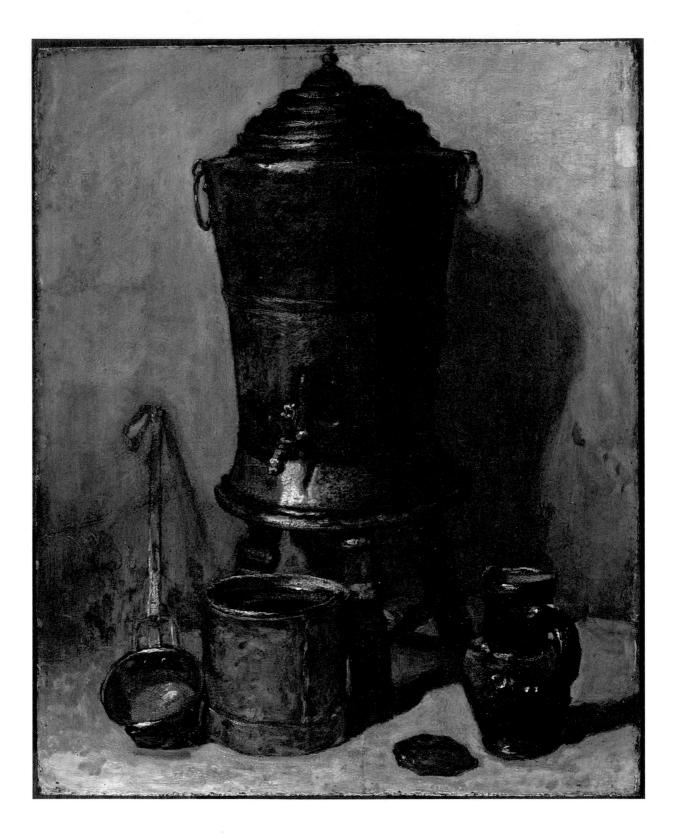

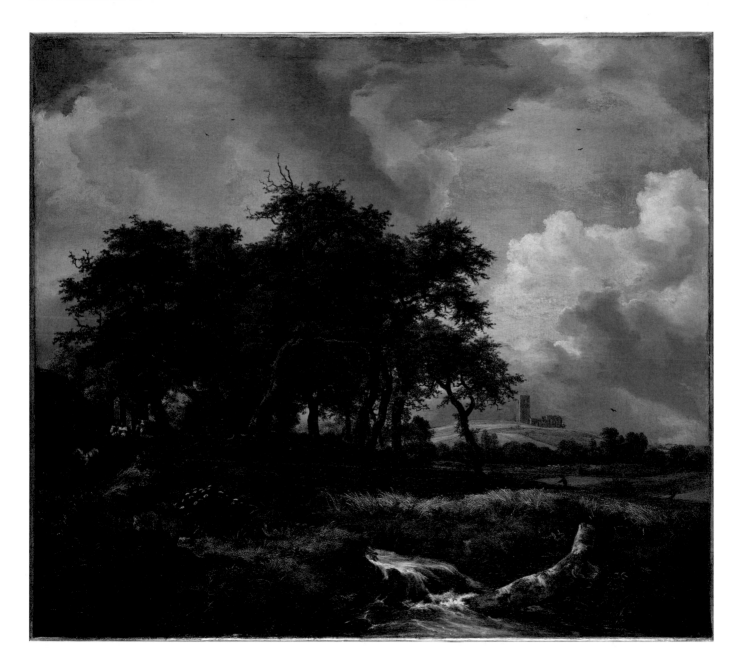

PLATE 6

Jacques-Louis David, *Belisarius Begging for Alms*, 1781. Oil on canvas. Lille, Musée des Beaux-Arts, inv. P436 (288 × 312 cm). Photo: © Réunion des Musées Nationaux / Art Resource, NY / © P. Bernard.

PLATE 7

Jacques-Louis David with François-Xavier Fabre or Anne-Louis Girodet-Trioson, Replica of *Belisarius Begging for Alms*, 1784. Oil on canvas. Paris, Musée du Louvre, inv. INV3694 (101 × 115 cm). Photo: © Réunion des Musées Nationaux / Art Resource, NY / © Daniel Arnaudet.

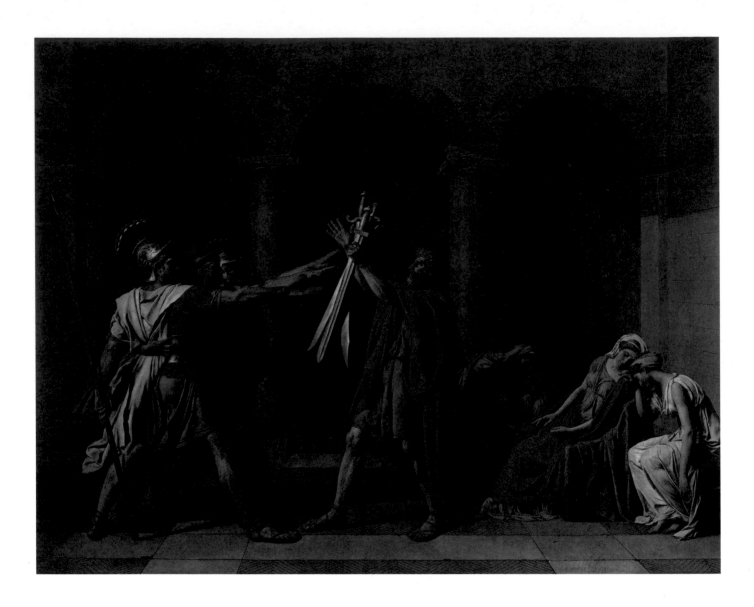

PLATE 8

Jacques-Louis David, *The Oath of the Horatii*, 1784. Oil on canvas. Paris, Musée du Louvre, inv. INV3694 (330 × 425 cm). Photo: © Réunion des Musées Nationaux / Art Resource, NY / © Gérard Blot / Christian Jean.

DESCRIPTIONS

3

The preceding chapter presented our concepts of diagram and diagrammatic knowledge chiefly within the visual forms and accompanying legends that characterize the plates of the *Encyclopedia*. We have shown how a deep understanding of the representational capacities of the print medium made it possible for the authors to break out of the binary categories of verbal and visual forms eventually crystallized by Lessing. They mobilized a flexible process of correlation to bridge this binary, making users both binding agents and beneficiaries. Learning and understanding along highly personal, unpredictable vectors became not only possible but necessary. These developments emerged against a backdrop of philosophic inquiry about the nature of language itself. Arguments like John Locke's that language was strictly a matter of convention were pitted against those of figures like Gottfried Wilhelm Leibniz, who believed that correspondences actually exist between words and their referents. At stake in these disagreements was the power of language to denote things in the world, an idea that harks back traditionally to Adam's naming of animals in the Garden. Language, in this view, is a noiseless and transparent index of the real. Adherents of the idea that language is a

system of conventions disavowed the myth of one-to-one correspondence between words and things, while offering few functional alternatives to the disillusioned.

The *Encyclopedia* as a project, and its internal logic as a cross-referenced dictionary, side-stepped contemporary debates about language by offering a novel and functional alternative that did not take sides. Rather, Diderot's system of cross-references [renvois] within the text and plates constantly reminded users that there was to be no final word, that the story could be continued ad infinitum according to expertise, inclination, or whim. In our reading of the *Encyclopedia* as an artifact of diagrammatic knowledge, it becomes possible to analyze its texts with the same conceptual lenses we have used to examine its plates. That is the ambition of this chapter.

The application of language to the world, whether as a direct one-to-one correspondence or strictly by convention, finds urgent expression with the problem of description.[1] The *Encyclopedia* article on description is a short text that is unusual in several ways. It was written as four discrete sections by four different authors, and was entirely rethought two decades later by Jean-François Marmontel in the *Supplément* (see Chapter 4). It distributes the problem across three large divisions of knowledge: natural science, geometry, and belles lettres. Finally, it does not attempt a synthetic view but holds competing views in a state of balance. We take this article—with its several parts and four disparate authors—to be a microcosm of the *Encyclopedia* itself, an instruction set for the protocols of correlation. The article's struggle to articulate the problem of description resonates with competing theories of language. It also maps a latent concept of diagram.

Systematic notations grounded in geometry and mathematics emerged during the decades prior to the *Encyclopedia* as binding elements of increasingly complex data displays. Modern readers may be surprised by the inclusion of mathematics in the domain of description, though one still says in geometry class that a figure is "described." Thomas Hankins and Robert Silverman have shown that graphs and other forms of visual notation accompanied growth in the volume of information and the complexity of analysis in every branch of science.[2] Notation, to early researchers, seemed to resemble language because it mediated between observers and the natural world. Thus, d'Alembert's few lines about geometry in

the description article will be crucial to our understanding of diagram at mid-century and for our attention to the interaction between concept and graphical trace in the performance of correlation.

Today, the informational and analytic value of graphs and related notations is taken for granted. This was not always the case. Lockeans distrusted graphs along with language as conventional constructs of limited descriptive power. Graphs plotted by instruments did not escape the hermeneutics of deception. By contrast, followers of Leibniz such as Johann Heinrich Lambert viewed graphs as the potential basis for a universal language of description. In his *Semiotik* of 1764, Lambert cited music as an example of notation that corresponds fully to the concepts it represents.[3] He aspired to a unified descriptive field where a single symbolic logic might signify wind direction, choreographic movement, musical harmony, and, ultimately, mathematical functions. About a century later, Charles Saunders Pierce, who credited Lambert with the creation of logical diagrams, was among the first to use the word "graph" for this kind of diagrammatic continuum.[4] Our treatment of the *Encyclopedia*'s plates—from the mixed codes of the hunting series to the abstract markings of military maneuvers—suggests that graphical notations became typical within the visual vocabulary of diagram by the 1760s.

New instrumentation proliferated in the century between Lambert and Pierce. The major development, in the words of Hankins and Silverman, was that "new recording devices . . . revealed 'secrets' that could not be obtained in any other way—certainly not by direct observation."[5] The emerging ability to learn of things beyond the range of ordinary experience overlaps with our historical account of the early culture of diagram. The user's activation of diagrammatic correlation coexists with analogous cultural forms that play to the viewer's secret emotions. These innovations include the novel's fictional narration of consciousness and the absorptive paintings by Jean-Baptiste Greuze and Jean-Baptiste-Siméon Chardin that so engaged Diderot. They also inspire important changes in the physical and verbal renovations of theater advanced by Diderot, elaborated by Marmontel, and eventually plotted by the heroic paintings of Jacques-Louis David. This chapter focuses on the *Encyclopedia*'s account of description, weaving together these diverse threads and showing their interfiliations.

Lambert and Pierce were optimists, for only under specific conditions do diagrams approach mathematics.[6] Our historical mentor here is another Leibnizian, Georges-Louis Buffon, naturalist, French translator of Newton's work on the calculus, and a powerful influence on the *Encyclopedia*'s article about description. Far from placing the physical sciences under the sign of mathematics, Buffon saw profound differences between those two domains. Consider the following excerpt from the introduction of his *Histoire Naturelle* published in 1749:

Physical . . . truths are in no way arbitrary, and in no way depend on us. Instead of being founded on suppositions which we have made, they depend only on facts. A sequence of similar facts, or, if you prefer, a frequent repetition and an uninterrupted succession of the same occurrences constitute the essence of this sort of truth. What is called physical truth is thus only a probability, but a probability so great that it is equivalent to certitude. In mathematics one supposes. In the physical sciences, one sets down a claim and establishes it. There one has definitions; here, there are facts. . . . In the first case one arrives at evidence, while in the other the result is certitude.[7]

Buffon draws a sharp distinction between mathematical definitions and the facts of physical science. Moreover, he allows that physical truths might be recorded by instruments that "in no way depend on us." Physical data must be repeated many times to develop a "probability" of truth ("frequent repetition . . . uninterrupted succession") and individual results must be arrayed in ways that permit formalized comparisons. Buffon's position was not unusual, for the development of calculus to treat curves that could not be described with the algebra of rational numbers—curves called "transcendental" by Leibniz—used differential procedures that were pure mental constructs.[8] Buffon was taking a stand when he declared, "Mathematical truth is thus reduced to the identity of ideas, and has nothing of the real about it."[9]

Buffon's insistence that natural science be grounded on physical truths established by frequent repetition is the guiding force behind the range of plates in the *Encyclopedia* on natural history.[10] Graphically, these differ from the plates discussed in the last chapter, for their task is to organize and to pattern the many detailed observations catalogued by the accompanying text. Consider the image (FIGURE 22) devoted to three animals

FIGURE 22
"Histoire Naturelle," pl. XVI.
Engraving by Robert Bénard after
a design by François-Nicolas Mar-
tinet for Diderot and d'Alembert,
Recueil des Planches, vol. 6.
Courtesy Department of Special
Collections, Stanford University
Libraries. Photo: Marrinan.

that "share the distinguishing characteristic of not having teeth": the anteater [fourmillier], the scaly anteater [pangolin], and the long-tailed pangolin [phatagin]. The visual medium of the plate is ill-adapted to display the remarkable lack of teeth for which these three animals are brought together, not to mention the detail that all three generally eat ants and termites. By contrast, it can render the differences in outward appearance used to distinguish two sub-groups within the trio: two of the animals are covered by scales, while the third has fur. The furry ant-eater (at the bottom) is native to South America, while the two scaly examples of pangolin are found in Africa. The three also vary greatly in size: the fourmillier runs to about four feet in length (its size is indicated by a scale in the plate); the pangolin (center), according to the text, can grow to about eight feet long; the phatagin (top), which was probably never seen in real life, is reported to be much smaller. These significant differences in locale, outward appearance, and size are mediated visually by the plate to reinforce the parallels and groupings established by the text. Note, for example, how each animal is deployed on a small rise of rock within identical rectangles. Light within each box falls from the right towards the left to cast similar shadows beneath each specimen and suggest that all three are "seen" within a common frame of reference. Finally, the two scaly specimens face left while the furry animal faces right, thus underscoring the "correctness" of the sub-division established by the accompanying text.[11]

The graphic qualities of such plates respond to the specific needs of natural history. By contrast, the métier plates focus on the bounded spaces of the workshop, the architectural spaces of production, or the limited geography of cultivated parcels to show a technical world in the process of evolution. In the métier plates, visual catalogues organize a virtual space of whiteness, while the correlations they mobilize refer objects back to the arena of use depicted in the vignette. The eye of natural history seems unbounded by such physical limits, for its plates render animals, plants, and minerals from around the world to estab-lish a domain of sight that explodes the optical field. Many of these plates, such as the anteaters, include a ruled measure to relativize the sizes of specimens, although the renderings themselves are of identical dimensions. The natural history plates mobilize correlations across time,

space, and scalar differences—a point made especially clear in the astonishingly large, fold-out image of a louse seen through a microscope (FIGURE 23). Here, the physical size of the image generates a surprise that is itself thrilling, while the presence of a single human hair serves as scale to remind us how powerful our vision can become with the aid of an instrument.

II

The graphical range of the *Encyclopedia*'s natural history plates suggests that researchers in the natural sciences were developing a menu of competing diagrams that structured in new ways the relationships among subjects and the physical world. Some diagrams challenged the old idea of humanist subjectivity by demanding that the terms of description be driven by the object under study rather than by the observer's perceptual skills. Others were developed to account for descriptions generated

FIGURE 23

"Histoire Naturelle, Le Pou vu au Microscope," pl. LXXXIV. Engraving by Robert Bénard after a design by François-Nicolas Martinet for Diderot and d'Alembert, *Recueil des Planches*, vol. 6. Courtesy Department of Special Collections, Stanford University Libraries. Photo: Marrinan.

Histoire Naturelle, LE POU VU AU MICROSCOPE.

by instruments like the microscope that record data whether or not an observer was, or is ever, present. Taken together, the plates of the *Encyclopedia* offer a compendium of visual options that do not so much de-privilege sight (the argument of Barbara Stafford and Martin Jay) as explode its potential.[12]

The recurring two-part components of the métier plates—vignette and visual catalogue—echo a contemporary and non-Cartesian notion of sight voiced in Joseph Addison's "Pleasures of the Imagination":

We cannot indeed have a single Image in the Fancy that did not make its first Entrance through the Sight; but we have the Power of retaining, altering and compounding those Images, which we have once received, into all the varieties of Picture and Vision that are most agreeable to the Imagination.[13]

For Addison, understanding emerges when the optical image is re-processed and re-shaped in the imagination, a second step analogous to, although not identical with, the correlations of diagrams. Diderot develops a comparable view of vision and its comprehension in his *Lettre sur les Aveugles*:

Thus, one must admit that we ought to perceive in objects an infinite number of things that neither an infant nor a person born blind will ever see, even if the objects are equally painted on their retinas, and that only experience teaches us how to compare sensations to what provokes them.[14]

Diderot's position in the debate about whether a blind person who gains sight would recognize objects known only by touch (the Molyneux problem) was that no human being—sighted or otherwise—understands primary visual data without a processing based in experience.[15] Diderot differs from Addison by not assigning primacy to sight—touch is far more important to Diderot's account—but both underscore correlation as fundamental to the formation of knowledge.

Diagrams crystallize collections of comparative data impossible to encounter in the realm of everyday vision; users process this information by tapping individual reservoirs of experience to produce knowledge. We might say that diagrams overstep the limits of ordinary vision and move outside the parameters of normal sight. In this way, they surpass the limits of the camera obscura model registered by Locke in the well-known passage of his *Essay Concerning Human Understanding*: "would

the Pictures coming into such a dark Room but stay there and lie so orderly as to be found upon occasion, it would very much resemble the Understanding of a Man."[16] Locke renders his metaphor in the subjunctive mood, making it clear that the camera obscura does not actually present detached reflection upon phenomena projected via its pinhole on the walls of a darkened chamber. Fixed pictures would do so, and would then parallel the understanding, but Locke is careful to separate production of images from understanding them. Addison, for his part, was also charmed by pictures "drawn on the Walls of a Dark Room" and attributed a good part of its attraction to the "Novelty of such a Sight." He goes on to say, however, that "the chief Reason is its near Resemblance to Nature, as it does not only, like other Pictures, give the Colour and Figure, but the Motion of the Things it represents."[17] Addison's position complicates the issue: the images are indeed drawn by the camera obscura, but their attraction does not depend upon the viewer's detached reflection so much as the movement that pushes them beyond what is normally expected from landscape pictures. Addison's thrill is more akin to the visceral experience of cinema or virtual reality than Locke's orderly perusal. Addison's remark that such images presented "the prettiest Landskip I ever saw" suggests the personal and accumulative dimension of his encounter, one fully consonant with Diderot's emphasis upon experience in the process of correlation that leads to understanding. Historically, the camera obscura is not Jonathan Crary's monolithic entity presupposing a body "marginalized into a phantom in order to establish a space of reason," but an arena of experience in which knowledge is constructed in the present.[18]

William Hogarth's 1754 "Satire on False Perspective" offers an English critique of the systematic representation of sight that parallels and prefigures the diagrams of the *Encyclopedia* (FIGURE 24). The engraving introduced a treatise on the value of accurate draftsmanship, but, as Ronald Paulson says, "the perspective errors (characteristic of signboards) are used to engender puns, to show not only how *not* to draw but, in a sense, *how* to draw—how to suggest a different set of relationships by using a different set of rules."[19] Paulson gets at only part of the problem because he links this plate to the later (1762) exhibition of signboards in which Hogarth was involved. He sees the plate as a celebration of the

Whoever makes a DESIGN without the Knowledge of PERSPECTIVE
will be liable to such Absurdities as are shewn in this Frontispiece.

W. Hogarth inv. et delin.

L. Sullivan Sculp.

FIGURE 24

William Hogarth, "Satire on False Perspective," 1754. Engraving. Manchester, The
Whitworth Art Gallery, University of Manchester, inv. P.1994.113 (22.3 × 17.7 cm).
Photo: The Whitworth Art Gallery, University of Manchester.

"naive." This it may be. When viewed through the lens of diagram, it becomes something more. The plate diagrams the phenomenon of perspective itself. The classic Albertian depiction of lines receding in an empty room or piazza gives way—through a parody of the protocols—to playing with alternatives to strict perspective.

Hogarth's engraving diagrams this play by overlapping a form of visualization strictly governed by perspective theory with one that responds empirically to the anomalies of human vision. It resonates with the visual mechanics of diagram that we find in the *Encyclopedia*: the sharp juxtapositions; the multiple points of view; the radical shifts of scale; the complex relationship of the page to picturesque perspective tableaux. Hogarth's humor erupts at the juncture where the fixed, mathematically governed focus of classical linear perspective meets the curvature of physical eyes and their continuous scanning motion. The "Satire" works by overlaying fractional visual fields, each of which is internally coherent. The plate's comic effects occur at nodes where these separate fields fail to integrate. Hogarth signals this game of planar enjambment by placing a large, flat placard behind trees on the hill far beyond the pub from which it supposedly is hung. A man reaches out from the pub window with a candlestick to light the pipe of another walking on a hill even farther back—a figure itself flattened and enlarged like a signboard. The gentleman in the foreground pulls a fish from the river at middle ground using a pole of exaggerated length. Its line implausibly crosses in front of the pole of a second fisherman in the near middle ground. And so forth. These failures of coherence disrupt the viewer's commonsense expectations, producing the effect of disequilibrium called amusement.

Nonetheless, Hogarth's "Satire" does not fracture into visual chaos because strategic patches of whiteness link the parts in a virtual space of bemused correlation. Like the plates of the *Encyclopedia*, Hogarth's use of multiple perspectives in the "Satire" is analytic and is governed by the variable scales and shifting points of view of visual catalogues. This internal mis-alignment visualizes an unraveling of perspective hegemony, and demands a continuous refocalization that mimics Diderot's appeal to active correlation by users. Knowledge about the nature of strict linear perspective emerges through negative example via manipulations of

scale and position that may seem arbitrary but actually are analytic. The Brobdingnagian size of the fisherman at front right forms part of a system of "punning," which, as Paulson says "in effect replaces the Renaissance man as the proper spectator with the 'common observation' of the ordinary viewer."[20] This large foreground figure, who is both viewer and participant, finds his parallel in other instances throughout the plate that purposely cross-cut and undercut the stabilizing power of his vantage point.

Other examples of English imagery related to the *Encyclopedia*'s range of subject matter help to clarify the particular diagrammatic nature of Diderot's enterprise. Renderings of complex instruments, such as the hydrostatic balance from a plate published in the *Universal Magazine of Knowledge and Pleasure* of 1749 (FIGURE 25), employ a system of letter keys, graphical scales, and textual explications very similar to those of the *Encyclopedia*.[21] But alongside these elements, and seemingly in the same space, appears a well-dressed gentleman sporting hat, sword, and walking stick, who seems to observe the device. If the plate is read normatively, the gentleman would be a Lilliputian twenty inches or the balance an enormous fourteen feet. The capacious text explaining the structure and operation of this balance for measuring specific gravity (one of its uses was to assay metals) never reveals the overall size, but a few clues suggest it would be about four and one-half feet tall. In this case, the man cannot exist in the same world and at the same scale: his presence is allegoric and emblematic. He personifies comprehension, someone who understands how the instrument works. His appearance and dress are emblematic of the gentlemen readers of the *Universal Magazine of Knowledge and Pleasure.*

The strategy of placing within the image an observer who stands for the power of correlation seems to be characteristic of this up-market English journal. This gentleman may also stand for the investigators typical of the English scientific community or the conversant public they felt compelled to address.[22] Occasionally, these little gentlemen participate in the action—witness the one who touches a static electric generator in a plate from 1747 (FIGURE 26)—but in most instances they simply allegorize the power to see, correlate, and understand (FIGURE 27). Normative and detached observers of this sort never appear in the plates of

FIGURE 25

"The Hydrostatic Balance to find
the Specific Gravities of Fluid
and Solid Bodies." Engraving for
*Universal Magazine of Knowledge
and Pleasure*, vol. 4 (1749). Photo:
Courtesy of the Bancroft Library,
University of California, Berkeley.

FIGURE 26

"Electrical Experiments by L'Abbé Nolet, F.R.S." Engraving for *Universal Magazine of Knowledge and Pleasure*, vol. 3 (1747). Photo: Courtesy of the Bancroft Library, University of California, Berkeley.

FIGURE 27

"Gerves's Engine for raising Water." Engraving for *Universal Magazine of Knowledge and Pleasure*, vol. 10 (1752). Photo: Courtesy of the Bancroft Library, University of California, Berkeley.

the *Encyclopedia*. Rather, scalar clues within images establish variable frames of reference keyed to the immediate task—calibrated measures for machines or natural history but also a human hair grasped by a magnified louse (FIGURE 23)—without specifying the user's personal stature, vantage point, or social position. In principle, the plates speak to any user who takes an interest, regardless of background or profession. The plates aspire to become simply things in the world likely to stimulate the thought processes of curious minds. They are more like a shiny pebble on the beach that appeals to any roving eye than representations of things arranged for a specified public. They work to elicit productive dialogue with users rather than to illustrate a fictive world. This is why we call them working objects. Our thinking about this distinction is shaped by the historical question of how to evaluate information produced by an expanding range of measuring instruments in the later eighteenth century.

III

Ann Banfield broaches such questions by locating specialized optical devices—including microscopes and telescopes—within a wider historical context of early scientific instrumentation not bound to the implied observer of an Albertian model of vision. The economy of Banfield's approach is that it connects the realms of science and instruments to those of literature and narrative, thereby articulating an important link between the natural sciences and the traditions of description. Banfield begins with Bertrand Russell's theory of knowledge because Russell had "severed the necessary link between the centered perspective and the observer's position" when he recognized that an incidence of sensibilia recorded "by a machine, by a scientific instrument, by a mechanical process . . . is no longer anyone's sensation, yet in a precise and restricted way it remains subjective."[23] Although the visual catalogues of the *Encyclopedia*'s plates are not, strictly speaking, produced by instruments, they simulate the mechanical recording of information later described by Russell. Their sensations belong to no one individual or group of individuals, but are accessible to each user's power of correlation. They are like a telescope which constantly forms images, but whose productivity broadens only when the sensibilia it registers are taken up by users to make working objects.

Banfield differentiates the presence of a human eye or body from the operation of instruments "utilising a lens as a refinement of human vision." Such instruments in the early modern scientific revolution "might be said to have opened up vast and terrifying epistemological perspectives that 'no one had ever seen.'"[24] The scepticism provoked by devices that permit atypical views of the world has a long history: Galileo, for example, had to convince people that telescopes actually improved vision rather than introducing untrustworthy distortions.[25] A similar scepticism marked eighteenth-century responses to the graphs of intangible data, like those devised by Johann Heinrich Lambert, William Playfair, and James Watt.[26] Playfair's graphs of the British national debt, for example, were criticized as "mere plays of the imagination."[27] Banfield traces doubts of this kind to the power of instruments that "allow the viewing subject to see, to witness, places where he is not, indeed, where no subject is present."[28] Following Russell, she reminds us that a telescope is *always* processing sense data, even if no eye is pressed to the eyepiece, and the same can be said of any type of sensing instrument.[29]

Russell used the word "sensibilia" to denote these "appearances that things present where there are no minds to perceive them," a situation most clearly illustrated if one thinks of a photographic apparatus set to trigger automatically: what the camera records when the shutter opens are sensibilia perceived by no person, but which might have been perceived had there been a person present.[30] The record made by such a camera is accessible after the fact to any number of viewers and could be interpreted in any number of ways. But legitimate inductions about the image should not invoke data not inscribed by the original instrument. Subjective responses to such works are necessarily limited by the technical or mechanical parameters of the camera's sensing range. Similar conditions pertain to information perceived in real time through instruments such as the telescope. "Each gathering of sensibilia, as on the ground glass of the telescope," writes Banfield, "represents . . . a perspective definable independent of whether or not it is given to any observer." The conclusion she draws, again following Russell, is that "those aspects of subjectivity built into the notion of a perspective limited to a unit of space-time inhere in the very appearances of things and not in the mind or eye to whom they may appear."[31] The neutral perception of things is one of

the working assumptions of description in early natural science—a belief in intrinsic attributes perceptible by impartial instruments or protocols of analysis. Banfield, by contrast, shows that viewing the world with instruments enlists several bandwidths of attention, but that presenting data to human perception always involves compression, translation, or refiguration of the world generating the presentation. Some branches of natural science—such as astronomy and microbiology—depend heavily upon viewing instruments. Others, notably Buffon's natural history, embrace a narrowed bandwidth of description in the interest of fine-grained discriminations and hierarchical clarity. Our point is that an expansion of scientific inquiry produced sectors of variable attention within the human perceptual field according to specialized domains, disciplines, and technologies. Sharp disagreements within the *Encyclopedia*'s account of description both replicate and enact this diversification.

Banfield mobilizes Russell's theory of knowledge to account for what might be called consciousness without subjectivity in recording instruments. By contrast, in his theory of language, Russell was no more suited to describe these sensibilia than were the authors of the *Encyclopedia*, for he assumed—incorrectly —"the necessary egocentricity of all deictic terms." In his account it would be impossible to point out and to name an element of sensibilia without invoking one's presence and that of an observer. Banfield observes that Russell could not imagine "a sentence which is at once subjective and subjectless, constituting a language of sense which is impersonal, a linguistic representation of the sensibilia recorded by the instrument."[32] By way of counter-example, Banfield cites statements of prose fiction in the mode of free indirect discourse to show that Russell was wrong. Free indirect discourse is a sentence or syntax of narration in which the first-person thoughts of a character are rendered in the third-person, as if objectively present to the reader independent of narratorial intervention.[33] She locates such statements in one form of written language—the language of novels—when an imperfect (past) tense is combined with present-tense markers such as *this*, *here*, or *now* as a way of registering a "this was now here." In these fictional statements, impersonal past tense narration allows the reader to witness, as if real, the interior thinking of others inaccessible in ordinary life. The reader encounters "in the very language of the novel a real and empiri-

cally determinable possibility, the disturbing presence of something im-personal, inhuman, past and, in that instant, distant."[34] This linguistic development was historically specific: Banfield locates the earliest French examples in the fables of La Fontaine and English variants in the novels of Jane Austen.[35] She situates "the sudden and contemporaneous appear-ance of represented speech and thought at the beginning of the modern period, an appearance coinciding with the rise of the novel itself."[36] Ban-field's account of a special kind of consciousness in instruments—and of the impersonal narration of thought in free indirect discourse—parallels our attention to the eruption of whiteness within the pages of the *Ency-clopedia*'s plates. All three disclose a space for the emergence of users, working objects, and the making of knowledge.

Banfield's chronology and association with modernity are vital, be-cause they bracket exactly the period of writing and producing the origi-nal volumes of the *Encyclopedia*, the publication of its accompanying plates, and the appearance of its supplement. Her account of linguistic representations that evoke, in the present, sense-data independent of any observer provides a succinct historical context for Michael Fried's discussion of absorption in French painting of the 1750s. According to Fried, "for French painters of those years the persuasive represen-tation of absorption characteristically entailed evoking the oblivious-ness or unconsciousness of the figure or figures in question to everything other than the specific objects of their absorption." Depictions of self-absorbed figures, writes Fried, tended to screen out a picture's audience, "to deny its existence, or at least refuse to allow the fact of its existence to impinge upon the absorbed consciousness of his figures. Precisely that refusal, however, seems to have given Greuze's contemporaries a deep thrill of pleasure and in fact to have transfixed them before the can-vas."[37] Fried claims this effect is a "paradox, one made all the harder to grasp by the utter transformation of sensibility between Greuze's age and ours." Banfield's analysis suggests that such pictures—like those novelistic sentences that "render the appearance of things to no one"—construct a "now-in-the-past" identical to the image produced on a light-sensitive plate by a camera. Such images transfix us today for the same reasons that Greuze's pictures transfixed his viewers: both register "the continued existence of things outside the mind which is disturbing

to the individual. . . . The viewer meets with a start his own absence."[38] The visual arrays of the *Encyclopedia*'s plates—their strict frontality, their discontinuity with the fictive spaces of tableaux, their pervasive whiteness that joins visual parts to the network of numbers and letters keyed to a text—fail to converge in a single vantage point or entity that might be called a viewer. Users of diagrams, unlike viewers, are functional components inseparable from the system in which they are imbricated. They are empowered to initiate a process of correlation even as they realize their subjective presence is liminal—almost non-existent. The situation replicates both the refusal of audience that Fried cites as crucial to absorption in the works of Chardin and Greuze, and the rendering of things to no one that Banfield locates in free indirect speech. In our account, these phenomena characterize the historical moment when diagrammatic knowledge moved to center stage, and they remain principal leitmotifs of the culture of diagram.

Users of diagrams practice correlation to make working objects. Modernist self-reflection is not the goal. Users might fabricate provisional stances or improvise responses from visual arrays, as does Diderot's salon viewer or the reader of novels, but these are merely thought experiments of no greater import than imagined machines or manufacturing processes. What Fried views as a paradox is not an effect of deep subjectivity, but simply an expedient response to confrontation with a visual field. The visual array as we conceive it appeals to users through its very indifference.

IV

Considerations of scientific instruments and free indirect discourse might seem at first a detour from the plates and texts of the *Encyclopedia*. The convergence germane to our story is the displacement of the self as center of knowledge formation: identity is the result of a user's work, not an immanent quality of his or her being. Banfield's analysis opens the door to recognizing that if an instrument registers or senses data even when unattended by a human being, then the sense data that Locke "placed within the mind of an observer is externalised and located within an instrument."[39] Similarly, her study of free indirect discourse suggests that certain material configurations of language generate representations of

another person's thoughts without positing a fictive, all-knowing character or narrator. The plates of the *Encyclopedia*, we argue, array bundles of data in visual catalogues held in variable and unstable relationships to one another and to tableau-like views of the world oriented towards a single viewer. These arrays of dispersed information are brought to cognitive stability by a user's active correlation across the whiteness of the print medium's support that can be read as open space, opaque field, and occasionally both at once. We want to underscore this variability, for it presumes that a user of the *Encyclopedia* is not a fixed subjectivity, but a component in a dynamic system of meaning.

By contrast, the "Description" article published in 1754 falters when trying to conjoin under a single rubric the different types of data appropriate to the natural sciences, mathematics, rhetoric, and aesthetics.[40] The four sections of the article reveal tensions one might expect between descriptive forms in natural science and belles lettres. But, within the latter, a new split appears between the approach to descriptive writing in traditional rhetoric aimed at externalized performance and a new aesthetic, typified by the mid-century novel, that evoked private emotional experience. Finally, the brief passage on geometry attempts to bridge the worldly concerns defined for description in the other three parts and the realm of pure mathematics beyond empirical experience or experimentation. The text does not produce a coherent explanation in the guise of a theory of language, vision, or the perceiving body. Rather, it establishes a cluster of foundational platforms from which the task of describing was launched in several directions at once. To make sense of the article means taking stock of its discontinuities, tracing out the paths suggested by its cross-references, and performing correlations in a process that echoes Diderot's *Prospectus* and prefigures by eight years the hybrid visualizations of the plates. These are some of the reasons we have called the article on description an instruction set for the protocols of correlation, and why it figures prominently in our discussion.

The article's ambition is "to discover the likenesses and differences" by comparison among natural objects, in order "to establish an array of facts that yields general knowledge." Yet achieving this goal dictates a range of distinct disciplinary practices. Each discipline must strictly adhere to a plan of inquiry built upon techniques scaled to its objects

of study: "the plan for descriptions must be relative to the object of knowledge in each domain but must be absolutely uniform within each." The expected practices of drawing similarities and establishing differences are invoked, but not indexed to uniform standards of reference. Rather, the focus and grain of analysis respond to properties inhabiting the group of objects under study, and will vary from one domain to the next. The text implicitly invokes a theory of correlation: understanding arises not from a technique that masters its object, but from a process of experiment fostered by the *Encyclopedia*'s dictionary form.[41] Here is revealed a paradoxical structure of the Enlightenment venture that we take as salient to the culture of diagram—very different from the prior unifying ambitions of Scholasticism, and quite unlike post-modern caricatures of the Enlightenment scientific impulse as monolithic, linear, and oppressive.

The section on natural history launches the article as a whole. For Diderot, the analytic description of nature defined modernity. The choice of Louis-Jean-Marie Daubenton to open this article gave pride of place to ideas from the most up-to-date institution, the Jardin du Roi. Daubenton worked there as Buffon's closest collaborator on the *Histoire Naturelle*, the great project that began to appear in 1749. Buffon considered description to be the foundation of any competent natural history. As he wrote in the manifesto that opens his monumental study, "The precise description and the accurate history of each thing is . . . the sole end which ought to be proposed initially. . . . [Natural history] ought to follow the description, and it ought to treat only relations which the things of nature have among themselves and with us."[42] In Buffon's spirit, Daubenton starts his account with words that seem to predict the visual catalogues that would be forthcoming in the plates of the *Encyclopedia*: "To describe the different productions of nature is to draw their portrait and to form a tableau that represents them in various views and states as much internally as externally."[43] He stresses that categories of description must vary for different objects according to their complexity (animals, plants, minerals), so as to bring each object clearly into view. Descriptive categories are not expected to line up with one another. Rather, language and scale are standardized within each category but not universalized across disciplines or fields of study.

Neither Buffon nor Daubenton strives for a comprehensive synthesis. The two-fold reason for the diversity they embrace is both connected to and disconnected from the body: on the one hand, the scale of representation must be flexible because primary sense perception is keyed to just one scale (the human); on the other, natural science demands that each thing be known at a sufficiently high resolution to allow classification. Daubenton insists that description maintain a hierarchy of detail and complexity based upon the complexity of its objects, not upon an external scale fixed by a priori terms of analysis. He condemns exhaustively detailed description because it swamps the observer's attention and thwarts classification. Unless description stays within "just boundaries" and subjects itself to "definite laws," it becomes simply "idle painting subject to frivolous curiosity."

Daubenton's account breaks with older models in two ways. First, he forms "general knowledge" not by establishing relationships among logical propositions, but empirically by "discovering resemblances and differences" among objects. Instead of scholastic integration, he seeks a relativity mobilized by correlation: "*descriptions* ought to be relative to the object of each scientific domain." Second, when Daubenton says that description must "form a tableau that represents . . . various views and states as much internally as externally," he invokes an idea of *tableau* quite unlike the consistently structured pictorial stage of Renaissance linear perspective. For Daubenton, the word *tableaux* refers not only to those picturesque scenes that would appear in many plates of the *Encyclopedia*, but also to the visual catalogues—multiple renderings, geometric figures, and semiotic arrays—that dominate most of the plates. Implicit in his differential view of representation is a theory of diagram.

The position of mathematics in the 1754 article is consonant with Diderot's belief that it would play, at best, a minor role in the new science of description. Diderot maintained that mathematicians

resemble those who gaze out from the tops of high mountains whose summits are lost in the clouds. Objects on the plain below have disappeared from view; they are left with only the spectacle of their own thoughts and the consciousness of the height to which they have risen and where perhaps it is not possible for everyone to follow and breathe.[44]

Buffon's more moderate assessment held that mathematics attains the status of description only when indexed to sensory observation:

[Mathematical] truths would have been perpetually matters of pure speculation, of simple curiosity, and entirely useless if the means had not been found of conjoining them to physical truths. . . . But when, after having determined the facts through repeated observations; when, after having established new truths through precise experiments, we wish to search out the reasons for these same occurrences, the causes of these effects . . . we must be content to call cause a general effect. . . . These general effects are for us the true laws of nature. All the phenomena that we recognize as holding to these laws and depending on them will be so many accountable facts, so many truths understood. . . . It is here that the union of the two sciences of mathematics and physics might result in great advantages. The one gives the "how many," the other the "how" of things.[45]

Against Diderot and Buffon stood d'Alembert. His *Preliminary Discourse to the Encyclopedia* of 1751 declared that "the most abstract notions, those that the common run of men regard as the most inaccessible, are often the ones which bring with them a greater illumination. Our ideas become increasingly obscure as we examine more and more sensible properties in an object."[46] D'Alembert admitted the importance of experimentation, but he showed little or no interest in performing experiments. He considered, writes Thomas Hankins, that "theory in every case predicts a precise result that can be checked by observation."[47] Two years later, Diderot replied to d'Alembert's optimistic view of mathematics, and underscored their differences, in *Pensées sur l'interprétation de la nature.*[48]

The separate entries of the 1754 article on "Description," along with their network of cross-references, evince this conflict of ideas among the *Encyclopedia*'s chief editors. The empirically based natural science of Buffon and Diderot jostles against the mathematically theorized "rational science" of d'Alembert in a fashion analogous to Hogarth's "Satire." Implicitly, d'Alembert's discussion of geometric descriptions yields to Buffon and Diderot, but the brevity and seemingly narrow scope of his text sidesteps his larger disagreements with Diderot about the nature of mathematics. For the purposes of description, d'Alembert accepts the inevitability of a limited number of observations by allowing for the estimation

of curves using geometrical construction. In this case, the finite intervals involved will always be measurable. He valued such concrete estimations of geometric figures as "sufficiently practical" for the needs of physical descriptions, even if they fall short of mathematical perfection.

D'Alembert's strict specification and material basis for estimating curves also intersects his ongoing disagreement with Leonhard Euler about the nature of mathematical functions. The two men clashed over how to analyze the motion of a plucked string.[49] D'Alembert insisted that the calculus could adequately treat only curves produced by continuous functions: consequently, his account of a string's oscillation was limited to treating it as a sine wave. Euler, by contrast, believed the calculus could describe any function so long as it is continuous over the required range, even if it becomes discontinuous for variables outside that range. Consistent with his stand on this issue, d'Alembert's essay on description allows for a literal, material tracing [décrire] of curves with the aid of a compass stroke that never leaves the paper, and the physical plotting of points that may be drawn into a continuous curve following the eye [à vue d'oeil].[50]

The physical process of connecting straight lines from point to point, conducted by the naked eye, produces an array that "forms these small lines into a curve sufficient to the senses and to practical applications." Such curves are neither traced by moving a point according to strict rules in a continuous physical motion (for example, a compass-drawn circle), nor estimated by the mathematical process of differentiation as a series of an infinite number of points. Rather, the lines complete a figure only partially sketched by the points: the user's estimation of the curve records a kind of correlation.[51] The estimated curves that d'Alembert ascribes to descriptive geometry are diagrams—physically produced, non-mimetic estimations in representational form.[52] They are also, to use the term of Daston and Galison, "working objects."

It is commonplace to think of the Enlightenment as the threshold of modernity and to believe that the step, circa 1750, from the physicality of d'Alembert's drawn curves to their mathematical estimations using the calculus was small. This was not the case. D'Alembert never mentions the calculus under the rubric of description, a move that implicitly sets higher mathematics apart from—and literally above—the domain of physical observation. Mathematics, to his mind, is a purely abstract

activity capable of predicting empirical results. For the purposes of his contribution to the description article, d'Alembert opted for practicality and technique over epistemology or real knowledge as he considered it. But d'Alembert's bias toward the strict, the pure, the complete always remains clear: if he situates hand-drawn curves in the article on description, it is to preserve for mathematics a purity and completeness. From an historical vantage point, one recognizes that d'Alembert and his antagonists, including Euler, were trapped by limitations in the calculus of their time, and these produced real disagreement that the clichéd idea of a monolithic Enlightenment occludes.[53] In our view, d'Alembert's embrace—almost against himself—of a descriptive geometry grounded on the relatively unrigorous practice of connecting dots is symptomatic of the disciplinary conflicts inherent in the culture of diagram.

The limited approach to mathematics adopted by d'Alembert for his section of the description article seems remarkable from a modern standpoint, where complex algorithms guide robots to dampen the tremor of a surgeon's hand in the operating room of our opening scenario. In fact, d'Alembert reveals his deep engagement with philosophical and metaphysical debates about mathematics by pointing the reader to his enormous essay on curves [courbe] where issues related to the calculus are explored in detail. Implicit in d'Alembert's separate treatment of the calculus is the problem of how to describe "transcendental" curves which, in the terminology of the period, cannot be "described" in the article's sense of drawing with a compass [tracer] because their discontinuites escape algebraic description and its assumption that functions are continuous. Transcendental curves must be thought, presumed, or approximated by the calculus. In other words, the sub-section on geometry lives at an odd juncture—a transient window opening—between d'Alembert's ideas about the independence of higher mathematics from the observations of rational science and Buffon's insistence upon determining "facts through repeated observations" prior to theory. For d'Alembert, descriptive geometry sits uneasily between the self-evidence that results from "the operations of the mind alone and is related to metaphysical and mathematical speculations," and the mere certitude "more appropriate to physical objects . . . knowledge of which is the fruit of constant and invariable testimony of our senses."[54] Descriptive geometry, which is here but a tenuous bridge linking d'Alembert to Diderot

and Buffon, would later become a vital tool of practical application in the hands of Gaspard Monge at the École Polytechnique.

The *Encyclopedia*'s emphasis on observation and technical practice, left unchallenged by d'Alembert's embrace of descriptive geometry, is both a statement about the empirical basis of knowledge and a symptom of contemporary limitations on the ability of higher mathematics, especially the calculus, to produce new forms of understanding. By the mid-eighteenth century, use of the calculus to solve problems of engineering had barely begun in the work of Euler, Daniel Bernoulli, Benjamin Robins, and others concerned with problems like the behavior of pendulums, ballistics, tides, and hydraulics.[55] Newton devised fluxions to describe planetary orbits mathematically and to estimate the forces of celestial mechanics. But even at this macro level anomalies remained, and Newton's laws were, as Hankins says, "insufficient to treat the new fields of mechanics which were developing in the eighteenth century. Fluid mechanics, the mechanics of rigid bodies, the mechanics of dynamical systems, the mechanics of elastic media—all required principles and mathematical methods unavailable to Newton."[56] Christiaan Huygens had already discovered in his work on pendulums that mathematics lacked the range of techniques required to form a complete theoretical description, much less to improve design through a theoretical approach.[57] In the 1740s, Robins made dramatic advances in accurately estimating the trajectory and range of bullets, but his work was little circulated before Euler translated it into German in 1745, and ultimately published his adaptation and commentary in the 1750s.[58] Robins pointed the way to fulfilling Newton's dream of harmonizing the realms of theory and empirical measurement, and producing results of the sort Buffon envisioned as yielding "great advantages." He exemplifies in many ways an engineering practice that would be fully realized over the next century.

Our point is that achievement of this harmony between theory and observation moves to center stage as a "scientific" enterprise much later; during the 1740s and 1750s in France, the two poles were seen as fundamentally compatible only in Buffon's limited sense and only, as he said, "for a very small number of subjects."[59] One of the ambitions of the *Encyclopedia*, symptomatic of the culture of diagram, was to yoke the natural and mathematical sciences into a kind of coexistence, although

the fractures within the article on description chronicle the limits of that enterprise.[60] The article also mimics the dispersal and sectioning of disciplinary knowledge characteristic of the overall structure of the *Encyclopedia*: the natural sciences exist alongside, but relatively independent from, geometry. There is a dissonance among competing voices about the nature and limits of mathematical descriptions, and the intellectual rifts—between Buffon or Diderot and d'Alembert—are cross-referenced into specialized articles where they do not threaten the power of language to render the world. Description survives the deep philosophical differences among its authors by a sleight of hand masked under the *Encyclopedia*'s dictionary form.

The final section of the 1754 article concerns belles lettres. Here, disagreements surface about the kinds of knowledge made possible by descriptive language; two protagonists write competing texts that face one another directly within the columns of a single article. Their differences hinge on the orientation of descriptive language: does it point mainly toward the external world of objects, or does it also address the internal world of emotions and aesthetic experience? For Edmé-François Mallet, "descriptions of things should present images that bring objects to presence." By contrast, Louis de Jaucourt is primarily interested in the pleasure arising from "a mental activity that compares ideas created by words with those produced by the actual presence of objects." Jaucourt starts his part of the article by taking exception: the conjunction *but* [mais] crowds in just after Mallet's signature pretends to close the discussion. Jaucourt reopens the entire topic, echoing and reorienting Mallet's words through the lens of Addison's ideas by asking: why do "all descriptions that depict things well" give us pleasure, even when rendering things "unpleasant to see"? His answer—"because the pleasures of the imagination are extremely vast"—articulates a view far removed from that of his colleague.

Jaucourt's and Mallet's backgrounds contrast sharply. Mallet, a clergyman who rose from his origins in a family of pewterers, took a "conservative cast of mind" and, according to Frank and Serena Kafker, was an "ardent royalist" whose articles "usually look backward in time for principles and models." He opposed "a philosophy of knowledge stressing sense perception," and feared that "the study of the English

language encourages the reading of Hobbes, Locke, and other scandalous writers."[61] Jaucourt, by contrast, was from a family of Burgundian aristocrats whose Protestant leanings led him to Geneva, England, and the Lowlands for the fundamentals of his education. Very much the Enlightenment polymath and anglophile, he contributed one-quarter of all the articles in the *Encyclopedia*, including the short but remarkable item on the novel [roman] that traces a history of the modern psychological novel along lines similar to those of present-day criticism. These two men speak for the Enlightenment with diametrically opposed views about the communicative potential of descriptive language.[62]

Mallet's conception of linguistic description as demonstrative, external, and directly representational openly confronts Jaucourt's mode of description that is fundamentally linked to and lodged within human reflexivity. The article as a whole refracts the epoch-making division of knowledge implicit in the empiricist enterprise as a break between science and the aesthetic. Science proposes a world perceived by the senses, or their extensions in instruments, but still external. The aesthetic orients knowledge to an internal world that is largely self-referential, although actuated by external phenomena. The culture of diagram, as we call it, embraces both scientific and aesthetic orientations, notably with shifts of scale, perspective, and imaginary points of view that follow from recasting innate and idealized knowledge in terms of the materiality and limits of human perception.

The decisive innovations in method, language, and form that we have in mind concern emerging standards of symbolic representation. These standards no longer converge in the human scale and organic continuites of the classical tradition, but remain distinct and specialized to the task at hand. Although the analytic methods of science and aesthetics are relatively autonomous, the two may be synchronized in a perceptual instant experienced, as Banfield suggests, by a machine or instrument as fully as by a human being. They also may be synchronized linguistically in those novelistic instances of free indirect discourse where subjective and private internal states are represented impersonally as if present to external perception. Impersonal, third-person grammar produces an effect of mental presence without narrative, analogous to the raw data of physical phenomena produced by recording instruments. The novel

of the mid-eighteenth century may be viewed in our context as a symptom of the culture of diagram, for its stimulates the reader to bridge the empirical and the affective in order to project coherent fictional worlds. Equally symptomatic would be Diderot's famous salon walk through the landscapes of Joseph Vernet, or his moments of reverie before the absorptive quietude of Chardin's figures.

The new methods summed up by Daubenton's account of natural history, or codified by the demands of Jaucourt's aesthetic, demand internal consistency within each analytic gesture or moment. Consistency is determined flexibly by function rather than by a fixed external scale or by the requirement that all observations integrate fully with one another. Nonetheless, a principal difference between the scientific and aesthetic systems lies in their respective orientations: on one hand, toward the object of study; on the other, toward the comprehending subject. The culture of diagram links the two via a spectrum of interpretation granted by correlation. The plates of the *Encyclopedia* would eventually formalize correlation as an established practice. At stake in the section on belles lettres, and orbiting around the Janus-faced *mais* that divides its parts, is a theory of what kind of knowledge correlation makes possible.

Daubenton considered description to be capable of yielding general knowledge in natural history and saw it as broadly inclusive though bounded. Mallet, by contrast, views description in the belles lettres merely as a truncated form of definition, "sufficient to give an idea and allow the distinction" of one thing from another yet "not unfolding its nature or essence." By his account, literary description catalogues the accidental qualities that allow us to distinguish individuals of similar nature from one another without "revealing or uncovering their essential attributes." Mallet wants description not to respond to the question *quid est*, but to the question *quis est*—not "what is it?" but "which is it?" His insistence upon confining descriptions in belles lettres to a narrow rhetorical role—an insistence repeated in his section of the article on definition—follows the classical model of setting the practical yet superficial language of persuasion against the precise distinctions of philosophical dialectic. Where the latter deals in the true and essential nature of things, persuasive descriptions traffic in illusions by "presenting certain images that render objects as if present." The classical paradigm assumed that philosophical

dialectic could stabilize the equation between words and things, and between words and ideas. Rhetoric, historically taken to be a simulation of dialectic, was suspect because it distorted the reasoned connections established by philosophy in order to move and persuade. Locke, following Bacon, cancelled all such equations: he separated verbal definitions from inquiry into the physical nature of things, and he established principles that located words and objects in different intellectual arenas or disciplines.

In the face of such difficulties, natural philosophy as construed by the encyclopedists turned away from dialectic towards mathematics and the physical sciences. The logical sequences of dialectic yield little knowledge about the physical world or the nature of the mind when compared to the empirical observations of natural history or the self-reflexive studies of mental experience. Where vigorous new disciplines like linguistics, natural history, and aesthetics embraced inductive methods, dialectic was left relatively arid fields of inquiry—for example, definition—still accessible to purely deductive methods. Thus, Mallet relegates philosophy to a narrowly confined formalism when he says that its business is definition. His version of literary description risks a similar fate. In contrast to the flexible, multi-scaled modes of description proposed for natural history by Daubenton, Mallet forces rhetoric and belles lettres into highly formalistic roles. He veers only slightly away from this path in a related sub-section on rhetoric within the article on definition. There, he limits rhetoric to six formal practices by which it deceptively projects the clarity and compactness associated with definitions. Provocative is Mallet's handling of metaphorical definitions, for he suggests that their terms and language are set by the specific disciplinary discourse—he cites poetry, astronomy, logic, geometry, and rhetoric—rather than the objects described. In the process, and almost by accident, he moves toward a new idea of literature in which belles lettres might reclaim a place under the banner of the aesthetic.[63]

Mallet's strategy was to preserve for literary descriptions the external effects that had long been the domain of rhetoric. Increasingly, however, natural philosophy was appropriating description of the external world by orienting primary sense perception not to words but to diagrammatic correlations of data about nature—especially data acquired by means of new instruments. Mallet responds to this shift by narrowing the range of verbal descriptions to the merely heuristic, on one hand, and to the

literal production of physical affects on the other. As we have seen, his treatment of description begins with the former, but it closes with the latter by citing a passage from Boileau that reveals a hidden power of descriptions to "present images that bring objects to presence."

La mollesse oppressée
Dans sa bouche à ce mot sent sa langue glacée,
Et lasse de parler, succombant sous l'effort,
Soupire, étend les bras, ferme l'oeil & s'endort.

[The suffocating languor
At this word, his tongue feels frozen in his mouth,
And, weary of speaking, overwhelmed by the effort,
To sigh, he stretches his arms, closes his eyes, and sleeps.]

Mallet holds that the assonance of vowels and the alliteration of sibilants in Boileau's verse affectively generate the lassitude and languor signified by the word *mollesse*. In play here is the materiality of language and its sounds, but not truth value. For Mallet, description evades the rigors of definition and achieves persuasion or belief by linking the surfaces of things to the surface effects of language, like assonant sounds.

The example from Boileau is powerful because it preserves a mimetic connection between the thing described and its rhetorical apprehension. The staging of affect here resembles that of the standardized physiognomies defined by Charles Le Brun during the preceding century, when he offered formulas for moving viewers by producing externalized ciphers of internal emotions.[64] But any grammar of externalized emotions, like the superficial appearance of dialectical reasoning in the rhetorical enthymeme, or the metaphor that appears to be a definition, brings a potential to deceive the perceiving subject. Ancient spectres haunt Mallet's rhetoric. The point is that he—along with many of his colleagues working on the *Encyclopedia*—was struggling with the general scepticism launched by Locke's empiricist attack upon innate ideas and transparent language. One could respond, like Mallet, by insisting upon precise definitions and only the most consecrated rhetorical forms, but doing so leaves language with little more than an empty shell of surface effects. Mallet abandons description, as we have seen, on a small and quite technical island.

An alternative tactic was to change the rules. Rhetoricians of mid-eighteenth-century Britain and America, as Jay Fliegelman argues, rejected the simulations of philosophical argumentation recommended by classical rhetoric. Rather, they adopted a vocabulary of sincerity in which the art of speaking well became the art of revealing a profoundly authentic self.[65] In a passage that might stand as a manifesto for the new novel of Samuel Richardson or Henry Fielding, the rhetorician Thomas Sheridan outlines a linguistic operation of psychological exchange entirely consonant with Jaucourt's discussion in his article on the novel for the *Encyclopedia*:

But as there are other things which pass in the mind of man, beside ideas; as he is not wholly made up of intellect, but on the contrary, the passions, and the fancy, compose great part of his complicated frame; as the operations of these are attended with an infinite variety of emotions in the mind, both in kind and degree; it is clear that, unless there be some means found, of manifesting those emotions, all that passes in the mind of one man can not be communicated to another. Now, as in order to know what another knows, and in the same manner that he knows it, an exact transcript of the ideas which pass in the mind of one man must be made by sensible marks, in the mind of another; so in order to feel what another feels, the emotions which are in the mind of one man must also be communicated to that of another by sensible marks.[66]

Both Mallet and Sheridan are attentive to the materiality of language. Separating them is Mallet's insistence that material sounds explicitly mimic the governing idea—as when Boileau's sibilant consonants become more widely spaced and "languor" [mollesse] slides into sleep. Because Sheridan recognizes that "great part" of experience is emotional and imaginative, he seeks a vocabulary for performing this inner, non-ideational realm with all its paradoxes and contradictions.

V

In such a context, the interjected *mais* by the committed anglophile Jaucourt redirects the entire thrust of the section within an empiricist frame by cutting descriptive language free from things, and by pointing to new forms of knowledge accessible to the inner life that might rival the success rate of science. Jaucourt takes literary description in directions compatible

with Sheridan's treatment of elocution. The reception of recent English novels in France, as well as Joseph Addison's preliminary treatment of issues we now call "aesthetic," legitimated Jaucourt's move. At the heart of Jaucourt's theory of description—indeed of his literary aesthetic—lies the statement:

One of the greatest beauties of the art of descriptions is to represent objects capable of exciting a secret emotion in the mind of the reader, and of bringing his passions into play. It is quite extraordinary that the same passions unpleasant everywhere else please us when they are produced in our hearts by fine and vivid descriptions. We sometimes like to be terrified or distressed by a description, although we are deeply troubled by the fear and grief that come our way from anywhere else.

The idea of unmediated communication that goes to the heart of the auditor—to the "secret emotion"—could not be farther from the classical ideals of persuasion through apparently strict argumentation and the crafted simulation of affect. As Diderot says of Richardson, "if there is a secret sentiment deep in the soul of a character he introduces, listen well and you will hear a discordant tone that reveals it." Diderot's *Éloge de Richardson* (1761) aligns with Jaucourt's focus on secret emotion. Diderot consistently employs diction of the elocutionary movement on both sides of the Channel where words like "action" (meaning pronunciation and gesture), "accent," "expression," and "tone" frequently recur:

Outbursts of the passions have often reached your ears, but you are far from understanding all that is secret in their inflections and expressions. Every single one of them has its own physiognomy; each appears on a face one after another without changing the face itself. The artistry of a great poet or painter is to show you a fleeting moment that you had overlooked.[67]

Diderot suggests that a gap between habitual experience and its reflective representation exists in the arts in general, not just in language.

Analysis of this gap reveals an overlap in the interests of Diderot, Jaucourt, and elocutionists like Sheridan. The fleeting affects of emotion and expression become their domain of study. The *Spectator* essays on the pleasures of the imagination, cited by Jaucourt, also promote an orientation to the inner world of experience, a world that for Addison is defined

by sight, the most vivid of the primary faculties. Diderot and Jaucourt, in common with the elocutionists, populate with inner life the breach between primary sense perception and language, on one hand, and between ordinary, habitual experience and its minutely reflective representation in the arts, on the other. Addison takes this gap as an object of critical discussion: the English writer's attempts to codify the literary language that produces these pleasures mark the beginning of modern critical discourse about the play of imagination in the arts. At stake in this is a theory of aesthetic knowledge, oriented to a taxonomy of the inner world of the mind and reflecting on the perceptual faculties. It is no less rigorous than Daubenton's theory of knowledge in natural history oriented to the external world of objects. Common to both, and characteristic of the culture of diagram, is a rejection of universal norms in favor of differential standards keyed to the object of study.

Both Jaucourt and Daubenton agree that description must break free of the traditions of rule-bound rhetoric. Where the descriptions of natural history are guided by the relative scale and complexity of external objects, those of belles lettres take shape within the imagination. In each case, and despite the vast differences between outer and inner orientations, successful descriptions point to a larger, more comprehensive world than the one available to ordinary, habitual experience. To underscore this distinction, Jaucourt focuses on a defining question in the aesthetics of the period: how are we to understand the pleasure we take in descriptions of the pain of others when these occur in the arts? Unlike Mallet, Jaucourt cares neither for "what is it?" nor "which is it?" Rather, he opts for the power of literary description to "sow illusion and enchantment in the soul," including the transformation of objective pain into subjective pleasure.

In the aesthetic realm, the focus upon internal affect and imagination inevitably relativizes the importance of primary sense perception. In the natural sciences, reliance upon visual arrays designed to organize primary sense perception—that is, an orientation to the external world— privileges correlation and minimizes both narrative and causal explanations. Yet the need remains to organize the flood of impressions washing the mind. Consequently, much of the eighteenth-century debate about scientific method centered on doubts about attributing causal sequences

in hypotheses.[68] Hume proposed, in his discussion of personal identity, that our mental processes habitually employ fictionality, presumed causes and effects, and thus narrative structure to handle the sensory overload. The delusion of narrative coherence lies at the core of ordinary experience and identity.

For Hume, imagination valorized by custom and "common life" underpins our mental existence: "The memory, sense, and understanding are . . . all of them founded on the imagination, or the vivacity of our ideas."[69] Yet, he cannot admit that the aesthetic possesses the critical power of philosophy or the convincing—if analytically questionable—vivacity of common life. The reason is that aesthetic power is based entirely upon illusions. "The question," as Hume says, "is how far we ought to yield to these illusions."[70] The aesthetic he writes:

is common both to poetry and madness, that the vivacity they bestow on the ideas is not deriv'd from the particular situations or connexions of the objects of these ideas, but from the present temper and disposition of the person. But how great soever the pitch may be, to which this vivacity rises, 'tis evident, that in poetry it never has the same *feeling* with that which arises in the mind, when we reason, tho' even upon the lowest species of probability. The mind can easily distinguish betwixt the one and the other; and whatever emotion the poetical enthusiasm may give to the spirits, 'tis still the mere phantom of belief or persuasion. . . . There is no passion of the human mind but what may arise from poetry; tho' at the same time the *feelings* of the passions are very different when excited by poetical fictions, from what they are when they arise from belief and reality.[71]

Hume is attuned to the interpenetration of our absorption in imaginative life and our awareness of its removal from the everyday. He implicitly points to the imagination's central role in the new aesthetic, with its affective difference from the disciplines of science. When he argues that the vivid impressions of poetic objects are never mistaken for reality, his reason is that the former are "mere phantoms of belief or persuasion." Which is another way of saying that Hume believes, contrary to conventional accounts of mimesis, that poetry is a correlative activity across mental distance triggered by impressions from the real world.

Jaucourt and Hume converge on the point that certain conventions of

representation—those that bring us into close contact with secret emotions—have the power to evoke guiltless pleasure in the pain of others. These conventions enable intense aesthetic response while juxtaposing—diagrammatically rather than rationally—their material artifice to the habitual repression of delight in suffering necessary to social commerce. But when the secret emotions produced by poetic correlation are placed in the foreground of representation—when the processes of imagination lie increasingly at the focal point of literary, painterly, and critical attention—incongruent effects, such as shifts in scale or point of view, develop a vividness that Hume cannot acknowledge to be real.

The 1754 article on description sidesteps Hume's dilemma by accepting a crucial division between natural science, where primary sense perception (often reinforced by instruments) organizes knowledge, and a collateral terrain where imagination reprocesses or even supplants primary sensory perception to produce surprising secret emotions. The one realm achieves authenticity—the real—by bracketing affect; the other by embracing it. Paradoxically, the realm of imagination so profoundly distrusted by Locke has become itself the object of a different order of inquiry and the locus of a new kind of knowledge. What is clear is that the old system of mimesis does not disappear. On the contrary, as attempts by elocutionists of the period to reconfigure classical rhetoric reveal, authenticity required connecting interior phenomena to the external world by means of gesture and tone in the context of a physical staging before a public. The projection of sincerity was tied, in Hume's terms, to custom and common life. To the degree that staging remained a central mode of expression, mimetic representation was not abandoned.

For all their innovative technologies and instruments of measurement and analysis, the sciences were not exempt from the physical parameters of spectacle. The results of scientific inquiry, often no less specialized or esoteric than mental constructs of the imagination, required some form of dissemination: this might be technical journals designed for insiders—the *Universal Magazine* is an example—or, as was frequently the case, demonstrations before a public. Larry Stewart documents the importance of virtual stagings, sometimes in coffee houses, for the popularization of Newton's ideas across a broad spectrum of the public.[72] Live demonstrations of this sort, in which the findings of science were given

concrete and tangible form, were essential to producing the broad base of assent necessary to the construction of scientific fact in eighteenth-century culture. Two famous pictures by Joseph Wright of Derby—*An Experiment on a Bird in the Air Pump* (FIGURE 28) and *A Philosopher Lecturing on the Orrery* (FIGURE 29)—are representations of just such stagings before a mixed public, where the findings of science produce a range of private responses from deep meditation to outright shock.

The highly personal unscientific impact upon viewers of such demonstrations led Joseph Priestly to distinguish between fictive simulacra—like orreries—and the hard fact of a dead bird produced by creating a

FIGURE 28
Joseph Wright of Derby, *An Experiment on a Bird in the Air Pump*, 1768. Oil on canvas. London, The National Gallery, inv. NG725 (183 × 244 cm). Photo: © The National Gallery, London.

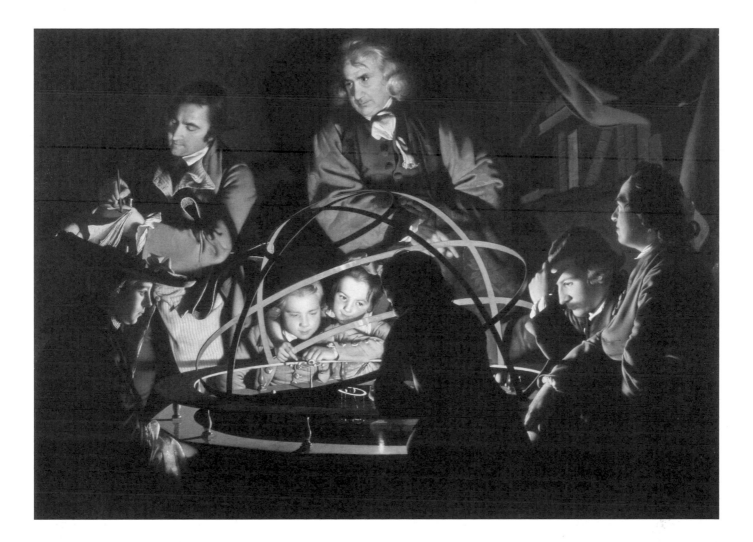

vacuum with the air pump.[73] His separation of these realms is consonant with the separation of knowledge implied by the analysis of description within the pages of the *Encyclopedia*: literature and science seemed to require unique domains. We have traced, by contrast, the rise of diagram as a hybridized form of knowledge in which a user's imagination intertwines with the world of fact to produce new understanding. Priestly would have struggled to explain the hybrid of fact and simulation presented to the eyes of our surgeon by his helmet; he certainly would not have wanted fiction to guide the scalpel.

FIGURE 29
Joseph Wright of Derby,
A Philosopher Lecturing on the Orrery, 1766. Oil on canvas.
Derby, Derby Museum and Art Gallery, inv. DBYMU 1884-168 (147.3 × 203.2 cm). Photo:
© Derby Museums and Art Gallery, 2008.

4 VISUALIZATIONS

Our reading of the 1754 article on description in the *Encyclopedia* reveals significant discontinuities across the domains of natural science, mathematics, and the arts. This single article offers more than a fleeting epitome of the much larger cultural situation in France, for the task of describing is central to every system of knowledge in the eighteenth century. Two of the article's four authors attend to descriptions in belles lettres—which is to say writing in and about the arts as opposed to science. The identity of the arts in a burgeoning scientific culture was not guaranteed: internal disagreement within the paragraphs on belles lettres signals a sense of change and urgency. The role of the visual and its effect on spectators, individually and as a public, moved to center stage in the wake of new theories concerning empiricist psychology and anatomical physiology. Diderot set the critical terms for discussion of theater and painting in the 1750s, and figures importantly in our story. Jean-François Marmontel, who, centrally for this chapter, revisited the subject of description in the *Supplément* to the *Encyclopedia*, tended to work within Diderot's critical framework while upholding the grand tradition and its established hierarchies.[1] Amidst this ferment, Jacques-Louis David burst on the scene in

1785 with an ambitious history painting that redefined the genre by grafting it to the descriptive and expressive potential of diagram. Thus, theater and history painting—the most ambitious, public, and discussed forms of artistic culture of the day—form the core of the present chapter.

A context for our discussion is the expansion of information and knowledge in the natural and mathematical sciences, which exerted pressure on established professional institutions to accommodate new research and the career ambitions of newcomers. In some cases entirely new institutions were founded, often against the interests and will of those already in place. Moreover, the expansion of experiment in every field of the physical sciences during the middle decades of the century accompanied an explosion of public interest in all matters scientific. "Scientific information was being diffused among the literate classes of France at a rapid pace," writes Roger Hahn, an expansion that supported growing numbers of practitioners as science became "at once a more popular and a more professional discipline."[2] Hahn outlines the contemporary vogue for anatomy and natural history that gave rise to collections among amateurs, along with guides, dictionaries, and lavishly illustrated compendia of observations made under the microscope. Both acknowledged experts and amateurs of botany ventured on field trips, but to different ends: for the expert, an outing offered the opportunity to identify local flora; for the amateur, it was an interesting diversion that required little preparation.[3]

Beneath this veneer of shared interests and cooperation, the new range of activity and public interest produced divergent practices within the larger scientific community. Growing numbers of trained experimenters with sophisticated specializations challenged official organizations, such as the Academy of Sciences, to consider broadening their membership. When the Academy proved reluctant to share its acquired privileges, young practitioners began to set up rival institutions. At the same time, growing interest in scientific issues by a knowledgeable public led to the founding of groups designed, in the words of Hahn, "for the mutual exchange of information and the sharing of pleasure rather than for the rigorous advancement of the discipline or for purposes of acting as government consultants."[4] The scientific culture of mid-century France was thus doubly divided, for the community of acknowledged experts was dispersed among official organizations and specialist groups, and held at

arm's length by elected academicians. A notable example of this division was the Academy's concerted effort to eliminate the Société des Arts, an organization founded in the 1720s. The Société included both trained experimenters and artisans with the goal of encouraging inventions and their publication.[5] The Academy responded to the growth of the Société des Arts by blocking its application to become a government-sponsored institution, and by electing its leading figures to membership—with the proviso that they resign from the upstart rival.

A striking example of the interplay between institutionalized science and an impressionable public was the rise and demise of Mesmerism in the 1780s. Robert Darnton has shown that Franz Anton Mesmer's theory of a superfine fluid that penetrates and surrounds all bodies participated fully in the late-eighteenth-century discourse on the existence of pervasive elements, including gases, fluids, electricity, magnetism, and gravity.[6] Scientists and non-scientists alike constructed systems—often fanciful—to explain the behavior of such elements in the physical world. Mesmer was unexceptional in this context. In response to the extraordinary fame and privilege enjoyed by Mesmer during the early 1780s, the Academy launched an equally extraordinary investigation of his claims. It was spearheaded by leading lights of the Académie des Sciences—including Antoine Laurent de Lavoisier, Jean-Sylvain Bailly, and a visitor to France named Benjamin Franklin. They concluded that Mesmer's "fluid" did not exist and that the effects of his procedures—convulsions, trances, and cures—were largely self-induced by the patients themselves.[7] Not surprisingly, the Academy's report did not finish off Mesmerist practices; rather, it provoked a flood of pamphlets defending his cause and belittling the Academy for its desperate attempt to quash a scientific theory it could not control. The Mesmer phenomenon typified the contemporary rift between high science and popular scientific interests.

The field of mathematics—both outside and inside the Academy—fractured along related lines. Mathematical principles circulated among interested amateurs by means of courses offered in the provinces at local institutions called *musées*. Applied mathematics was taught at technical and military schools, where faculty appointments were added and curricula revised to enhance instruction in practical calculation.[8] Despite this double-pronged proliferation of mathematical inquiry, the Academy

closely guarded its hierarchical privilege. Even Pierre-Simon Laplace, brilliant and well-placed in a post at the École Militaire, had to present no fewer than thirteen remarkable papers before he was admitted to the Academy. Laplace emerged as an innovator in applying the infinitesimal calculus to a study of probability that eventually challenged the systematic certitude of established mechanics. Where d'Alembert maintained a strict ontological separation between mathematics and physics, Laplace worked to bring these two domains together using the tools of probability and analysis.[9] In Chapter 5 we will focus on mathematical description, including the broader implications of Laplace's probabilistic turn. For now, Laplace's institutional career, alongside his running debates with Buffon, d'Alembert, and Condorcet, registers that the discontinuities implicit in d'Alembert's contribution to the article on description ran deep through the terrain of mathematics and the institutions of the period.

Discussion of belles lettres in the mid-1750s presents a rather more textured situation than either natural science or mathematics, for there was a long tradition of debate about the very nature of representation.[10] Jaucourt's contribution to the 1754 article on description emphasizes above all the "secret emotion" elicited in the spectator of a stage production, the reader of a novel, or the viewer of a picture. As we have argued, his position, following Addison, stresses the role of imagination in the production of personal affect. Mallet, by contrast, strove to uphold the author's responsibility to employ any such affect in the service of moral or ethical improvement. At stake in their disagreement is the place of the reader's or viewer's emotional response in the spectrum of ideas and values mobilized by the work of art. The disagreement transcends personalities. To establish its historical context, and to clarify its importance to our story of diagram, means engaging some contemporary texts on developments in the theater. Theater emerged in mid-eighteenth-century France as a vital institution where the nature of aesthetic representation was actively debated and defined.

II

Hovering behind the positions of both Mallet and Jaucourt is the critical presence of Diderot, whose writings on the theater began in 1751 with *Lettre sur les sourds et muets*. Notable in this text is the passage in which

Diderot describes his efforts to judge "the movements and gestures" of a performance. He would begin by taking a seat in the highest loge and plugging his ears so as not to hear the dialogue. "I worried very little about making judgments," he writes, "and I stubbornly plugged my ears so long as the action and the acting seemed to correspond to the dialogue that I remembered. I listened only when I was thrown off by the gestures, or thought that I had been."[11] By his own account, Diderot had committed to memory most of the plays he viewed in this way, so that he could weigh the silent stage movements he saw against an "ideal" version of the script stored in his head. Diderot's isolation of the visual qualities of staging and gesture indexes an important shift of his critical attention, so that his experience of the spectacle assumes a greater interest than the author's words. His choice of a seat far from the stage, along with his blocking of most of the dialogue, are two willful gestures that physically disarticulate the theatrical production.

Seeing the actors from afar, and hearing only his own inner voice speak the dialogue, allowed Diderot to relocate himself (the spectator) at the very center of the experience, constantly weighing the appropriateness of its visual appearance. Here, we rediscover the Diderot of the *Encyclopedia*'s *Prospectus* discussed in Chapter 1, where the user (or, in this case, spectator) is immersed in a continuous process of comparative evaluations leading to critical understanding. The theater assumes a special status for Diderot because it defines an environment where primary input from the sensory faculties and internal mental processes—such as reason, judgment, and imagination—are joined to the affects or passions. This is particularly true of the genre he defined as *drame*, which in his own words "was between comedy and tragedy."[12] Drame transgresses the classic genres by mixing them. It immerses the spectator in a give-and-take animated by words, gestures, and feelings without specifying moral improvement or critical acuity. Its formal discontinuities stimulate sensibility. It is a kind of correlation proper to theater, yet shares the operating principles that animate the plates of the *Encyclopedia*. It also offers the potential to transcend the specificity of individual, private synthesis and to reach toward a collective ennobling experience of didactic ambitions that approaches the moral force of tragedy.[13]

Diderot's silent mode of theater-going implies critical concepts that

he clarified in the *Entretiens sur le Fils naturel* of 1757 when drawing a distinction between *coup de théâtre* and *tableau*: "An unforeseen incident that occurs in the plot and suddenly changes the disposition of the characters, is a *coup de théâtre*. An arrangement of these characters on the stage, so natural and true that it would please me on canvas if rendered by a painter, is a *tableau*."[14] Diderot's point of reference for this distinction lies outside the world of contemporary theater since *tableau* was a term generally applied to painted representations. His use of the term registers an interest in pictures that would find its most direct expression in the *salons* he wrote for Grimm's *Correspondance littéraire* beginning in 1759.[15] Diderot's notion of tableau in the theater assumes an estrangement between the stage space and audience akin to that he achieved by sitting high in the loges and blocking his ears. A tableau is "natural and true" if actors avoid any gestures openly directed to the audience that signify they are acting. In a well-known formulation of 1758, Diderot enjoins both playwrights and actors: "So, whether you are writing or acting, don't think about the audience any more than if it didn't exist. Imagine a great wall at the edge of the stage separating you from the parterre; act as if the curtain didn't go up."[16] Diderot's imaginary *grand mur* (today usually called the "fourth wall") establishes an important asymmetry between the stage space and the auditorium: actors, in order to move spectators by the naturalness of their actions, must pretend the audience is not there; viewers, who see and hear the actors across this invisible barrier, are allowed no physical interference in the staging. Their alienation is ultimately rewarded by a compelling illusion able to move them deeply.[17]

Diderot's propositions about the structure of tableau and theatrical illusion later became commonplaces, but when he wrote they were calls for a drastic reform of stage practice in France. It was usual for important members of the audience to be seated upon banquettes placed on the stage itself, close to the action and even flanking the actors. A standard French stage, such as the Comédie-Française, almost always comprised an apron that extended the acting space well into the main amphitheater. Moreover, the usable space behind the curtain drop tended to be shallow, owing to the difficulty of lighting it from the wings. The result was that theatrical illusion was undermined by the presence of contemporary viewers mixed into the staged drama, a situation deplored by the actor

Claude Crébillon: "The actor always messed up his entrance, appearing either too early or too late; emerging from amidst the audience like a ghost, he vanished likewise without anyone noticing the exit. Finally, not all of the great tragic gestures could be performed, and *coups de théâtre* always fell short."[18] There were occasional calls to remove the banquettes from the stage—notably by Voltaire, who believed the presence of spectators on stage had spoiled the effect of his *Semiramis* in 1748.[19] Actors resisted this reform because they earned considerable income from selling these select seats to well-heeled patrons.[20] Only in 1759, at the instigation of a published appeal by the actor Henri-Louis Lekain, were the banquettes finally removed from the Comédie-Française. The change was widely acclaimed, notably for the increased level of theatrical illusion. Charles Collé recorded an enthusiastic approval in his journal:

This produces the best of all possible results; I thought I sensed that one heard infinitely better the actors' voices. Theatrical illusion is now complete; gone is Caesar on the verge of depowdering some fop seated in the front row and Mithridates dying amidst a group of our personal friends. . . . This new form of theater opens to tragic writers a new career of lavishing on the poetry some spectacle, some pomp, and more action.[21]

In the words of the theater historian Gösta Bergman, "the event was to prove one of the great turning points in the history of the Comédie-Française confirming that a new concept of illusion was slowly emerging."[22] Within two years, the chandeliers that had long hung above the proscenium were removed, and with them a source of light common to both the stage and the auditorium.[23] There were now distinct spaces and lighting schemes for the actors and the audience: Diderot's invisible wall had begun to take shape.

Theatrical illusion for Diderot proceeds from the dual nature of this immaterial wall between audience and actors. For the audience, it is an aperture opening onto a represented world framed within a wider field of vision. For the actors, it is an imaginary screen blocking direct address to the auditorium. Although actors and audience share an actual architectural space, Diderot wants to distinguish psychologically their respective domains by minimizing any overt signs of social exchange. If actors refrain from acknowledging the audience, viewers will sense an

alienation from the drama that paradoxically heightens its impact. This is the crux of Diderot's theory of dramatic affect: the play must be vividly present to the audience and simultaneously held at a distance, so that one never feels able to intervene in the unfolding events. In Diderot's scheme, illusion is not only an optical or auditory effect upon the audience, but also an affective power that arises when viewers sense that the dramatic action unfolds beyond their control with the inevitability of real life.

Diderot's view that theatrical illusion emerges from a complex, multi-sensory experience is consonant with his general theory of perception. In *Éléments de physiologie* he writes, "Objects act upon the senses; sensation within an organ has duration; the senses act upon the brain, and this action has duration: no sensation is simple or momentary because, if I may put it this way, it is a bundled sheaf. From this arise thought and judgment."[24] There is no good reason to value optical information over other sensations on the grounds that it is more immediate or direct, since every sensory organ receives information and transmits it over time. Temporal distinctions between poetry and painting, often discussed in the eighteenth century, are irrelevant for Diderot, which is why he can think about pictures temporally and experience theater statically.

Diderot also believed that each organ had its own specialized nerves and function, and that the brain was a kind of clearing house where diverse data were organized. "The brain does not think by itself, any more than the eyes see or the other senses act by themselves. The brain needs objects to think, just as the eye needs them to see. Aided by memory, the brain tries in vain to envision, mix up, combine, and create fantastic creatures, but they live a scattered existence."[25] When we look at a tree, we see its many parts. These sensations give rise to others that "are invented, linked together, and arranged" into a bundled sheaf [faisceau] of information: "a connected and coherent set of sensations, ideas, and words."[26] Diderot's bundled sheaf is not given in the object per se, but created by our active filtering of sensory data through layers of memory and experience. Moreover, we do not stop at simply looking: "We sniff a carnation and take in a scent that is strong or weak, pleasant or disagreeable—suddenly a different set of sensations, ideas, and words. The power to judge, to reason, and to speak arises from this situation, even if we cannot attend to two things at once."[27] A direct line leads from Diderot's account

of perception over time, aided by the integrating function of the brain, to the process of correlation highlighted in the texts and plates of the *Encyclopedia*, where ideas and terms branch via cross-references to related areas that invite the user to exercise his or her brain to form judgments.

A corollary of Diderot's argument situating the senses on a flat plane of significance is that spoken words do not automatically take precedence in experience. His position raises special issues for the stage, since the playwright's words constitute only the aural dimension of the complete theatrical experience. Not surprisingly, Diderot took issue with the tendency in France to emphasize the author's text over the effects of staging. "We talk too much in our plays, and consequently our actors don't act enough," he wrote in *Entretiens sur le Fils naturel*; "we have lost an art whose potential the Ancients understood very well."[28] A few years later, in his essay *De la poésie dramatique*, Diderot enjoined actors not to become controlled by the author's text, but to employ their entire physicality for expressive ends:

Actors, take possession of your rights; do whatever the occasion and your talent might suggest. If you are made of flesh, if you have guts, everything will go well without me meddling in it; everything will go badly, and I will have wasted my time getting involved, if you are made of marble or wood.[29]

Diderot's thoughts during this period return frequently to a topic that had emerged as central in contemporary discussions of the theater: the role, place, and power of pantomime.

Pantomime had long been treated by critics with suspicion, for it seemed too closely allied with forms of popular entertainment, such as the commedia dell'arte or spectacles at the fairs, to have a place in serious theater.[30] Defenders of the classical tradition believed that wordless gestures or movements on stage would only detract from the moral force of reasoned dialogue: for them, actors should move their bodies only to accent their delivery of words according to patterns established by the rules of rhetoric. Jean-François Marmontel's article on the art of declamation for the *Encyclopedia* sketches a rationale for the classical sign system governing face and gesture in speech:

We share these signs with other animals: they were the only language of humans before ideas were associated with articulated sounds. One still has recourse to

them when speech is lacking or not adequate; witness mutes, children, those who have trouble speaking a language, or whose lively imagination or restless sensitivity clash with the slowness of phrases and the deficiency of words. The art of declamation was created by transforming these natural signs into patterns.[31]

Marmontel insists that gestures became truly human only when linked to speech and organized into patterns. Gestures without language are of a lesser order, reserved for creatures unable to express complex ideas: animals, deaf-mutes, children, or people too impatient to reason fully.

Declamation in the theater emphasized an expressive use of face and hands, orchestrated in tandem with the cadence and rhythm of voice, to produce a measured visual supplement to the spoken lines of a play. Movement remained subject to the power and reasoning of the word and, for this reason, gestures without speech were to be avoided. This system, which ensured a preeminence for the dramatic author, was seldom challenged before the 1750s. One important exception was the abbé Jean-Baptiste Dubos, whose *Réflexions critiques sur la Poésie et sur la Peinture* includes (beginning with the edition of 1732) a discussion of pantomime that celebrates its ability to express thoughts without words. He cites an experiment orchestrated by the Duchesse du Maine in 1714: two dancers were asked to perform the fourth act of Corneille's *Horace* accompanied only by music.[32] Dubos uses the story to claim that gestures are as likely as words to produce emotion, but his larger interest goes further. "I believe that Painting has a greater power over humans than Poetry," he wrote, because it acts visually and employs signs that are "natural" rather than artificial.[33] Dubos's ultimate goal was to construct a theory of art that hinged on the emotional power of visual affect: in his scheme, a painted tableau produces a more powerful impression on us than verse because it acts more quickly and all at once; by contrast, a play—a series of unfolding tableaux—will always exceed the power of any single painting.[34]

Diderot's thinking about the theater is indebted to Dubos's earlier essay, especially when he attends to the visual impact of acting. He admits, in *Lettre sur les sourds et muets*, that most gestures can be translated into words, but is careful to reserve those "sublime movements that no amount of oratorical eloquence will ever render." Diderot singles

out the image of Lady Macbeth sleepwalking on the stage and gesturing as if washing her hands: "I know of no speech so full of pathos as the silence and the hand movements of this woman," he exclaims. "What an image of remorse!"[35] Lady Macbeth does not speak or look at the audience. For Diderot, the scene's emotional impact depends upon a vivid presence made more poignant by the silence of her gestures: "I would add that there are whole scenes where it is far more natural for the characters to move around than to speak."[36] Lady Macbeth's pantomime sketches the parameters of a wordless drama with an enormous expressive potential.

Diderot imagined theater as a total art form that integrated speech, visual imagery, movement, action, and precise mimetic detail into a surrogate world with the kind of emotional power brought to the novel by Samuel Richardson. He revealed this ambition when describing *Le Fils naturel*: "I added to it a few of my ideas about poetry, music, elocution and pantomime; from the whole I fashioned a kind of novel."[37] Diderot deplored the "pedantry" with which French actors "arrange themselves in a circle . . . step out of the narrative . . . speak to the parterre" and "are held in check by the presence of another who controls them."[38] He believed such practices would hamper the development of pantomime in France unless playwrights took the lead by actually writing stage directions.[39] Diderot insisted, almost in the manner of a novelist, that writing out pantomime should be a perfectly normal practice for authors, since "pantomime is the picture [tableau] that lived in the poet's imagination when he was writing, and how he would want the stage to appear at each moment of a performance. This is the simplest way of teaching the public what it has the right to demand from its actors."[40] Stage directions ensure that the author will retain general control of the scenic effect without asking actors to become simple marionettes. Moreover, the physical situation implied by the concept of *tableau* establishes a critical model for the playwright's work: "a theatrical audience is like a viewer before a canvas where the pictures follow one another by magic. . . . Apply the laws of pictorial composition to pantomime, and you will see that they are identical."[41] Diderot imagines that the structure of serious drama must change in response to the interjection of visual presence that he advocates.

The analogy between stage and painting is more than a leitmotif in Diderot's thinking; it becomes a project for the renovation of French drama: "As for me, I think that if a dramatic work is well made and well played, the stage could offer the audience as many real tableaux as there are propitious moments in the action for the painter."[42] The integration of effects that Diderot sought occurs only when the experience of theater-goers is "like a viewer before a canvas where the pictures follow one another by magic."[43] On the other side of Diderot's invisible wall, his staging demands a set of diverse technical devices and practices that cross the divide between highbrow and lowbrow forms. Declamation and stylized gesture had been the province of serious theater. Pantomime was little practiced by actors at the Comédie-Française but was common at fairs, boulevard theaters, and the Opéra-Comique. Diderot reported to Voltaire that the actors in his *Le Père de famille* felt the diversity of techniques he required "was so unfamiliar that most confessed to me they trembled when making their entrance, as if it were the first time."[44] The actors' classical training had not prepared them for improvising the extended moments of mute action or broken and interrupted phrases interwoven with silent action specified by Diderot for scenes like the recognition in *Le Père de famille* (I.vii).

Pictorial tableaux were the province of painting. Diderot's innovation was to carry a body of established critical terms from the picture gallery to the stage: "Theatrical action must still be far from perfect, since one almost never sees a staged situation from which a tolerable composition of painting could be made. What's that? Is truth any less essential on the stage than on canvas?"[45] For Diderot, theatrical illusion will be most powerful when authors construct coherent tableaux via pantomime rather than localized coups de théâtre driven by dialogue. He understood that this shift meant authors must begin to specify detailed stage directions: "Pantomime must be written out whenever a tableau is formed, whenever it energizes or clarifies a speech, unifies dialogue, defines a character, comprises a refined effect that cannot be predicted, takes the place of a reply, and—above all—whenever it opens a scene."[46] This is not to say that Diderot wanted actors simply to follow directions, for his goal was not to "reduce a man of talent to a machine-like state."[47] On the contrary, a respect for their expertise is why he exhorted actors to

"take possession of your rights" and to play their roles as living beings of flesh and guts rather than statues of marble or wood.

The certitudes of a theater centered on words, declamations, and conventionalized gestures eroded as a demand for integrated sensory experience took hold. Declaimed direct address to the audience, often in the guise of highly stylized speeches appropriate to a debating chamber or court of law, failed to shape feeling as fully as the multiple, fractionated practices—verbal, vocal, visual, gestural, and pantomimic—envisioned by Diderot. This diagram-like range of devices need not be fully integrated, for Diderot trusted the synthetic faculty of the audience—which he called sensibility—to unite a succession of tableaux and trigger profound feelings. Where were the actors to find their new tools? Diderot suggested to Marie-Jeanne Riccoboni that she study "painting, good painting, the great pictures—those are your models; attention and zeal—those are your teachers and guides. Let them speak to you and affect you with all their might."[48] Such advice is consonant with the critical connection between stage and painting that so interested Diderot. By contrast, the great actress Hippolyte Clairon, famous for her introduction of a conversational style on stage, recommended that actors study anatomy or consult Buffon's *Histoire Naturelle* to learn about facial muscles and, by extension, to master a full range of natural expression.[49] Her advice, which eschews traditional forms of representation like history painting, steered actors to the natural sciences, where the seemingly objective recording of physical facts might rejuvenate acting techniques. This disciplinary cross-over is an example of how the fragmentation of method indexed by the several voices writing on description for the *Encyclopedia* entered contemporary thinking about representation.

Experienced actors quickly became aware of the expressive potential opened by the mix of words and gestures punctuated by the silence advocated by Diderot. Perhaps the greatest practitioner of the new methods on the Paris stage was François-Joseph Talma, whose pantomime earned grudging admiration from his arch-rival Fleury: "Certainly, we were not able to recognize that this fledgling tragedian would produce such an effect; above all, we did not foresee the sublime expression of his features, his eloquent pantomime . . . we did not know that Talma would attain this grand style of comprehension and creation."[50] In the same spirit,

a leading actress of the Comédie-Française, Louise-Rosalie Dugazon, underscored the unorthodox ability of pantomime to produce dramatic continuity from disconnected fragments:

Yet there are certain parts of theatrical science about which neither tradition nor rules have ordained anything, nor could they. This is especially the case for pantomime. This universal language of action, intelligible to even the dullest minds, should be spoken constantly by the actor whenever he is on stage: it fills the empty spaces of the episode, the gaps in the dialogue. . . . During these moments of lack, pantomime appears, is deployed, and makes itself understood. . . . Without pantomime one can hear a beautiful delivery accompanied by learned gestures, but there will never be proper diction and true gestures: it's the combination of these two, which I would call harmonic, that produces expression.[51]

Dugazon touches upon several themes already introduced: a science of theater for which there are neither rules nor tradition; a language of movements universally understood; a filling of silences with meaning that unfolds in a "harmonic combination" visible only to the audience for whom words and gestures are clearly separate yet newly rejoined in the dramatic experience. Consciousness of this willed effort is the effect Diderot tried to elicit by plugging his ears and sitting far from the stage.

Diderot's attention to the constructive dimension of this effort emerges in his project to write scripts in two columns—one for dialogue and the other for simultaneous pantomime—that permit synchronizing the two without recourse to a linear, linguistic thread.[52] It seems that Diderot never actually wrote a play this way, but the idea is provocative, because it implies a graphically diagrammatic form for the play akin to the diagrams of the *Encyclopedia* discussed in Chapter 2. Importantly, Diderot did not envision pure pantomime without words, but rather a mix of mute gestures and dialogue, sometimes running simultaneously.[53] Theater needs words to guide the correlative energy of the audience, just as the diagrams of the *Encyclopedia* need letter keys referenced to texts to guide the reader or user. In Diderot's emerging theory of the theater, pantomime provides a material of palpable experience across the visible holes and linguistic emptiness separating a succession of tableaux. This emptiness, like the whiteness of the *Encyclopedia*'s plates, is where the audience—separated from the stage by an invisible wall—discovers

the terrain of *rapport* germane to Diderot's materialist understanding of expression, affect, and beauty. "Thus, when I say that a creature is beautiful because of the correlations [rapports] discerned in it, I'm not talking about intellectual or supposed correlations that our imagination brings to bear, but correlations that are really there, and which our judgment picks out with the help of our senses."[54] For Diderot, the silences of pantomime are not empty voids, but elements of the bundled sheaf [faisceau] of orchestrated stimulations that permit the brain of each spectator to fashion the dramatic impact. In Diderot's scheme, spectators literally complete the playwright's work. This is a thoroughly modern concept that presupposes a kind of audience immersion in the expressive mechanics of the stage. It was not universally accepted. Jean-François Marmontel was among those who tried to reign in the most radical aspects of Diderot's thinking without completely returning to the old order of things.

III

Marmontel became editor of the *Mercure de France* in 1758, at the height of debate about the nature of theater. At that time, his views about spectacle aligned closely with Diderot's own. Marmontel's later articles on "Description" and "Pantomime" for the *Supplément* to the *Encyclopedia* (1776 and 1777), as well as his 1782 essay "Drame" for the *Encyclopédie méthodique*, reveal substantial changes in perspective.[55] While Marmontel acknowledges the power of tableaux and pantomime to engage emotion, he insists on the primacy of dialogue. In serious theater, the ear should eclipse the eye because words carry an ethical weight that images and gestures alone cannot guarantee: "To the extent that theatrical action contributes less to eloquence and more to pantomime, and is careless about speaking to the soul in order to impress only the eyes, the show becomes more attractive and less beneficial to the crowd."[56] Here, and in his *Mémoires*, Marmontel clearly separates himself from Diderot, Jaucourt, and other advocates for a theater of affect.[57]

In the later article "Drame," Marmontel criticizes those so-called modernists who believe that all of the arts should be concerned with "affect, that is, illusion and the strongest possible emotion."[58] Marmontel acknowledges the complete illusion and pathetic power of Diderot's

drame, but he now views it as deceptive and false. He singles out the ear as the organ "especially reserved for conveying to us the spoken word, and with it, thought."[59] He admits that pantomime occurs naturally in speech and serves to clarify thought. He cites the history of Roman theater to argue that gestures detached from words are ungoverned by thought and that they may corrupt as easily as edify. For this reason, Marmontel recommended that wise governments should discourage a taste for pantomime. It can but temporarily move the emotions, while tragedy and comedy instruct by appealing to reason. "The pleasure of pantomime" is not forbidden, but it must be "neither the sole nor the dominant aim of a play." In pantomime, "passion acts on its own and addresses only the senses: nothing corrects nor restrains it," whereas in tragedy and comedy, "reason, wisdom, and truth each speak in turn." Like Jean-Jacques Rousseau in *Lettre sur les spectacles* on the theaters of Geneva (1758), Marmontel favors "plays in which reason shines forth, and sensibility is refined and ennobled."[60]

Diderot had tried, with *Le Fils naturel*, to invent "the notion of a drama between comedy and tragedy" and inspired by "human situations."[61] Marmontel eventually marked his distance from Diderot's *drame* by suggesting that authors who "render vulgar truth bluntly" exhibit the talent of simple workers, whereas genius always improves nature by embellishing while imitating. Marmontel refused to situate *drame* on a continuum with serious theater. He dismisses the genre as "a kind of popular tragedy." He cites approvingly the observation of a wag: "I never go to the theater in order to see and hear what I can see and hear by standing at my window."[62] For Marmontel, serious theater always adheres to the standards of genre hierarchy and supports the principles of idealization and decorum that Diderot tried systematically to undermine.

When Marmontel took up the topic of description in the supplement of the *Encyclopedia*, his principal interest was epic poetry. Nonetheless, he mobilizes several concepts invented or promulgated by Diderot about the theater. Foremost among these is the idea of tableau. Marmontel's opening statement is that "description is not content with characterizing its object, but often presents a picture of it [tableau] with the most interesting details and to the fullest extent."[63] He thus broadens the stringent limits on description proposed for natural science by Daubenton, who

declared that description must remain within "appropriate limits." By invoking the concept of tableau, Marmontel betrays his debt to Diderot's analysis of the relationship between stage and auditorium.

At the same time, he stakes out a position unlike that developed by Mallet in the original article on description. On one hand, Marmontel assumes many principles from the lexicon of classical rhetoric: choice of object; point of view; selection of the moment to be portrayed; attention to the revelatory trait; the use of telling contrasts. On the other, and rather unlike Mallet, Marmontel is no narrow technician. Mallet argued that descriptions do not define essence but are rooted in the practice of enunciation: he claimed they "should offer images that render objects as if present" with little regard for their reception. Descriptions are products of rhetoric that exist like things, signs in a system of meaning whether or not anyone is listening. Marmontel boldly rearticulates Mallet's narrow account by attending to the physical and fundamentally public relationship between speaker and audience.

Marmontel's focus upon the ear as the organ most conducive to receiving thought implicitly understands words as physical things. He takes theatrical declamation to be a "mixed or composite performance, where circumstances modify the expression of feeling," and where words and gestures—sounds and sights—constantly play against one another.[64] Marmontel's premise of a mixed mode accepts some elements of Diderot's theory of tableau in which dialogue works alongside pantomime. Moreover, his conceptual model of the situation, like Diderot's, is the space of a theater with auditorium and stage. Marmontel assumes that a description's point of view "from object to audience is relative: appearance of the one, position of the other, work together to render the description more or less interesting." But Marmontel's next sentence opens a large distance between himself and Diderot, for he claims that every time a description "has listeners on stage, the reader puts himself in their place, and it's from there that he sees the tableau." Although Marmontel refers to readers, his observation rests upon an unspoken distinction between the stage where action occurs and the auditorium from which the viewer or reader witnesses the action.

Implicitly, Marmontel's projected identification of spectator with actor denies the "fourth wall" separation essential to Diderot's notion of

tableau. Marmontel rejects the possibility of Diderot's state of oblivious coexistence, whether in practice or in imagination. Players who react to actions on stage, even if they avoid overt gestures to the audience [coups de théâtre], are experienced as surrogates by readers or viewers. Diderot had recommended that actors adopt technical practices designed to sever the emotional and psychological links between themselves and their audience so as to maximize illusion and affect. For Marmontel, such a separation is impossible to achieve and the mechanics of illusion are far more complex. Marmontel insists upon the basic facts of the theatrical situation: "the real site of the action is a theater, everyone around you has come, like you, to have a good time, the characters you are watching are actors . . . all of this is true." The illusion of any play necessarily unfolds within a real architectural framework. A viewer's awareness of that framework compromises the membrane of illusion and, once destroyed, illusion "cannot recur in the next instant with the same intensity."[65] The facts of staging both challenge illusionistic representation and offer to audiences the potential for self-conscious reflection. Marmontel in 1774 was taking direct aim at Diderot, who held that serious theater should be a series of powerful tableaux magically strung together.

For Diderot, theatrical experience is built around moments of intense illusion that completely engage members of the audience. Marmontel certainly values illusion, but he believes that when such moments are produced on stage they are always framed by a mindfulness of the fact that theatrical machinery is present. Intense illusion might rise and fall, start and end: this continual and disruptive texture is what Marmontel calls "demi-illusion" in his article "Illusion" for the supplement. It is a "continuous and endless mistake mixed with a self-reflection that belies the error." Demi-illusion is such a strange state and so subtle in its effect that some people mistakenly take it to be the product of sequential and "perpetual oscillations between fallacy and truth." Their error, says Marmontel, is to consider only rational processes, whereas experience of everyday life reveals that diverse impressions and continuing thoughtfulness occupy the mind simultaneously. One impression or another might dominate our attention, yet others also are present and "each of them will have left its mark in memory." The subtlety of demi-illusion assumes an effect that is not too powerful, "because the more the illusion is vivid

and strong, the more it animates the soul, and it leaves accordingly less freedom for self-reflection and less of a purchase on truth." This point is essential. Marmontel theorizes a theater—like epic poetry, painting, and opera—composed of elements that balance sufficient illusionism with the thoughtful awareness of its operation.

In Marmontel's scheme, perfect resemblance in art is not possible, since one eventually returns to the reality of the staging framework. Nor is it desirable, since total illusion in tragic scenes "would be revolting or cruelly painful." Even comedy should avoid complete illusion because "the audience, thinking it sees nature, would forget the artifice and be deprived, by the illusion itself, of one of the pleasures of performance." Marmontel's ideal is a level of resemblance [vraisemblance] in drama that crafts a synthesis of illusion, action, and dialogue to mobilize the full range of human capacities.

It was to furnish imitation with all the external appearances of reality that the genre of drama was invented, where not everything is illusion as in a painting, nor real as in the natural world, but where the mingling of fiction and truth produces this restrained illusion that constitutes the magic of theater. . . . The illusion exists only in my head. Such is the art of dramatic poetry.[66]

For Marmontel, the audience ought to be simultaneously immersed in illusion and actively reflect on the artfulness of the spectacle before them.

What is the pleasure of illusion that Marmontel claims is "common to every type of art"? It is the pleasure of aesthetic awareness. For him, a perfectly painted picture will appear to be a real piece of architecture or a landscape when seen from a distance. In this moment, he writes, "all the charm of artifice will be lost on you." But upon approaching the canvas, as one gradually begins to see how exactly the painter's brush has rendered things, the artfulness of art appears. Marmontel generalizes: "it's the same for every kind of imitation: one wants to enjoy both nature and artifice at the same time; thus, one wants to be fully aware that art and nature are joined as one." For him, and quite contrary to Diderot, the experience of art combines immersion in an illusion with simultaneous awareness of being immersed.

Marmontel rescues a reflexive faculty from Diderot's theory of total absorption to ensure a domain of pleasure for aesthetic experience. "The

aim of the arts that affect the spirit is not only an emotional state, but also an accompanying pleasure. Thus, it's not enough for the emotion to be strong, it must also be pleasing."[67] His theory of illusion posits a second-order, reflective self-consciousness that integrates thinking, reason, and pleasure. Marmontel lays the groundwork for a theory of aesthetic distance. To be moved while knowing we are being moved is a higher order of understanding than simply to be moved or simply to know, since reflective reason is engaged. The paradoxical and multiple experience of demi-illusion accommodates didacticism to the theater of sentiment defined by Diderot. Marmontel retains the ethical understanding claimed for literature, painting, and drama by classical theory, but attaches a quite modern account of the pleasure and value derived from art.[68]

Marmontel's precarious synthesis acknowledges the power of individual subjectivity within a set of cultural and physical limits that include opinions, habits, and the framework of possibilities for illusion at any given time or place. This social grounding of affect returns in his discussion of description when he advocates using witnesses to set the emotional register—a technical effect aimed at fusing the heterogeneous audience into a collective whole. The most effective descriptions, he writes, are those spoken from the point of view of emotionally involved characters so that "the emotion that prevails on the stage spreads throughout the auditorium, and a thousand souls act as one, reunited around a single interest." Marmontel resembles Jaucourt when he argues that descriptions emanating from the inner life of a specific character produce the most potent effect because they spread an emotion throughout the audience.

If in poetry the most convincing descriptions come from the mouths of involved characters, the most convincing illusions in theater mimic the structure of description itself. They form tableaux that may be apprehended as if possessing the attributes of poetry—including the potential for multiple points of view. Poets would do best to imagine a theater of infinite proportions upon which they could expand and arrange settings following the guidelines offered by nature: "the ideal scheme that he will make for himself will be patterned on description, and if he has clearly pictured the action when describing it, it will look the same when read." Marmontel imports the tightly controlled viewing options offered by the model of theater to emphasize that the "straight line of sight from object

to us" links the several arts of poetry, drama, and painting. His central concern with public forms of representation and experience implies that spectators might be united into a community of shared interests without regard to rank or other attributes. It will take a painter, Jacques-Louis David, to exploit fully the potential of Marmontel's aesthetic theory in the public arena of the Paris Salon.

A theme that runs through Marmontel's thinking, according to Annie Becq, is that art allows spectators to discern relationships that otherwise would not be apparent.[69] "Pleasure of the eyes, like that of the ears, is associated with certain impressions, and these impressions depend upon certain correlations [rapports] that nature has introduced between the object and the sensory organ. To grasp these correlations is not to imitate nature, but rather to intuit it."[70] Marmontel posits a process of correlation that does not mirror the natural world, but actually reveals its truth: in his scheme, aesthetic knowledge rivals the descriptions of natural science. Thus, he intersects Diderot's thinking exactly in the domain of aesthetics. Diderot used nearly the same vocabulary to characterize beauty: "perceiving correlations is thus the foundation of the beautiful; accordingly, the perception of correlations is what languages have signified by a host of different names, all of which only denote different kinds of beauty."[71] Importantly, Marmontel takes up the subject of beauty in the *Encyclopedia*'s supplement by agreeing in principle to what had been written by Diderot in the original publication.

Marmontel's discussion of description within the supplement of the *Encyclopedia* responds broadly to Diderot's critique of contemporary stage practice, including the evocative power of tableaux, the use of pantomime, and an attention to the relationship between stage and auditorium. Marmontel assimilates many of the successful practices of Diderot's middlebrow *drame* in his attempt to rejuvenate the tradition of high art, notably epic poetry and tragedy. Predictably, he insists upon grandeur of subject, centrality of plot, and the primacy of language, but he also champions a self-conscious emotional distance that balances affect with thought. Jaucourt's entry on description attended to a "secret emotion" that threatened to atomize the audience in moments of imaginative isolation similar to the private experience of reading a novel. Marmontel's supplementary essay responds with an ideal of theatricalized descriptions

in a social space where identification between stage and audience is essential. In this way, he counters Diderot's insistence upon the affective and psychological alienation of the audience from the performers under the influence of compelling illusion. Marmontel, by contrast, encourages authors to position interlocutors on stage so that their reactions to events will spread throughout the auditorium and unite the audience in a community of shared interest.

Marmontel's attention to tradition seems to motivate his disagreements with Diderot and Jaucourt. Marmontel always keeps in view the traditional hierarchy of genres in which visual forms apprehended by the eye are subordinate to dialogue addressed to the ear. Similarly, he values plot over pantomimic tableaux. At the same time, his articles for the *Encyclopedia*—description, illusion, vraisemblance, and pantomime, among others—are products of an historical moment that he shared with his contemporaries. Marmontel foregrounds, and sometimes worries about, the capacity of viewers to fabricate meaning from a necessarily limited slice of potentially boundless experience.[72] Since pantomime speaks directly to the passions, its effects are unmoderated by reason. Thus, pantomime can elicit social behavior that wise governments might normally want to discourage. Vraisemblance, which for Marmontel reveals the marvelous in familiar objects, can extend the range of human thought and establish new capacities of understanding that replace "the chain that binds events together and the law that lays them out."[73] Here, Marmontel suggests that even if vraisemblance traffics in the marvelous, it is nonetheless a form of knowledge. Similarly, illusion in poetic drama, which hovers between reality and fiction, "is only in my thoughts" but is no less real.[74] The subtle effects of demi-illusion might seem at first to be products of thought or reason but are, according to Marmontel, entirely real things that emerge from a constant process of "mistake . . . mixed with a self-reflection that belies the error."[75] A recurring idea in each of these formulations is that the pleasure and value of art depend upon a self-conscious ability to reflect on the artifice of representation.

Marmontel emerges in our account as a subtle thinker quite unlike the typical caricature of him as a rear-guard conservative. Engaged with critical issues of subjective response, yet unwilling to let go of traditional certainties, Marmontel figures himself within contemporary debates about

the nature and limits of knowledge. His analysis of the way affect should be shaped, expressed, and distributed throughout an audience echoes the process of correlation outlined by Diderot in the *Encyclopedia*'s *Prospectus*, but with a concern to isolate an actual social situation in which this process unfolds. A little later, Diderot wrote in "Beau" that the power "to combine ideas received separately, to compare objects by means of the ideas that one has of them, to point out the correlations that they have in common, to expand or contract one's thinking at will" are the constituent qualities of abstraction.[76] Marmontel opts for a concrete understanding of the potential yield from such mental activity by proposing spectators who are active users of the total theatrical system, not simply witnesses absorbed in total illusion. Unlike Diderot's free-wheeling expansion or contraction according to the will of the spectator, Marmontel's interactive shaping of affect operates like the *Encyclopedia*'s plates—keyed to legends and texts—by prompting individual thought and keeping it focused within clearly defined guidelines. Marmontel's theory of description is both theatrical and diagrammatic: his concern to foster and delimit imaginative activity signals his tacit participation in the culture of diagram.

IV

In late-eighteenth-century Europe, only theater offered the integrated spectacle of movement, light, color, sound, and language advocated by Marmontel. Although he is oddly silent on the special requirements of staging works of opera, it comes as no surprise that the physical architecture of theaters figures importantly in his essay. Theaters are arenas of representation, saturated in primary sense perceptions, where every sense plays a role in our apprehension. Sight, however, remains crucial to an appreciation of staged works: without good sight lines, theater loses the quality of spectacle and approaches simple declamation. Theaters are also socially hierarchical: some seats really are better than others, they cost more or, as in the eighteenth century, are reserved for rulers or other notables. Following the reforms of 1759 that removed banquettes from the stage of the Comédie-Française, theater designs begin to reflect an increased attention to sight.

Comparing two sets of the *Encyclopedia*'s architectural plates—plans of the existing Comédie-Française and of the new Opera built adjoining

the Palais-Royal—makes this shift clear, though their respective archi-
tects certainly responded to the different needs of spoken and musical
drama. The stage of the old theater retained a deep apron flanked by
balconies. Much of the drama unfolded on this forward extension, while
a relatively shallow space was allotted to scenery (FIGURES 30, 31). The
layout of the Comédie-Française established a rather close integration
between stage and auditorium; the illusory effects of tableau were con-
stantly compromised by a configuration that did not clearly distinguish
between the two domains. By contrast, the new Opera designed by
Pierre-Louis Moreau-Desproux is based on the premise of very separate
spheres: a deep stage extended forward only slightly by a shallow apron
overlooked by balconies; a space for the orchestra also with balconies; an
oval-shaped auditorium with curving walls sharply truncated where they
meet the straight walls of the stage space (FIGURE 32). The plate shows
that the architect juxtaposed these two volumes without transition. The
conceptual separation between stage and auditorium is bridged on the
plan by an overlay of dotted lines that mimic a perspective diagram.
Imaginary orthogonals drawn along the inner edges of stage flats inter-
sect with one another, and they cross a line drawn through the building's
axis, outside the theater's walls in the courtyard of the Bons Enfans. A
line perpendicular to the center axis intersects the orthogonals almost
exactly where the auditorium's oval meets the stage space. Moreau in-
scribed this diagram of sight into his plan to suggest that his Opera was a
perspective-based viewing machine in which the edge of the stage, where
the curtain drops, defines the picture plane of an illusionist tableau built
into the fabric of the structure. Certainly part of this deep spatial illusion
responds to the special needs of staging opera, including both orchestra
and chorus of dancers, but we can also say that the plan physically em-
bodies Diderot's fourth wall so that, on this stage, illusionist theatrical
tableaux are not simply possible, they are inevitable.

The evolution of theater design in the 1770s signals maturation of a
new version of the old idea that both the visual arts and theater present
pictures or tableaux. The modernist account of tableaux—whether the
strong formulation of Diderot or Marmontel's more disciplined interpre-
tation—enlists the faculties of a spectator to encounter diverse stimuli and
to bundle them physiologically into a pleasurable whole that provokes

FIGURE 30
"Théatres, Salles de Spectacles, Plan au Rez de Chaussée de la Salle de Spectacles de la Comedie Françoise," pl. I. Engraving by Robert Bénard for Diderot and d'Alembert, *Recueil des Planches*, vol. 10. Courtesy Department of Special Collections, Stanford University Libraries. Photo: Marrinan.

Théatres.

PL. II.

Salles de Spectacles.

Plan du premier Etage de la Salle de Spectacle de la Comedie Francoise.

V

FIGURE 31

"Théatres, Salles de Spectacles, Plan du premier Etage de la Salle de Spectacle de la Comedie Francoise," pl. II. Engraving by Robert Bénard for Diderot and d'Alembert, *Recueil des Planches*, vol. 10. Courtesy Department of Special Collections, Stanford University Libraries. Photo: Marrinan.

FIGURE 32

"Théatres, Salles de Spectacles, Plan du Théatre et des premieres Loges de la nouvelle
Salle de l'Opera exécutée au Palais Royal sur les Desseins de M.ʳ Moreau Architecte du
Roy et de la Ville," pl. II. Engraving by Robert Bénard for Diderot and d'Alembert,
Recueil des Planches, vol. 10. Courtesy Department of Special Collections, Stanford
University Libraries. Photo: Marrinan.

both emotion and reflection. Vision plays the principal role. Implicit in the modern view is an analogy between a picture's visual screen and the imaginary wall separating actors from spectators. The identification works both ways: theatrical performances can resemble pictures and pictures can resemble stage productions. The validity of this proposition is born out by the surprising, theater-like picture with which Jacques-Louis David earned *agrégation* in the Royal Academy of Painting and Sculpture: *Belisarius Begging for Alms* of 1781 (FIGURE 33 / PLATE 6).[77]

The subject of David's picture lands us squarely in the orbit of Marmontel, for it was inspired by the writer's novel of 1767 based loosely on the history of Belisarius.[78] Marmontel's text was notable for its advocacy of religious tolerance and was vehemently attacked by the Church. Its success sparked a heated debate between religious scholars at the Sorbonne, who censured the work, and the circle of philosophes—including Voltaire and Diderot—who defended it in print. The episode reminds us of Marmontel's professional links to the editors of the *Encyclopedia* and explains why he is counted among its many authors. Marmontel was also defended by powerful figures close to the throne: notably, Anne-Robert-Jacques Turgot, named Comptroller-General of the kingdom in 1774, and Charles-Claude Flahaut de la Billaderie, comte d'Angiviller, who became director of the *Bâtiments du Roi* in the same year. Their rise to power coincides with Marmontel's essay on description for publication in the supplement to the *Encyclopedia*. Marmontel's two powerful protectors shared many of the political ideas about social reform formulated by encyclopedists and physiocrats, but neither Turgot nor d'Angiviller dared to challenge the king's absolute authority or the power of the state.[79] Marmontel understood fully the advantages of friends in high places. He cultivated a close enough relationship with d'Angiviller to be appointed *historiographe du roi* in 1772.[80] Marmontel was very much a courtier whose social rise dramatically eclipsed his origins as the son of a tailor. His social ambitions and self-promotion find echoes in David's attention to aristocratic patrons and public favor during the late 1770s.[81] Indeed, the monumental scale and pictorial ambitions of David's *Belisarius* may well be attempts to quash the reputation of his most immediate rival, Jean-François-Pierre Peyron, who had painted a *Belisarius* two years earlier.[82]

David's interest in the story of Belisarius suggests a kinship with Marmontel deeper than accidents of patronage, social relations, or converging ambitions. Belisarius was a successful and popular general who had won many battles serving the Byzantine emperor Justinian (527–65). The emperor disgraced his general and, according to the twelfth-century historian John Tzetzes, blinded Belisarius after having him denounced for conspiracy. Marmontel's heavily fictionalized novel took up and popularized the general's misfortunes, though contemporary historians doubted the punishment of blinding. David's old and sightless Belisarius was conceived in the wake of Marmontel's novel. The painter invented a composite moment that joins a soldier's surprised recognition of his former general to a woman's gesture of dropping a piece of money into the old man's helmet. No such scene appears in Marmontel's text, although the soldier's gesture and certain architectural details may have been inspired by engravings accompanying publication of Marmontel's novel.[83] David's dramatic invention linking the soldier's surprise to the woman's donation plays to contemporary interest in scenes of sensibility entirely consonant with Diderot's conception of *drame*.[84]

Diderot wrote admiringly in general terms about the *Belisarius* in 1781, although he pointedly refrained from praising the soldier, the woman, or the pantomimic play of hands at the center of David's picture.[85] He complained that the painter gave an unbecoming gesture of begging to the old general who had already suffered enough humiliation. Why was Diderot so little moved by David's bold attempt at dramatic staging? Perhaps Diderot failed to see—or was unable to appreciate—a critical link between Marmontel and the young painter. For David's picture was not simply inspired by Marmontel's novel; it sits firmly within the context of the younger critic's writings about theater, tableaux, and stage practice, many of which take issue, as we have seen, with Diderot's own.

David's placement of the amazed soldier is a recurring theme in both contemporary and modern commentaries about the *Belisarius*, usually to underscore the defective spatial illusion in the left side of the picture.[86] The soldier's right foot, for example, nearly touches the woman's left heel, though this proximity subverts the depth required by the soldier's upper body and expansive gesture. The paving stones at the lower

left accentuate the problem by suggesting a perspective system of overly splayed orthogonals that simultaneously flatten the space and align viewers with the soldier. Our drift to the left side of the canvas is reinforced by an affinity between our vertical posture before the picture and the dark silhouette of a background obelisk that seems to continue the vertical lines of the paving stones linking near and far. Nudged into position by this odd perspective grid, viewers must then turn slightly to the right to look at the old general and his young guide: doing so forces a bodily rotation that is, in fact, a mirror image of the soldier's own. This corporeal identification is crucial, for it suggests that David mapped his picture to guide viewers into identifying both visually and bodily with the soldier. David mobilizes, almost to the letter, Marmontel's important observation about descriptions: readers or viewers tend to identify with characters who react to actions within a tableau and to "see the tableau" from this assumed point of view.[87]

Our prior discussion of Marmontel's stage theory suggests that David's perspective may be more meaningful than erroneous. The so-called mistakes might be part of a deliberate strategy. Consider again Marmontel's formulations of demi-illusion and vraisemblance on stage: the subtle play of illusion with a self-conscious awareness of its operation; the pleasure that arises from this self-awareness; the danger presented by complete illusion to destroy this dialectic. By Marmontel's criteria, the dramatic power of David's canvas depends upon the simultaneous awareness of being coaxed into exchanging places with the soldier and of the unfolding artifice.

David was surely aware of the perspective defects at the left side of his *Belisarius*. Three years later, probably with the assistance of Anne-Louis Girodet-Trioson or François-Xavier Fabre, he painted a small replica of the picture in which he revisited many of these points of visual stress (FIGURE 34 / PLATE 7).[88] In this revision, the paving stones describe more conventional orthogonals converging just to the left of center, the soldier's gesture and open stance are allotted plenty of space, and characters behind the soldier are free to roam an entire piazza that extends to a background staircase and wall. The replica improves the illusion of space but its gestures feel histrionic: the new version plays to an audience like those coups de théâtre rejected by Diderot rather than establishing the

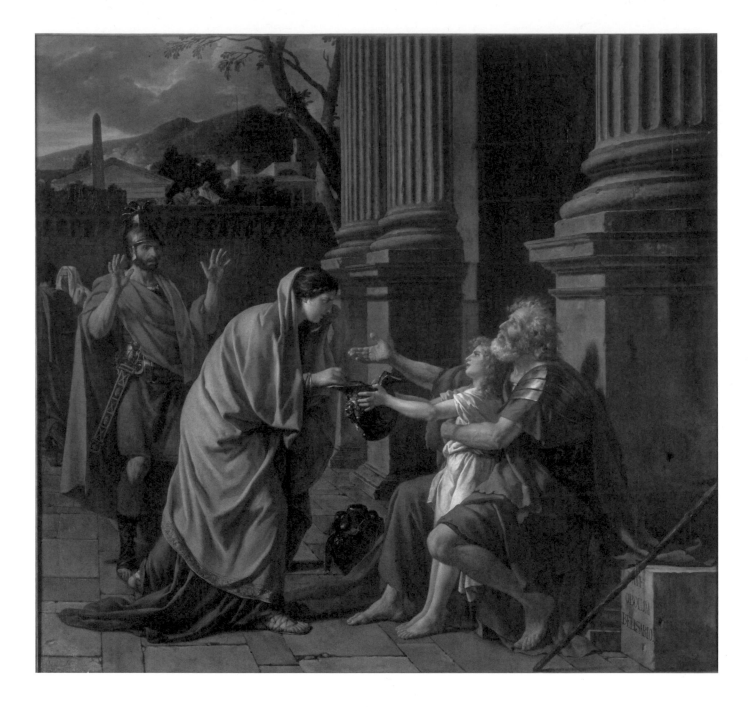

FIGURE 33

Jacques-Louis David, *Belisarius Begging for Alms*, 1781. Oil on canvas. Lille, Musée des Beaux-Arts, inv. P436 (288 × 312 cm). Photo: © Réunion des Musées Nationaux / Art Resource, NY / © P. Bernard.

FIGURE 34

Jacques-Louis David with François-Xavier Fabre or Anne-Louis Girodet-Trioson, Replica of *Belisarius Begging for Alms*, 1784. Oil on canvas. Paris, Musée du Louvre, inv. INV3694 (101 × 115 cm). Photo: © Réunion des Musées Nationaux / Art Resource, NY / © Daniel Arnaudet.

compelling, almost hallucinatory presence of a tableau. Lost in David's reworking is the close identification between soldier and viewer that animates the original canvas.

By contrast, the first picture's effect of demi-illusion or vraisemblance is supported by pictorial devices that resonate with contemporary theatrical practice. Notable is the blunted perspective field that situates the characters as if on a stage, pressed close to the picture plane so as to remain within plain sight of an implied audience. David managed the light to illuminate brightly the principal figures, but the brightness falls off sharply beyond the foreground screen of bodies. Dramatists of the time did struggle with the uneven visibility of actors on the typically narrow, deep, and poorly lighted stages of France. We know that Diderot longed to use all of the stage; his exchange of letters with Madame Riccoboni hinges on the technical difficulties of being seen and heard if too far from the footlights.[89] We surmise that David composed his picture within the expectations established by the spatial and luminary parameters of contemporary stage practice.

Three influential treatises about stage design, scenery, and lighting were published in Paris in 1781, the year David exhibited the *Belisarius*. Jean-Georges Noverre lamented the narrow, deep stages of French theaters: he called for oblique perspectives, the suppression of footlights, and lighting devices installed to the sides and above the stage so it might be illuminated like paintings.[90] Antoine Laurent de Lavoisier carried the debate about stage lighting to the Académie des Sciences with an address in which he promoted lights equipped with concentrating reflectors and mounted on pivots so that figures on stage could be highlighted from several different angles.[91] Charles-Nicholas Cochin's *Lettre sur l'opéra* advocated several devices to heighten theatrical illusion, including asymmetrical stage settings and costumes made of simpler materials than the glossy silks that were the norm.[92] The next year, in 1782, Pierre Patte argued the advantages of a narrow fore-stage with no spectators above so that actors and audience would occupy distinct spaces.[93] Patte also wanted to suppress the footlights. He suggested their replacement with reflecting fixtures attached to tiers of boxes near the stage—a thoroughly modern location that would allow for more precise highlights.

Several apparently new formal qualities of David's picture resonate within this debate about scenery and lighting—a debate that reached a particular intensity during the months when the painter worked on his canvas. The broken light of David's *Belisarius* produces areas of brightness amidst a generally dark setting parallel to the effects that Patte and Lavoisier wanted to see on stage. The picture's sharply defined lighting from the left throws the actors into crowded relief and further narrows the downstage plane they occupy. The off-center perspective and strong diagonal of massive architecture at the right of *Belisarius* suggest that David was conversant with current interest in off-center and asymmetric stage sets. Finally, we know that Diderot admired the heavy, thick-textured fabric worn by David's characters, writing that the painter "knows how to drape fabric and to arrange fine folds, its color is beautiful without being bright."[94] The rough-hewn character of David's fabrics resonates with calls for a simplified wardrobe on stage.

David's original idea for the painting goes back at least two years to his time in Rome at the French Academy. A carefully elaborated drawing of the subject, dated 1779 and executed in ink and wash, documents his early exploration of the theme (FIGURE 35). It appears that Peyron, who was painting a *Belisarius* of his own, lent his copy of Marmontel's novel to David.[95] Even at this stage, David imagined the frozen gestures that are so striking in his final picture: the soldier caught in a moment of recognition and surprise; the woman on the verge of dropping her coin into the old man's helmet; the extended open hand of Belisarius silhouetted in light against the dark architecture. This gestural pantomime is seconded in the drawing by the open-mouth expressions of hero and background soldier, as if their respective voices have been cut short. In the final picture, these arrested articulations are joined by the less obvious, but nonetheless visible, open mouths and seemingly arrested speech of the woman and young boy. The entire cast is caught in a moment of stilled motion and halted speech—a moment of pure pantomime undisturbed by the flow of words.

In view of Diderot's sustained advocacy for pantomime on the stage, and his own use of suspended, open-ended dialogue known as *style rompu*, his critical rigor with the *Belisarius* is surprising. He pointedly refrains from talking about the soldier's expression, the woman's gesture

FIGURE 35

Jacques-Louis David, Study for *Belisarius Begging for Alms*, 1779. Ink, wash, and gouache. Paris, École Polytechnique (47.5 × 36 cm). Photo: © Collections École Polytechnique, Palaiseau, France.

of alms-giving, or the interplay of extended hands—ostensibly from fear of ruining his pleasure and distressing the artist. But he proceeds to write a stage direction for the painter: "Don't you think that receiving the alms is enough humiliation for Belisarius? Did you have to make him ask for it? Let this outstretched arm grasp the child, or else raise it to the heavens, whose severity he will reproach."[96] Following his own advice that authors write out pantomime to script the expressive potential of lapses in dialogue or action, Diderot corrects David's gestures to modulate the picture's pathos. He offers two basically incompatible options: one would have Belisarius clutching the boy, as if desperately clinging to the eyes he has lost; the other would have him cursing heaven for his miserable fate. Diderot's first option would render Belisarius a hobbled old man resembling a character by Greuze. The second option would make him an angry old man defying the gods. Curiously, both are more extreme, histrionic statements than David's own, a difference that clarifies the painter's understanding of pantomime. For David, pantomime remains a tool of narrative and thus subject to the parameters set out by the man's act of begging. Diderot, by contrast, wanted those gestures to accommodate a wider, more imaginative reading rooted in the viewer's identification with the old man rather than the witnessing soldier. Diderot's criticism both pinpoints and respects David's reticence. The picture aligns less closely with Diderot's wish that an audience live a virtual, first-hand immersion in the lives of characters than with Marmontel's thinking about pantomime. Like Marmontel, David believed that dialogue and plot should occupy the foreground, even if both are suspended for an instant.

Another intersection between Marmontel and David further distinguishes them from Diderot. Where Diderot championed a theater of total illusion separated from its audience by an imagined fourth wall, David's picture enacts Marmontel's demi-illusion, where the power of representation is balanced by an awareness of its artifice. Alongside the many visual clues within the fabric of David's *Belisarius* that establish the picture's inherent theatricality, we find a notable component of self-reflection. The soldier interlocutor, who guides our reaction to the old man's plight, also divides our attention. Three poles of interest—soldier, viewer, Belisarius—triangulate, surround, and isolate the woman and

boy. These two standing figures occupy center stage, yet are the most emotionally neutral characters of the drama. David camouflaged much of the woman's emotion and deflected our own when, as he moved from drawing to painting, he enveloped her body in a heavy drape. David stages what Marmontel called a "straight line of sight from object to us" that links every observer to Belisarius via the soldier and, by extension, every observer to one another. Here, David mobilizes a "reflective emotion" central to the concept of description outlined by Marmontel in his article for the supplement to the *Encyclopedia*: "the emotion that prevails on the stage spreads throughout the auditorium, and a thousand souls act as one, reunited around a single interest." Marmontel had built much of his theory of description, illusion, and affect upon the premises and practices of theater. For Marmontel, the purpose of theater is to actuate moral and ethical knowledge amongst the audience, both individually and as a public. His ideal theater, and David's picture, elicit a double awareness within which disparate elements are actively unified in sensibility, yet retain their autonomy in a borderland between illusion and consciousness of its devices. The ensuing dialectic is closer in kind to the production of knowledge engaged by users of the *Encyclopedia* when exercising a faculty of correlation [rapport] than to the intensely affective theatrical ideal promoted by Diderot.

V

David's *Belisarius* produced a novel visualization from the same constellation of ideas that links contemporary theater to diagrammatic knowledge, but it was only a partial success. Three years later, David burst upon the art world with the *Oath of the Horatii*, a picture that pushed the homology among painting, theater, and diagram to an extreme (FIGURE 36 / PLATE 8). Tradition says that a 1782 production of Corneille's *Horace* at the Comédie-Française inspired David to paint the *Horatii*.[97] Corneille's final scene did inspire David's first idea for the picture: old Horace pleads for leniency on behalf of his eldest son who, having returned victorious from battle with the rival Alban family, killed his sister Camilla for grieving the death of her fiancé, a brother from the opposing clan. Camilla is very much alive at the far right of the final composition.[98] David's change of narrative focus has inspired much discussion of the

FIGURE 36

Jacques-Louis David, *The Oath of the Horatii*, 1784. Oil on canvas. Paris, Musée du Louvre, inv. INV3694 (330 × 425 cm). Photo: © Réunion des Musées Nationaux / Art Resource, NY / © Gérard Blot / Christian Jean.

painter's motives when shifting from Corneille's grisly ending to a more refined, morally uplifting drama—a change apparently encouraged by some of the painter's writer-patrons.[99] David's solution, at once brilliant and original, was to invent a moment of oath-taking that occurs neither in Corneille's play nor in any other texts David might have known.[100]

Regardless of its exact textual source, the picture presents to the viewer the good sight lines and clear drama of a well-produced play that balances, as Marmontel wanted, theatrical illusion with thoughtful self-awareness. The German painter Wilhelm Tischbein, writing from Rome where David exhibited the work in the summer of 1785, underscored precisely this balance:

> The whole arrangement of the picture is masterly; nothing is in excess; nothing is farfetched either in principal or secondary matters. All that is there belongs there and contributes to the effect of the whole. Therefore the expression, which without doubt forms the most essential part of this picture, is naturally very much heightened. . . . The eye wanders from the group of men to the women, and the spectator feels in himself conflicting emotions: the heroically agreeable element of painful virtue, a most terrible contrast with inevitable desolation. It would be necessarily quite unpleasant and painful, if the spectator *did not remember in time that he has only a picture before him*. He now begins to marvel at the master hand able to bring him this mixture of conflicting emotions.[101]

Tischbein literally enacts for his readers a shift from the complete illusion championed by Diderot to the reflective aesthetic distance favored by Marmontel. He responds in the first instance to the almost spell-binding physical presence of the scene before him, yet he cannot let go of the idea that expression "forms the most essential part" of the work. His eye "wanders" from group to group, driven by a play of "conflicting emotions" that confound the seeming clarity of the picture's perspective and presentation of data. Tischbein recognizes that the expressive effect might even become "unpleasant and painful" if he did not suddenly realize "that he has only a picture before him." When he marvels at the "master hand" responsible for producing this rich mix of emotions, Tischbein discovers the pleasure of art that Marmontel took to be the core of any aesthetic experience.

We have encountered thresholds of pain or shock similar to that sensed by Tischbein before David's *Horatii*. Barthes's astonished reaction to the diagram of the human venous system is one (FIGURE 4). Jaucourt's "secret emotion" able to produce pleasure from "strong feelings that are unpleasant to us at any other time" is a second. Hume's deep-seated distrust of "poetical enthusiasm" is a third. Marmontel's suspicious approbation of pantomime, which he took to be a dangerous attraction for the general public if not checked by reason and dialogue, approaches the same threshold from another direction.

What elements of David's picture fall under the sign of pantomime? The implied immobility of his figures, whether tensed into the taut poses of the men or wilted into the nearly unconscious swoon of the women, is the most obvious marker. That no one moves is made vividly apparent because the painting depicts plenty of empty space within which action might potentially unfold. The floor tiles articulate a considerable depth, although the slightly splayed side walls tend to undermine any systematic spatial illusion. The implied orthogonals of the architecture intersect in the space between the fingertips of the three boys and the father's outstretched hand—a studied placement of the vanishing point that reinforces awareness of the picture's schematic plotting. The figures stand or sit within the spatial box near the picture plane, as if close to the edge of an actual stage, in a formation that resonates with the tripartite architectural arcade of the background. Light enters from the left and from slightly in front of the picture with a direction and intensity far exceeding the parameters of natural sunlight. David's stark rendering of light is consonant, however, with contemporary trials of more powerful Angrand footlights on the new stage at the Odéon theatre—experiments with which the painter was surely familiar.[102] Similarly, the stark emptiness of the staged space and absence of daily household implements abstracts the dramatic action from the duration of everyday life to freeze it in time. Although the highly stylized moment of oath-taking painted by David ought to include a verbal eruption echoing through its spare setting, David exploited masterfully the truth that pictures cannot speak. The silence of the *Horatii* becomes a deafening absence in an emptied space that serves to increase the picture's engagement with pantomime by demanding a surplus of effort from its viewer.

The extreme and risky form of pantomime so vital to the expression of David's picture generates many of the formal qualities that animate Thomas Crow's analysis of the divided public response to the *Horatii* in 1785.[103] Crow highlights the mitigated, hedged, and conflicted enthusiasm of critics. The *Mercure de France* saw the work as announcing "a brilliant and courageous imagination," but worried that "the severity of style and extreme expression on view there are very particular virtues, appropriate to the subject, the abuse of which would be extremely dangerous."[104] Another critic, more troubled by the unruly behavior of certain visitors to the Salon than by the actual picture, complained about the cadre of David's students "who form a party and take over the whole Salon, seeking out one another, hectoring and crying in the ears of the public: 'This is sublime!'"[105] He goes on to imply that David's picture was no rival to Raphael or Titian, to Corneille or Racine, by observing that truly great work needs no such bullying "by intoxicated dunces." Last, he catalogues some of its failures:

This picture displays a sublime execution, superb drawing and a fine style—in places. The first of the Horatii shows an astonishing severity and strength . . . his brothers are not so lucky. . . . The architecture is handsome, but too obtrusive. . . . The women in the picture are stiff. . . . Truthfully I no longer know where I am. What has spirit and movement is called folly, while what is cold and stiff is called genius. This is a depravity of taste which I absolutely fail to comprehend.[106]

Confronting David's image of severity, stiffness, and awkward transitions, yet crowded, jostled, and intimidated by a band of ferocious partisans, our critic loses his grip on values and falls, disoriented, into an abyss of bad taste.

By contrast, one of David's defenders at the Salon was Antoine-Joseph Gorsas, whose circle of friends included some of the most influential radical thinkers of the early 1780s. Gorsas's fictive narrator also experienced a kind of vertigo in front of David's canvas: "I was beginning in effect to lose my head; after having pledged along with them to conquer or die, I had already seized a sword." He suddenly snaps out of immersion in the illusion to remember that he was not in ancient Rome but in a picture gallery in Paris.[107] The narrator reenacts a sudden awakening very simi-

lar to that experienced by Tischbein in Rome—an abrupt self-awareness of artifice that was central to Marmontel's theory of aesthetic pleasure. Yet important differences distinguish the German painter's commentary from that of Gorsas. Tischbein seemed not to see pictorial ruptures when he wrote that "the whole arrangement of the picture is masterly; nothing is in excess; nothing is farfetched." Gorsas recognized many of the supposed defects of David's painting only to celebrate them as virtues: "I don't know in which critique I read that the groupings are too dispersed. Throw that critique into the fire. . . . If M. David has divided his groups without reflection, then I give thanks to chance."[108] Separating the two critics is a fluency with the language of pantomime. Gorsas knows how to read more productively than Tischbein the stilled, dispersed, and extreme gestures of David's picture. He is more conversant in the gestural vocabulary of theatrical pantomime, and more familiar with the discussions of its power that animated contemporary criticism in Paris. An opponent of the political status quo, Gorsas recognized in David's use of arrested gesture an occasion for exploiting exactly what Marmontel feared: pantomime's lowbrow appeal to the crowd. Gorsas uses the *Horatii* to drive a wedge between aristocratic affectations and the earnest emotions of the reading public targeted by his pamphlet:

I was seeing two or three hundred perfumed, overdressed, and affected people, who in the morning were contemplating David's *Horatii* with admiration, and who would go in the evening to *La Folle journée* to cry "bravo" at some nonsense, and who would not go the following day to see the last of the three brothers return victorious to his household gods and restore peace and the palm to his aged and honorable father.[109]

Gorsas divides the Salon public between those who superficially admire the *Horatii*'s severity but are equally charmed by a fluffy comedy, and those so deeply moved by the David that they are haunted by the drama and the spectre of the story's denouement.

Gorsas's two publics resonate within contemporary ideas of theatrical affect: on one side, Marmontel's fear that pantomime uncontrolled by reasoned dialogue might descend into fashionable frisson; on the other, Diderot's ideal of a pantomime so full of illusion that it grips viewers profoundly and actually changes their lives. The *Horatii* is poised between

these two views. Without the guiding interlocutor so present in the *Belisarius*, viewers of the *Horatii* struggled to find a character and an emotion with which to identify. They confronted a perspective system that presumes a physically present viewing audience and surreptitiously locks the attention and emotional response of that audience to the abstract diagram of its visual array. Some viewers sensed that they were being asked to perform a new species of interpretation that engaged collective sentiment yet remained imaginatively open-ended. The effect could be disarming. A pamphlet called *Avis important d'une femme sur le Salon de 1785* makes this clear:

It is far more agreeable to the eye as it is to the hand to traverse the whole extension of an object without encountering rough spots or gaps which arrest its progress, repel it, and make it jump; its sensibility wants to be led gently and wander without difficulty through all parts of the chain of a composition. That is why one rightfully demands in every subject a gradually progressive series of bodies, light effects, and color transitions. According to these criteria, the picture of the *Horatii* is faulty; it represents three groups on three barely distinguishable planes: the group of brothers, then a hole; the old Horatius, then a hole; and finally the group of women who alone preserve among themselves that graduated linkage demanded by the example and teaching of the great masters.[110]

This is a candid reaction to the picture's robust pantomime. It registers frank perplexity about the perceptual skills required of viewers—skills that seem to depart importantly from those of everyday life. The writer recognizes that the world of the *Horatii* is not one of continuities, gentle wanderings, and gradual discoveries. She registers the brusque ruptures, barely discernable elements, and empty voids. She fully perceives the picture's interpretive challenge, yet is either unwilling or ill-equipped to shape its discrete bundles into a whole.

David's choice of a moment not part of a familiar story denies viewers the refuge of narrative certainties attached to a text. This is neither the first nor last time David would opt for pictorial improvisation over simple illustration. His potent use of this ploy in the *Horatii* requires a leap of imaginative synthesis beyond the range of art critics committed to the "graduated linkage" of the grand tradition, but well within the set of associative skills that Diderot claimed were essential to the

mental processes that produce knowledge. For Marmontel, such skills were essential to aesthetic comprehension. Similar skills must be enlisted to produce knowledge from the diagrammatic arrays of the *Encyclopedia*, where words are not denied so much as deferred, moved outside the visual field into legends tethered to their referents by keys. David's picture indexes no single master text and it gestures to its literary sources indirectly, without the seamless closure of exact illustration. The *Horatii* is not literally a diagram, but it asks to be read like one.

To shift consideration of the *Horatii* from the world of ambitious painting to the visual culture of the *Encyclopedia* is not so farfetched as it might seem. Our motive for making the bridge between high art and low is not because the *Horatii* exemplifies "the style of the French bourgeoisie on the eve of the Revolution."[111] We do not take it to be a "rallying symbol within the confines of the exhibition space" able to "mobilize some important segment of the Salon audience into an oppositional public."[112] Nor are we suggesting that the picture "operated on the same stripping principle evident in the anatomical plates of the *Encyclopedia*."[113] Nonetheless, the reactions of some critics to the *Horatii* parallel Barthes's response to the plates of the *Encyclopedia*: their strangeness; their "displacement of the level of perception"; their "severe demand for objectivity" coupled with a poetry "in which the real is constantly overcome by some other thing"; finally, their juxtaposition of tableau-like vignettes to analytic arrays in which "the world's peaceful order gives way to a certain violence" that opens up nature in "a kind of wild surrealism."[114] We place David in a milieu that struggled to balance the truth claims of natural science and geometry against the affective powers of the imagination. We agree with Michael Fried's assessment that the *Horatii* marks "a new, more assertive or emphatic ideal of pictorial unity, according to which the discreteness, realism, and isolation of the principal figures and/or figure groups would make almost diagrammatically perspicuous their recuperation in a single, life-size, intensely dramatic *tableau*."[115] We differ from Fried on how to interpret that observation. In our account, theater was the most powerful conceptual model for guarding a coherent human subject from the splintering effect of specialized viewing protocols proposed by natural science.

What assumptions about representation emerge, in this context, to

link David and the Marmontel of his article on description for the *Supplément*? Both respond positively to the importance of natural science and its procedures by insisting on a foundation of primary sense data derived from an exacting study of nature and the model. Both assume that descriptions must vary according to the dictates of taste and the relative importance of the object described. Marmontel invoked taste at the start of his article on description. David later regretted his own lack of taste during the years he admired robust Old Masters such as Caravaggio and Ribera.[116] Marmontel and David also converge in thinking that the most appropriate schemes of exposition are tableaux that impose regular order on the viewing situation. "The point of view from object to audience is relative," Marmontel had written; "appearance of the one, position of the other, work together to render the description more or less interesting." When elaborating the *Horatii*, David consciously adjusted the ideal viewing point (vanishing point) to join the viewer's presence (imagined as an audience) to the picture's storyline. He cross-cut the underlying structure of good sight lines with a planar frieze of disjunct figural groups rendered with great visual acuity.[117] David forced the viewer to adopt a differential attention before this visual array, which is ostensibly packaged as a coherent tableau but perforated by the lapses in action and dialogue common to pantomime. The epistemological premises of diagram hovering in the wings of Marmontel's essays on description and related topics from the 1770s become palpably present in David's *Horatii* of 1784.

Standing alongside contemporary discussions about pantomime in the theater engaged by Diderot, Marmontel, and others, the *Horatii* appears to be a fortuitous incarnation of what Roland Barthes took to be the crux of Racine's *tenebroso*:

Both tableau and theatre, or *tableau vivant*, frozen movement, accessible to an endlessly repeated reading. The great Racinian tableaux always offer this great mythic (and theatrical) combat of darkness and light: on one side, night, shadows, ashes, tears, sleep, silence, timid sweetness, and continuous presence; on the other, all the objects of stridency: weapons, eagles, fasces, torches, standards, shouts, brilliant garments, linen, purple and gold, steel, the stake, flames, and blood. Between these two classes of substances, there is an ever-immanent

but never-achieved exchange that Racine expresses by a specific word, the verb *relever* [gather, collect], to designate the constitutive (and delectable) act of the *tenebroso*.[118]

Corneille may have provided David's original inspiration, but we cannot imagine a more fitting gloss of the *Horatii* than Barthes's commentary on Racine. The *Horatii* stages contrasts left and right, held in place by a "never-achieved exchange" of swords. The oath provides a "constitutive" gathering that rings silently through the picture's empty space so that—to cite Marmontel—"the emotion that prevails on the stage spreads throughout the auditorium" of its viewing public. We believe the picture's engagement with the two greats of French theater enacts Marmontel's desiderata for the highest mode of aesthetic expression.

VI

Marmontel's article on "Drame" for the *Encyclopédie méthodique* of 1782 coincides uncannily with the award of David's commission for the *Horatii*. In a range of articles for the *Supplément* analyzed earlier in this chapter, Marmontel advanced a program that brought together time-honored values for art with new theories of physiology, empathetic psychology, and societal ties, along with new forms of scripting, acting, pantomime, scenery, lighting, and theater architecture. These articles consistently weave together concepts of theater with those of painting. Marmontel's aesthetic accorded generally with Diderot's thinking about a viewer's engagement before staged or painted representations, even when he differed from the older critic on crucial questions about pantomime, illusion, and dialogue. Although much of Marmontel's attitude on *drame* was in place during the 1770s, his break with Diderot on the matter of the tragedy of everyday life became absolute in 1782.[119] Marmontel's retreat into a more conventional critical frame might be part of a self-fashioning geared to his bid to become permanent secretary of the Académie française, a post he assumed in 1783.[120] Marmontel came to view bourgeois drama as tedious, trivial, and without ethical value. Its events are commonplace and its plots merely accidents in which man is the "victim without being the cause." He now writes that "a *drame* that aims neither to instruct nor improve is, relative to tragedy, what farce is to comedy proper."[121] Marmontel seems to have forgotten that *Belisarius*—his novel

written fifteen years earlier when he was much closer to Diderot's circle—was really a bourgeois drama set in antiquity.

Could heroic tragedy or history painting in the 1780s connect emotionally with an audience without some recourse to bourgeois drama? A litany of references to the last act of Corneille's *Horace* in writings on the arts from Dubos to Diderot to Marmontel poses the question. The murder of the sister Camilla at play's end—the scene that initially attracted David—sets the values of nation and family in stark conflict. The scene fascinated eighteenth-century sensibilities attuned to the pathos and conflicted emotions of the moment more than to the play's overall message of stoic patriotism. Yet the decorum of tragedy required any such killing to be off stage. David's invention of an oath before battle visualized the undercurrent of conflict that already split the family across lines of marriage and gender and foreshadows Camilla's gruesome end. At the same time, David's ambition to garner a place in the grand tradition of Nicolas Poussin structured the picture. His asymmetric division of the vast canvas, two-thirds given over to the warriors and their father, is the mark of an effort to concentrate on the masculine, martial action. He aggressively signals male resolve with striking red garments and three finely sharpened swords. Yet the painter cannot fully repress the feminine, domestic drama so much a part of his inspiration from Corneille: the women, tucked to one side, refuse to disappear. Why do they so command attention? They are set back slightly from the front plane, yet receive quite a bit of light. Their bodies close the right corner of the picture like a period at the end of a sentence. Almost lost in shadow between the two main groups, we discover a vestige of Marmontel's engaged interlocutor, whose onstage witnessing embodies a prototype for that of the audience. An older woman tries to shield two small children from observing the scene. One of them stares out wide-eyed from between her fingers. The child's expression of fascination and fear is barely visible, an almost-erased cue left by a witness lifted from the world of Greuze's bourgeois drama. The child watches like us, and realizes that something terrible is about to happen to the family. He indexes the sentimental underside of the story and shifts our empathy from the histrionics at center stage to the pathos playing at the far right. Like Marmontel, David walked a fine line between the trivial and the sublime.

It is significant that both Marmontel and David enjoyed the protection of d'Angiviller.[122] They shared with their lofty patron a basic assumption about the social power of art: that the persuasive enactment of good examples will reverberate through a theater or gallery and circulate in the larger community. These aspirations for improving a public thought too easily given to embracing—through unreflective sympathy—the dangerous side of illusion or base, merely personal sentiments, meshed with traditional ideas about the didactic value of the arts. D'Angiviller has long been recognized for his role, as *Directeur général des Bâtiments du Roi*, in the government's attempt to rejuvenate French history painting by steering it towards edifying themes of moral utility.[123] As early as July 1775 he enjoined Jean-Baptiste-Marie Pierre, *Premier peintre du Roi* and director of the Academy of Painting and Sculpture, to allow into the annual exhibition "no work that might alarm public morals with unseemly nude figures." He concluded imperiously: "I take pride in the fact that the purpose and projects concerning the influence of the arts upon public morals, which I stated to the Academy in my letter of 7 April 1775, will become . . . a principle."[124] The next year, d'Angiviller reminded Pierre of his intent to "encourage large format painting" by commissioning "several pictures to be done for the King, the majority of which will have subjects of historical deeds suitable for rekindling virtue and patriotic sentiments."[125] D'Angiviller's call for the rejuvenation of history painting is of a piece with Marmontel's framework for the renovation of French classic theater by embracing modern ideas on the psychology and technology of staging. Marmontel's essays were manifestoes of these lofty ambitions. David's *Belisarius* invoked the heritage and prestige of Poussin while transposing those values into painting. Acclaim for that picture, along with David's active involvement in stage production at the Comédie-Française, positioned him for an important commission from d'Angiviller. In February of 1782 d'Angiviller ordered from David the painting that became the *Oath of the Horatii*.[126]

David did almost no work on the *Horatii* for more than a year, preferring instead to secure a place in the Academy by completing his reception piece, *Andromache Weeping over the Body of Hector*.[127] Even the exact choice of subject from Corneille's *Horace* remained in flux for several years.[128] In July 1784, David received permission to go to

Rome for eighteen months on the pretext of needing to paint his picture amidst the antiquities of the Eternal City. The artist arrived on 8 October with his wife and several students. He was reported to be hard at work in early December by Louis Lagrenée, director of the French Academy in Rome.[129] By June 1785, David began to arrange for transportation of the *Horatii* to Paris in time for the Salon.[130] Meanwhile, about two weeks before shipment, David placed the picture on view in his Roman studio. It quickly garnered an almost mythic reputation.[131] His letter of 8 August to the Marquis de Bièvre speaks of the "unforeseen success of my picture," tells of the foreigners and nobles who come in droves to see the work, and asks Bièvre to arrange for its good placement in the Salon.[132] He also delivers important news:

I exceeded the dimensions given to me on the King's behalf. I was given the size 10 by 10, but having turned my composition every which way and seeing that it lost energy, I quit making a picture for the King and did it for myself. No one will ever make me do anything to the detriment of my fame, so I made the picture 13 by 10 feet.

Scarcely a year after his reception by the Academy, David had moved boldly on his own initiative to execute the *Horatii* on a scale usually reserved for only the most eminent academicians.

Apart from the trail of written documents left by the *Horatii*, we know little of David's actual working procedures in Rome. In December 1784, he wrote to his former teacher Joseph-Marie Vien that "during the day I work on my picture and in the evening I draw after the antique."[133] The notebooks used by David in Rome do record this student-like return to drawing from ancient art, witness the two sketches he made of the Torso Belvedere (FIGURES 37, 38).[134] Just across the binding from the second of these lies a much different kind of image—an anatomical drawing probably made from an *écorché* by Jean-Antoine Houdon, a sculpture still used by artists to analyze musculature (FIGURE 39).[135] The two sculptures cannot have been accessible together, yet David arranged them on facing pages to juxtapose two ways of looking: an aesthetic eye attuned to the grand tradition set against an eye of scientific analysis trained by anatomy. David, like the actress Hippolyte Clairon cited earlier, turns to anatomy to refresh his purchase on the real. He also sets up a confrontation parallel to

FIGURE 37

Jacques-Louis David, Drawing after the *Torso Belvedere*, 1784–85. Black lead. Paris, Musée du Louvre, Département des Arts Graphiques, inv. RF 4506,38 (18.9 × 13.3 cm). Photo: © Réunion des Musées Nationaux / Art Resource, NY / © Madeleine Coursaget.

FIGURE 38

Jacques-Louis David, Drawing after the *Torso Belvedere*, 1784–85. Black lead. Paris, Musée du Louvre, Département des Arts Graphiques, inv. RF 4506,72 (18.9 × 13.3 cm). Photo: © Réunion des Musées Nationaux / Art Resource, NY / © Madeleine Coursaget.

FIGURE 39

Jacques-Louis David, Drawing after an *écorché*, possibly by Houdon, 1784–85. Black lead.

Paris, Musée du Louvre, Département des Arts Graphiques, inv. RF 4506,71 (18.9 × 13.3 cm).

Photo: © Réunion des Musées Nationaux / Art Resource, NY / © Madeleine Coursaget.

the one we outlined in Chapter 2 between the plates of the *Encyclopedia* on fine art drawing and those on anatomy (FIGURES 8, 10). His notebook reenacts the *rapport* across white space that we characterize as an essential component of diagrammatic knowledge.

Elsewhere in the same sketchbook David sets these two modes of vision close together on a single sheet, as if testing their respective limits (FIGURE 40).[136] To the right, a rendering in outline imagines the father's left foot nearly devoid of mass; to the left, a sketch of the right leg of Houdon's *écorché* carefully articulates the physicality of muscles. The finished painting fuses these two modes of vision in the vivid musculature and swollen veins of legs modeled boldly in a harsh light. We can follow the process of David's transformations by considering a study of a left leg (FIGURE 41).[137] This sheet, which may be loosely connected to the Borghese *Gladiator*, no longer depicts a flayed limb but still registers separate muscles as distinct, bulging masses. This specific study moved almost without change to the final painting, where it became the left leg of the brother closest to the front plane. The painted figure's anatomy

FIGURE 40

Jacques-Louis David, Drawing for the left foot of Horace and after the right leg of Houdon's *écorché*, 1784–85. Black lead. Paris, Musée du Louvre, Département des Arts Graphiques, inv. RF 4506,42 (18.9 × 13.3 cm). Photo: © Réunion des Musées Nationaux / Art Resource, NY / © Madeleine Coursaget.

FIGURE 41

Jacques-Louis David, Drawing of a left leg, 1784–85. Black lead. Paris, Musée du Louvre, Département des Arts Graphiques, inv. RF 4506,4 (18.9 × 13.3 cm). Photo: © Réunion des Musées Nationaux / Art Resource, NY / © Madeleine Coursaget.

reflects the peculiar history of his leg within David's working practice, for its relationship to the hip joint cannot be anatomically rationalized. A normal body with such a placement of foot and lower limb could never turn its buttocks toward the picture plane as does this young man. His disjoint anatomy—hyper-correct in specific elements but fantastic in its ensemble—had to be concealed under fabric so that its rubberized thigh does not become a distraction.[138] Under close observation, the frieze of figures becomes increasingly a collage of separately observed anatomical parts suspended—like marionettes—in an illusionistic box.

The picture's visual impact evokes Diderot's theatrical illusion which, though entirely convincing from the parterre, arises from elements that appear disparate and uncoordinated when viewed from backstage. The *Horatii* took its shape from a cluster of analytic modes—idealizations of ancient sculpture, anatomical observations from natural science, differential points of view—that are epistemologically mis-aligned but still pull together. The woman who called attention to holes in the composition in her review of the 1785 Salon was on the right track. Just how right is signaled by David himself. On the last page of the sketchbook he used in Rome are some fragmentary notes that summarize his working method:

Method of placing my models into my picture . . . for the head of the father I made him get up on the table and sit on the tall chair . . . for his arms he stood on a chair . . . for his legs I had my picture raised up on two chairs and the model stood on the ground . . . for the head of Horace *fils* I moved my picture close to the daylight, I stood on a chair and the model stood on the main step of the terrace.[139]

This vivid account confirms Fried's trenchant comment that a work's first beholder is the artist.[140] David both imagined and created the *Horatii* from near and far, from below and above, in bright light and in shadow. His physical movements are registered on the canvas as variegated parcels of data that require integration. The picture's perspective armature, at once intrusively present and structurally flawed, attempts to forge a coherent tableau from kaleidoscopic data.

The confrontation we emphasize produces odd pictorial irruptions in unexpected places: a closely observed hand grasping the nearest son seems to float free of its arm; medical-book renderings of the distended

muscles and bulging veins of legs that refuse to connect anatomically to their presumed bodies; what Crow calls the "weird and pointless way the foremost son holds his spear."[141] The resulting clash is akin to the dispersal of data and attention about which Daubenton wrote when discussing description in the natural sciences. David invites viewers to integrate heterogeneous details within a fictive space—to replicate in the major register of history painting the productive exercise of *rapport* that animates the *Encyclopedia*'s plates. His picture is both product and symptom of the culture of diagram.

In the *Horatii*, disparate passages of localized illusion coexist in strained relationships to one another, like the suspended elements of visual catalogues separated by white ground in the plates of the *Encyclopedia*. Typically, painters elide lapses in spatial or anatomical coherence using tricks of drawing, perspective, or rich, even virtuosic impasto: witness the still-lifes of Desportes (FIGURE 5 / PLATE 3) and Chardin (FIGURE 7 / PLATE 4). Marmontel, as we know, believed such sleights of hand were springboards to aesthetic pleasure. If a painting of perfect illusion seen from a distance suppresses the awareness of art, approaching the canvas brings the artifice of its brushwork into focus and actuates our capacity "to enjoy both nature and artifice at the same time." By contrast, critical commentary on the *Horatii*—whether in David's studio, at the 1785 Salon, or by modern writers—dwells upon its refusal of painterly artifice. Apparently, Tischbein already was seduced by the painting's thingness in 1785, for he was relieved to discover in the end that it was only a picture. His momentary reverie was akin to Diderot's total immersion in illusion; pulling back from the painful spectacle let him marvel at the hand of a master able to command such conflicting emotions. A salon critic of the time characterized David's stark artlessness: "it is by the opposition of objects to one another that he seeks to produce an effect rather than by what painters call the magic of chiaroscuro." Both the marked absence of painterly magic and the palpable tension among David's objects simulate the effect of collage. Thomas Crow interprets these elements as marks of an extreme naturalism, verging on hallucination, that willfully excludes art and assumes the status of a natural object in its own right.[142] Like diagrams, the *Horatii* is more a working object for thought experiments than a window opening onto a fictive world.

What is the net gain of embedding the *Horatii* in the culture of diagram? Tischbein was certainly more attentive to the picture's affecting mise-en-scène than to the artisan's hand—to a stage director's guidance rather than a painter's flourish. He frames his experience of the picture as if a staged performance, where the fourth wall remains transparent as if there is no pictorial surface. David's canvas did not impress him with its impasto, though he noted that all parts "have been diligently worked" and that secondary objects are "painted with astonishing reality." In general, David's fine, flat, and almost invisible brushwork elicited little comment, apart from the remark in one Roman periodical that the painter "might have shown off the brushwork a little more, giving more attention to the reflected light." Tischbein does speak of the strong light, faulting the shadows as "hard, unpleasant, and without soft reflections." Perhaps in response to the lack of mid-range transitions between areas of light and shade, Tischbein astutely observes that the eye perceives "little that flatters in the play of colors."[143] Paradoxically, close scrutiny does not break down completely the illusion of the *Horatii*, nor does it yield aesthetic delight in the master's touch. Rather, close viewing calls attention to the picture's variable resolution. Viewers tend to notice those areas where, in the words of Tischbein, David seems to have drawn "the forms of the legs and arms of the brothers who swear the oath more vigorously than the occasion demanded merely to make his knowledge of anatomy and drawing more striking." The *Horatii* rejects the unifying personal touch of impasto to locate the double character of aesthetic distance in an awareness of holes, breaks, and discontinuities. These gratuitous moments, out of synch with their surroundings, generate a new kind of cognitive experience. We might say that David in 1785 invented, with the *Horatii*, a working object in the visual arts—a *thing* that belongs neither to the world of nature nor of artifice but nonetheless constitutes knowledge.

VII

David's painting was not an heroic, isolated, or idiosyncratic attempt to face the challenge of new descriptive modes. It was embedded in a peculiar and specific historical moment. Writers on theater of the time struggled with the relationship between action and pantomime, between

narrative and description, in an attempt to reshape the limits of repre-
sentation.[144] For a critic like Marmontel, concerned to define a middle
ground between modern affect and the grand manner in both theater
and painting, imagination should operate within bounds set by the rep-
resentation itself. His concept of tableau, like Diderot's, was an attempt
to situate personal response in a social milieu. David was a painter who
knew theater well. The uncanny and empty space of his *Horatii*—nearly
devoid of props—mirrors the closed-loop economy of what was increas-
ingly possible on stage.[145] He orchestrates emptiness and stillness to stim-
ulate the imagination and produce the intense, conflicted emotions that
disturbed Tischbein. The space both draws viewers into its illusion and
signals by its strangeness that their suffering will end. In this dialectic,
Diderot's imaginary fourth wall suddenly becomes an opaque screen.
The shift does not so much destroy the picture's affect as produce Mar-
montel's supplement of aesthetic pleasure—a surplus of meaning located
nowhere in the picture.

Tischbein's experience before the *Horatii* enacts the paradox of any
representation that oscillates between physical presence as illusion and
the self-evident display of constituent signs. The viewer is caught between
ways of seeing: absorbed as participant in an event and detached as a
witness to a play of meaning. Michael Fried's study of figures absorbed
in their own thoughts or actions has charted much of this terrain for the
history of art.[146] Yet, the non-declamatory mode defined by Fried was
not limited to painted images, for it was central to the critical debate
about pantomime and characteristic of the impersonal form of address
found in the plates of the *Encyclopedia*. Much of the information arrayed
in the plates could be more accurately sensed, registered, and recorded
by instruments rather than by human beings. Many plates disperse vi-
sion across descriptive arrays that recur only occasionally to the viewer-
anchoring, beholder-affirming formal setup of tableaux.[147] To focus only
on absorptive behavior in paintings occludes the growing importance of
instrument-like perception in eighteenth-century culture.

In Chapter 3, we showed how the generation of encylopedists sought
to assimilate an explosion of fundamentally impersonal information
produced by new technology and instrumentation. The impact was not
limited to scientific disciplines. Historians of the novel find that writers

like Horace Walpole, Frances Burney, Jane Austen, and Johann Wolfgang von Goethe experimented with an impersonal form of narration that has, retrospectively, been called *style indirect libre*, *Erlebte Rede*, or free indirect speech.[148] In our earlier discussion of this phenomenon, we linked its appearance to the rise of diagrammatic knowledge and processes of correlation. We concur with Roy Pascal's suggestion that a simplified definition of free indirect speech would be that "the narrator, though preserving the authorial mode throughout and evading the 'dramatic' form of speech or dialogue, yet places himself, when reporting the words or thoughts of a character, directly into the experiential field of the character, and adopts the latter's perspective in regard to both time and place."[149] The inner thoughts of characters (we might say, with Jaucourt, their "secret emotions") are revealed without external commentary from a narrator or author and without being overtly expressed—an attitude consonant with Fried's absorption. This inner state erupts within the text as an apparently objective physical presence, spoken by no identifiable character yet constituting an impersonal, third-person voice. By definition, such phrases are strictly literary; they make no sense in ordinary speech. "What is espoused," writes Ann Banfield, "is the idea that in such sentences there is a blending of two points of view or 'voices,' the character's, whose consciousness is linguistically represented, and the narrator's who 'adopts the character's point of view.'"[150] The "blending of two points of view"—a technique that appears increasingly in novels after 1760 and becomes mainstream in the nineteenth century with Gustave Flaubert and Émile Zola—intertwines two modes of address in ways analogous to the multiple points of view physically enacted by David in his studio while painting the *Horatii*.

Art history has placed David as the founder of a new school who renovated tradition by breaking with his own training. We put him in a cultural matrix composed of several intersecting threads: the immense absorptive emotionality of the new novel; a recrudescent, newly illusionistic theater where visual effects rivaled dialogue; impersonal scientific illustrations that address ever-present virtual witnesses.[151] Certainly, the *Horatii* was a striking pictorial intervention, though it did not violate the grammar of history painting. Critics found David's style compelling or disturbing but not incomprehensible. His idiom quickly became the norm.

Novels exhibit a parallel fluency with free indirect speech which, from its first appearance, "is already used with the greatest skill and propriety," and writers "working unknown to one another and ignorant of the rules governing the style know how to use it." Readers "faced for the first time with a linguistic form unfamiliar to them from their experience as speakers" know how to interpret it.[152] Pascal suggests that "linguistic habit" guides the early but already expert use of free indirect speech. Banfield explains this expertise with a theory of generative grammar. Without trying to settle this disagreement among specialists, we note that both schools of thought cite, among the indices of free indirect speech, "ejaculations and oaths, particles and verbs with a subjective reference, rhetorical questions, etc."[153] These linguistic features allow us to frame in a new way David's invention of an *oath* to organize the *Horatii*. His choice of the oath testifies both to his profound understanding of dramatic action and to his intuitive grasp of its grammar. David recognized oath-taking as a performative gesture that could unite disjointed elements—narrative, emotional, and descriptive—into objective statement. He introduced an analytic, impersonal syntax within the autographic tradition of painting. The *Horatii* is a symptom of a broad-based effort—including the reform of theater and the *Encyclopedia*'s endorsement of user-based arrays of data—to situate aesthetics and the imagination within an expanding field of knowledge ever more inhabited by natural science.

5 NUMBERS

The *Encyclopedia* was limited by the material constraints of print culture: its diagrams and explanations rely on ink and paper and a sequential presentation defined by the folio book. In other domains, notably the real-time forms of theater and spectacle, experiments in correlation were pushed much further and eventually came to affect—in a kind of feedback loop—other kinds of representation such as history painting. But arenas of correlation supported by oil and canvas offer only a slight improvement over ink and paper in the character and range of connections they make possible. During the course of the nineteenth century, mathematics moved to center stage as the notation most likely to improve this state of affairs. In this chapter we revisit the question of mathematics—notably geometry and probability—in the context of non-mimetic, diagrammatic forms of representation. Mathematical notations were devised to define fields and time, specify spaces and movement, and predict future events. Figures like Hermann von Helmholtz enlisted the mathematics of error-correction to account for the body's vagaries of perception. The tools of probability produced working objects with which physicists described elements not visible to the human sensorium in any sense of the word.

Mathematics seemed able to produce such objects of no material substance, yet useful nonetheless for making correlations of practical value in the real world.

To grasp the significance of this development, three interrelated components of our story remain to be told. The first, which is to discuss the rise of descriptive geometry, relates to our early remark that diagrams often are structured geometrically. The second is to resituate historically the treatment of geometry in the *Encyclopedia* article of 1754 about description, so as to reveal the emerging importance of the calculus and probability that d'Alembert did not address in his contribution. The trajectory of that exposition will lead us from tangible objects and social statistics to quantum physics. The third is to elaborate our view of diagram as involving the dissolution of fixed points of reference into the shifting material web that we have designated with the shorthand term "whiteness."

We have pointed to these three areas of concern when discussing David's *Oath of the Horatii*. This painting crystallizes for us the complexities of the culture of diagram toward the end of the eighteenth century. Certainly, it is a picture in perspective, apparently seen from a single point of view. Yet in its final elaboration, and in David's working process, competing points of view both produced the frequently noticed tensions among elements of the canvas and also complicated its meaning. A geometry of straight lines and triangles lies under the organization of David's figural frieze, a set of schemata that sits uneasily within the strongly articulated space of the containing perspective box. We have argued that the tableau-like presentation of David's story registers his engagement with the affective potential of theatrical tableaux on the stage. The protocols of ambitious painting, contemporary stage productions, and theater design converged on a geometry of good sight lines and on the formal requirements of a compelling illusion.

Our discussion of David and the theater in general suggests beginning with the geometry and mathematics of perspective. The formal tensions of David's *Horatii* signal the presence of contemporary challengers to the seeming naturalism of one-point perspective. Adherents of descriptive geometry, and those endorsing a fully mathematical description of space, concurrently challenged the established Renaissance model.

Amongst theorists of perspective, as James Elkins writes, there opened a dramatic split in how best to render space mathematically. On one side lay a continuation of perspective formulas and artistic techniques inspired by Alberti's and other Renaissance systems, including the distance point method common in Northern Europe. On the other, there arose alongside and ultimately competing with the practical tradition a theoretical analysis of perspective driven by two ambitions. First, was to probe the origins of perspective itself and to understand the constructed, invented qualities of Alberti's system. We might call this a meta-critique of perspective. Second, was the wish, as Elkins observes, to "free perspective from its burden of conventions and restore it to a more universally valid state."[1] In pursuit of this goal, theorists strove to describe space in purely geometric terms without reference to scale, gravity, or the horizon line that had tied Alberti's schema to the natural world. Elkins cites the example of Johann Heinrich Lambert's *Freye Perspektive* (1759), in which an innocent country landscape embraced by the night sky is redescribed with a horizonless network of interlocking triangles written into the heavens and extending outside the picture frame as if they were folded-down popups. Elkins' point is that these geometrical descriptions cannot be read spatially; ours is that the white of their pages becomes an integral part of the spatial description.

Geometric experimentation with the description of space during these decades eventually splintered into three related domains: descriptive geometry, projective geometry, and analytic perspective (itself a branch of analytic geometry). In each of these practices, high level analysis of perspective tended to migrate into mathematics. Diagrammatic proofs, like those characteristic of descriptive geometry, became increasingly denaturalized and accessible only to trained experts. In some of the most extreme examples of treatises in analytic perspective, such as that published by Johann Gustav Karsten in 1777, illustrations are almost entirely replaced by formulas, and physical sight is almost entirely replaced by equations.[2] These investigations of descriptive systems with neither a single point of reference nor a stable set of coordinates parallel developments in aperspectival objectivity that Lorraine Daston associates with the first manifestations of modern scientific objectivity. Central to the experiments she cites is the withdrawal of a single subjective

witness and its replacement by multiple points of attention—exactly in keeping with the dispersed vantage points characteristic of the plates of the *Encyclopedia*.[3]

The turn taken by theoreticians of perspective, already in the 1750s, complicates the neat division that d'Alembert attempted to establish in his short entry about geometry under the rubric of description in the *Encyclopedia*. We noted in Chapter 3 his distinction between pure mathematics, concerned only with intangible ideas, and the mixed mathematics concerned with practical applications used in experimental inquiry and descriptions. Geometers expert in perspective were devising descriptions of domains cut free from the real world, and were edging toward accounts of infinite space. Inquiries of this kind may have begun in the realm of practice, but they moved steadily to embrace pure theory, equations, and abstractions of insensible worlds. In fact, d'Alembert enacted the division of knowledge that Michel Foucault placed later in the eighteenth century: separation of the deductive formal sciences "based on logic and mathematics" from the empirical sciences devoted to the study of things "which employ the deductive forms only in fragments and in strictly localized regions."[4] Foucault dramatized this conflict as the triumph of mathematics at the rupture between what he called the "classical" age and modernity.

By contrast, practitioners of pure mathematics at the time were worrying that their discipline had reached a dead end. In a letter of 1781, Joseph-Louis Lagrange wrote to his mentor Jean d'Alembert:

I begin to sense my "force of inertia" growing little by little, and I am not sure that I will still be able to pursue Geometry ten years from now. It seems also that the mine is almost too deep already, and that unless new seams . . . are discovered, it will be necessary to abandon it sooner or later.[5]

Lagrange was preaching to the converted, for d'Alembert had sensed already that the application of mathematics to object-oriented descriptions presented the field with deep epistemological problems.[6] Writing from Berlin, where he was mathematician to Frederick the Great, Lagrange was perhaps unaware that a younger man, deeply inspired by his own work, was developing a new set of tools in the military school of Mézières that would take center stage within a generation.

II

The application of geometry to practical constructions was a principal concern of Gaspard Monge. In the context of his teaching drawing to the students at Mézières in 1765, Monge solved a problem of gun emplacement so quickly, and without the customary time-consuming arithmetic procedures, that the local commander refused to credit the solution.[7] Descriptive geometry, as Monge ultimately named his scheme, soon proved so powerful that the military kept it a closely guarded secret: Monge's lectures only began to appear in print in 1795. His method projects objects onto two usually perpendicular planes, which in turn are flattened and rotated to "produce a diagram in two dimensions of the three dimensional object." The central device of Monge's system was to detach his axes of representation from the vertical and horizontal grid of ordinary vision. As Ken Alder observes:

These views were rigorously interrelated, consistently laid out, and coupled to the world of mathematical analysis. As a result, the descriptive geometry was also a "constructive" technique, allowing its possessor to solve for new shapes and configurations. By permitting engineers to analyze and manipulate these physical objects on paper, it helped them solve problems in fortress construction, stone cutting, and even machine design. This then is the story of what happens to the world of things when people inscribe them on paper.[8]

These are drawings without a normative point of view that exemplify the aperspectival objectivity identified by Daston (FIGURE 42). That they can be manipulated like objects to solve problems places them in the category of working objects, analogous to engineering drawings and prefiguring computer assisted displays in today's design studios.

How are Monge's projections—his demonstrations in descriptive geometry—related to the plates of the *Encyclopedia*? Formally, they are of the same family, with an important difference. Taken as a whole, the plates do not employ a single mode of correlation like Monge's but rather invite users to encounter visual arrays from individual orientations, imaginative positions, and subjective platforms. Meanings are not fixed but vary in the manner of aesthetic experience. Our analysis of the plates is consonant with Daston's very large generalization that "aperspectivist objectivity first made its appearance not in the natural

FIGURE 42
"Géométrie descriptive," pl. I.
Engraving by Delettre after a
design by Girard for Gaspard
Monge, *Géometrie descriptive*,
1799. Photo: Courtesy of the
Bancroft Library, University of
California, Berkeley.

sciences, but rather in the moral and aesthetic philosophy of the latter half of the eighteenth century."[9] Monge by contrast proposed a series of geometric protocols to link part to part and produce a single perceivable object that is both internally consistent and of direct practical use in the physical world. In his scheme, the white of the paper is surely an arena of *rapport*, but one in which every move is plotted geometrically and defined by algebra. The object that comes into view can be called imaginary, but is closer to engineering than to aesthetics.[10] The mathematical rigor that Monge championed in his method was possible only when the imaginary and subjective secret emotion of the user was completely disciplined by geometry. The ascendancy of Monge and his school in the 1790s signals the apex of efficacy for the medium of paper and print in the culture of diagram.

There can be no doubt that Monge's descriptive geometry was eminently useful. When the National Convention initiated reforms of instruction in 1792 to serve the common good of the new French republic, schools were founded that broke with the heritage of aristocratic patronage. The École Centrale des Travaux Publics became the premier training ground for engineers, at the summit of an educational system largely redesigned by the Marquis de Condorcet.[11] Monge emerged as the school's leader mainly because his system of descriptive geometry, earlier implemented at Mézières, worked so well. Descriptive geometry held the potential of linking conception, design, and construction in a language of the arts. His system seemed to promise a universal language of the kind Diderot had dreamed of when he aspired to break the monopoly and secrecy of the guilds and trades.[12] Under Monge's guidance, descriptive geometry formed the basis of instruction at the École Centrale: 48 percent of course time was devoted to descriptive geometry and only 9.3 percent to abstract mathematics and mechanics.[13] Monge was keenly aware of the materialist direction of the curriculum and celebrated it in his report to the administrative council of the school in February 1795:

These drawings, these constructions require deep thinking on the part of students, but no time will be devoted solely to such ponderings; rather, they will have occurred throughout the making of the constructs and the student, who has simultaneously exercised his intelligence and his manual dexterity, will have

as recompense for this twofold labor the exact Description of the knowledge he has acquired.[14]

There could be no more eloquent statement about the status of Monge's drawings as working objects than his summary of how actually making them produces a descriptive knowledge that is both intellectual and material.

Monge's ascendancy over the curriculum at the École was short-lived, partly because of his absence during 1796–99 in service with Bonaparte.[15] In 1795 the school was renamed École Polytechnique and the great mathematician Pierre-Simon Laplace appointed a final examiner. He focused examinations on problems of pure mathematics, purposely avoiding questions about descriptive geometry and its applications.[16] In this way, Laplace tacitly reshaped Monge's curriculum. By 1797 the artisan-assistants in charge of practical labs had been dismissed, with emphasis newly placed upon courses in abstract mathematical analysis that would ensure passing Laplace's examinations.[17] These changes were formalized in 1799 when Laplace, recently appointed Minister of the Interior, strengthened the roster in mathematics by replacing older faculty and adding a new chair in analysis.[18] The effect was striking. By 1810 the balance between geometry and mathematical analysis was nearly the reverse of fifteen years earlier: the school's two-year curriculum required 137 lessons in analysis and only 85 in geometry.[19] Alder reminds us that a factor in the shift toward mathematics was Bonaparte's wish that the school be the principal training ground for a new class of military elite. This meant reducing the number of scholarships, making the entrance exam more rigorous, and renouncing the Revolution's combination of practical and academic training in favor of the mental work represented by courses in mathematics.[20]

III

The brief triumph of descriptive geometry at the École Polytechnique permits a two-pronged view of diagrammatic knowledge at the turn of the century. On the one hand, the decline of descriptive geometry signals that the yield from *rapports* achieved by a graphical, hand-drawn technology had reached its outer limits. On the other, the power to explain

observations newly attributed to mathematical analysis, particularly in the realm of celestial mechanics, situates theory as the engine able to extend inquiry into domains beyond the human sensorium and beyond visual representation. Laplace's own work on celestial mechanics was a monument to the mathematical management of the irregularities that characterize empirical data. As Roger Hahn writes, "Laplace's *Mécanique* spelled the complete victory of theory over brute data, generalized in empirical formulae." Laplace's goal was to ground theoretically the interpretation of observations flowing from astronomers and, increasingly, from instruments. These measurements of minute quantities were to be mastered by means of the highly formalized, abstract language of mathematics.[21]

Lagrange worried in 1781 that mathematics had reached a dead end. Within twenty years the field exhibited a fresh vitality as new questions and new tools emerged from the mathematical study of probability. Laplace had written several memoirs in the 1770s and 1780s to determine the probability of causes lying behind events by working backwards from observations.[22] He was, thus, very interested in precise instrumentation, which led him to collaborate with Antoine Laurent de Lavoisier.[23] In a quest to apply the formulas he had derived to large compilations of data, and even to predictions of the future, Laplace took up the analysis of populations and variations in birth rate of the sexes.[24] These aspects of his work, which partake of late-eighteenth-century optimism concerning the possibility of social improvement, were received enthusiastically by political theorists like Condorcet. Writing in the preface to the volume in which Laplace's *Mémoire sur la probabilité des causes par les événements* (1774) appeared, Condorcet notes that probability "comprises all the applications that can be made of the doctrine of chance to the uses of ordinary life and of that whole science; it is the only useful part, the only one worthy of the serious attention of philosophers."[25] However, Laplace was careful not to over-extend claims about the application of his theories to social or political life—a reserve that kept him within the orbit of his mentor d'Alembert, who opposed applying the calculus of probability to physical problems in the real world.[26]

The study of probability was the natural outgrowth of Laplace's belief

in an orderly, even mechanistic natural world whose operations sometimes simply exceeded the limits of human understanding:

There are things uncertain for us, things more or less probable, and we seek to compensate for the impossibility of knowing them by determining their different degrees of likelihood. So it is that we owe to the weakness of the human mind one of the most delicate and ingenious of mathematical theories, the science of chance or probability.[27]

Thirty-eight years later, in the *Théorie analytique des probabilités*, Laplace repeated this statement nearly verbatim.[28] Nonetheless, his return to questions about probability in the early nineteenth century did not signal a change in his world view. Laplace was motivated by new research in the field that he incorporated into his existing framework of celestial mechanics. By contrast, others would depart from contemporary work on probability to undermine Laplace's orderly view of nature. To sketch the origins of this development, we must turn to the pioneering publications of Adrien-Marie Legendre and Carl Friedrich Gauss.

In March of 1805 Legendre published a small volume on how to plot a comet's path, where he introduced as an appendix the "method of least squares." This was a formula for distributing the errors introduced by multiple sightings of bodies moving in space so that "a kind of equilibrium is established among the errors which, since it prevents the extremes from dominating, is appropriate for revealing the state of the system which most nearly approaches the truth."[29] Mathematically speaking, Legendre's formula was simple: it involved taking the sum of the squares of the errors to a minimum so that each observation plays a part, but those with large errors do not unbalance the findings. Within ten years of its first presentation, the method of least squares had become a standard tool of astronomy and geodesy throughout Europe.[30]

The most astonishing proof of the usefulness of mathematics in astronomical observation came on 23 September 1846. Using coordinates that John Couch Adams and Urbain Le Verrier had derived from mathematical analyses of perturbations in the orbit of Uranus, the Berlin observatory discovered the planet Neptune. Astronomers had failed to find the planet by direct observation, but they were successful when mathematics was trusted literally to point them in the right direction. Speaking at the

opening of the British Association held at Oxford in 1847, Robert Harry Inglis underscored the importance of the event:

The progress of astronomy during the last year has been distinguished by a discovery the most remarkable, perhaps, ever made as the result of pure intellect exercised before observation, and determining without observation the existence and force of a planet; which existence and which force were subsequently verified by observation.[31]

Inglis did not praise mathematics for moving astronomy to a higher plane of knowledge. Rather, he celebrated the power of mathematical theory to formulate true statements *in advance* of experience—notably when dealing with the presumably stable forces of planetary motion. The important point to take away from this example of mid-nineteenth-century astronomy is that scientists faced, and were willing to accept, situations in which mathematical calculations might guide both experience and experiments.[32] The Neptune incident proved in dramatic fashion that mathematics could be eminently useful to actual practice in an important branch of natural science.

Legendre had attacked the problem of error correction in the highly specialized subculture of astronomy. This same world was rocked in 1809 by Carl Friedrich Gauss, who recast Legendre's intuitive insight about the method of least squares in explicitly probabilistic terms.[33] Gauss suggested that the method worked only if one assumes a distribution of errors in what eventually came to be known as the "normal distribution" or "binomial" curve.[34] Ultimately, Gauss's reasoning was flawed because it was circular: to assume a normal distribution at the outset was tantamount to positing the conclusion he sought to prove. Laplace, who had been exploring since the 1770s how probability equations might be used to predict future events based on past occurrences, immediately grasped the importance of Gauss's publication in spite of its mistaken logic. Even before reading Gauss, Laplace had presented the central limit theorem in a paper of April 1810 where he generalized that any sum or mean will be distributed normally for a large number of terms.[35] His procedure was to transform the mean result of an indefinite number of observations into a convergent series.[36] The probability of a result falling within the infinitely small interval between the converging limits could be said to approach the certainty of truth.[37]

Laplace realized that his central limit theorem justified and generalized the unproven assumption of Gauss's paper, and that the binomial curve would define the distribution of variations produced by any observation made in very large numbers. In the words of Stephen Stigler:

The Gauss-Laplace synthesis brought together two well-developed lines—one the combination of observations through the aggregation of linearized equations of conditions, the other the use of mathematical probability to assess uncertainty and make inferences—into a coherent whole. In many respects it was one of the major success stories in the history of science.[38]

At this decisive moment, mathematics joined with direct observation to produce descriptions that could be corrected for errors and to make predictions. The surprising part is that this union is neither natural nor inevitable, since most human beings perceive the world through the vagaries of their senses rather than the rigor of mathematical equations.

A new class of working object appeared for which uses were yet to be defined. This powerful tool permits generalizations from small, even incomplete, data sets and simultaneously accounts for recording errors. It can predict the outcome of future observations within limits and tolerances specified by probability. It was not, however, entirely without ancestry. The diagrams of the *Encyclopedia* were also working objects that produced knowledge. They, too, defined the range of correlations within limits: the physical limits of paper, engraving, printing, and of the book market. By contrast, the new working objects based on probability immaterially specified their limits by means of abstract equations. The domain of diagrammatic knowledge expanded from the physical world alone to embrace that of numbers, from the realm of the human sensorium to a universe of invisible entities. Explanations may shift from graphics to notations, but a functional continuity among the class of working objects threads through the culture of diagram and undermines an historical view that assumes the presence of epistemic breaks in history.[39]

IV

Could the twinning of mathematics with observation be useful in other fields of study? Laplace certainly thought so. Writing in 1825 for a wide public, near the close of *Essai philosophique sur les probabilités*, he

predicted, "Analytic expressions of probabilities . . . can be thought of as the necessary complement of sciences based on a collection of observations subject to error. They are even essential for solving a great number of questions in the natural and moral sciences."[40] Laplace's project continuously motivated the work of Adolphe Quetelet, one of the nineteenth century's most prolific statisticians.[41] Educated at a French lycée in Belgium during the Napoleonic occupation, Quetelet completed a dissertation on conic sections in 1819 and began teaching mathematics in Brussels. In the early 1820s he spearheaded a movement to found an observatory in Brussels, and during 1823 spent several months at the Royal Observatory in Paris to master the basics of astronomy. Quetelet learned the practical aspects of running an observatory and was introduced to the newest practices of scientific observation, including the method of least squares that was already in routine use by astronomers. He returned from Paris deeply impressed by the way astronomy used probability theory to reveal cosmic regularities.

Quetelet's appointment in 1826 to the statistical bureau of Belgium gave him access to large bodies of social data that included births, deaths, criminality, and suicides. Taking a cue from astronomy, he published a series of memoirs during the late 1820s in which he extracted periodic patterns from the raw data of social statistics using the analytical tools of probability learned from Laplace. In one of his first articles, Quetelet assembled census data on changes in population produced by births and deaths, on the number of marriages, and children of those marriages (separated into male and female).[42] In each category, he calculated a mean based on the entire population of the country, and then individual ratios of variation against that mean for each province. He displayed these numbers in a table (FIGURE 43) that places the provinces in order of death rate, expressed as a ratio to their population. The ratios for other categories—like birth, marriage, number of children, proportion of girls to boys—are similarly arrayed in parallel columns. Quetelet understood that all of this is quite messy. To express these relationships more accessibly, he enlisted a model from the physical sciences:

To make all these correlations more perceptible, we have added to the numerical tables a plate in which different curves represent, by their sinuosity, the variations

sur la population entière du Royaume et sur les totaux, pour les naissances, les décès et les mariages.

PROVINCES.	RAPPORTS					
	de la POPULATION.	De la pop. au décès.	De la pop. aux nais.	De la pop. aux mariages.	Des naissances féminin. aux naiss. masc.	Des naiss. aux mariages.
Zélande . .	128,045	31,4	20,7	113,7	0,960	5,49
Nord-Hollan.	385,696	34,5	23,2	104,4	0,956	4,50
Sud - Holland.	429,019	35,0	23,9	113,3	0,959	4,74
Utrecht . .	115,980	36,3	24,3	118,2	0,939	4,86
Brab-Méridio.	478,005	38,2	26,1	142,2	0,970	5,45
Fland.-Occid.	556,459	40,7	27,5	137,7	0,930	5,01
Overyssel . .	158,453	43,5	26,5	121,9	0,937	4,60
Fland.-Orien.	679,525	44,8	28,4	165,3	0,946	5,82
Frise . . .	199,492	46,1	27,1	128,7	0,944	5,75
Liége . . .	329,119	46,2	28,9	154,1	0,942	5,33
Limbourg .	317,388	47,5	29,2	90,3	0,956	3,09
Anvers. . .	320,362	48,8	30,7	142,9	0,960	4,65
Groningue. .	153,908	49,3	28,9	149,3	0,898	5,17
Hainaut . .	538,105	51,1	27,4	136,5	0,921	4,98
Brab-Septent.	319,371	51,4	29,2	150,0	0,974	5,14
Gueldre . .	277,135	53,7	27,6	131,1	0,952	4,75
Luxembourg.	287,351	53,8	27,9	149,9	0,967	5,37
Drenthe . .	52,926	55,0	27,8	130,3	0,895	4,69
Namur. . .	187,207	57,9	29,8	150,9	0,907	5,06
Pour 1824. .	5,913,526	43,8	27,0	132,4	0,947	4,90
Pour 1825. .	6,059,506	41,0	27,1	127,2	0,943	4,70

FIGURE 43

Adolphe Quetelet, "Statistical Table." From *Recherches sur la population, les naissances, les décès, les prisons, les dépôts de mendicité . . . dans le royaume des Pays-Bas*, 1827, page 7. Photo: Courtesy Department of Special Collections, Stanford University Libraries.

FIGURE 44

Adolphe Quetelet, "Statistical Graph." From *Recherches sur la population, les naissances, les décès, les prisons, les dépôts de mendicité . . . dans le royaume des Pays-Bas*, 1827, foldout page 90. Photo: Courtesy Department of Special Collections, Stanford University Libraries.

of these numbers within the different provinces of the kingdom. This method is very like the one used by physicists, who express fluctuations in temperature and barometric pressure as variations in the ordinates of a curve.[43]

Quetelet's metaphor of thermometers and barometers is telling. It reveals that his procedure treats numerical data about human beings impersonally as if they were recorded by instruments, and his analysis of the data parallels that of a physical scientist.

Quetelet eventually refers the reader to a plate at the end of his study to "make the results of the preceding tables perceptible to the eye by means of lines."[44] The image in question (FIGURE 44) is a remarkable exercise in the diagrammatic array of statistical data. The base-line coordinates are horizontally inscribed mean terms for the different categories, crossed by a vertical axis for each province. The principal organizing curve tracks the ratio of population size to numbers of deaths, moving left to right from the highest rate in Zéland to the lowest in Namur. Curves appear below to correlate marriages and births to population, and births to marriages. Their "sinuousness" relative to the straight-edged medians generates for the viewer a sense of the animating life behind the impersonal numbers. The vertical alignment of data connected by each province line pictures a complex of knowledge—the relationship of population to deaths, marriages, and births—that demands a graphic expression. For example, the province of North Holland exhibits a high death rate, almost the highest number of marriages, a fairly high birth rate, and a sub-average fertility rate. By contrast, Luxembourg has a lower death rate, fewer marriages and births, but higher fecundity.

These conjunctures of variables not surprisingly led Quetelet to take sides in a current controversy:

Here again the principle of Malthus finds its application, because we see that the provinces most exposed to mortality are also those where births are most numerous: in this way, drops in population are made up almost as fast as they develop. But these quick successions are produced to the detriment of the society which, relatively speaking, must number fewer mature men fit for producing and contributing to its well-being.[45]

Specialists might have recognized the Malthusian implications of Quetelet's findings, but such conclusions could not have been expressed

mathematically. His graphical representations of ratios depict nothing real in the physical world. The white spaces of his plate, unlike those of the *Encyclopedia* or of descriptive geometry, never slip into an illusion of three dimensions. They are never more than a field for notations upon which tabular knowledge is visually recast to facilitate comparative analysis. Yet the whiteness makes it possible to read differences among the provinces quickly and to understand the causal forces underlying national demographics. The plate generates a surplus of understanding—proper to the diagram—distilled from numbers that cannot speak for themselves. Quetelet's plate not only illustrates his data, but also produces new understandings of it.[46] As such, it is a working object. Herein lies a convergence with the plates of the *Encyclopedia*, for Quetelet's image instantiates a form of knowledge that can only be called diagrammatic.

In a paper of March 1831 Quetelet suggested explicit analogies between the celestial mechanics of astronomy and the "social mechanics" revealed by his own investigations. "Prominent among these," remarks Theodore Porter, "was the distinction between the constant forces of nature and perturbational forces, generated by the conscious decisions of man."[47] Quetelet moved from simple identification of these "perturbational forces" to studies of their statistical distribution. He soon discovered that they fell into regular patterns that could be plotted mathematically using the same binomial equations employed by astronomers to correct for errors in observation. He realized that deviations from "normal" human behavior—such as criminality or suicide—were distributed in the same manner as physical variations—such as height or chest size—amongst large samples of human beings. His innovation, first expressed in the influential book *Sur l'homme* of 1835, held that these regular patterns of variations, if postulated over very large numbers of individuals, pointed to the existence of an average man [homme moyen] for any specifically defined social group.[48] "It was the relationship between these average men," writes Stigler, "that was the focus of Quetelet's attention, their rates of development and their differences and similarities. The average man was a device for smoothing away the random variations of society and revealing the regularities that were to be the laws of his 'social physics.'"[49] Quetelet assumed that the

regularity of variations in human physique and social behavior within large aggregates pointed to a "persistence of causes," and he believed an ability to plot them as forms of error revealed a key homology between social and celestial science.[50] But the aspect of Quetelet's average man most relevant to our archaeology of diagrammatic knowledge is that it was a *fictional* entity constructed by mathematics from observed data. Even though most of what Quetelet claimed was subsequently disproved, his work nonetheless "succeeded in showing that nature could be counted on to obey the laws of probability."[51] Quetelet's use of probabilistic mathematics to explain phenomena was adapted by researchers in many fields: the migrations most salient to our account of the culture of diagram were those of Hermann von Helmholtz in the domain of physiology, and those of James Clerk Maxwell and Ludwig Boltzmann in atomic physics.

V

For Quetelet, the diffusion of diagrammatic models in the construction of knowledge assumed manipulating large samples with mathematical procedures able to find regularities amongst a wide range of individuals. His method systematically ignored the mechanics of individual perceptions and responses in favor of patterns leading to statements about behavior on the scale of "the human" proper to a social science. Despite the permeation of mathematics—and especially probability and error-correction—in his analytic procedures, Quetelet never broached the topic of what constitutes the human subject per se: his field of research concerned those human entities only when their social characteristics were subject to sorting and tabulation. A turning point meaningful to our account occurred when the statistical methods of Quetelet were taken over to characterize physical operations of the human organism, notably the senses. Helmholtz was an important figure in defining this direction. His research was deeply informed by the rethinking of space proposed by a somewhat older colleague, Johann Friedrich Herbart. These two men, as Timothy Lenoir has shown, moved the study of subjectivity and perception onto a new plane of functionality and physiology governed, importantly, by the same mathematical rules of probability and error-correction that guided Quetelet's social science.[52]

Questioning, much less subverting, the tradition of a stable anthropocentric view of perception means reconceptualizing the space within which human beings are located. Alberti's system placed the perceiving subject at the center of a world mapped geometrically around a vanishing point that was, not incidentally, the mirror-image of the eye's viewing point. The camera obscura model of vision, as it is sometimes called, replaced the eye with an aperture but did not disturb the geometric structure of space. In our account, competing theories of perspective in the later eighteenth century, along with Monge's system of descriptive geometry, performed the crucial task of unmooring the geometric description of space from a single point of view: space became a system of mobile grids without a center. In such a construct, where do human perceivers find a place from which to negotiate the world?

Kant argued in the *Inaugural Dissertation* of 1770 that space and time are apprehended as intuitions that provide necessary frameworks for making sense of the raw data of perceptions. He opposed Newton's view of space as an independent, self-subsistent object without relinquishing its autonomy: Kant's solution was to posit a distinct faculty of intuition for the sensible cognition of space and time. This allows human beings to generalize from sensuous experience without relying upon a materialist foundation that demands empirical confirmation of every idea. Kant's goal was to defend certain ideas—such as those produced by mathematics—from epistemological questioning. For Kant, in the words of Michael Friedman, "space and time can . . . in no way be derived from our cognition of the underlying monadic realm . . . but constitute instead the autonomous subject matter of the mathematical exact sciences." There is a fundamental disconnect in the Kantian system between representations of time and space—produced by the human mind and articulated by pure mathematics—and the material world around us which is, nonetheless, the cause of our sensations.[53] This worrisome disconnect was where Herbart began to rework Kant's notion of space.

Herbart side-stepped the Kantian problem by adopting the unorthodox assumption that space does not exist per se, but is an actively constructed "symbol of the possible community of things standing in a causal relationship."[54] Human beings are motivated to produce space from their diverse and qualitatively separate perceptions of these things.

In a passage that dramatically underscores his departure from Kant's faculty of spatial intuition, Herbart wrote:

Sensory space, to be exact, is not originally a single space. Rather the eyes, and the sense of feeling or touch *independently of one another* initiate the production of space; afterward both are melted together and further developed. We cannot warn enough against the prejudice that there exists only one space, namely phenomenal space. There *exists* no such thing as space; but there do exist motivations for generating a system of perceptions by fusing them through a network of laws of reproduction, whose perceived object is something spatial for the perceiver.[55]

Lenoir is right to say that Herbart's space is "not something real—a single container in which things are placed—but is rather a tool for symbolizing and representing various modes of interaction between the world and our senses."[56] We suggest a three-way analogy among Herbart's constructed symbolic space, the whiteness of the *Encyclopedia*'s visual arrays, and the emptiness that surrounds and interpenetrates the figures of Monge's descriptive geometry. The connective tissue linking these three is the assumption that space does not pre-exist experience, and that each of them provokes the user's powers of correlation to generate systems of meaning across and through the seemingly empty fields.

Herbart's revisions of Kant guided Helmholtz to theorize representations of the empirical world as constructed operationally through experience. What is experienced as the real is a grid of signs derived by an organism from sense data, and arrayed in patterns guided by a mathematical calculus that Herbart called sequential forms. Herbart envisioned a calculus of perception that described mathematically—in terms of intensity, quality, and quantity—the forces or vectors in a field of sensibility generated by a mobile encounter of the senses with the physical world. Herbart's theory of space, as Lenoir writes, offered Helmholtz "an exciting blueprint for a constructivist theory of sensation."[57] Herbart made it possible for Helmholtz to think of representations other than as mirrors of the phenomenal world. For Helmholtz, representations of space do not map directly onto the cortex, because the visual world only leaves a trace of forces upon the retina, not a coherent image, and sounds register nothing but the magnitudes of a varying force against the ear. Rather,

representations are objects in their own right that must be correlated with physical objects in time and space—a process that constitutes effective interaction with the world around us. Within Herbart's space of functionality and experience, Helmholtz erected a model of the observer predicated upon a continuum of sensibility that links the human organism to the instruments of science.

Helmholtz consistently dismissed Kant's intuitive apprehension of space as arising from the earlier philosopher's historical circumstances. In an address of August 1878 before the Berlin University, he looked back on Kant from the perspective of experimental empiricism.[58] "In his contention that spatial relations which contradict Euclid's axioms cannot even be conceived," observed Helmholtz, "Kant was influenced by the state of development of mathematics and sensory physiology prevailing at that time." Helmholtz remarks that "the concept of spatial structures which cannot correspond to ordinary perception, can be developed reliably only by analytical geometry," and he cites both Gauss and Riemann as exemplars of what he called "meta-mathematical" investigations. At about the same time, Helmholtz published a rebuttal to Jan Pieter Nicolaas Land, who took issue with the way Helmholtz treated Kant in a lecture of 1870, "On the Origin and Significance of Geometrical Axioms."[59] Helmholtz's rebuttal is two-fold. He again cites, contrary to Kant, "meta-mathematical" investigations that have shown one can, in fact, conceive of non-Euclidean spatial relations. Always the good empiricist, Helmholtz argues that one ought to be able to correlate by experience the magnitudes of space given by transcendental intuition with magnitudes measured by experiment in the physical world. The catch, as he was eager to point out, is that we can only evaluate experience of the physical world, and this ultimately defines the limits of what we know. Even if the spatial magnitudes culled from experience could be compared in some way to those given by intuition, we would still be justified in discounting the latter as "a deceptive appearance."

Nonetheless, Helmholtz walks a fine line between experience and transcendence, between his hard-core empiricism and the idealism of a Kant or Schopenhauer. Premising what he called the Causal Law is crucial to his project, for it ensures "that the concepts occurring within us having the character of perception occur according to strict laws, so that

when different perceptions suggest themselves to us, we are justified in concluding from this a difference of the actual conditions under which they were formed."[60] Never mind that we cannot know these conditions, nor anything about "the truly real" that produces variations in perceptions. Adopting a strict lawfulness rationalizes his attention to the infinite variations of perceptual response that can be measured by instruments. Helmholtz smoothed over the seeming paradox of his position with a theory of perception built on a concept of signs:

Our sensations are only effects which are produced by external agents upon our organs, and the way in which such an effect is manifested, of course, depends essentially on the nature of the apparatus which is affected. As far as the quality of our perception gives us information about the characteristic nature of the external source of stimulation, it can be regarded as a symbol, but not as an image of this source. For an image some kind of identity with the portrayed object is demanded. . . . A symbol, however, does not have to possess any kind of similarity with the object it represents: the relation between them is confined to the fact that the same object, acting under the same circumstances, will produce the same symbol; and that unlike symbols thus always correspond to unlike influences.[61]

Several profound implications are embedded in Helmholtz's sign theory of perception and concomitant Causal Law. Although perceptual data are decoupled from essential truths about objects in the world, this does not preclude our learning about the world. Changes in percepts signal changes in the world. Human organs are apparatuses that register the flux and variation of stimuli according to the parameters of their specialized design, and report those variations in measurable patterns that constitute the symbols of perception.[62]

For Helmholtz, the perceiving body receives no direct image of a three-dimensional spatial container, but explores the existence of solid bodies "by comparing the image in the two eyes, or by moving the body with respect to the hand."[63] First must come the idea of a solid body, after which one extrapolates an idea of the space it requires, especially in the company of similar bodies. His theory of perception is anchored by a notion of concept [Begriff] "which grasps and includes an infinite number of single, successive apperceptions, that can all be deduced from it."

Sometimes he refers to these psychic acts as "unconscious judgments" or "unconscious conclusions from analogy"—terms that his critics did not accept universally.[64] Precisely because "they are not free acts of conscious thought," Helmholtz believed "these unconscious conclusions from analogy are irresistible." Perception was tantamount to facing a field of spatial incertitude—and a flux of discrete data elements—with the task of making sense. An analogy would be the whiteness of visual arrays deployed in the plates of the *Encyclopedia*. In our account, Helmholtz's theory of perception, which links subjects to their environment in an unfolding process of making correlations across and through an uncharted field of presentation, must be called diagrammatic.

For empiricists like Helmholtz, a study of the world around us begins with the evidence most at hand: close attention to the body's physiological response to stimulation. Therein lies the motor energy of his entire research program. Helmholtz pushed hard the idea that the sensory equipment of human beings should be treated as instruments and studied for their deficiencies as well as their perfections. Like many of his contemporaries, Helmholtz compared the human eye to a camera obscura, not to champion its superior qualities but to argue that it is, in fact, a rather poor instrument.

We have now seen that the eye in itself is not by any means so complete an optical instrument as it first appears: its extraordinary value depends upon the way in which we use it: its perfection is practical, not absolute, consisting not in the avoidance of every error, but in the fact that all its defects do not prevent its rendering us the most important and varied services.[65]

If a camera obscura were to be designed with all the optical imperfections of the eye, it would produce very poor images.[66] How does the eye avoid this? By constant movements that provoke a staccato-like stream of perceptual moments that are continuously checked and corrected when constructing the flux of experience.[67] Importantly for Helmholtz, what distinguishes the eye from any similar instrument—even those optically superior—is the "rapidity with which we can turn the eye to one point after another of the field of vision, and it is this rapidity of movement which really constitutes the chief advantage of the eye over other optical instruments."[68] It is no wonder that Helmholtz and his assistants

(notably Wilhelm Wundt) spent considerable time and energy studying eye movements. What did they find?

The long chapter of Helmholtz's *Treatise on Physiological Optics* devoted to eye movements provides the most pertinent thumbnail history of the research with which Helmholtz was working at the time.[69] He sketches the experiments of a whole group of researchers, including Franciscus Cornelis Donders, Ludwig Fick, Georg Meissner, Wilhelm Wundt, Alfred Wilhelm Volkmann, Christian Georg Ruete, and Johann Benedict Listing. All were devising strategies to measure the angles of eyeball rotation set in motion when subjects scan the visual field. Three axes were identified: horizontal or frontal, vertical, and sagittal along the line of sight.[70] The detailed tabulations of data from these experiments need not figure here, except to note that Helmholtz and his colleagues depended upon them absolutely when placing their confidence in two laws related to eye movements. They are Donders' Law for the angle of torsion when the lines of attention are parallel and Listing's Law for the angle of torsion when the line of attention is moved from its position of rest to any other position. What concerns us is how these two laws were both verified and explained by Helmholtz mathematically.

Helmholtz's attention to eye movements marches in step with his likening of the human sensory nerves to instruments, each attuned to register specific sensations that fall into the five groups commonly referred to as the senses. Thus rays of the sun may be perceived as light by the optic nerve or heat by the nerves of the skin, since the quality of the sensation is

in no way identical with the quality of the object by which it is aroused. Physically, it is merely an effect of the external quality on a particular nervous apparatus. The quality of the sensation is, so to speak, merely a symbol for our imagination, a sort of earmark of objective quality.[71]

Further investigations of retinal sensitivity, in particular the production of positive and negative after-images, made it clear that the eye responds quickly to primary light but if the stimulation continues its sensitivity to new stimuli is reduced. "That stimulation leaves behind a condition of lowered stimulation for stimuli," writes Helmholtz, "is something that takes place also in the motor nerves and in other sensory nerves. Such a condition is called fatigue."[72] Study of the respective

thresholds of sensory nerve fatigue remained a major theme of Helmholtz's research.

Many of Helmholtz's experiments explored both the limits and the productive capacities of vision. He was especially interested in retinal after-images. He remarks that if an experimenter wants to obtain "really beautiful positive after-images" care must be taken not to move either the eye or the body since doing so causes the effects to vanish. Awareness of the disruptive effects of movement when trying to maximize after-images, along with experiments using rotating disks of discontinuous colors that are perceived as continuous by the eye, led Helmholtz to posit the importance of movement to the operation of vision. He later extended that insight to the operation of all sensory nerves:

I will now return to a discussion of the primary, fundamental facts concerning our perception. As we have seen, we have not only changing sensory impressions which occur without any action on our part, but we also make observations during our own constant activity, and thereby we arrive at the knowledge that a lawful relation exists between our innervations and the appearance of different impressions from the range of existing presentabilia. Each voluntary movement by which we change the appearance of objects must be regarded as an experiment, by which we test whether we have correctly interpreted the lawful behavior of the phenomenon in question, i.e. its postulated existence in a definite spatial arrangement.[73]

Helmholtz returns repeatedly to this model of bodily experiments by which we test our sensations.[74] He was especially keen to understand how the eyes—physically rather poor optical instruments—were able to produce precise and extensive information about our surroundings.

Following the general line of reasoning sketched above, Helmholtz came to view each and every eye movement as an experiment yielding "a constant system of changes of sensation in the fibres of the optic nerve."[75] Yet rotations of the eyeball in the course of these movements would result, as numerous experiments showed, in a series of misapprehensions within the visual field. How to explain this paradox: movements that facilitate retinal apprehension also yield optical distortions? Helmholtz's insight was to adopt procedures for handling variations in data from other scientific fields. His premise was that our eyes are designed to minimize errors. Since

"such rolling motions of the eyes as are responsible for misapprehensions of this sort cannot be entirely avoided in an extensive field," he writes, "all that can be demanded is that . . . these particular movements shall be such that the sum of all errors of orientation due to rollings of the eye shall be as small as possible." He concludes this important passage with the general law: "the sum of the squares of these errors, for all infinitesimal movements of the eye, shall be a minimum. The reason for taking the squares of the errors here is the same as that in estimating the errors by the method of least squares."[76] By this route we arrive at an extremely important moment in our story, for Helmholtz argues that the practice of human perception operates under the same law of probabilities that guided Adams and Le Verrier to pinpoint the location of Neptune, and justified Quetelet's construction of the average man from reams of statistical data. With the work of Helmholtz and his colleagues, the human body becomes part of a continuum of technical sensing devices that collect great quantities of data, and process them with the mathematical probabilities of error-correction.[77] At this historical juncture, it becomes conceptually possible to imagine a surgeon, connected to a patient via computers and a battery of sensors, about to embark on a delicate eye surgery.

VI

We are tracking the convergence of a mathematical procedure across several disciplines at a particular moment in the history of nineteenth-century science. Borrowing from astronomers, who first used the method of least squares to correlate and correct a large number of sightings taken from different geographical positions, Quetelet developed tools for organizing large sets of social statistics. Similarly, Helmholtz analyzed the seemingly continuous flux of perceptual data presented to human organisms by dividing it into infinitely small parts defined and governed by muscular movements. He theorized that probabilities described by a binomial curve also govern our physiological responses to stimuli—a hard-wired, involuntary drive to minimize perceptual errors. Where Quetelet focused on aggregate social behavior, Helmholtz discovered error-correction in the very nerve endings of our bodies.

At about the same time, a young Scottish physicist named James Clerk Maxwell recognized in Quetelet's work a prospect for rejuvenating

physics. Although the specific impact of Quetelet on Maxwell is debatable, we know that he read in 1850 an extensive review of Quetelet's work by John Herschel.[78] Maxwell later became personally familiar with Quetelet's method. Writing in 1850, he remarked:

The true Logic for this world is the Calculus of Probabilities, which takes account of the magnitude of the probability (which is, or which ought to be in a reasonable man's mind). This branch of Math, which is generally thought to favour gambling, dicing, and wagering, and therefore highly immoral, is the only 'Mathematics for Practical Men,' as we ought to be.[79]

Maxwell proved the worth of this method in his prize-winning essay on Saturn's rings, first elaborated in 1857 and published in 1859. He treated the rings as a collection of individual particles circling the planet: since it was impossible to track the motion of every single particle, he derived a statistical description of particle clusters that explained the coherence and rotation of the rings.[80] Although Maxwell's solution employed statistical analysis, his explanation of many elements moving as one remained within the paradigm of Newtonian mechanics.

Maxwell quickly intuited that the same statistical method could be applied to substances comprising very large numbers of discrete components—notably gas molecules. In 1859, when the paper on Saturn appeared, Maxwell wrote to George Gabriel Stokes with a working hypothesis about the behavior of gases. He took as a central assumption that, "my particles have not all the same velocity but the velocities are distributed according to the same formula as the errors are distributed in the theory of least squares."[81] This first attempt at a theory of gases encountered criticisms. Maxwell worked to refine his thinking throughout the 1860s, a time that included years of empirical experiments. These confirmed his calculations on the independence of viscosity and density in gases and dramatically changed his assumptions about molecules.[82] Maxwell's practical research culminated in a major statement, "On the Dynamical Theory of Gases," delivered to the Royal Society of London in 1866. He reconsidered and fundamentally reconceived the nature of molecules as no longer "elastic spheres of definite radius, but as small bodies or groups of smaller molecules repelling one another" with a force "whose magnitude is represented very nearly by some function

of the distance of the centers of gravity." The important shift is that the exact physical character of molecules now becomes irrelevant because, in Maxwell's analysis, they are statistical facts "acting as centres of force." Their actual being may resemble "mere points," a cluster of several such centers bound together, or "if necessary, we may suppose them to be small bodies of a determinate form."[83] At the same time, a paradigmatic tension in Maxwell's epistemology treats these purely statistical entities mechanistically, as if they were bodies in a Newtonian framework.

Maxwell underscored the tension deep in his structure of thinking in the "Introductory Lecture on Experimental Physics," with which he began his chair at Cambridge.

In applying dynamical principles to the motion of immense numbers of atoms, the limitation of our faculties forces us to abandon the attempt to express the exact history of each atom, and to be content with estimating the average condition of a group of atoms large enough to be visible. This method of dealing with groups of atoms, which I may call the statistical method, and which in the present state of our knowledge is the only available method of studying the properties of real bodies, involves an abandonment of strict dynamical principles, and an adoption of the mathematical methods belonging to the theory of probability.[84]

For Maxwell, "dynamical principles" would be able to trace the paths of each and every atom mechanistically, according to Newton's laws of motion. The dynamical principle falters when confronting an overwhelming number of atoms. Maxwell grounds his recourse to statistics in the "limitation of our faculties," a line of reasoning that mirrors Laplace's own much earlier view that the use of probability extends the limits of human capacity. For both men, probability supported an overarching mechanistic view of matter.[85]

The tension in the Cambridge lecture occurs at the border between Maxwell's commitment to experimental evidence and his recourse to statistical analysis. The parable now known as Maxwell's Daemon is a thought experiment designed to illustrate this tension as a consequence of the limits on human understanding invoked at Cambridge. The problem, as he explained to Peter Guthrie Tait, is that humans are not "clever enough."[86] Maxwell imagined a being possessed of infinitely vast perceptions, instantaneous reactions, and a crucial thermodynamic neutrality.

It would be able to deal with molecules one by one without expending any energy. Such a creature would not need statistics because it could account for every particle at every instant. The daemon's assigned task in Maxwell's parable was to monitor the movement of molecules between two vessels separated by an infinitely thin membrane. Maxwell assumes the contents of each vessel to be at the same pressure and temperature.

According to the second law of thermodynamics such a system would remain at equilibrium unless external energy is applied in the form of work: in this state, the system is said to be at maximum entropy. Maxwell's daemon recognizes molecules moving toward the membrane from either direction, and opens a magic hole allowing them to pass. Hypothetically, the daemon could over time concentrate all the molecules moving more quickly than the average on one side and all of those moving less quickly on the other. Since one side would be at a higher energy level than the other, the system would now be able to produce work, thus violating the second law of thermodynamics. Entropy in this case would be reduced, yet the total energy has not changed. Maxwell's point was that the second law is "undoubtedly true as long as we can deal with bodies in one mass, and have no power of perceiving or handling the separate molecules of which they are made up."[87] In other words, the law is not a dynamical principle concerned with the movement of individual molecules but a statistical law that holds only when the components are treated as masses. Maxwell even wrote a parodic catechism asserting that the daemon's "end" was to "show that the second law of thermodynamics has only a statistical certainty."[88] Statistics makes it possible to treat a container of molecules as a single mass, which is the best that normal human beings can hope to do. There is an extremely small chance that nature could replicate spontaneously the daemon's actions, but Maxwell was willing to write this off as impossible.

Ludwig Boltzmann had followed Maxwell's research since 1859. He was especially impressed by the 1867 publication of "The Dynamical Theory of Gases" and Maxwell's modeling of molecules as mass points interacting at a distance rather than as static centers of force. Molecules so conceived continuously jostle one another to produce shifts in velocity, deflections of trajectory, and alterations of spin. Maxwell's paper produced a kinetic theory of gases that led to a set of new problems about mathematical descriptions for a range of molecular activity—from direct

collisions and slight deflections to variations in speed and rotation. The mathematical study of viscosity and heat transfer now became possible, along with an understanding of these properties relative to temperature and pressure. In the course of his 1867 paper, Maxwell offered the first mathematically precise analyses of these so-called transport properties of gas molecules, thus opening the door to a more general and rigorous analysis of particle motion. This dimension of Maxwell's study especially attracted Boltzmann. He published a paper in 1868, using established data on the change of air pressure relative to altitude, that proved the general case of Maxwell's formula for the distribution of velocities among particles. It has since been known as the Maxwell-Boltzmann distribution.[89]

In 1872 Boltzmann read a decisive paper before the Vienna Academy in which he argued for the use of ratios and averages in kinetic theory. Given the need to account for very large numbers of incidents, Boltzmann, like Maxwell, looked to Quetelet's apparent ability to handle large bodies of data using statistical tools.[90] Boltzmann's reasoning was very close in kind to Maxwell's own:

Nothing ever becomes perceptible to us except as averages. The regularity of these mean values may be compared to the astonishing constancy of the average numbers furnished by statistics. . . . The determination of averages is the task of the calculus of probability. . . . It would be a mistake, however, to believe that the theory of heat involves uncertainty because the principles of probability come into application there. An incompletely proven proposition, whose correctness is for that reason problematical, is not to be confused with completely proven propositions of probability.[91]

Boltzmann's distinction between an "incompletely proven proposition" and "completely proven propositions of probability" reiterates exactly Maxwell's stand on the second law of thermodynamics: it can be considered a "law" because it has proven to be statistically certain. Uniting both men is their acceptance of statistically defined terms as entities susceptible to further manipulation, even though they cannot be physically indexed. Like Quetelet's average man, such terms are mathematically derived working objects.

Boltzmann's ambition in the 1872 publication was "an extension of the statistical treatment to irreversible phenomena."[92] Here Boltzmann

parts company with Maxwell, whose response to the question of reversibility—how a closed system might reduce entropy—was to invent the daemon. Boltzmann wanted to compute the probability of such an event. His 1872 paper culminated in what is now called the H-Theorem, a formula that yields a "numerical quantity defined in terms of the velocity distribution of the atoms, whatever form that might take." Boltzmann insightfully recognized that his formula for H, although framed with the language of statistics, predicted an irreversible increase in entropy despite an infinite number of molecular collisions. In fact, his theorem implied that the random collision of particles in a system would gradually reduce the *distribution* of velocities to a minimum, signaling a state of equilibrium or maximum entropy.[93]

Maxwell immediately noted a troubling implication of Boltzmann's formulation: if the motion of particles was by itself sufficient to move a system towards entropy, a statistical possibility must exist for some of these motions to produce an increase in energy along the lines of his infamous daemon. Even if the random velocity of particles tends toward a mean distribution, one should not conclude that all of them are tending toward the mean. Yet Boltzmann's equation seemed to imply just this possibility. Boltzmann's first response was to backtrack slightly. He admitted that entropy might decrease in some very specialized cases when particles fell into what he called special arrangements. This tack necessarily undermined his theorem's claim to generality. To resolve the dilemma, Boltzmann reformulated his theory over the next several years by relying more heavily on probability than mechanics.[94] Boltzmann begins to value correlations inferred by probability—from situations defined and described by the equations of mathematical practice—over those promoted by a visual schematic or spatial representation. Despite his professed disdain for philosophical systems, Boltzmann's bold embrace of a cognitive space accessible neither to experience nor to direct intuition was possible only in the wake of Herbart's critique of Kant.[95] Thus, the shift in his thinking from bodies in space to fields of force in time signals an important development in our story about the role of mathematics in the culture of diagram. With Boltzmann, mathematics takes center stage as the language of diagrammatic correlation.

It is no surprise that Maxwell correctly identified the flaw in Boltzmann's theory, for his own use of probabilities straddled the same gap

between the ideal world of theory and the real world of experiment. In fact, the more familiar Maxwell became with Boltzmann's work, the less he understood it. "By the study of Boltzmann I have been unable to understand him," wrote Maxwell to Tait in 1873. "He could not understand me on account of my shortness, and his length was and is an equal stumbling block to me."[96] More was at stake than prose style, for Boltzmann was gradually abandoning a mechanistic theory of particles in motion to embrace a concept of energy states in time. The H-Theorem evaluates the energy state of a gas at a given instant. At the next moment, as particles collide with one another, a different energy state is produced. This process, occurring constantly at the level of microscopic particles, generates a continuous but infinitesimal energy flux.

How might Boltzmann manage the infinite number of permutations required by even a finite number of particles? He imaginatively divided the total energy state of the gas into a collection of "cells."[97] He presumed each cell to contain the same finite amount of energy, although the actual number of particles producing that energy level will vary from cell to cell depending on the density and velocities of the particles it contains. From one instant to the next, particles might jump from cell to cell, altering their distribution of particles and the state of the gas. Yet the overall number of particles and total energy of the gas do not change. Physical characteristics remain constant but energy states constantly fluctuate. According to Boltzmann's definition, to specify the state of the gas at any instant would mean listing the number of particles in each cell. Counting them was not possible. Boltzmann proposed the radical idea that calculating the probable distribution of particles among energy cells constitutes a *description* of the total energy of the gas. His findings were published in 1877.

Boltzmann's research program led him to conclude that the most probable disposition of particles was an equilibrium specified by the Maxwell-Boltzmann distribution. The implications of this move were profound. Boltzmann could now say that thermal equilibrium (maximum entropy) was simply the most *probable* way for a fixed number of particles to share a fixed amount of energy. He could also write an equation for the entropy of any distribution of particles ($S = k \log W$). The formula, which adorns his tombstone in Vienna, is variously called Boltzmann's law or principle. It was essentially a restatement of the H-Theorem on entirely

new grounds. Where the early formulation was anchored in a world of finite particles and eternal collisions, the new work proceeds from an imagined universe of possible states and arrangements of particles existing nowhere but the mind. Boltzmann's law, and his concept of energy cells, later became the foundation upon which Max Planck erected his theory of quanta.

Boltzmann's use of probability shifted the description of molecules from observation to an arena of abstract correlations navigated by mathematical equations. The implications of his method for experimental science resonated widely, and many of Europe's leading physicists greeted his findings with scepticism. "You substitute mathematics for thought and thus betray healthy empirical research," is how Tait confronted Boltzmann in a sharp rebuttal written in 1886; "instead of using mathematics as an aid to thought in the investigation of reality, you turn the physical sciences into an empty play of abstract symbols and hide thoughts behind a barrier of 'terrific arrays of signs.'"[98] Tait was a close collaborator of Lord Kelvin, and seems to have been urged by the latter—that is, by the most influential physicist of the day—to launch a series of pointed attacks on the theories and methods of Boltzmann.[99]

Why was Boltzmann's work perceived as a threat to the status quo? The short answer, as Enrico Bellone has suggested, is that Boltzmann

does not seem to accept the constraints directly imposed by nature, and appears as an attempt to substitute for empirical research the insane pretension to deduce natural laws a priori, using assumptions that are not nearly coincident with observation, as well as formal methods that are quite far from being practically sufficient.[100]

The long answer, which we cannot explore in depth, is that Kelvin and Tait were committed Newtonians who believed "the naturalist may be content to know matter as that which can be perceived by the senses, or as that which can be acted upon by, or can exert, force."[101] Kelvin had laid the foundations for modern thermodynamics in 1851 by arguing for a dynamic theory of heat.[102] But Kelvin's insistence on the priority of material experiment presented him with a thorny problem. He accepted the first law of thermodynamics that posits the conservation of energy. He also realized that experiments tended to support Sadi Carnot's proposition

that work is derived from heat only when the temperature is allowed to fall from a higher to a lower level—perpetual motion machines are not physically possible.[103] As early as 1852 Kelvin drew the inevitable and pessimistic conclusion:

There is at present in the material world a universal tendency to the dissipation of mechanical energy. . . . Within a finite period of time past, the earth must have been, and within a finite period of time to come the earth must again be, unfit for the habitation of man, as at present constituted, unless operations have been, or are to be performed, which are impossible under the laws to which the known operations going on at present in the material world are subject.[104]

Kelvin was forced to accept a cyclic view of the world that ends with entropy, as predicted by the second law of thermodynamics: any reversible change occurring in an isolated system leaves unchanged the value of the total entropy of the system, and any irreversible change causes an increase in the total entropy.[105] Maxwell's daemon proposed a fantastical way out of this dilemma, but in real life changes appear to be only irreversible. The world seems doomed to run out of usable heat.[106]

Boltzmann realized that entropy presented a paradox more than an ultimatum: although the flow of heat depends upon the direction of time (entropy seems to be a non-reversible state in which heat flows from warm to cool bodies), the laws of mechanics governing molecular movements are not so constrained: perfectly reversible elastic collisions among particles can be imagined. Boltzmann's answer to the energy riddle involved showing that the molecular velocities in a body, because one is dealing with large numbers of particles, tend to be distributed according to the laws of probability. "If now in a system of bodies there is a given amount of energy," he wrote in 1886, "the latter will not arbitrarily transform itself now in one now in another manner, but it will always go from a less to a more probable form; if the initial distribution amongst the bodies did not correspond to the laws of probability, it will tend increasingly to become so."[107] Which means that what Kelvin called "degraded" forms of energy characteristic of the entropic state are, in Boltzmann's account, "none but the most probable forms" and the second law of thermodynamics relates nothing more serious than the tendency of a system of molecular velocities to approach its most probable state.

The importance of Boltzmann's conjunction of probability with entropy cannot be overestimated, because it allowed him to suggest that simply because no one has observed any instances of spontaneous entropy reduction does not mean that it is impossible—only highly improbable—given the extreme complexity of the natural system in which we live. If the second law of thermodynamics is taken to be an expression of probability and not, as Kelvin believed, a physical law of absolute validity, one can legitimately posit the existence of events that might never (or not yet) be observed. "Assuming the universe great enough," wrote Boltzmann in 1895,

the probability that such a small part of it as our world should be in its present state, is no longer small. If this assumption were correct, our world would return more and more to thermal equilibrium; but because the whole universe is so great, it might be probable that at some future date some other world might deviate as far from thermal equilibrium as our world does at present.[108]

Boltzmann's challenge to Kelvin was to claim for mathematics a cognitive value, even if never verifiable by practical experience.

These specialized scientific disagreements spilled over into philosophical debates in the writings of Ernst Mach, who countered Boltzmann with a sensationalist view that refused to recognize statistical particles as anything but imaginary concepts since they could not be perceived. Mach upheld the positivist notion that our ideas about nature must proceed from experience, and he refused to accept that Boltzmann's correlations had anything to do with the real world.[109] Mach understood fully that Boltzmann's position implied the death knell of Locke's clear and distinct ideas. Knowledge for Boltzmann did not necessarily originate with sensations. He could point to the discovery of Neptune as an example where calculations successfully predicted the presence of an unobserved object. Boltzmann also cited contemporary examples of engineering, such as "the gigantic structures of the Brooklyn Bridge that stretches beyond sight and the Eiffel tower that soars without end rest not only on the solid framework of wrought iron, but on the solider one of elastic theory."[110] The reference to Eiffel's tower was especially timely in 1890, but Boltzmann was also right to emphasize that Eiffel and his engineers had calculated the feasibility of building the tower—its weight, static

forces, and the effects of wind—well in advance of beginning any actual work.[111] The Paris tower was an everyday example of theory guiding practice, an instance no less radical than what Boltzmann proposed for the study of thermodynamics.

VII

Boltzmann's work was hotly debated at the time of his first presentations, even if it lost prestige by the 1890s amidst continuing controversy over the very principle of atomism. However, by the early decades of the twentieth century he was acknowledged as a pioneer in the statistical analysis of mechanical phenomena. Boltzmann's expansive use of mathematics was of seminal importance to the development of quantum physics.[112] Shortly after 1900, Max Planck transferred Boltzmann's probability theorem for thermodynamic entropy to studying the thermal radiation of energy.[113] Although Planck eventually adopted statistically defined cells analogous to those the older physicist had employed when studying gases, his relationship to Boltzmann was complex. Planck sharply criticized, for example, Boltzmann's underlying assumption that transformations in nature always tend to move from the least probable state to the most probable—that is, toward equilibrium. In a letter of 1897 to a friend, Planck admitted that "probability calculus can serve, if nothing is known in advance, to determine the most probable state." However, probability was useless for computing any specific state on the trajectory to equilibrium, since those states are "determined not by probability but by mechanics."[114] Planck was attempting at this stage to produce a direct proof of irreversibility without recourse to the statistical method or special assumptions employed by Maxwell and Boltzmann. He remained committed to a mechanistic vision of physics built on the presumed continuity of energy and matter.

Planck's papers before the mid-1890s concerned an issue related to Boltzmann's domain of thermodynamics—the so-called black-body problem. The question was this: why does heat energy, when applied to a material such as iron, cause it first to radiate infra-red radiation, then gradually glow red, and eventually generate the full spectrum of white light? What is the relationship between the frequency of radiation emitted and the temperature or amount of energy applied to the

system? Mechanical theories developed by Maxwell and Wilhelm Wien had offered close approximations to experimental results within a narrow spectrum of wave lengths. Planck had been working within Wien's experimental framework for several years. Thomas Kuhn remarks that Planck would have had a perfectly respectable legacy had he remained within the world of Wien. By 1900, however, improved instruments for detecting long-wave radiation could demonstrate that predicted distributions were off by as much as fifty percent.[115] Here Planck's research trajectory intersects with the legacy of Helmholtz's insight that human perception operates with the protocols of instruments. New devices, designed and built to measure the energy of waves above the visible spectrum, yielded results that were almost never challenged as viable perceptions. In response to these new findings, Planck plunged into the problem of reconciling a theory of electromagnetic energy, made apparent by new instruments, with the established laws of conservation and equilibrium.

His first efforts posited fictive "resonators" to calibrate his equations with the new experimental observations. Planck describes the operation of these frictionless, resistance-free devices:

Any such resonator is excited by absorbing energy from the vibration which falls upon it and is damped by radiating energy. The radiated energy is, however, generally not of the same sort as the absorbed, so that the vibrations of the resonator alter the character of the electromagnetic waves propagated in its vicinity.[116]

At this stage of his thinking, these fictive devices were required to hinge together Planck's world. They were no less imaginative or fantastic than Maxwell's daemon, but had the advantage of being mathematically describable. Planck's resonators existed as thoughts and on paper but could not be indexed in the material world.

Kuhn describes how Planck gradually shifted the basis of his analysis from a strict mechanics to a probabilistic formulation closely related to Boltzmann's H-Theorem. For his model of electromagnetic radiation, Planck returned to features of Boltzmann's 1877 paper that had remained somewhat idiosyncratic—notably, the use of probability calculus and a combinatorial definition of entropy. Planck correctly understood

that Boltzmann had turned to probability calculus to avoid the seeming paradox of entropy. The peculiar twist in Planck's recourse to probability was that he wanted to invest his law "with a real physical meaning and that issue led me of itself to the consideration of the relationship between entropy and probability, and thus to Boltzmann's line of thought."[117] Emulating Boltzmann's tactic of imagining "cells" of equivalent energy, Planck divided the continuum of radiant energy into packets, but with an important difference: where Boltzmann allowed the number of cells to vary with the square of molecular energy, Planck stipulated their number as finite and proportional to wave frequency.

Planck realized that if energy cells relate to wave frequency in a linear manner, then cell size must be constant.[118] There no was apparent reason to believe that this relation should be linear. Nonetheless, Planck was predisposed to accept linearity by his own work of 1899 in which he attempted to prove theoretically Wien's distribution of radiant energy in a black-body chamber. Planck proposed two natural constants similar to the speed of light and gravitational force. Taken together "they permit," in the words of Kuhn, "the first definition of a set of units of mass, space, time, and temperature that share their absolute character." If Planck's recourse to a radiant energy constant proceeded logically from his prior work, it was seconded by the latest experimental data from a new black-body apparatus put in service at Charlottenburg in the laboratories of Otto Lummer and Ernst Pringsheim.[119]

Planck worked intensely between 1901 and 1906 on several elaborations of a general formula for radiation distribution. Gradually, he adopted a method that paralleled Boltzmann's approach to thermodynamics, even relying on many of Boltzmann's descriptive terms and complex integrals. Assuming resonators in a state of equilibrium (maximum entropy), and making fulfillment of Wien's distribution law a precondition for his derivation, Planck concluded that total equilibrium is possible only if the size of energy cell ε is proportional to frequency. Planck's decisive precondition became $\varepsilon = h\upsilon$ where h is the now famous "Planck's constant." This derived formula also justifies, in retrospect, his definition of the energy cells as finite in number and equal in size. Kuhn remarks that there was much ad hoc in Planck's proof: "Accuracy was not . . . what made the new consequences of Planck's theory especially impressive. Rather, it was

that, in this area, he had obtained any results at all. Planck had produced a concrete quantitative link between electromagnetic theory, on the one hand, and the properties of electrons and atoms on the other."[120] The central point is that his solution, with its damped resonators absorbing and reemitting energy, remained inscribed within classical models of a mechanical universe.

Planck's original paper of 1901 immediately provoked a flurry of peripheral research, both experimental and theoretical. Mathematicians tried without success to prove Planck's theory without his precondition $\varepsilon = h\upsilon$. Nor were they able to derive ε from strictly classical principles. As late as 1906, Planck remained attached to the analogies between his theory and that of Boltzmann on gases, and to the classical mechanics of both. Nonetheless, he recognized that stipulating the special relation $\varepsilon = h\upsilon$

marks an essential difference from the expression of entropy for a gas. . . . The thermodynamics of radiation will therefore not be brought to an entirely satisfactory conclusion until the full and universal significance of the constant h is understood. I should like to label it the "quantum of action" or the "element of action."[121]

Kuhn views these words as marking an important shift. The constant has become in Planck's thought a "quantum" that threatens "a break with classical physics far more radical than I had initially dreamt of." Planck was responding to questions about the underlying structure of his system. In a letter of July 1905 to the physicist Paul Ehrenfest, he admitted that "resonator theory (including the hypothesis of natural radiation) does not suffice to derive the law of energy distribution in the spectrum, and the introduction of a *finite* energy quantum $\varepsilon = h\upsilon$ is an additional hypothesis, foreign to resonator theory itself."[122] Eventually, in June 1906, Ehrenfest published a paper that concluded with the startling view that Planck's theory holds if an additional constraint is placed on the value of ε, restricting it to integral multiples of the quantum $h\upsilon$. The complex relationships between damped resonators and the energy field with which Planck had struggled could be dispensed with entirely, but only if one gives up the principle of continuity, the foundational idea of classical mechanics, and embraces a world of

discontinuous quanta. Mathematics had charted the path to this historic fork in the road with the same precision and inevitability that earlier had guided astronomers to find the planet Neptune in 1846. Now, however, the entire cosmology of Newton's celestial machine was being called into question.

Writing in 1925, Niels Bohr opened a short overview of quantum theory by acknowledging that the entropy law of Boltzmann, "derived from the statistical behavior of a large number of mechanical systems," was of great interest because "statistical considerations have permitted the description not only of the average behavior of atoms, but also of the fluctuation phenomena, which have led by the investigation of Brownian motion to the unexpected possibility of counting atoms."[123] Between Boltzmann and Bohr the study of physics had crossed a monumental threshold: the concept that atoms are the single smallest entities had given way to the idea that they are composed of separate particle elements—a nucleus surrounded by a number of electrons—and a pattern of behavior that could not be explained by the laws of classical mechanics. The first tendency was to imagine atomic structure as an ultra-miniaturized solar system in which electrons circle the nucleus just as earth orbits the sun. This was the model promulgated by Ernest Rutherford in 1911. Bohr, one of Rutherford's young collaborators, realized that the solar system model of the atom must be stable, neither emitting nor absorbing energy. He applied Planck's idea of energy quanta to propose a model in which electrons shift orbits by discontinuous jumps. A decrease in energy emits a quantum of light as the electron moves to a lower orbit. An energy increase absorbs a quantum of light and the electron moves to a higher orbit. Bohr's revolutionary model maintained the seemingly natural stability of a planetary atomic structure and accorded with experimental results on the spectrum of light emitted by atomic hydrogen. He was awarded the Nobel Prize in 1919.[124]

Bohr remarks that "in the general problem of the quantum theory, one is faced not with a modification of the mechanical and electrodynamical theories describable in terms of the usual physical concepts, but with an essential failure of the pictures in time and space on which the description of natural phenomena has hitherto been based."[125] Attempts to imagine extremely small particles in a correspondingly small

space challenge the basic premises of a theatrical model of visual representation—a model that is mechanical by nature for its assumption that objects are situated in a space. Further research on the behavior of light spectra eventually forced experimental physicists of Bohr's generation "to assume the presence of a mechanically indescribable 'strain' in the interaction of electrons which prevents a unique assignment of quantum indices on the basis of mechanical pictures." For physicists, Bohr concludes in his 1925 essay, "it will at first seem deplorable that in atomic problems we have apparently met with such a limitation of our usual means of visualization. This regret will, however, have to give way to thankfulness that mathematics in this field, too, presents us with the tools to prepare the way for further progress." In contrast to Tait's 1886 rebuke of Boltzmann that pitched mathematics against empirical research, Bohr welcomed mathematics as a powerful tool in the repertory of physical science. He openly accepts that mathematics permits correlations in physics beyond the human sensorium, and that this development is essential to further progress. For Bohr, mathematics does not hide the world behind Tait's "empty play of abstract symbols," but explores its most profound workings. Bohr's commentary reveals that mathematical reasoning had solidly established its credentials as an avenue to physical truth.[126]

Two years later, in 1927, amidst a series of fast-breaking developments in theoretical physics, Bohr suggests that observation is itself a construct contingent upon what one wants to see:

If, in order to make observation possible, we permit certain interactions with suitable agencies of measurement, not belonging to the system, an unambiguous definition of the state of the system is no longer possible, and there can be no question of causality in the ordinary sense of the word. The very nature of quantum theory thus forces us to regard the space-time co-ordination and the claim of causality, the union of which characterizes the classical theories, as complementary but exclusive features of the description, symbolizing the idealization of observation and definition respectively.[127]

Bohr's point of departure in this essay was that "the concept of observation is in so far arbitrary as it depends upon which objects are included in the system to be observed." His position emerges from the systemic

view of observation initiated by Helmholtz, and later theorized by Albert Einstein's study of relativity and Werner Heisenberg's uncertainty principle.[128] Bohr ends the piece by suggesting that "adaptation of the relativity requirement to the quantum postulate" will require physicists to "be prepared to meet with a renunciation as to visualization in the ordinary sense going still further," even to the point of "adapting our modes of perception borrowed from the sensations to the gradually deepening knowledge of the laws of Nature."[129] Like Helmholtz before him, Bohr believes that the narrow bandwidth and established habits of human perception actually hinder our understanding: he suggests that human capacities will eventually adapt to the types of data being produced by highly specialized instrumentation. We take this to indicate that the man/machine interface of science, powerfully challenged by Helmholtz, is evolving into an immersive system of instrument/user interaction prophetic of the eye surgeon who opened this book. Diagrammatic knowledge, as we have sketched it from the late eighteenth century, was an interactive and immersive form of reasoning. Bohr is predicting, in effect, that the practice of science will become ever more diagrammatic.

VIII

We might seem to be far from those descriptions of natural science, based on the human sensorium and rooted in language, that "trace the portrait and make a picture of what they represent" discussed by Daubenton in the *Encyclopedia*. In fact, Bohr addressed that distance in two articles published in 1929 where he spins in interesting ways many of the terms of description that had been put into play by the *Encyclopedia*.[130] By way of closure, we revisit the *Encyclopedia* to read its fractionated treatment of description against Bohr's roadmap of obstacles facing physics in the quantum age. Marmontel, for instance, had written about description in belles lettres that "since almost everything in nature is in motion, and since everything in it is made of parts, imitation can vary infinitely in the details."[131] Bohr carries an analogous elasticity over to descriptions of the natural world because, in his words, "the rise of the theory of relativity . . . by a profound analysis of the problem of observation, was destined to reveal the subjective character of all the concepts of classical physics."[132] Bohr claims that Einstein's theory of relativity approaches

"the classical ideal of unity and causality in the description of nature." But he also suggests that Planck's discovery of the quantum of action, with its inherent discontinuity and (since Heisenberg) "exchange of energy between the individuals and the measuring rods and clocks used for observation," has led "to a break in the causal chain."

Under these circumstances, Bohr observes that descriptions of atomic events resemble those of "mental activity" for which there is "no sharp distinction between object and subject." He concludes that we must "be prepared to accept the fact that a complete elucidation of one and the same object may require diverse points of view which defy a unique description." Here, Bohr the quantum physicist enters the orbit of Jaucourt the *littéraire*, who had written: "since the imagination can visualize by itself things greater, more extraordinary, and more beautiful than those that nature usually offers to the eyes . . . they should not be represented the way chance presents them to us every day, but how we imagine they ought to be."[133] In each instance, descriptions tackle unknown terrain: for Jaucourt, they articulate a world given shape by the imagination; for Bohr, they address a world of facts, "outside the domain of our ordinary forms of perception," revealed by the mathematics of quantum theory. Viewed in this light, two points of convergence between Bohr and Jaucourt become visible: on one hand, both recognize that sense perceptions are at best limited forms of knowledge; on the other, both accept the idea that description itself operates in a regime of variable subjectivity. The convergence is all the more surprising because, even if the scientist's world seems not to intersect that of literature, the task of describing cross-wires those domains and generates original hybrids of extra-sensory knowledge.

In a second essay of 1929 concerned with the interface between atomic theory and sensory-based descriptions of nature, Bohr addressed the "peculiar situation" produced when increasingly detailed knowledge about the structure of atoms simultaneously reveals "the natural limitation of our forms of perception."[134] After reviewing some recent discoveries about atomic structure, and why mechanical descriptions can no longer account for the definite properties of elements, Bohr explains how Planck's quantum of action theory solved several key theoretical problems. Nonetheless, adopting Planck's theory entailed an important

concession. "In contrast with the demand of continuity which character-izes the customary description of nature," writes Bohr, "the indivisibility of the quantum of action requires an essential element of discontinuity in the description of atomic phenomena." If the new theory "offers a consistent way of ordering the experimental data," it also requires "the renunciation of all attempts to obtain a detailed description of the indi-vidual transition processes." Bohr correctly assesses the damage done to causality:

We are here so far removed from a causal description that an atom in a station-ary state may in general even be said to possess a free choice between various possible transitions to other stationary states. From the very nature of the mat-ter, we can only employ probability considerations to predict the occurrence of the individual processes.

Contemporary physics has advanced far beyond Bohr's understanding of the problem of atomic structure, but this passage reveals several assump-tions that remain operative in theoretical physics and influence its regime of description. Foremost is the idea that one cannot establish a step-by-step causal explanation. This does not mean that physicists forego explanations; rather, their understanding consists of inferred correlations from one state to the next. Equally important is the idea that one cannot predict exactly an atom's next move. The abandonment of predictive power is part of Boltzmann's legacy to contemporary physics.

Correlation, we argue, lies at the core of diagrammatic knowledge. Diagrams stage nodal points where users are free to branch in various ways, and where the yield of knowledge is not exactly fixed—although its range could be described by probability. The symmetry we underline between diagrammatic knowledge and the cognitive procedures of theo-retical physics depends upon recognizing that both forms of understand-ing are correlations made by users immersed in their field of study. In short, we find an unacknowledged kernel of modernity lurking amidst the plates of the *Encyclopedia*.

One of the recurring themes in the writings of Bohr from this period is the idea that even if quantum mechanics forces physicists to accept "res-ignation as regards visualization and causality" they must understand this renunciation "as an essential advance in our understanding."[135] Bohr

does not accept this break with the past, which Foucault later defined as a mathematical formalization able "to discover at some other level the unity that has been lost." Bohr recognized that the quantum calls into question the basic premises of describing:

The discovery of the quantum of action shows us, in fact, not only the natural limitations of classical physics, but, by throwing a new light upon the old philosophical problem of the objective existence of phenomena independently of our observations, confronts us with a situation hitherto unknown in natural science. As we have seen, any observation necessitates an interference with the course of the phenomena, which is of such a nature that it deprives us of the foundation underlying the causal mode of description. The limit, which nature herself has thus imposed upon us, of the possibility of speaking about phenomena as existing objectively finds its expression, as far as we can judge, just in the formulation of quantum mechanics.[136]

Bohr does not champion quantum mechanics as a master theory of high-order unity. Rather, he welcomes the liberating effect of dispensing with causality and visualization as necessary components of natural descriptions. With Bohr, the splintering of description evident in the texts and plates of the *Encyclopedia*, the superhuman bandwidth of the Helmholtz sensorium, and the taming of chaos by the mathematics of Boltzmann become part of the scientist's toolbox. Lord Kelvin would not have approved.

Historians of science usually divide the story of modern physics at the quantum. Its emergence as a working object was the result of several converging threads of research—both theoretical and practical—that challenged classical mechanics and its assumptions of continuous action and energy. We cannot write the long history of the investigators and the experiments that shaped the atomic-level view of the universe in the early twentieth century. As cultural historians, however, we are fascinated by the emergence of the quantum working object and its eventual acceptance by research scientists and the general public. At best, quanta leave momentary traces at the extreme limits of instrument-aided perception. Why should they be taken for granted?

The short answer is that, like any working object, they do things in the world. Their usefulness becomes a thing in itself, obviating the need

to worry about their ontological status. The longer answer, which this book has sketched, is that working objects have a history and quanta are part of that history. We began with the *Encyclopedia* because it incarnates a coherent and massive attempt to give shape to the correlative understanding that human beings have long exercised, and to make possible its transmission to others—to make it social. Therein lies the utopian project of Diderot and d'Alembert.

The experimental tradition that produced quantum mechanics certainly did rupture around 1900—the sheer number and novelty of new instruments attests to that break.[137] A thread of continuity remained, one tethered to the striking redescriptions of the natural world produced by Planck, Bohr, Einstein, and others. This thread takes us back to the fragmented and splintered regime of description articulated in the plates of the *Encyclopedia*. The world of Diderot and d'Alembert was built from images and words arrayed on sheets of paper. The white of the page was the space of their correlations. The mathematics of probability produced an arena of correlations existing on an unprecedented level of abstraction, well beyond the range of the human sensorium. D'Alembert could neither have foreseen nor predicted that shift when he separated the calculus from useful descriptions of the world, but we believe that he would have embraced the quantum as a good tool with which to think.

6 CROSSINGS

Our archaeology of diagram has sketched the contours of a long process by which instruments and tools of analysis expanded the horizons of knowledge beyond the range of the human sensorium. The dominant mode of visualization, established since the Renaissance, placed an object in space under the gaze of a precisely positioned observer. The *Encyclopedia* registers how much description already was fragmented by the mid-eighteenth century, in part because new instruments could see farther, in more detail, or with a finer grain than human beings, and generated data sets demanding new formulas of presentation. We have read the plates of the *Encyclopedia* as concerted efforts to materialize these new configurations, albeit within the technical limits of the printed page. The salient quality of the plates, in our account, is their surprising, sometimes shocking use of visual arrays: the relative scales, vantage points, and shifting relationships among numerous elements in these arrays configure the open-ended form of presentation that characterizes diagrams. Actuated by a viewer's complicity in bridging the fields of white that both bind together and separate the component parts, the diagrams of the *Encyclopedia* produce a cognitive yield not predicted by the model

of a single observer acting within the technical limits of human sight. Even in those contemporary arenas where situated viewers remained paramount—notably theatrical stagings and history paintings—multiple forms of stimulation and attention began to erode fixed meaning and invite spectatorial improvisation analogous to the cross-references of the *Encyclopedia* and the white spaces of its plates.

Although the authors of the *Encyclopedia* embraced the diagrammatic turn in descriptions of the world, they failed to agree upon its implications. They remained committed to an implicit hierarchy of visualization in which the perceiving human body, and thus the human sensorium, retained pride of place. Their physicalist bias necessarily placed limits on the usefulness of descriptions drawn with equations rather than the tools of geometry. Our trajectory through the nineteenth century has charted those moments when mathematics, especially calculus and probability, were adopted as essential working objects, even if doing so meant displacing sight as the primary vehicle of understanding. With Laplace, probability entered the domain of celestial mechanics to shake the foundations of Newton's positivist reasoning. Legendre and Gauss deployed it as a tool for predicting and correcting errors. For Quetelet, probability became a device to master the data of large samples and to formulate normative extrapolations. Boltzmann used probability to predict physical phenomena beyond the limits of perception and to sidestep the question of Maxwell's daemon. Quantum mechanics, as formulated by Planck, Bohr, and Einstein, dispensed with assumptions that "description" means to visualize in space, and that "observation" occurs from a vantage point independent of what is studied. To accept the findings of quantum mechanics meant abandoning sense perceptions as the foundation of knowledge about the world.

Eventually, the abstract precision of mathematical terms and the implacability of instruments displaced the coarse-grained, fatigue-prone senses of the human body as the cornerstone of knowledge. Helmholtz, in particular, effected a convergence of physiological studies and mathematical reasoning. His findings—that the limits of human perceptions are predicted and defined by probabilities of error-correction—paved the way to imagining a continuum between the relatively narrow bandwidth of the human senses and the broad-band receptivity of instruments designed to detect wavelengths, particles, and movements both infinitely large and infinitely small.

Although Helmholtz did not liquidate the human subject at the center of life, he did immerse human beings in a blur of discontinuous, only partially registered data constantly shaping the world by means of correlations guided by error-correction. For Helmholtz, perception itself is diagrammatic.

Our survey of the complexities of nineteenth-century diagrammatic culture has necessarily taken a specialized view. We have drawn vividly the migration of correlative processes from the literal white spaces of the *Encyclopedia*'s plates, and the pages of Monge's descriptive geometry, to the virtual whiteness of mathematical space inhabited by the algebraic discontinuities of both calculus and probability. By way of anchoring and broadening our discussion, especially as it pertains to the development of mechanical imaging technologies, we now turn briefly to the work of two important, but very different figures from the history of photography: Louis-Jacques-Mandé Daguerre and Étienne-Jules Marey.

History remembers Daguerre for the device that bears his name and was announced with great fanfare in 1839. His invention recorded on a plate of copper the image of whatever a lens might focus. Daguerre discovered, some say by accident, that a plate coated with silver iodide and exposed to light would "develop" an image when fumigated with mercury vapors, and that washing it in saline solution would "fix" the image permanently. Daguerreotype images created a sensation, all the more because the very fine-grained resolution of Daguerre's process, operating at the level of molecules, meant that the degree of visible detail was breathtaking. "The exquisite minuteness of the delineation cannot be conceived," wrote Samuel Morse in a letter from Paris to his brother in New York, "No painting or engraving ever approached it."[1] Nature seemed to be mirrored with an hallucinatory rigor and no human intervention, fulfilling at last the Renaissance dream of a fully comprehensive rendering of the world in one-point perspective. Daguerre's device seemed, on the surface, to produce perfectly descriptive tableaux.

The rhetoric of unvarnished objectivity that celebrated early daguerreotypes was, as Joel Snyder points out, deeply flawed and overdetermined by critical expectations informed by that ideal Renaissance tableau.[2] Daguerreotypes were at first so slow to register an image that exposure times of thirty minutes were common. During that time, many elements of the scene might move, especially if the camera was directed

out a window to the cityscape: the bustle of people, carriages, boats, and animals unfolds under the implacable gaze of the lens but is not recorded. Paradoxically, the developed prints showed only a city devoid of people, traffic, and life.[3] Not surprisingly, the long exposures also made satisfying portrait likenesses impossible. It is true that improvements in chemicals and lenses eventually recovered the movements of everyday life—often rendered as blurs across the visual field—and made portraits feasible. But the point is that Daguerre's device was, above all, an austere implement very unlike the human eye, and its shortcomings laid bare the myths of truth and objectivity clinging fiercely to the Renaissance theory of sight.

The history of photography branched importantly in the 1870s. On one hand, technical improvements in emulsions, cameras, and optics pushed photography towards an ever more perfect illusion of completely mimicking an idealized human eye—a central chapter of the story that will not concern us here. A completely different branch of experiment sought to transform photography from merely replicating human sight into a technology that might supplement human vision by making things visible that the eye cannot see. These researchers were both kindred spirits and colleagues of Helmholtz. Foremost among them was Étienne-Jules Marey.[4] Writing in 1878 about some of his devices, Marey makes clear his view of their superiority to human senses: "Not only are these instruments designed to replace the observer, and in such circumstance to carry out their role with an incontestable superiority, but they also have their own domain where nothing can replace them."[5] At the time he wrote these words, Marey was mainly concerned to design and build mechanical sensors able to register and graph the physiological processes of living bodies. The best-known of these, the sphygmograph, could draw in real time, and with no human intervention, the curve of blood pressure changes produced by a pumping heart. The resulting graph made clearly visible a heart's double-sequence rhythm and made it possible to calculate internal qualities of the human circulatory system such as the speed with which blood flows. These were entirely new forms of knowledge built upon the non-invasive approach to the body of Marey's device and its extreme sensitivity, far beyond the limits of human touch or hearing.

Historians of Marey's long career agree that an important break occurred about 1878, the year he published his influential *La méthode*

graphique, a summary of his experiments and inventions to date. The same year, Marey first saw Eadweard Muybridge's photographs of the horse in motion published in the journal *La Nature* by Marey's friend Gaston Tissandier. Within days, Marey asked Tissandier to put him in touch with Muybridge, for he realized that photographs might effectively replace the stylus and moving graphical surface that had, up to now, been his principal mode of recording data. Over the course of the next several years Marey tinkered with the general structure of a camera, effectively deconstructing the tableau-making, Renaissance perspective view of Daguerre's original invention. Muybridge had not truly altered the operating parameters of the photographic apparatus, although he vastly increased the number of cameras and sequenced their triggering using trip wires. Marey, by contrast, introduced several innovations at the very heart of the device that fundamentally changed the camera's relationship to its subject. The first was to use a single light-sensitive plate rather than many plates, and to direct the camera towards a black ground. Ever since Daguerre's original announcement, the photographic apparatus had claimed to be an all-seeing eye on the world at large. Marey's seemingly innocent gesture, which made the camera but one component of a larger recording system, effectively dislodged the photograph as an all-purpose form of representation. Marey's camera "saw" nothing until a figure, dressed in white, moved across its field of view and was registered as a continuous blur of light.

These results led to Marey's second important innovation: the usual single shutter, mechanically limited to a certain speed, was replaced by a spinning, slotted disk that exposed the plate in a series of quick successions, each exposure registering the moving subject in a different place on the plate. The spinning disk shutter, which "sampled" the visual field at a regular rate, produced a systematic set of multiple exposures of the figure's movement upon a single photographic plate (FIGURE 45). We might say that Marey's slotted shutter applied the logic of calculus to the continuous curve traced by the figure in space. He called them chronophotographs. Marta Braun rightly underscores their startling novelty:

Since the advent of linear perspective in the Renaissance, the frame of an image has, with rare exceptions, been understood to enclose a temporal and spatial unity. We read what occurs within the frame as happening at a single moment

in time and in a single space. Marey's photographs shattered that unity; viewers now had to unravel the successive parts of the work in order to understand that they were looking not at several men in single file, but at a single figure successively occupying a series of positions in space. Viewers had to allow themselves to be led from one figure to another, reading the several images of the single figure as it moved through time and space. The result, a vision that goes beyond sight, was a new reality.[6]

Braun's characterization of the cognitive effort and complicity in reading Marey's chronophotograph dovetails exactly with our description of the correlative process at the core of diagrammatic knowledge. Marey's modifications to the camera transformed it from a device for rendering the world as tableaux into one component of a total system dedicated to diagramming time and motion—a system able to see things well beyond the limits of the human eye.

Marey introduced one final tweak to his system. In his quest for ever narrower slices of timed exposures to multiply the number of images left upon a single plate, Marey realized that the camera's ability to capture

FIGURE 45
Étienne-Jules Marey, "The Successive Phases in the Motion of a Man Running." Similgravure of a chronophotograph from *Scientific American*, vol. 47 (9 September 1882). Courtesy Stanford University Libraries. Photo: Marrinan.

THE SUCCESSIVE PHASES IN THE MOTION OF A MAN RUNNING.

detail actually hindered legibility. He was able to produce photographs with "such numerous superimpositions that the only result is a lot of confusion."[7] Paradoxically, and in the interest of increased clarity, Marey systematically "blinded" the camera by dressing his models entirely in black, except for shiny buttons at the skeletal joints linked by narrow strips of bright metal. Against the already black ground, only the buttons and lines of these costumes were visible to the camera and were registered on the plate. Marey was thus free to increase greatly the number of takes without losing graphic clarity. The results were astonishing: a walking soldier is registered as pattern of points and lines that seem to articulate fully the motion of his body through time and space (FIGURE 46).

Technically, we have come a long way from the plates of the *Encyclopedia* devoted to military maneuvers (FIGURES 20, 21), yet the goal is identical: the visual rendering of bodies moving in space. Both Marey's chronophotographs and the military plates analyze bodies under study as points and lines. Both invoke a blank space (one white, the other black) in which we are invited to imagine that movement. Both elicit a kind of seeing that is not an experience of everyday life. The *Encyclopedia* juxtaposes a tableau view to its diagrammatic arrays whereas Marey's image declares its visual strangeness against the grain of our usual expectations for photographs. These striking similarities separated by more than a century reinforce our claim that the culture of diagram has both an unfolding history and a core set of recurring themes.

Marey undercut the camera's claim of mirroring the world, neatly packaging it for the viewer's optical delight, by demonstrating that photographic utility might lie in a completely different, more diagrammatic

FIGURE 46
Étienne-Jules Marey, *Joinville Soldier Walking*, 1883. Chronophotograph on glass negative (here printed positive). Paris, Collège de France, inv. III-Bb5 (2.8 × 13 cm). Photo: Archives du Collège de France.

direction. We have sketched some of the ways that others—from Laplace to Legendre, from Monge to Quetelet, from Boltzmann to Bohr—realized that the most useful working objects for understanding our world might have little in common with the protocols of mimesis. But, of course, tableaux did not disappear altogether. They were the staple of most painters working in the nineteenth century, on both sides of the divide between academic and modernist aesthetics. David's taut pictorial formulas of the *Horatii* (FIGURE 36 / PLATE 8) may have instantiated the exertions of natural science in 1785, but no painter—including David himself—dared to push the premises of scientific description as forcefully as Marey's diagrammatic turn from photographic illusion around 1880. This is because painting remained intertwined with the mimetic representation of space throughout most of the nineteenth century: for a painter to imagine a picture that was not of something in space was to cross the threshold of abstraction that few were willing even to approach much before the turn of the century. We want to indicate very broadly why it became possible about 1910.

It is commonplace among cultural historians to detect a convergence between quantum theory and the development of Cubism by Georges Braque and Pablo Picasso between about 1908 and 1911. One of the more amusing documents in this literature is the letter written in 1946 by Albert Einstein to Paul Laporte, in response to an article Laporte had written on the analogies between Cubism and the theory of relativity: "This new artistic 'language,'" wrote Einstein, "has nothing in common with the Theory of Relativity."[8] We will not suggest that Planck's efforts in 1906 to formulate the concept of quantum had any discernible effect on the pictorial explorations of Braque and Picasso, nor that the painters were somehow subsumed in the zeitgeist of their time. Rather, we maintain that quantum mechanics and advanced painting converged at this time—for completely different reasons—on the usefulness of diagrammatic protocols. The concept of a quantum was an indispensable working object of enormous practical value to Planck. For Braque and Picasso, the shift to diagram entailed thinking past the surfaces that separate things in the world, piercing their outer skins, and searching for ways to trigger memories of comprehension that might be tactile, auditory, or olfactory rather than visual. The pictorial tool that made possible connections of

this sort is called *passage*—a material trace on the surface of the canvas lacking any specific reference. Picasso's use of an arbitrary and artificial element to achieve pictorial coherence was as diagrammatic a gesture as Planck's invention of the quantum to explain atomic structure.

In his pioneering and still canonical essay on the development of Cubism, Daniel-Henry Kahnweiler situates Picasso's grasp of this new tool of *passage* in the late summer and fall of 1910.[9] The charcoal drawing of a *Standing Female Nude*, now in the Metropolitan Museum of Art (FIGURE 47), is a good example from just these months that demonstrates Picasso's experimentation with *passage*. A lattice-work of lines and regular curves establish a denisty of marks down the center of the sheet that simulates the standing figure's sculptural presence. Shadings from these linear edges bleed towards areas of white where the spatial placements among the planar edges merge, are confounded, and shuffle against one another. Crucial here is the role of material whiteness to elicit instability and unfixity, a sensation that the subject is not fully apprehended all at once, but is grasped from several different vantage points. Kahnweiler summarizes the effect:

This new language has given painting an unprecedented freedom. It is no longer bound to the more or less verisimilar optic image which describes the object from a single viewpoint. It can, in order to give a thorough representation of the object's primary characteristics, depict them as a stereometric drawing on the plane, or, through several representations of the same object, can provide an analytical study of that object which the spectator then fuses into one again in his mind.

Kahnweiler effectively summarizes all that we have argued about the nature of diagrammatic knowledge and the user's role in the processes of correlation. Picasso's drawing of the nude fails as a study of physical anatomy useful to an orthopedic surgeon, but it does produce an understanding of the figure that is unexpected, perhaps even disturbing. We would call it a working object, one that incites us to ask "what is it?" in an echo of the question posed by Barthes when confronting the exploded body plates of the *Encyclopedia* (FIGURE 4).

Our discussion of Picasso's 1910 drawing through the lens of Kahnweiler's appreciation of 1915 demands comparison with an exactly contemporary eruption of diagrammatic whiteness within the matrix of

FIGURE 47

Pablo Picasso, *Standing Female Nude*, summer/fall 1910. Charcoal on paper. New York, The Metropolitan Museum of Art, Alfred Steiglitz Collection 1949, inv. 49.70.34 (48.3 × 31.4 cm). Photo: © The Metropolitan Museum of Art.

language: the posthumous publication in 1914 of *Un coup de Dès jamais n'abolira le Hasard*, Stéphane Mallarmé's 1897 masterpiece of poetic and typographic experiment (FIGURE 48). Mallarmé's preface outlines explicitly the poem's diagrammatic procedure:

The "whites," as a matter of fact, take on importance, strike one first of all; verse requires white, like silence around it, ordinarily, to the point that a piece, lyrical or of a few feet, occupies, in its middle, about a third of the page: I do not transgress this measure, merely disperse it. The paper intervenes each time that an image, of itself, ceases to be or returns, accepting the succession of others.[10]

Mallarmé draws our attention to the uneven pressure of material whiteness against the regular march of words arrayed on the page. Just as

Picasso's drawing invites us to find the nude amidst its weave of lines and space, Mallarmé invites us to participate in making the poem. Correlations among type faces, font sizes, and relative positions present an open-ended aesthetic experience of give-and-take that historians have rightly aligned with modernity itself. We would also align the immersive and collaborative cognitive systems mobilized by Picasso, Mallarmé, and Marey with a tradition of correlation and diagrammatic knowledge that harks back to the plates of the *Encyclopedia*.

When the eye surgeon with whom we began this book enters an operating room equipped with biofeedback servos to steady her hand, with real-time monitoring of her patient's vital signs, and with video images of a virtual world that places her inside an eye, she becomes one component among many of the descriptive system that will guide the surgery. Her immersion precludes the possibility of forming an objective or external view of the systemic whole. Our surgeon lives the paradox that so fascinated Bohr and his colleagues in the 1920s: the increase of knowledge and experience inside the system entails an awareness of the limits upon our natural powers of perception and the self-consciousness of their expansion from within the machine. We think it is not too extreme to claim that this double-edged attentiveness—both to our human limits and to what we might do when those limits are crossed—explains today's fascination with those virtual reality action games so avidly played by millions of users around the world.

We raised at the outset an issue about trust: how is it that all the parties involved in our eye surgery scenario—doctor, patient, hospital as institution—accept their roles within the panoply of computer, sensors, cameras, and digital encoders with enough confidence to risk an eye under a scalpel? All along the chain of image-capture and production, specialized modules perform error-analyses and corrections to compensate for the inherently discontinuous—albeit very high speed—flow of data through the system. Even the surgeon submits her gestures and expertise to the computerized error-checking of the whole. Our book has traced across time, cultures, and disciplines the trajectory whereby humans came to believe that the body's sensory equipment is actually enhanced by electronic appendages. This journey began with the *Encyclopedia*, when first-hand enactment of the processes of correlation became cultural practice. Working objects

that emerged from contingent systems of knowledge came increasingly to assume material form, and to be accepted as inventions rooted in multiple realms of experience. A collage of disparate data types is the core of those graphic arrays of juxtaposed information that comprise the plates of the *Encyclopedia*. We have argued that the format and information of the *Encyclopedia*'s arrays, fixed by the protocols of print culture, established patterns of presentation and juxtaposition that still influence the design of human–machine interfaces. The ambition of the *Encyclopedia* was clear: to correlate data gathered from diverse points of view, from a range of magnifications, and from different times. These recombinations built new forms of understanding even as they destroyed the priority of normative visualization of objects in space. The plates synthesize information in the patterned arrays of *diagrams*.

Certainly, our surgeon's virtual environment of an operating room organizes even more diverse data into strictly patterned diagrammatic arrays. These are constantly updated by computers unimaginable twenty years ago, much less by the *encyclopédistes*. Nonetheless, we believe the systemic regime of description deployed both in the *Encyclopedia* and the operating theater points to a pattern of similarities more significant than their technological differences. Both systems cut description free from the model of presentation that assumes an observer before an object in space, and both presume a bandwidth of perceptual discrimination far in excess of the human sensorium. What holds together these systems of disparate data? Here we return to the process of correlation [rapport] and the technology of cross-references [renvois] so crucial to Diderot's thinking about the *Encyclopedia*. By our account, the *Encyclopedia* is a panorama of working objects, a labyrinth of information through which users chart routes of understanding in the course of unpredictable and highly personal encounters with the material. The interests, passions, and quirks of users merge with the experience of those materials to shape a cognitive yield. Obviously, our surgeon faces neither white pages nor volumes of text, but she must contend with no less a labyrinthine flow of data presented to her sight and touch. Many of the correlations are orchestrated by an underlying matrix of mathematical relationships that constantly redescribe space—less material but no less real than the *Encyclopedia*'s fields of whiteness—and that one now calls virtual reality.

To suggest that convergent data create working objects in time and space, along with new forms of knowledge, does not imply the liquidation of human thought and consciousness: life continues "off line" when the surgery is complete, the computer is shut down, and the patient and doctor see one another with normal vision. Our book suggests that the descriptive regimes of our digital age, bound historically and philosophically to those of the *Encyclopedia*, are capable of producing working descriptions for living, despite—or even because of—their reliance on sampling, calculations, and probability. Digital data technologies may have finally killed off spatial illusion as the most compelling re-presentation of the world. Perceptual certainty has been sacrificed, but human beings are highly adaptable: our fascination with new media means that we have all become creatures of chance. Reality returns as virtual so that we might see.

NOTES

CHAPTER 1

1. Description based on the ophthalmic virtual environment published in I. W. Hunter et al., "Ophthalmic Microsurgical Robot and Associated Virtual Environment," *Computers in Biology and Medicine* 25, 2 (1995): 173–82.

2. Walter Benjamin, "The Work of Art in the Age of Mechanical Reproduction," in *Illuminations*, trans. Harry Zohn (New York: Schocken, 1969), 233.

3. John Locke, *An Essay Concerning Human Understanding*, ed. Peter H. Nidditch (Oxford: Clarendon, 1975), 300.

4. The field of robotic surgery is expanding exponentially and we make no claims to cover the literature. Some of the papers that have influenced our thinking include: Jeffrey V. Rosenfeld, "Minimally Invasive Neurosurgery," *Australian and New Zealand Journal of Surgery* 66 (1996): 557–58; Raymond Sawaya et al., "Advances in Surgery for Brain Tumors," *Neurologic Clinics* 13, 4 (November 1995): 757–71; S. Hassfeld et al., "Intraoperative Guidance in Maxillofacial and Craniofacial Surgery," *Proceedings of the Institution of Mechanical Engineers: Part H, Journal of Engineering in Medicine* 211, 4 (1997): 277–83. One commercial product now in use that plans robotic surgical moves based on MRI data is the NeuroMate device manufactured by Integrated Surgical Systems of Sacramento, California. For a positive evaluation of the NeuroMate in Movement Disorder Surgery, see T. R. K. Vasna et al., "Use of the NeuroMate Stereotactic Robot in Frameless Mode for Movement Disorder Surgery," *Stereotactic and Functional Neurosurgery* 80 (2003): 132–35. For a popular gloss on robotic surgery, see Michelle Andrews, "A Guiding Hand," *U.S. News & World Report* 141, 4 (31 July 2006): 59–62.

5. James M. Drake et al., "Computer- and Robot-assisted Resection of Thalamic Astrocytomas in Children," *Neurosurgery* 29, 1 (1991): 32; Karol Miller and Kiyoyuki Chinzei, "Constitutive Modeling of Brain Tissue: Experiment and Theory," *Journal of Biomechanics* 30, 11/12 (1997): 1115–21; Michael L. J. Apuzzo, "New Dimensions of Neurosurgery in the Realm of High Technology: Possibilities, Practicalities, Realities," *Neurosurgery* 38, 4 (April 1996): 625–37; R. S. Douglas, "Robotic Surgery in Ophthalmology: Reality or

Fantasy?" *British Journal of Ophthalmology* 91, 1 (January 2007): 1. For a concise history on the use of robotics in neurosurgery, see the website: http://biomed.brown.edu/Courses/BI108/BI108_2005_Groups/04/neurology.html.

6. For details on da Vinci, see the manufacturer's website: www.intuitivesurgical.com. On the use of da Vinci see: Garth H. Ballantyne and Fred Moll, "The da Vinci Telerobotic Surgical System: The Virtual Operative Field and Telepresence Surgery," *Surgical Clinics of North America* 83 (2003): 1293–1304; Johannes Bodner, Florian Augustin, et al., "The da Vinci Robotic System for General Surgical Applications: A Critical Interim Appraisal," *Swiss Medical Weekly* (19 November 2005): 674–78; Catherine J. Mohr, Geoffrey S. Nadzam, and Myriam J. Curet, "Totally Robotic Roux-en-Y Gastric Bypass," *Archives of Surgery* 140 (2005): 779–86; A. Tsirbas, C. Mango, and E. Dutson, "Robotic Ocular Surgery," *British Journal of Ophthalmology* 91 (2007): 18–21.

7. H. Vasarius et al., "Man-Machine Interfaces in Computer Assisted Surgery," *Computer Aided Surgery* 2, 2 (1997): 102–7.

8. B. L. Davies et al., "Active Compliance in Robotic Surgery—The Use of Force Control as a Dynamic Constraint," *Proceedings of the Institution of Mechanical Engineers: Part H, Journal of Engineering in Medicine* 211, 4 (1997): 286.

9. Nelson Goodman, *Languages of Art: An Approach to a Theory of Symbols* (Indianapolis: Hackett, 1976). Goodman would admit the coexistence of two distinct syntactic systems inside the head-mounted display of our surgeon (FIGURE 1). He would call its array of digital and analog data a mixed type of diagram. He would also maintain that its digital components are different in kind from its analog components. For Goodman, the formal characteristics of mixed type diagrams might approach the appearance of a representation (see his comparison of an electrocardiogram with a Hokusai drawing of Mt. Fuji, 229–30), and both can be considered dense, rather than articulate, schemes. A diagram, in his view, depends upon an "expressly and narrowly restricted" view of the features that make up the array. Any feature lying outside this narrow set is "contingent" and dismissed when reading the diagram (229). Pictorial schemes, by contrast, are "replete": one cannot de-

termine what elements of a painting—if any—are contingent. Goodman concludes that the differences between diagrams and pictorial schemes are, at best, a "matter of degree" (230). Controlling Goodman's entire discussion are protocols of reading within the "grounded technical requirements for a notational language" (171). Given these ground rules, Goodman is right to say that "diagrams are flat and static models" that convey finite and fixed packets of knowledge. We argue, by contrast, that diagrams are working objects able to produce new insights by juxtaposing otherwise incommensurate information. In the surgery example we cite in the text, the head-mounted display is simply one component of the real-time configuration of bodies, sensors, computers, and displays that produce sufficient knowledge for surgery to occur. That complete system of cognition is what we place under the rubric of diagram. For a detailed engagement with Goodman's ideas, and one that has affected our thinking, see James Elkins, *The Domain of Images* (Ithaca NY: Cornell University, 1999), 68–81.

10. The term "diagram" is applied to an enormous range of things, some of which lie outside the concerns of this book. Discussions that do intersect with our own include: Goodman and Elkins (see preceding note); Peter Galison, *Image and Logic: A Material Culture of Microphysics* (Chicago: University of Chicago, 1997), which should be read alongside the review by James Elkins, "Logic and Images in Art History," *Perspectives on Science* 7, 2 (Summer 1999): 151–80, and Galison's reply, "Reflections in Image and Logic: A Material Culture of Microphysics," *Perspectives on Science* 7, 2 (1999): 255–84; Reviel Netz, *The Shaping of Deduction in Greek Mathematics: A Study in Cognitive History* (Cambridge UK: Cambridge University, 1999); Barbara Maria Stafford, *Good Looking: Essays on the Virtue of Images* (Cambridge MA: MIT, 1996); Brian Rotman, "Thinking Dia-Grams: Mathematics, Writing, and Virtual Reality," in *Mathematics, Science, and Postclassical Theory*, eds. Barbara Herrnstein Smith and Arkady Plotnitsky (Durham NC: Duke University, 1997), 17–39; Sharon Helmer Poggenpohl and Dietmar R. Winkler, "Diagrams as Tools for Worldmaking," *Visible Language* 26, 3/4 (Summer/Autumn 1992): 252–69. Discussions that treat diagrams as embodiments or formulations of experimental

output include: Galison, *Image and Logic*; Michael Lynch and Steve Woolgar, eds., *Representation in Scientific Practice* (Cambridge MA: MIT, 1990); Michael Lynch, "Science in the Age of Mechanical Reproduction: Moral and Epistemic Relations between Diagrams and Photographs," *Biology & Philosophy* 6, 2 (April 1991): 205–26; Michael Lynch, "Discipline and the Material Form of Images: An Analysis of Scientific Visibility," *Social Studies of Science* 15 (1985): 37–63. Yet another branch of inquiry considers diagrams as devices for presenting or deriving logical and computational concepts. For an introduction to the contributions of Leonhard Euler, Charles Pierce, and John Venn, see Sun-Joo Shin and Oliver Lemon, "Diagrams," *Stanford Encyclopedia of Philosophy*, ed. Edward N. Zalta, http://plato.stanford.edu/entries/diagrams/. Other works to consult include: Sun-Joo Shin, *The Logical Status of Diagrams* (Cambridge UK: Cambridge University, 1994); Eric M. Hammer, *Logic and Visual Information* (Stanford CA: CSLI Publications, 1995); Mark Greaves, *The Philosophical Status of Diagrams* (Stanford CA: CSLI Publications, 2002); David Kaiser, *Drawing Theories Apart: The Dispersion of Feynman Diagrams in Postwar Physics* (Chicago: University of Chicago, 2005).

11. Netz, *The Shaping of Deduction*, 35.

12. Denis Diderot and Jean Le Rond d'Alembert, *Encyclopédie, ou dictionnaire raisonné des sciences, des arts et des métiers*, 17 vols. (Paris: Briasson et al., 1751–65), "Diagramme," 4, 933. Hereafter cited as *Encyclopedia*, followed by article name, volume number, and page. For practical reasons, we have worked with the reprint of the Paris edition published by Pergamon Press, 1969.

13. Jean Starobinski, "Remarques sur l'*Encyclopédie*," *Revue de Métaphysique et de Morale* 75, 3 (1970): 284; Michel Foucault, *The Order of Things: An Archaeology of the Human Sciences* (New York: Vintage Books, 1973), esp. chap. 7.

14. Annie Becq, "Continu et discontinu dans l'écriture de l'*Encyclopédie*: Le choix de l'ordre alphabétique," in *L'Encyclopédie et ses lectures* (Caen: Éditions de l'École normale du Calvados, 1987), 31.

15. Denis Diderot, *Prospectus de l'Encyclopédie*, in *Œuvres*, ed. Laurent Versini (Paris: Robert Laffont, 1996), 1: 220.

16. Cited from Diderot's footnote to the word *encyclopédie* on the first page of the *Prospectus*; ibid., 211.

17. See, for instance: Keith Michael Baker, "Épistémologie et Politique: Pourquoi l'*Encyclopédie* est-elle un dictionnaire?" in *L'Encyclopédie: Du réseau au livre et du livre au réseau*, eds. Robert Morrissey and Philippe Roger (Paris: Honoré Champion, 2001), 51–58; David Bates, "Cartographic Aberrations: Epistemology and Order in the Encyclopedic Map," in *Using the Encyclopédie: Ways of Knowing, Ways of Reading*, eds. Daniel Brewer and Julie Candler Hayes (Oxford: Voltaire Foundation, 2002), 1–20; Jean Ehrard, "L'arbre et le labyrinthe," in *L'Encyclopédie, Diderot, l'esthétique: Mélanges en hommage à Jacques Chouillet*, ed. Sylvain Auroux et al. (Paris: Presses Universitaires de France, 1991), 233–39; Becq, "Continu et discontinu dans l'écriture de l'*Encyclopédie*"; Herbert Dieckmann, "The Concept of Knowledge in the *Encyclopédie*," in *Essays in Comparative Literature*, eds. Herbert Dieckmann, Harry Levin, and Helmut Motekat (St. Louis MO: Washington University, 1961), 73–107; Starobinski, "Remarques sur l'*Encyclopédie*."

18. Diderot, *Œuvres*, 1: 235. For a discussion, see Bernard Ludwig, "L'utilisation des renvois dans la lecture de l'*Encyclopédie*," in *L'Encyclopédie et ses lecteurs* (Caen: Éditions de l'École normale du Calvados, 1987), 35–54.

19. Diderot, *Œuvres*, 1: 212.

20. We use the notion of "working objects" as developed by Lorraine Daston and Peter Galison, "The Image of Objectivity," *Representations* 40 (1992): 81–128. See also Lorraine Daston, "Objectivity and the Escape from Perspective," in *The Science Studies Reader*, ed. Mario Biagioli (New York: Routledge, 1999), 110–23. Daston and Galison have both expanded and thoroughly historicized the arguments sketched in these two early articles in their comprehensive, book-length study *Objectivity* (New York: Zone Books, 2007).

We invoke the term *bricolage* following Claude Lévi-Strauss, *The Savage Mind* (Chicago: University of Chicago, 1966), 16–33. Our emphasis intersects Nelson Goodman's notion of "worldmaking," in which the average man in the street operates in a "familiar serviceable world he has jerry-built from fragments of scientific and artistic tradition and from

his own struggle for survival," but we shall avoid becoming entangled in arguments about the nature or relativity of reality. Citations from Nelson Goodman, *Ways of Worldmaking* (Indianapolis: Hackett, 1978), 20.

21. Some of the texts that have informed our thinking on these issues are: Jonathan Crary, *Techniques of the Observer: On Vision and Modernity in the Nineteenth Century* (Cambridge MA: MIT / October Books, 1990); Jonathan Crary, *Suspensions of Perception: Attention, Spectacle, and Modern Culture* (Cambridge MA: MIT / October Books, 1999); Galison, *Image and Logic*; Ian Hacking, *Representing and Intervening: Introductory Topics in the Philosophy of Natural Science* (Cambridge UK: Cambridge University, 1983); Martin Jay, *Downcast Eyes: The Denigration of Vision in Twentieth-Century French Thought* (Berkeley: University of California, 1993); Hilary Putnam, *Realism and Reason* (Cambridge UK: Cambridge University, 1983) and *Representation and Reality* (Cambridge MA: MIT, 1988); Barbara Maria Stafford, *Body Criticism: Imaging the Unseen in Enlightenment Art and Medicine* (Cambridge MA: MIT, 1991), and *Good Looking*.

22. Netz, *The Shaping of Deduction*, 60.

23. Stephen Werner parallels our point in his book on the plates of the *Encyclopedia*: see *Blueprint: A Study of Diderot and the Encyclopédie Plates* (Birmingham AL: Summa Publications, 1993), esp. 109–12. He invokes the metaphor of a blueprint when describing the plates, which he sees as "connected with issues that bear on the aesthetics of representation and the role of the mimetic." Werner suggests that the blueprint "can never provide a complete portrait of its subject." Rather, it presents a "virtual" side, the potential to create things—actual objects—that are virtually "present in the technical plates of the *Encyclopedia*." Werner characterizes this as a style of process that "is never openly defined or explained," whose "inner shape has to be intuited by the reader." He views process as a "freeing of images" aimed at bringing them "to light." Our analysis, which is more literal than metaphoric or poetic, intersects with Werner when we emphasize user process. Correlation for us is an autonomous form of knowledge produced by diagrams, that is, things of use. We view the plates as examples of working objects—as

diagrams—not simply technical drawings from which to reconstruct a building or machine in a "final or definitive shape" that previously has existed "only in outline." Other texts on the plates of the *Encyclopedia* that have influenced our thinking include: Daniel Brewer, *The Discourse of Enlightenment in Eighteenth-Century France* (Cambridge UK: Cambridge University, 1993), esp. chap. 1; Madeleine Pinault, "Diderot et les illustrateurs de *l'Encyclopédie*," *Revue de l'Art* 66 (1984): 17–38.

24. Diderot's retrospective article "Encyclopédie," published in 1755, acknowledges many of his project's predecessors. Scholarship on the relationship of Diderot and d'Alembert to Chambers and other encyclopedic precursors includes: Jacques Bernet, "La *Cyclopaedia* d'Ephraïm Chambers (1728), ancêtre de *l'Encyclopédie* de Diderot et d'Alembert," in *Les sources anglaises de l'Encyclopédie*, eds. Sylvaine Albertan-Coppola and Madeleine Descargues-Grant (Valenciennes: Presses Universitaires de Valenciennes, 2005), 25–38; Richard Yeo, *Encyclopaedic Visions: Scientific Dictionaries and Enlightenment Culture* (Cambridge UK: Cambridge University, 2001), 35–58 and 120–44; Robert Collison, *Encyclopaedias: Their History throughout the Ages*, 2nd ed. (New York: Hafner, 1966), 114–37; Werner, *Blueprint*, 43–50. On the controversy over Diderot's appropriation of materials prepared for the plates of René Antoine Ferchault de Réamur's *Description des Arts et Métiers*, see John Lough, *The Encyclopédie* (New York: David McKay, 1971), 86–91. On the rendering of machines and other forms of engineering drawing before the eighteenth century, see the volume of essays edited by Wolfgang Lefèvre, *Picturing Machines 1400–1700* (Cambridge MA: MIT, 2004). A good sampling of the wide variety of images used by encyclopedists and other compilers before Diderot can be found in Barbara Stafford, *Artful Science: Enlightenment, Entertainment, and the Eclipse of Visual Education* (Cambridge MA: MIT, 1994).

25. Jean Le Rond d'Alembert, *Preliminary Discourse to the Encyclopedia of Diderot*, trans. Richard N. Schwab (Indianapolis IN: Bobbs-Merrill, 1963), 110. D'Alembert's *Preliminary Discourse* was originally published in the first volume of the *Encyclopedia*, which appeared in 1751. The passage on Chambers was lifted verbatim by d'Alembert from Diderot's

original *Prospectus de l'Encyclopédie*, published in 1745: see Diderot, *Œuvres*, 1: 213–14.

26. D'Alembert, *Preliminary Discourse*, 110–11.

27. Diderot, *Prospectus de l'Encyclopédie*, 214.

28. D'Alembert, *Preliminary Discourse*, 124.

29. Ibid., 126.

30. Philip Stewart attributes to Chambers the originality of a design that links a comprehensive set of illustrations to supporting text, but he admits that the completed *Cyclopaedia* fell far short of its conception. See Philip Stewart, "Illustration encyclopédiques: de la *Cyclopaedia* à l'*Encyclopédie*," *Recherches sur Diderot et sur l'Encyclopédie* 12 (1992), 75–76.

31. D'Alembert, *Preliminary Discourse*, 125.

32. Ibid., 126.

33. Ibid., 126–27.

34. Ibid., 135.

35. Gotthold Ephraim Lessing, *Laocoön: An Essay on the Limits of Painting and Poetry*, trans. E. A. McCormick (Baltimore MD: Johns Hopkins University, 1984). Gombrich challenged the originality of Lessing's essay without, however, seriously dislodging him from consideration. See Ernst H. Gombrich, "Lessing (Lecture on a Master Mind)," *Proceedings of the British Academy* 43 (1957): 133–56.

36. The first quotation is from Samuel Y. Edgerton, *The Renaissance Rediscovery of Linear Perspective* (New York: Harper & Row, 1975), 56. Edgerton puts a metaphorical spin on the argument that perspective was a convention established by its utility and familiarity as developed by William M. Ivins, *On the Rationalization of Sight* (1938; rpt. New York: Da Capo, 1973), 14. The strong proponent for a typically Northern European mode of rendering is Svetlana Alpers, *The Art of Describing: Dutch Art in the Seventeenth Century* (Chicago: University of Chicago, 1983), esp. chap. 2. On the persistence of the Albertian model, see Peter de Bolla, *The Education of the Eye: Painting, Landscape, and Architecture in Eighteenth-Century Britain* (Stanford CA: Stanford University, 2003), esp. introduction and chap. 1. For an account of perspective concerned with the shift from optical tool to metaphoric symbolization, see James Elkins, *The Poetics of Perspective* (Ithaca NY: Cornell University, 1994), and his slightly earlier article

"Clarification, Destruction, and Negation of Pictorial Space in the Age of Neoclassicism, 1750–1840," *Zeitschrift für Kunstgeschichte* 53 (1990): 560–82.

37. *Encyclopedia*, "Description," 4: 878–79.

38. Citations from Stafford, *Artful Science*, 220; *Good Looking*, 110; and *Body Criticism*, 5.

39. Stafford, *Good Looking*, 97.

40. Stafford, *Artful Science*, 292

41. Stafford, *Body Criticism*, 179–80.

42. This is not to suggest that "shooter" video games or flight simulators are to be equated with the surgical environment with which we opened the chapter. The simple reason is that while no one is actually killed in a video game and no one dies if a flight simulator is crashed on landing, the surgeon effects genuine cuts on a living patient. Our scenario participates in the radical interdisciplinarity sketched by Barbara Stafford in *Good Looking* (p. 39), although we do not want to slip into a world of analogy as she seems to suggest in the last chapter of that book. We attend to the material interplay of data in correlations that might not be visual data, but digital readouts of non-optical instruments. For this type of correlation, all forms of data are relevant, and it might actually be preferable to have a micro-chip inserted directly into the user's brain than a headset before his or her eyes. We tend to believe that Stafford, and many other apologists for image-based knowledge, would not want to make so radical a leap.

CHAPTER 2

1. [Denis Diderot and Jean Le Rond d'Alembert], *Recueil de Planches sur les Sciences, les Arts libéraux, et les Arts méchaniques, avec leur Explication*, 11 vols. (Paris: Briasson, David, Le Breton, Durand, 1762–72). All references in our text to the plates and captions of the *Encyclopedia* are keyed to these volumes.

2. James Elkins uses the concept of "negative white space" in his discussion of the theoretical relationships among writing, picture, and notation when responding to Nelson Goodman's ideas. See Elkins, *The Domain of Images*, 85–89.

3. The effects we are describing align in many ways with those accounted for in Steven Shapin and Simon Schaffer,

Leviathan and the Air-Pump: Hobbes, Boyle, and the Experimental Life (Princeton NJ: Princeton University, 1985), 60–65. The effects of light and shade in the plates often go beyond the demands of strict delineation of the objects represented and work instead to project a sense of conviction about the real-life functioning of the tools and equipment depicted. Shapin and Schaffer account for virtual witnessing as a system of persuasion, a verbal and pictorial means of proving the accuracy and truth of experiments that were actually seen by only a handful of colleagues and were difficult to duplicate. What strikes us as important about Boyle's engraving of the air pump is not the elements of mimetic representation that stand for what "was really done," but the array of those elements in a graphic field that both requires and incites the viewer to an imaginative reconstruction of the procedure.

4. For a different reading of the relative emptiness in the métier plates, see Ken Alder, *Engineering the Revolution: Arms and Enlightenment in France, 1763–1815* (Princeton NJ: Princeton University, 1997), 136–39. See also William H. Sewell, "Visions of Labor: Illustrations of the Mechanical Arts before, in, and after Diderot's *Encyclopédie*," in *Work in France: Representations, Meaning, Organization, and Practice*, eds. Steven L. Kaplan and Cynthia Koepp (Ithaca NY: Cornell University, 1986), 258–86.

5. Roland Barthes, "The Plates of the Encyclopedia," in *A Barthes Reader*, ed. Susan Sontag (New York: Hill and Wang, 1986), 218–35. Although he is principally concerned with the output of scientific analysis, our thinking on the non-representational quality of the *Encyclopedia*'s plates has been influenced by Michael Lynch, "The Externalized Retina: Selection and Mathematization in the Visual Documentation of Objects in the Life Sciences," in *Representation in Scientific Practice*, eds. Michael Lynch and Steve Woolgar (Cambridge MA: MIT, 1990), 153–86.

6. Barthes, "The Plates of the Encyclopedia," 225.

7. Ibid., 224.

8. "I reason thus," wrote Lessing in chapter 16, "if it is true that in its imitations painting uses completely different means or signs than does poetry, namely figures and colors in space rather than articulated sounds in time, and if these signs must indisputably bear a suitable relation to the thing signified, then signs existing in space can express only objects whose wholes or parts coexist, while signs that follow one another can express only objects whose wholes or parts are consecutive" (Lessing, *Laocoön*, p. 78). For a detailed discussion of Lessing's *Laocoön*, see David E. Wellbery, *Lessing's Laocoon: Semiotics and Aesthetics in the Age of Reason* (Cambridge UK: Cambridge University, 1984), esp. chap. 3. Ernst Gombrich challenged Lessing's account in "Moment and Movement in Art," *Journal of the Warburg and Courtauld Institutes* 27 (1964): 293–306.

9. Barthes, "The Plates of the Encyclopedia," 228–29.

10. Ibid., 230 (emphasis in the original).

11. Ibid., 231.

12. Ibid., 231–32.

13. Ibid., 233 (emphasis in the original).

14. Ibid., 234 (emphasis in the original).

15. Daston and Galison, "The Image of Objectivity," 85. Further citations to this text in the following paragraphs are from pages 81 and 94. The argument sketched in this article receives a full treatment in Daston and Galison, *Objectivity*, chaps. 2 and 3.

16. A recent, year-long seminar at Stanford University, organized by the present authors, explored this history and its future in the age of digital imaging. The seminar was sponsored by the Sawyer Seminar Program of the Andrew W. Mellon Foundation. The archive of *Visualizing Knowledge* can be found on the web at visualization.stanford.edu.

17. The classic study of perspective as a humanist enterprise is Erwin Panofsky, *Perspective as Symbolic Form*, trans. Christopher S. Wood (New York: Zone Books, 1991). Recent discussions of this seminal essay include Hubert Damisch, *L'Origine de la perspective* (Paris: Flammarion, 1987), and Elkins, *The Poetics of Perspective*.

18. Neither Jonathan Crary's claims about the demise of the "camera obscura model," nor Martin Jay's concern to chart the denigration of "ocularcentrism" in Western thought, engages what we see as the radical nature of the *Encyclopedia*'s project. Both discussions proceed from the assumption that perspective was the only viable model for structuring the

relationship between a subject and his or her world during the eighteenth century. Neither recognizes that perspective was but one diagram among several options, some of which we discuss in Chapter 3. See Crary, *Techniques of the Observer*, and Jay, *Downcast Eyes*.

19. Elkins, *Domain of Images*, 85.

20. [Diderot and d'Alembert], *Recueil de Planches*, 1, "Art Militaire," 1.

CHAPTER 3

1. The issue of description, especially during the eighteenth century, has become in recent times something of a fertile field of research. Background studies would include the following: Philippe Hamon, *Introduction à l'analyse du descriptif* (Paris, 1981; new ed. Paris: Hachette supérieur, 1993); the anthology of original and contemporary texts assembled in Philippe Hamon, *La Description Littéraire* (Paris: Macula, 1991); Denis Reynaud, "Pour une Théorie de la Description au 18e siècle," *Dix-Huitième Siècle* 22 (1990): 347–66. A collection of relevant essays based on a 1996 conference is John Bender and Michael Marrinan, eds., *Regimes of Description: In the Archive of the Eighteenth Century* (Stanford CA: Stanford University, 2005). An ongoing Research Centre project at King's College Cambridge, entitled "The History and Theory of Description," has focused some of its attention on the eighteenth century. Recent publications include Cynthia Wall, *The Prose of Things: Transformations of Description in the Eighteenth Century* (Chicago: University of Chicago, 2006), and a forthcoming monograph by Joanna Stalnaker, *The Unfinished Enlightenment: Description in the Age of the Encyclopedia*, (Ithaca NY: Cornell University), based on her 2002 New York University dissertation, "In Visible Words: Epistemology and Poetics of Description in Enlightenment France." We are especially grateful to Stalnaker for sharing some of her research on Marmontel.

2. Thomas L. Hankins and Robert J. Silverman, *Instruments and the Imagination* (Princeton NJ: Princeton University, 1995), 113–47.

3. Ibid., 119.

4. Ibid., 140–44.

5. Ibid., 128.

6. Here we differ from Barbara Stafford, who believes that diagrams are "the graphic rudiments of an undefiled alphabet," abstractions modeled on a mathematics that claims to be "the single unsullied method of knowing" (Stafford, *Body Criticism*, 150 and 133). Our approach is more akin to the distinctions drawn by James Elkins when he writes: "Nothing approaching the complexity and versatility of modern notations existed before the Enlightenment. . . . Now it is common in science and technology to find images that are entirely opaque to untrained eyes, not only because they depend on specialized concepts but because they are organized according to specialized notational structures" (*The Domain of Images*, 234).

7. Buffon, "Initial Discourse," reprinted in *From Natural History to the History of Nature: Readings from Buffon and His Critics*, ed. and trans. John Lyon and Philip R. Sloan (Notre Dame IN: Notre Dame University, 1981), 123.

8. Carl B. Boyer, *A History of Mathematics*, 2nd ed. (New York: John Wiley, 1989), 382, 449, 480, 503, 538, 575.

9. Buffon, "Initial Discourse," 123. On Buffon, see Jacques Roger, *The Life Sciences in Eighteenth-Century French Thought*, ed. Keith R. Benson, trans. Robert Ellrich (Stanford CA: Stanford University, 1997), chap. 9, and Jacques Roger, *Buffon: A Life in Natural History*, trans. Sarah Lucille Bonnefoi, ed. L. Pearce Williams (Ithaca NY: Cornell University, 1997), esp. chap. 17.

10. The texts accompanying the natural history plates were written by Louis-Jean-Marie Daubenton for the animals and plants and by Baron Paul-Henri Thiry Holback for the section on minerals. Daubenton, a close collaborator with Buffon at the Jardin du Roi, was also responsible for the overall organization and illustration of the natural science plates and, as discussed below, authored the section of the essay on description devoted to natural science.

11. Pangolins are no longer grouped with anteaters and sloths and armadillos in the order Edentata (toothless) but are classified separately (see "mammal," *Encyclopedia Britannica*, http://search.ed.com/eb/article?eu-108386, and "pangolin," *Encyclopedia Britannica*, http://search.eb.com/eb/article?eu=59720).

12. For Stafford, the "theoretical marginalization of imag-

ery that occurred throughout the eighteenth century" implied a "deflation, subjugation, and reconstruction of the sensory along the lines of the logical," under control of "ruling metaphors" established by Cartesian and Newtonian thinking. Stafford sketches the results as a downward spiral in which images have been systematically relegated to the second tier of knowledge *because* they are nonverbal, a narrative that glosses over the irruption of diagram we are describing (Stafford, *Body Criticism*, 5–6). Martin Jay finds, broadly, that from the time of Descartes, who he suggests is the "founding father of the modern visualist paradigm," to "a great deal of recent French thought in a variety of fields," there emerges "a profound suspicion of vision and its hegemonic role in the modern era." Jay's sweeping analysis of the "denigration of vision" is fundamental, but his narrative concerns the demise of "ocularcentrism" and that concept remains firmly at the center of his story: he characterizes the Enlightenment as "the tacit continuation of an ocularcentric bias," and veils what we consider to be a moment of rupture. Cited from Jay, *Downcast Eyes*, 70, 14, 85.

13. *The Spectator*, ed. Donald F. Bond (Oxford: Clarendon, 1965), 3: 537 (paper no. 411, 21 June 1712). Addison's group of essays was published in eleven issues of *The Spectator* from 21 June to 3 July 1712. On Addison's ideas, see H. B. Nisbet and Claude Rawson, eds. *The Cambridge History of Literary Criticism*, vol. 4, *The Eighteenth Century* index entries passim, esp. 369–71; James Engell, *The Creative Imagination, Enlightenment to Romanticism* (Cambridge MA: Harvard University, 1981), esp. chaps. 2 and 4; Eva T. H. Brann, *The World of the Imagination, Sum and Substance* (Lanham MD: Rowman & Littlefield, 1991), esp. 15, 473, 499; and, more generally, John Brewer, *The Pleasures of Imagination* (Chicago: University of Chicago, 1997).

14. Denis Diderot, *Lettre sur les Aveugles*, in *Œuvres, 1: Philosophie*, 176–77. In Diderot's account, the first experience of vision is a disorganized field of sensation analogous to the undifferentiated white ground upon which visual catalogues are arrayed. He concludes: "that it is not enough for objects to strike us, we must also be attentive to their imprints; that, consequently, nothing is seen the first time our eyes are used;

that in the first moments of vision we are impressed only by a mass of confused sensations that are sorted out only over time, and by means of habitual reflection upon our state of mind."

15. Discussed in Jay, *Downcast Eyes*, 98–102.

16. Locke, *An Essay Concerning Human Understanding*, 162–63. See Crary's discussion of this passage in *Techniques of the Observer*, 42.

17. Bond, *The Spectator*, 3: 550–51 (paper no. 414, 25 June 1712).

18. Crary, *Techniques of the Observer*, 41. The whole of chapter 2, "The Camera Obscura and Its Subject," is relevant. The observer in the camera obscura model faced, for Crary, a "unified space of order, unmodified by his or her sensory and physiological apparatus, on which the contents of the world can be studied and compared, known in terms of multiple relationships" (55). During the nineteenth century, he argues, this model of the eye as a kind of data collector, transmitting information to the mind much like other senses such as touch, was challenged by experiments in physiology and psychology that established the importance of the entire body in perception (67–86 and 88–94). Nineteenth-century empirical descriptions of the human sensory apparatus produced "not a unitary subject but a composite structure on which a wide range of techniques and forces could produce or simulate manifold experiences that are all equally 'reality'" (92). Yet, the shift from a camera obscura world of unified space to a composite structure of manifold experiences that Crary takes as the fundamental rupture à la Foucault between eighteenth- and nineteenth-century visual culture was already mapped in the plates of the *Encyclopedia*. Diagrams that juxtapose vignettes to visual catalogues already assume that break and—more important—turn it to positive use.

19. Ronald Paulson, *Hogarth*, 3 vols. (New Brunswick NJ: Rutgers University, 1993), 3: 356. The plate was produced in the midst of a controversy over the appropriate use of perspective by painters in which Joseph Highmore demanded that serious art frame nature within a mathematically strict perspective, while Hogarth insisted upon delineations that compensate empirically for distortions introduced by the physiology of sight. Joshua Kirby had argued for flexible visualization in his

book, *Dr. Brook Taylor's Method of Perspective Made Easy* (Ipswich: W. Craighton, 1754). Paulson discusses perspective jokes in the cycles of "modern moral subjects" and notes that Hogarth "plays with [the] sense of spectator identification" (*Hogarth*, 3: 61). See also, Paulson's *Popular and Polite Art in the Age of Hogarth and Fielding* (Notre Dame IN: University of Notre Dame, 1979), chap. 4. For further discussion see John Bender, "Matters of Fact: Virtual Witnessing and the Public in Hogarth's Narratives," in *Hogarth: Representing Nature's Machines*, eds. David Bindman, Frédéric Ogée, and Peter Wagner (Manchester: Manchester University, 2001), 49–70.

20. Paulson, *Hogarth*, 3: 61.

21. "The Use and Principles on which the Hydrostatic Balance acts . . . ," *Universal Magazine of Knowledge and Pleasure* 4 (1749), 310–17. Simon Schaffer kindly directed us to this plate and signaled its implications for our argument.

22. Steven Shapin, *A Social History of Truth: Civility and Science in Seventeenth-Century England* (Chicago: University of Chicago, 1994), esp. chap. 3.

23. Ann Banfield, "L'Imparfait de l'Objectif: The Imperfect of the Object Glass," *Camera Obscura* 24 (1991): 73. Much of this early discussion of Russell is taken up again in Ann Banfield, *The Phantom Table: Woolf, Fry, Russell and the Epistemology of Modernism* (Cambridge UK: Cambridge University, 2000), chap. 2. The relationship between recording instruments and subjective observers, a topic of much discussion in the history of science, is laid out in Zeno G. Swijtink, "The Objectification of Observation: Measurement and Statistical Methods in the Nineteenth Century," in *The Probabilistic Revolution*, 2 vols., eds. Lorenz Krüger, Lorraine J. Daston, and Michael Heidelberger (Cambridge MA: MIT, 1990), 1: 261–85. A recent and broad treatment is Daston and Galison, *Objectivity*, esp. 32–38.

24. Ann Banfield, "Describing the Unobserved: Events Grouped Around an Empty Centre," in *The Linguistics of Writing: Arguments between Language and Literature*, eds. Nigel Fabb, Derek Attridge, Alan Durant, and Colin MacCabe (Manchester: Manchester University, 1987), 265.

25. Galileo went on to suggest that the telescope actually dispels illusions generated by a defect in the eye. See Harold I.

Brown, "Galileo on the Telescope and the Eye," *Journal of the History of Ideas* 46, 4 (1985): 487–501. See also Hankins and Silverman, *Instruments and the Imagination*, 177.

26. "Graphs, unambiguously recognizable as such, appeared in the last quarter of the eighteenth century, probably independently, in three places—in the indicator diagram of James Watt, in the lineal arithmetic of William Playfair, and in the scientific writings of Johann Heinrich Lambert" (Hankins and Silverman, *Instruments and the Imagination*, 118–20).

27. Hankins and Silverman, *Instruments and the Imagination*, 120.

28. Banfield, "Describing the Unobserved," 265.

29. Banfield, "L'Imparfait de l'Objectif," 71.

30. Ibid., 71–72.

31. Banfield, "Describing the Unobserved," 267.

32. Ibid.

33. Free indirect discourse [style indirect libre] consists in the use of third-person, past-tense grammar to represent present first-person thoughts and mental states in narration. See, for instance, Dorrit Cohn's discussion of Jane Austen's *Emma*, in *Transparent Minds: Narrative Modes for Presenting Consciousness in Fiction* (Princeton NJ: Princeton University, 1978), 113. See also John Bender, "The Novel as Modern Myth," in *Defoe's Footprints: Essays in Honour of Maximillian E. Novak*, Robert M. Maniquis and Carl Fisher, eds. (Toronto: University of Toronto, 2009), 223–37. For discussion of the early history of free indirect discourse, see Marshall Brown, *The Gothic Text* (Stanford CA: Stanford University, 2005), chaps. 3 and 4.

34. Banfield, "Describing the Unobserved," 278–79.

35. Ann Banfield, *Unspeakable Sentences: Narration and Representation in the Language of Fiction* (Boston: Routledge & Kegan Paul, 1982), esp. 225–54. For a gloss on the larger problem, see Martin Jay, *Cultural Semantics* (Amherst: University of Massachusetts, 1998), 47–61.

36. Banfield, *Unspeakable Sentences*, 231. Making a similar point, see Mikhial M. Bakhtin and Valentin N. Voloshinov, *Marxism and the Philosophy of Language*, trans. Ladislav Matejka and I. R. Titunik (New York: Seminar, 1973), part 3, chap. 4.

37. Michael Fried, *Absorption and Theatricality: Painting and Beholder in the Age of Diderot* (Berkeley: University of California, 1980), 31 and 68.

38. Ibid., 68, and Banfield, "L'Imparfait de l'Objectif," 75–79.

39. Banfield, "Describing the Unobserved," 265.

40. "Description," in Diderot and d'Alembert, *Encyclopédie*. This same article is analyzed to somewhat different ends by Stalnaker, "In Visible Words," 24–43 and 69–92.

41. Baker, "Épistémologie et Politique," 51–58.

42. Lyon and Sloan, *From Natural History to the History of Nature*, 111. On Daubenton, see Frank A. Kafker and Serena L. Kafker, *The Encylopedists as Individuals: A Biographical Dictionary of the Authors of the Encyclopédie* (Oxford: Voltaire Foundation, 1988), 88–91. On Buffon's place, and for contemporary comments about Daubenton, see Roger, *The Life Sciences in Eighteenth-Century French Thought*, chap. 9.

43. Daubenton's use of *tableau* in this passage is general, comprising both the visual catalogues and the more specialized meaning that we have used when discussing the plates.

44. Cited from Thomas L. Hankins, *Jean d'Alembert: Science and the Enlightenment* (Oxford: Clarendon, 1970), 9. On Diderot's position, see Thomas L. Hankins, *Science and the Enlightenment* (Cambridge UK: Cambridge University, 1985), 16–17, 28, 45. Also see Jonathan Kemp, ed. and trans., with Jean Stewart, *Diderot, Interpreter of Nature* (Westport CT: Hyperion, 1937; reprt. 1979), 49–63.

45. Lyon and Sloan, *From Natural History to the History of Nature*, 124–25.

46. D'Alembert, *Preliminary Discourse*, 27. On d'Alembert's disaccord with the position of Diderot and Buffon concerning the importance of mathematics, see Hankins, *Jean d'Alembert*, 85–96.

47. Hankins, *Jean d'Alembert*, 28, 3–4, and 94–97. See also Hankins, *Science and the Enlightenment*, chap. 2, esp. 17–28. D'Alembert's belief in the primacy of "rational science," which is to say the prior status of analysis over experimentation, is a major motif in Hankins's *Jean d'Alembert* (see index entries under "Rationalism"). For this reason Hankins asserts that "D'Alembert's positivism and rationalism were much more extreme than anything Newton ever professed and he can be classified as a Newtonian only with serious qualification" (*Jean d'Alembert*, 3).

48. On Diderot's position, see Hankins, *Science and the Enlightenment*, 16–17, 28, 45. Also see Kemp, *Diderot, Interpreter of Nature*, 49–63.

49. Hankins, *Jean d'Alembert*, 47–49. Hankins observes: "D'Alembert believed that any mathematical curve, if it were to be treated adequately in the calculus, had to be like a vibrating string: continuous, without any breaks or kinks in it, and stretched between fixed end points. Euler argued that these were unnecessary restrictions and that a mathematical function could describe any curve, even one 'drawn by hand,' as long as the function was defined over the periodic interval" (Hankins, *Science and the Enlightenment*, 28). On the debate about functions, see also Judith V. Grabiner, *The Origins of Cauchy's Rigorous Calculus* (Cambridge MA: MIT, 1981), 88–90.

50. On the seventeenth-century background to d'Alembert's mechanical understanding of geometry, see Peter Dear, *Discipline & Experience: The Mathematical Way in the Scientific Revolution* (Chicago: University of Chicago, 1995), 210–16.

51. A clear example of how thinking with diagrams can bridge productively the limits of physical and mathematical space is the work on pendulums and the cycloid done around 1660 by Christiaan Huygens. See Michael S. Mahoney, "Drawing Mechanics," in *Picturing Machines: 1400–1700*, ed. Wolfgang Lefèvre (Cambridge MA: MIT, 2004), esp. 289–97. A twentieth-century example would be what Matt Ridley reports as Francis Crick's "habit of squinting in a special way at models to see them stereoscopically." Crick recalled his ability to see intuitively the space-group symmetry of a crystal's unit cell: "Although it is necessary to be able to handle the algebraic details, I soon found I could see the answer to many of these mathematical problems by a combination of imagery and logic, without first having to slog through the mathematics." See Matt Ridley, *Francis Crick: Discoverer of the Genetic Code* (New York: HarperCollins, 2006), 39.

52. Rotman, "Thinking Dia-Grams," 17–39, esp. 27–29.

53. On the controversy and some of the problems perceived at the time with the calculus, see Hankins, *Science and the En-*

lightenment, 22–28, and Morris Kline, *Mathematical Thought from Ancient to Modern Times* (New York: Oxford University, 1972), chap. 19. The calculus seemed to produce a paradox that was unresolved until the nineteenth century. These uncertainties produced debates about the standing of the calculus as a form of knowledge and also about the implications for theology of its manipulations of infinitude. Buffon entered the fray on these issues in the preface to his translation of Newton's calculus, *La méthode des fluxions, et des suites infinies* par M. le Chevalier Newton (Paris: Chez de Bure l'Aîné, 1740).

54. D'Alembert, *Preliminary Discourse*, 44.

55. See, for instance, Ivor Grattan-Guinness, *The Norton History of Mathematical Sciences* (New York: W. W. Norton, 1998), chap. 5, "The Calculus and Its Consequences," esp. 295–98; Gerd Gigerenzer et al., *The Empire of Chance: How Probability Changed Science and Everyday Life* (Cambridge UK: Cambridge University, 1989), chap. 1; Brett D. Steele, "Muskets and Pendulums: Benjamin Robins, Leonhard, Euler, and the Ballistics Revolution," *Technology and Culture* 35, 2 (1994): 348–82; Simon Schaffer, "'The charter'd Thames': Naval Architecture and Experimental Spaces in Georgian Britain," in *The Mindful Hand: Inquiry and Invention from the Late Renaissance to Early Industrialisation*, eds. Lissa Roberts, Simon Schaffer, and Peter Dear (Amsterdam: Royal Netherlands Academy of Arts and Sciences, 2007), 279–305.

56. Hankins, *Jean d'Alembert*, 7.

57. Michael Mahoney characterizes Huygens's use of drawings as "a visual interface between the physical and the mathematical" in "Drawing Mechanics," esp. 289–306. For a more detailed account, see Michael S. Mahoney, "Huygens and the Pendulum: From Device to Mathematical Relation," in *The Growth of Mathematical Knowledge*, eds. Herbert Breger and Emily Grosholz (Dordrecht: Kluwer Academic Publishers, 2000), 17–39, and "Charting the Globe and Tracking the Heavens: Navigation and the Sciences in the Early Modern Era," in *The Heirs of Archimedes: Science and the Art of War through the Age of Enlightenment*, eds. Brett D. Steele and Tamera Dorland (Cambridge MA: MIT, 2005), 221–30. For a gloss, see Grattan-Guinness, *The Norton History of Mathematical Sciences*, 268–71.

58. See Steele, "Muskets and Pendulums," 355, 366, 638–67, et passim.

59. Lyon and Sloan, *From Natural History to the History of Nature*, 125.

60. The combination would not be attempted academically in France until the founding of the École Polytechnique in 1792 by the National Convention, and the shift of its curriculum toward the application of abstract mathematics by Pierre-Simon Laplace beginning in 1795. See Bruno Belhoste, "Un modèle à l'épreuve: L'École polytechnique de 1794 au Second Empire," in *La Formation polytechnicienne, 1794–1994*, eds. Bruno Belhoste, Amy Dahan Dalmedico, and Antoine Picon (Paris: Dunod, 1994), 9–30, esp. 17–23. See also Roger Hahn, *Le système du monde: Pierre-Simon Laplace, un itinéraire dans la science*, trans. Patrick Hersant (Paris: Gallimard, 2004), chap. 7.

61. Kafker and Kafker, *The Encyclopedists as Individuals*, 239–40.

62. On Jaucourt, see ibid., 175–80. His insight as a literary critic representative of his age is indicated by the citations in Nisbet and Rawson, *The Cambridge History of Literary Criticism* 4, passim.

63. See Wellbery, *Lessing's Laocoon*.

64. Charles Le Brun, *L'expression des passions & autres conférences*, ed. Julien Philipe (Paris: Éditions Dédale, 1994); *The Passions Of The Soul: As They Are Expressed In The Human Countenance, Shewing Its Various Changes & Appearances Under The Influence Of Different Passions: Engraved In A Manner Which Represents Real Drawings Almost As Large As Life From The Celebrated Designs Of Monsieur Le Brun, With Extracts From His Discourse On The Passions, Describing Their Influence On The Features And Muscles Of The Face* (London: Robert Wilkinson, 177-?).

65. See the discussion in Jay Fliegelman, *Declaring Independence: Jefferson, Natural Language, and the Culture of Performance* (Stanford CA: Stanford University, 1993), 30. Fliegelman quotes from Thomas Sheridan, *A Course of Lectures on Elocution. . . .* (London: A. Millar et al., 1762), reprinted by the Scolar Press (Menson UK, 1968), x.

66. As quoted from *Lectures on Elocution*, 99, in Wilbur Samuel Howell, *Eighteenth-Century British Logic and Rhetoric*

(Princeton NJ: Princeton University, 1971), 241–42. On the elocutionary movement in France and in Britain, see Howell, chap. 4, esp. 160–81 on the Continental background and Michel Le Faucheur.

67. "Éloge de Richardson," in Diderot, *Œuvres*, 4: 157, and 159.

68. See John Bender, "Enlightenment Fiction and the Scientific Hypothesis," *Representations* 61 (1998): 6–28.

69. David Hume, *A Treatise of Human Nature*, eds. L. A. Selby-Bigge and P. H. Nidditch, 2nd ed. (Oxford: Clarendon, 1978), 265; see 255–65 and the following account of "custom."

70. Ibid., 266–67. On Hume's ideas about the relationship of philosophy to the necessary illusions of common life, see Donald W. Livingston, *Hume's Philosophy of Common Life* (Chicago: University of Chicago, 1984), and Engell, *The Creative Imagination*, chap. 5.

71. Hume, *A Treatise of Human Nature*, 630–31 (emphasis in the original). Note that Hume continues at once to discuss precisely the paradox of such keen interest to Jaucourt—that we may gain aesthetic pleasure from the pain of others.

72. Larry Stewart, *The Rise of Public Science: Rhetoric, Technology, and Natural Philosophy in Newtonian Britain, 1660–1750* (Cambridge UK: Cambridge University, 1992).

73. Joseph Priestly, *The Theological and Miscellaneous Works of Joseph Priestly*, 25 vols., ed. John Towll Rutt (London: G. Smallfield, 1817–31), 24: 27–28.

CHAPTER 4

1. *Supplément à l'Encyclopédie, ou Dictionnaire raisonné des Sciences, des Arts et des Métiers par une Société de gens de lettres*, 4 vols., ed. Jean-Baptiste Robinet (Amsterdam: M. M. Rey, 1776–77).

2. Roger Hahn, *The Anatomy of a Scientific Institution: The Paris Academy of Sciences, 1666–1803* (Berkeley: University of California, 1971), 86.

3. Ibid., 87–91.

4. Ibid., 106.

5. Ibid., 108–110. Also see, more generally, Roger Hahn, "The Application of Science to Technology: The Societies of Arts," *Studies on Voltaire and the Eighteenth Century* 25 (1963): 829–36.

6. Robert Darnton, *Mesmerism and the End of the Enlightenment in France* (Cambridge MA: Harvard University, 1968), 10–20.

7. See ibid., 64n10: *Rapport des commissaires chargés par le Roi de l'examen du magnétisme animal*, drafted by Bailly (Paris: Moutard, 1784); *Rapport des commissaires de la Société Royale de Médécine, nommés par le Roi pour faire l'examen du magnétisme animal* (Paris: Imp. royale, 1784).

8. Hahn, *Anatomy*, 95–96.

9. Hahn, *Le système du monde*, 45–52 and 62–68.

10. For a discussion of this issue relative to the theater, see Angelica Goodden, *Actio and Persuasion: Dramatic Performance in Eighteenth-Century France* (Oxford: Clarendon, 1986), 28–47.

11. Diderot, *Lettre sur les sourds et le muets*, *Œuvres*, 4: 21.

12. Diderot, *De la poésie dramatique*, *Œuvres*, 4: 1279.

13. Derek F. Connon, *Innovation and Renewal: A Study of the Theatrical Works of Diderot* (Oxford: Voltaire Foundation, 1989), 100–104.

14. Diderot, *Entretiens sur le Fils naturel*, *Œuvres*, 4: 1136. See the important discussion of this passage and its critical implications in Pierre Frantz, *L'esthétique du tableau dans le théâtre du XVIIIe siècle* (Paris: Presses Universitaires de France, 1998), 153–95.

15. Angelica Goodden, "'Une Peinture Parlante': The *Tableau* and the *Drame*," *French Studies* 38, 4 (October 1984): 397–413; Dorothy Johnson, "Corporality and Communication: The Gestural Revolution of Diderot, David, and *The Oath of the Horatii*," *Art Bulletin* 71 (March 1989): 92–113; Fried, *Absorption and Theatricality*, 92–105; Connon, *Innovation and Renewal*, esp. 128–32.

16. Diderot, *De la poésie dramatique*, *Œuvres*, 4: 1310.

17. For a full discussion of the "fourth wall," see Frantz, *L'esthétique du tableau*, 60–71.

18. Crébillon, *Lettre sur les spectacles*, cited in Adolphe Jullien, *Les Spectateurs sur le Théâtre : Établissement et suppression des Bancs sur les Scènes de la Comédie-Française et de l'Opéra* (Paris: A. Detaille, 1875), 8.

19. "Mémoire qui tend à prouver la nécessité de supprimer les banquettes de dessus le théâtre de la Comédie-Française, en séparant ainsi les acteurs des spectateurs," in Henri-Louis Lekain, *Mémoires de Lekain, précédé de réflexions sur cet acteur et sur l'art théâtral par François-Joseph Talma* (Paris: E. Ledoux, 1825), 135ff.

20. Voltaire remarked: "One of the biggest obstacles in our theater that stands in the way of any grand or pathetic action is the crowd of onlookers mixed up on stage with the actors: this indecency was especially felt at the opening performance of *Semiramis*. . . . That error was corrected in subsequent performances of *Semiramis*, and it could easily be abolished forever." Cited from *Dissertation sur la tragédie ancienne et moderne*, in *Théâtre complet de M. Voltaire*, 9 vols. (Caen: G. Le Roy, 1788), 3: 364. Also see the discussion in Frantz, *L'esthétique du tableau*, 42–60.

21. Charles Collé, "Avril 1759," in *Journal et Mémoires*, 3 vols., nouv. éd. (Paris: Firmin-Didot, 1868), 2: 172.

22. Gösta M. Bergman, *Lighting in the Theatre* (Stockholm: Almqvist & Wiksell, 1977), 175. See also David Alston, "David et le théâtre," in *David contre David*, 2 vols., ed. Régis Michel (Paris: La documentation française, 1993), 1: 165–98.

23. Bergman, *Lighting in the Theatre*, 175

24. Diderot, *Éléments de physiologie*, *Œuvres*, 1: 1284.

25. Ibid., 1287.

26. Ibid., 1285.

27. Ibid.

28. Diderot, *Entretiens sur le Fils naturel*, *Œuvres*, 4: 1343.

29. Diderot, *De la poésie dramatique*, *Œuvres*, 4: 1143.

30. For a succinct survey of pantomime in France during the eighteenth century, see Goodden, *Actio and Persuasion*, 94–111. About the fashion for pantomime in Paris, see Gösta M. Bergman, "La grande mode des pantomimes à Paris vers 1740 et les spectacles d'optique de Servandoni," *Theatre Research / Recherches Théâtrales* 2, 2 (1960): 71–81. On the debate about pantomime in the theater, see Frantz, *L'esthétique du tableau*, 115–52, and Kirsten Gram Holmström, *Monodrama–Attitudes–Tableaux Vivants: Studies on Some Trends of Theatrical Fashion 1770–1815* (Stockholm: Almqvist & Wiksell, 1967), 11–40.

31. Marmontel, "Déclamation (Belles-Lettres)," *Encyclopédie*.

32. "In those sections where none of the dance steps were very obvious, our two novice pantomimes so mutually enlivened one another by their gestures and movements that they went so far as to shed tears. One need not ask if they moved the audience." Jean-Baptiste Dubos, *Réflexions critiques sur la Poésie et sur la Peinture*, 7th ed., 3 vols. (Paris: Pissot, 1770; rpt. Geneva: Slatkine, 1967), 3: 311–14. The particular scene described by Dubos, in which young Horace kills his sister, will return in our discussion of David's *Oath of the Horatii*.

33. Ibid., 1: 413.

34. Ibid., 1: 424; Holmström, *Monodrama*, 15–21; Frantz, *L'esthétique du tableau*, 20–23.

35. Diderot, *Lettre sur les sourds et muets*, *Œuvres*, 4: 17.

36. Diderot, *De la poésie dramatique*, *Œuvres*, 4: 1337.

37. Ibid., 1303. In a passage where Diderot expresses his admiration for the "details of Richardson" he also remarks that "sometimes the gesture is as sublime as the word" (Diderot, *Éloge de Richardson*, *Œuvres*, 4: 159).

38. Diderot, *De la poésie dramatique*, *Œuvres*, 4: 1336.

39. "I have said that pantomime is a part of drama; that the author should attend to it in earnest; that if it is not familiar to him and on his mind, he will neither know how to begin, nor manage, nor finish his scene with some kind of truth; that sometimes gesture should be written in place of speech" (ibid., 1337).

40. Ibid., 1343.

41. Ibid., 1342.

42. Diderot, *Entretiens sur le Fils naturel*, *Œuvres*, 4: 1137.

43. Diderot, *De la poésie dramatique*, *Œuvres*, 4: 1432.

44. Denis Diderot, *Correspondance*, ed. Georges Roth, 16 vols. (Paris: Éditions de Minuit, 1955–70), 3: 291. Cited in Connon, *Innovation and Renewal*, 26.

45. Diderot, *Entretiens sur le Fils naturel*, *Œuvres*, 4: 1137.

46. Diderot, *De la poésie dramatique*, *Œuvres*, 4: 1338.

47. Ibid., 1343.

48. Diderot, "Lettre à Madame Riccoboni," *Œuvres*, 5: 81.

49. Mlle [Hippolyte] Clairon, *Mémoires de Mlle Clairon*, nouv. éd (Paris: Ponthieu, 1822; rpt. Geneva: Slatkine Reprints, 1968), 268. For a discussion, see Holmström, *Monodrama*, 28–29.

50. Fleury [pseud. Joseph-Abraham Bénard], *Mémoires de Fleury de la Comédie-Française, 1789–1820*, 6 vols. (Paris: Ambroise Dupont, 1835–38), 4: 73–74.

51. Louise-Rosalie Dugazon, cited in Jean-Joseph Regnault-Warin, *Mémoires historiques et critiques sur F.-J. Talma et sur l'art théâtral* (Paris: A. Henry, 1827), 111–13.

52. Diderot, *De la poésie dramatique*, *Œuvres*, 4: 1323.

53. Connon, *Innovation and Renewal*, 24. Connon suggests that Diderot uses the word "pantomime" for lack of any better term to suggest gestures other than the standard repertoire.

54. Diderot, "Beau," *Encyclopédie*.

55. Michael Cardy, *The Literary Doctrines of Jean-François Marmontel* (Oxford: Voltaire Foundation, 1982), 118–22. Marmontel wrote over one hundred articles for the supplement, chiefly in the summer of 1772. For a comprehensive account of the supplement and its relationship to the *Encyclopedia*, see Kathleen Hardesty, *The Supplement to the Encyclopédie* (The Hague: Martinus Nijhoff, 1977).

56. Marmontel, "Pantomime," *Supplément*.

57. Marmontel distances himself from Jaucourt when writing about his engagement to prepare some articles for the supplement to the *Encyclopedia*: "You must know that after publication of the seventh volume of the *Encyclopedia* the following volumes, having been suspended by a decision of the court of justice, were worked on silently by a small number of collaborators that did not include me. A hardworking compiler, the Chevalier de Jaucourt, was entrusted with the literary section and worked it up in his own style, which was not mine." Jean-François Marmontel, *Mémoires*, eds. Jean-Pierre Guicciardi and Gilles Thierriat (Paris: Mercure de France, 1994), 318.

58. Jean-François Marmontel, "Drame," *Œuvres complètes de Marmontel*, 19 vols. (Paris: chez Verdière, 1818), 13: 189.

59. Marmontel, "Arts libéraux," *Supplément*.

60. Marmontel, "Pantomime," *Supplément*.

61. Diderot, *De la poésie dramatique*, *Œuvres*, 4: 1279–80.

62. Marmontel, "Drame," *Œuvres complètes*, 13: 189, 176, 186.

63. Marmontel, "Description," *Supplément*. The discussion that follows both quotes and paraphrases this article.

64. Marmontel, "Déclamation (théâtrale)," *Encyclopédie*.

65. Marmontel, "Illusion," *Supplément*. The discussion that follows both quotes and paraphrases this article.

66. Marmontel, "Poète," *Œuvres complètes*, 15: 82. Cited by Cardy, *Literary Doctrines*, 112. In chapter 4 Cardy offers a full account of Marmontel's place in eighteenth-century French theater.

67. Marmontel, "Essai sur les Révolutions de la Musique en France," *Œuvres complètes*, 10: 404. Cited by Annie Becq, "Les idées esthétiques de Marmontel," in *Jean-François Marmontel (1723–1799)*, ed. Jean Ehrard (Clermont-Ferrand: G. de Bussac, 1970), 171.

68. Annie Becq concludes: "These aesthetic analyses of pleasure, dispersed in the *Éléments de littérature* and sometimes adjacent to traditional notions that Marmontel was not willing to give up, have struck us as opening onto the modernist values of creative power and originality" ("Les idées esthétiques de Marmontel," 172–73).

69. Ibid., 171–73.

70. Marmontel, "Arts Libéraux," *Œuvres complètes*, 12: 286.

71. Diderot, "Beau," *Encyclopédie*.

72. See the discussion in Marc Buffat, "L'âme contre les sens ou l'esthéthique spiritualiste des Éléments de littérature," in *Marmontel: Une rhétorique de l'apaisement*, ed. Jacques Wagner (Louvain: Éditions Peeters, 2003), 35–49.

73. Marmontel, "Vraisemblance," *Œuvres complètes*, 15: 540–41.

74. Marmontel, "Poète," *Œuvres complètes*, 15: 82. Cited by Cardy, *Literary Doctrines*, 112.

75. Marmontel, "Illusion," *Encyclopédie*.

76. Diderot, "Beau," *Encyclopédie*.

77. Salon of 1781, no. 311 under the title *Bélisaire reconnu par un soldat qui avait servi sous lui, au moment qu'une*

femme lui fait l'aumône. The picture is now in the Musée des Beaux-Arts at Lille, inventory P. 436. For a complete bibliography on the picture, see Paris, Musée du Louvre, *Jacques-Louis David 1748–1825*, exhibition catalogue (Paris: Réunion des Musées Nationaux, 1989), no. 47.

78. For a modern reprint with a comprehensive introduction, see Jean-François Marmontel, *Bélisaire*, ed. Robert Granderoute (Paris: Société des Textes Français Modernes, 1994). About the controversy, see John Renwick, "Marmontel, Voltaire, and the *Bélisaire* Affair," *Studies in Voltaire and the Eighteenth Century* 121 (1975): 155–305; Albert Boime, "Marmontel's *Bélisaire* and the Pre-Revolutionary Progressivism of David," *Art History* 3, 1 (March 1980): 81–101; Thomas Crow, *Painters and Public Life in Eighteenth-Century Paris* (New Haven CT: Yale University, 1985), 198–200.

79. Crow, *Painters and Public Life*, 189.

80. Kafker and Kafker, *Encyclopedists as Individuals*, 252.

81. Boime, "Marmontel's *Bélisaire*," 91–94; Crow, *Painters and Public Life*, 196–209.

82. Peyron's 1779 picture, *Bélisaire reçevant l'hospitalité d'un paysan ayant servi sous ses ordres*, is now in the Musée des Augustins at Toulouse, inventory RO-195.

83. Boime, "Marmontel's *Bélisaire*," 87–88. Michael Fried argues that an engraving after a picture by Antony van Dyck, about which Diderot wrote a commentary, was an important source for David (*Absorption and Theatricality*, 146–48).

84. Norman Bryson, *Tradition and Desire: From David to Delacroix* (Cambridge UK: Cambridge University, 1984), 54–62.

85. Diderot, "Salon de 1781," *Œuvres*, 4: 998.

86. Crow, *Painters and Public Life*, 204–6; Fried, *Absorption and Theatricality*, 155–58.

87. "Every time that it [description] has listeners on stage, the reader puts himself in their place, and it's from there that he sees the tableau" (Marmontel, "Description," *Supplément*).

88. For a complete bibliography on this replica, see Paris, Musée du Louvre, *Jacques-Louis David*, no. 51.

89. See "Lettre de Madame Riccoboni," in Diderot, *Œuvres*, 10: 434–35. For Diderot's response, which included a call for better-designed theaters and the exhortation for actors to speak more forcefully, see "Lettre à Madame Riccoboni," in *Œuvres*, 10: 440–41. For a discussion of this exchange, see Bergman, *Lighting in the Theatre*, 77.

90. Jean-Georges Noverre, *Observations sur la construction d'une salle d'Opéra* (Paris, 1781), discussed in Bergman, *Lighting in the Theatre*, 188.

91. Antoine Laurent de Lavoisier, *Mémoire sur la manière d'éclairer les salles de spectacles* (Paris, 1781), discussed in Bergman, *Lighting in the Theatre*, 189–92.

92. Charles-Nicholas Cochin, *Lettres sur l'Opéra* (Paris, 1781), discussed in Bergman, *Lighting in the Theatre*, 189–90.

93. Pierre Patte, *Essai sur l'architecture théâtrale* (Paris, 1782), discussed in Bergman, *Lighting in the Theatre*, 193–95.

94. Diderot, "Salon de 1781," *Œuvres*, 4: 998.

95. About Peyron's lending the book to David, see Pierre Rosenberg and Udolpho van Sandt, *Pierre Peyron, 1744–1814* (Paris: Arthena, 1983), 93.

96. Diderot, "Salon de 1781," *Œuvres*, 4: 998.

97. Alexandre Péron, *Examen du tableau du serment des Horaces peint par David* (Paris: Impr. de Ducessois, 1839), 27–28.

98. A drawing now in the Albertina at Vienna (inventory 12676), dated 1781 and presumably by David, represents the actual murder and suggests the painter's interest in the story well before his reported attendance at a production of Corneille's play. A second drawing now in the Louvre depicts the scene of old Horace defending his son (inventory RF1917r).

99. Thomas Crow, *Emulation: Making Artists for Revolutionary France* (New Haven CT: Yale University, 1995), 38, and Crow, *Painters and Public Life*, 212–13; Norman Bryson, *Word and Image: French Painting of the Ancien Régime* (Cambridge UK: Cambridge University, 1981), 231–33. See also Antoine Schnapper's catalogue entry for the picture in Paris, Musée du Louvre, *Jacques-Louis David*, 166.

100. The classic studies of David's invented conceit are Edgar Wind, "The Sources of David's *Horaces*," *Journal of the Warburg and Courtauld Institutes* 4 (1940–41): 124–38, and Robert Rosenblum, "Gavin Hamilton's *Brutus* and Its

Aftermath," *Burlington Magazine* 103 (1961): 8–16. See also Andrew Stewart's suggestion that ancient sculptures arranged to show the battle among the warring brothers at the Palazzo Farnese might have shaped David's thinking: Andrew Stewart, "David's *Oath of the Horatii* and the *Tyrannicides*," *Burlington Magazine* 143 (2001): 212–19.

101. Johann Heinrich Wilhelm Tischbein, "Briefe aus Rom, über neue Kunstwerke jetzlebenden Künstler," *Der Teutscher Merkur* (February 1786), in *The Triumph of Art for the Public, 1785–1848: The Emerging Role of Exhibitions and Critics*, ed. Elizabeth Gilmore Holt (New York: Anchor Books, 1979), 18–19 (our emphasis).

102. During the months just before David left Paris to paint the *Horatii* in Rome, he was deeply involved with the Comédie-Française in selecting a new stage set designer. See Alston, "David et le théâtre," 171–76, and Bergman, *Lighting in the Theater*, 200–203.

103. Crow, *Painters and Public Life*, 215–41, and Crow, "Painting and Pre-Revolutionary Radicalism in France," *Art History* 1, 4 (December 1978): 424–71.

104. "Exposition des Tableaux au Louvre," *Mercure de France*, September 1785, *Deloynes Collection* no. 348, 758–59. Cited in Crow, *Painters and Public Life*, 214. All translations used here are Crow's.

105. "Supplément du Peintre Anglais au Salon," *Deloynes Collection*, no. 328, 4. Cited in Crow, *Painters and Public Life*, 214–15.

106. "Supplément du Peintre Anglais au Salon," *Deloynes Collection*, no. 328, 2–3. Cited in Crow, *Painters and Public Life*, 219.

107. "Promenade de Critès au Sallon de l'année 1785," *Deloynes Collection*, no. 333, 35. Attributed to Gorsas and cited in Crow, *Painters and Public Life*, 227.

108. Ibid.

109. Ibid., 226–27.

110. *Avis important d'une femme sur le Salon de 1785 par Madame E.A.R.T.L.A.D.C.S. Dédié aux femmes, Deloynes Collection*, no. 344, 29–30. Cited in Crow, *Painters and Public Life*, 236.

111. Frederick Antal, "Reflections on Classicism and Ro-

manticism," in *Classicism and Romanticism with Other Studies in Art History* (New York: Basic Books, 1966), 9.

112. Crow, *Painters and Public Life*, 220.

113. Stafford, *Body Criticism*, 18.

114. Barthes, "The Plates of the Encyclopedia," 231–34.

115. Fried, *Absorption and Theatricality*, 193n81.

116. Delécluze reports that David admitted "at that time my eyes were still so unrefined that, far from being able to train them profitably by steering them towards exquisite paintings such as those by Andrea del Sarto, Titian, or the most skilled colorists, they really only perceived and fully understood works executed brutally but otherwise full of merit—the Caravaggios, the Riberas, and those of Valentin who was their student. For me, taste, habits, even intelligence had something of Gallic coarseness, of uncouthness, which had to be thrown off to reach the state of erudition and purity without which one admires only dimly the *stanze* of Raphael, without understanding anything about them and not knowing how to make the most of them" (Étienne Delécluze, *Louis David: Son école et son temps* [Paris: Didier, 1855], 114).

117. Norman Bryson underscores this feature of the *Horatii*. See Bryson, *Word and Image*, 229–30, and *Tradition and Desire*, 76–80.

118. Roland Barthes, *On Racine*, trans. Richard Howard (New York: Hill and Wang, 1964), 21–22.

119. See Cardy, *Literary Doctrines*, chap. 4, esp. 119–20.

120. Kafker and Kafker, *Encyclopedists as Individuals*, 251–52.

121. Marmontel, "Drame," *Œuvres*, 13: 178 and 180.

122. Boime, "Marmontel's *Bélisaire*," 91–94.

123. The classic account of d'Angiviller's efforts, as *Directeur général des Bâtiments du Roi*, to reanimate the noble genre of history painting is Jean Locquin, *La Peinture d'Histoire en France de 1747 à 1785* (Paris: 1912; rpt. Paris: Arthena, 1978), 41–69. See also Crow, *Painters and Public Life*, 186–98.

124. Letter from d'Angiviller to Pierre dated 4 July 1775, reprinted in "Correspondance de M. d'Angiviller avec Pierre," ed. Marc Furcy-Raynaud, *Nouvelles Archives de l'Art Français*, 3rd series, 22 (1905): 45–46.

125. Letter from d'Angiviller to Pierre dated 14 March

1776, reprinted in "Correspondance de M. d'Angiviller avec Pierre," 80–81.

126. For a complete bibliography on the work and its history, see Paris, Musée du Louvre, *Jacques-Louis David*, 162–71.

127. Daniel Wildenstein and Guy Wildenstein, *Documents complémentaires au Catalogue de l'œuvre de Louis David* (Paris: Fondation Wildenstein, 1973), nos. 110–13. The painting is on deposit at the Louvre.

128. O¹ 1925b, cited in Paris, Musée du Louvre, *Jacques-Louis David*, 164. A letter from Pierre to d'Angiviller dated 2 January 1784 shows that David was proposing two possibilities: Horace defended by his father at the moment of being arrested for killing his sister, and the oath of the Horatii in the presence of their father. A marginal note on the document suggests that d'Angiviller preferred the first subject.

129. Wildenstein and Wildenstein, *Documents complémentaires*, nos. 119, 125, 131.

130. Ibid., nos. 138–43.

131. Ibid., nos. 145, 147. Shortly afterwards, Lagrenée wrote to d'Angiviller that the *Horatii* would be ready for transport in about two weeks. One of the first critical reviews appeared in the *Giornale delle belle arti* on 30 July 1785.

132. Wildenstein and Wildenstein, *Documents complémentaires*, no. 152. He trusts that Bièvre will do his best to explain the increase in size—and presumably price—to d'Angiviller.

133. Ibid., no. 132.

134. Pierre Rosenberg and Louis-Antoine Prat, *Jacques-Louis David, 1748–1825: Catalogue raisonné des dessins*, 2 vols. (Milan: Mondadori Electa, 2002), 2: no. 1306 (Folio 23r) and no. 1328 (Folio 45r).

135. Ibid., no. 1327 (Folio 44v). The French Academy at Rome owned a cast of Houdon's *écorché*.

136. Rosenberg and Prat, *David*, 2: no. 1308 (Folio 25v).

137. Ibid., no. 1286 (Folio 2v).

138. For clarifications of this soft upper limb, see the sketches at Lille and the Louvre (Paris, Musée du Louvre, *Jacques-Louis David*, nos. 68 and 71).

139. Rosenberg and Prat, *David*, 2: no. 1367 (Folio 84r). David's comment is written in broken phrases, reflected in our citation by ellipses.

140. See Michael Fried, *Courbet's Realism* (Chicago: University of Chicago, 1990), chap. 2, esp. 68.

141. Crow, *Painters and Public Life*, 240.

142. Ibid., 235–41. The quotation comes from an anonymous pamphlet of 1787 cited and translated by Crow.

143. Tischbein, "Briefe aus Rom," 18–19, 21, 23. The Roman journal is *Memorie per le belle Arti* 1 (September 1785): 135–44, reprinted in Holt, *Triumph of Art*, 24–28.

144. The issue has a long history in the Western tradition. See Svetlana Alpers, "Describe or Narrate?" *New Literary History* 8 (1976–77): 15–41. See also Thomas Puttfarken, *The Discovery of Pictorial Composition: Theories of Visual Order in Painting, 1400–1800* (New Haven CT: Yale University, 2000), chap. 12.

145. Much is made in the literature on the *Horatii* of David's successive stripping away of descriptive details in tandem with the gradual clarification of its narrative structure. See, for example, Robert Rosenblum, *Transformations in Late Eighteenth-Century Art* (Princeton, NJ: Princeton University, 1967), 71–72, and Crow, *Painters and Public Life*, 236–38.

146. See especially Fried, *Absorption and Theatricality*, chap. 1.

147. Ibid., 100–105.

148. The history of this literary phenomenon is discussed in Roy Pascal, *The Dual Voice: Free Indirect Speech and Its Functioning in the Nineteenth-Century European Novel* (Manchester UK: Manchester University, 1977), esp. 34–60, and Banfield, *Unspeakable Sentences*, notably 228–32.

149. Pascal, *Dual Voice*, 9.

150. Banfield, *Unspeakable Sentences*, 185.

151. Shapin and Schaffer, *Leviathan and the Air-Pump*, 60–65.

152. Pascal, *Dual Voice*, 34, and Banfield, *Unspeakable Sentences*, 233.

153. Pascal, *Dual Voice*, 20.

CHAPTER 5

1. James Elkins, "Clarification, Destruction, and the Negation of Pictorial Space in the Age of Neoclassicism, 1750–1840," *Zeitschrift für Kunstgeschichte* 56 (1990): 560–82,

notably 567. For a broad discussion of perspective from the Renaissance onward, see Elkins, *The Poetics of Perspective*, especially "Mathematics and Perspective," 273–78. For the place of Albertian perspective in the larger context of Renaissance geometry, see George L. Hersey, *Architecture and Geometry in the Age of the Baroque* (Chicago: University of Chicago, 2000), 161–68.

2. Elkins, "Clarification," 572–74.

3. Daston, "Objectivity and the Escape from Perspective," 110–23.

4. Foucault, *The Order of Things*, 239–40 and 246.

5. Letter from Lagrange in Berlin to d'Alembert dated 21 September 1781, Joseph-Louis Lagrange, *Œuvres de Legrange*, 14 vols., ed. Joseph-Alfred Serret (Paris: Gauthier-Villars, 1867–92), 13: 368–70. Translation from Hankins, *Jean d'Alembert*, 99–100. Hankins notes that Diderot had expressed similar views in the mid-1750s.

6. For discussion of this moment in French mathematics, see Lorraine Daston, "The Physicalist Tradition in Early Nineteenth-Century French Geometry," *Studies in the History and Philosophy of Science* 17 (1986): 269–95.

7. François Pairault, *Gaspard Monge: Le fondateur de Polytechnique* (Paris: Tallandier, 2000), 24–25.

8. Citations from Boyer, *A History of Mathematics*, 531; and Alder, *Engineering the Revolution*, 139–40. See also, Peter-Jeffrey Booker, *A History of Engineering Drawing* (London: Chatto & Windus, 1963), chaps. 9 and 10; Joël Sakarovitch, *Épures d'architecture: De la coupe des pierres à la géométrie descriptive XVIe–XIXe siècles* (Basel: Birkäuser Verlag, 1998), chaps. III and IV; Grattan-Guinness, *The Norton History of the Mathematical Sciences*, 369; Daston, "The Physicalist Tradition," 280–81; and Bruno Latour, "Drawing Things Together," in Lynch and Woolgar, *Representation in Scientific Practice*, 52–53.

9. Daston, "Objectivity and the Escape from Perspective," 111.

10. Bruno Belhoste, Antoine Picon, and Joel Sakarovitch, "Les Exercices dans les écoles d'ingénieurs sous l'Ancien Régime et la Révolution," *L'Histoire de l'éducation* 46 (1990): 53–109, esp. 91–108 on the arduous training required to master descriptive geometry at the École Polytechnique.

11. Bruno Belhoste, "École de Monge, école de Laplace: le débat autour de l'École polytechnique" in *L'Institution de la raison: La Révolution des idéologues*, ed. François Azouvi (Paris: Vrin, 1992), 101–12. See also Belhoste, "Les origines de l'École Polytechnique: Des anciennes écoles d'ingénieurs à l'École centrale des travaux publics," *L'Histoire de l'éducation* 42 (1989): 13–53.

12. Belhoste, "École de Monge, école de Laplace," 106–7; Alder, *Engineering the Revolution*, 306–7.

13. Janis Langins, *La République avait besoin de savants* (Paris: Belin, 1987), 27–28.

14. *Extrait des Procès-Verbaux des Séances du Conseil d'administration de l'École centrale des travaux publics 20 pluviôse an III (8 février 1795)*, reprinted in Langins, *La République avait besoin de savants*, 116–19.

15. Pairault, *Gaspard Monge*, chaps. 5–7.

16. For an analysis of the letter written by Laplace to the director of the École Polytechnique in December 1796, see Janis Langins, "Sur l'enseignement et les examens à l'École polytechnique sous le Directoire: à propos d'une lettre inédite de Laplace," *Revue d'histoire des sciences* 40 (1987): 145–77. Laplace remarks that many of his examinees seem insufficiently trained in mechanics.

17. Bruno Belhoste, "Un modele à l'épreuve: L'École polytechnique de 1794 au Second Empire," in Bruno Belhoste, Amy Dahan Dalmedico, and Antoine Picon, *La Formation polytechnicienne, 1794–1994* (Paris: Dunod, 1994), 9–30, esp. 17–23.

18. Roger Hahn, "Le rôle de Laplace à l'École polytechnique," in Belhoste, Dalmedico, and Picon, *La Formation polytechnicienne, 1794–1994*, 45–57, esp. 54.

19. Belhoste, "Un modèle à l'épreuve," 20–22.

20. Alder, *Engineering the Revolution*, 308–10.

21. Roger Hahn, *Pierre Simon Laplace: A Determined Scientist* (Cambridge MA: Harvard University, 2005), 149. For full discussion of the *Celestial Mechanics*, see ibid. chap. 9, and Charles C. Gillispie, *Pierre-Simon Laplace, 1749–1827: A Life in Exact Science* (Princeton NJ: Princeton University, 1997), chap. 21.

22. Gillispie, *Laplace*, 13–28.

23. Hahn, *Pierre Simon Laplace*, 81–97.

24. Gillispie, *Laplace*, 78–84.

25. Cited in ibid., 15.

26. Ibid., 23–28; Hankins, *D'Alembert*, 145–49.

27. Cited and translated by Gillispie, *Laplace*, 27. On the place of Condorcet in discussions of probability, including the theories of Laplace, see Keith Michael Baker, *Condorcet: From Natural Philosophy to Social Mathematics* (Chicago: University of Chicago, 1975), 155–89. See also, Lorraine Daston, *Classical Probability in the Enlightenment* (Princeton NJ: Princeton University, 1988).

28. Pierre-Simon Laplace, *Théorie analytique des probabilités* (Paris: Courcier, 1812; rpt. Brussels: Culture et Civilisation, 1967), 177–78 (Bk. 2, chap. 1); discussed in Gillispie, *Laplace*, 224–28.

29. Adrien Marie Legendre, *Nouvelles méthodes pour la détermination des orbites des comètes* (Paris: Courcier, 1805), 72–73. On the importance of Legendre's formula, see Stephen M. Stigler, *The History of Statistics: The Measurement of Uncertainty before 1900* (Cambridge MA: Harvard University, 1986), 12–15 and 55–61; Theodore M. Porter, *The Rise of Statistical Thinking, 1820–1900* (Princeton NJ: Princeton University, 1986), 95–96. About the broader implications for objectivity when the method of least squares became widely accepted, see Swijtink, "The Objectification of Observation," 261–65.

30. In fact, its importance generated a heated controversy around the year 1809 between Legendre and Carl Friedrich Gauss, who claimed that the formula was his invention because he had been using it since 1795. Stigler suggests that although Gauss may have used the method he failed to see its implications until after Legendre's treatise had been published (Stigler, *History of Statistics*, 145–46).

31. R. Harris Inglis, "Address," in *Report of the Seventeenth Meeting of the British Association for the Advancement of Science held at Oxford in June 1847* (London, 1848), cited in Enrico Bellone, *A World on Paper: Studies on the Second Scientific Revolution*, trans. Mirella and Riccardo Giacconi (Cambridge MA: MIT, 1980), 36–37.

32. On the increasing importance of mathematics in the field of physics, see Ivor Grattan-Guinness, "Mathematical Physics in France, 1800–1840: Knowledge, Activity, and Historiography," in *Mathematical Perspectives: Essays on Mathematics and Its Historical Development*, ed. Joseph W. Dauben (New York: Academic Press, 1981), 95–138.

33. Carl Friedrich Gauss, *Theoria Motus Corporum Coelestium in Sectionibus Conicis Solum Ambientum* (Hamburg: Perthes et Besser, 1809).

34. Porter, *Rise of Statistical Thinking*, 93–100; Stigler, *History of Statistics*, 136–48; Alain Desrosières, *La Politique des grands nombres* (Paris: Éditions de la Découverte, 1993), 82–84.

35. Pierre-Simon Laplace, "Supplément au Mémoire sur les approximations des formules qui sont fonctions de très grands nombres et sur leur application aux probabilités," in *Mémoires de l'Académie des sciences de Paris*, 1er série, 10 (1810): 559–65. Republished in Pierre-Simon Laplace, *Oeuvres Complètes de Laplace*, 14 vols. (Paris: Gauthier-Villars, 1878–1912), 12: 349–53. Laplace's formulation of the central limit theorem was published as a last-minute supplement to this *mémoire*: see Stigler, *History of Statistics*, 143–45; Hahn, *Pierre Simon Laplace*, 176–79; and Gillispie, *Laplace*, 216–23.

36. Stigler, *History of Statistics*, 136–38; Gillispie, *Laplace*, 216–17.

37. Gillispie, *Laplace*, 218.

38. Stigler, *History of Statistics*, 158.

39. For the analogous development of working objects in organic chemistry following the adoption of the system of notation devised by Jacob Berzelius, see Ursula Klein, *Experiments, Models, Paper Tools: Cultures of Organic Chemistry in the Nineteenth Century* (Stanford CA: Stanford University, 2003). Klein shows that, increasingly from the 1820s onward, experiments were devised first on paper and served as guides in the laboratory for work in this physically complex field.

40. Pierre-Simon Laplace, *Essai philosophique sur les probabilités*, 5th ed. (Paris: Bachelier, 1825), 273–74. Laplace's view expanded regularly from the first edition of 1814 to include, as here, almost every branch of scientific knowledge.

41. For a succinct account of Quetelet's career and importance, see Stigler, *History of Statistics*, 161–220, and Porter, *Rise of Statistical Thinking*, 41–55 and 100–109. See also, Ian Hacking, *The Taming of Chance* (Cambridge UK: Cambridge

University, 1990), 105–14, and I. Bernard Cohen, *The Triumph of Numbers: How Counting Shaped Modern Life* (New York: Norton, 2005), 124–46.

42. A characteristic early work is Adolphe Quetelet, "Recherches sur la population, les naissances, les décès, les prisons, les dépôts de mendicité, etc., dans le royaume des Pays-Bas," *Nouveaux mémoires de l'Académie Royale des Sciences et Belles-Lettres de Bruxelles* 4 (1827): 117–92, with two plates.

43. Ibid., 122.

44. Ibid., 125.

45. Ibid., 127.

46. Howard Gray Funkhouser, "Historical Development of the Graphical Representation of Statistical Data," *Osiris* 3 (1938): 269–404, esp. 290–310.

47. Porter, *Rise of Statistical Thinking*, 47.

48. Adolphe Quetelet, *Sur l'homme et le développement de ses facultés, ou Essai de physique sociale* (Paris: Bachelier, 1835; rpt. Paris: Arthème-Fayard, 1991), esp. 491–522. The average man, according to Quetelet, "was always just what times and places made of him and required of him" (*Sur l'homme*, 508). See the discussion in Stigler, *History of Statistics*, 170–72.

49. Stigler, *History of Statistics*, 171.

50. Porter, *Rise of Statistical Thinking*, 106.

51. Quotation from Stigler, *History of Statistics*, 220. The later work of Wilhelm Lexis demonstrated the fallacy of assuming the persistence of causes from the binomial distribution of patterns: see Desrosières, *La Politique des grands nombres*, 119–21; Porter, *Rise of Statistical Thinking*, 247–55; Stigler, *History of Statistics*, 229–38.

52. Timothy Lenoir, "Operationalizing Kant: Manifolds, Models, and Mathematics in Hemholtz's Theories of Perception," in *The Kantian Legacy in Nineteenth-Century Science*, eds. Michael Friedman and Alfred Nordmann (Cambridge MA: MIT, 2006), 141–210, and "The Eye as Mathematician: Clinical Practice, Instrumentation, and Helmholtz's Construction of an Empiricist Theory of Vision," in *Hermann von Helmholtz and the Foundations of Nineteenth-Century Science*, ed. David Cahan (Berkeley: University of California, 1993), 109–53. On Herbart, also see Crary, *Techniques of the Observer*, 100–102.

53. Michael Friedman, *Kant and the Exact Sciences* (Cambridge MA: Harvard University, 1992), 29–34, quotation from 31.

54. Johann Friedrich Herbart, "Psychologie als Wissenschaft," as cited and translated in Timothy Lenoir, *Instituting Science: The Cultural Production of Scientific Disciplines* (Stanford CA: Stanford University, 1997), 143. Our account of Herbart's ideas relies especially on Lenoir, "Operationalizing Kant," 148–60.

55. Herbart, "Psychologie als Wissenschaft," as cited and translated in Lenoir, *Instituting Science*, 143 (emphasis in the original).

56. Lenoir, "Operationalizing Kant," 153.

57. Ibid., 156.

58. Hermann von Helmholtz, "The Facts of Perception," in *Helmholtz on Perception: Its Physiology and Development*, eds. Richard M. Warren and Roslyn P. Warren (New York: John Wiley & Sons, 1968), 218–19.

59. Helmholtz's lecture was eventually published in *Mind, A Quarterly Review* 1 (1876): 301–21. Land's response to the article is "Kant's Space and Modern Mathematics," *Mind* 2 (1877): 38–46. The published version of Helmholtz's rebuttal is "The Origin and Meaning of Geometric Axioms (II)," *Mind* 3 (1878): 212–25. Our citations are from the reprint in *Selected Writings of Hermann von Helmholtz*, ed. Russell Kahl (Middletown CT: Wesleyan University, 1971), 360–65, esp. 361.

60. Helmholtz, "Facts of Perception," 244.

61. Ibid., 212.

62. Hermann von Helmholtz, "The Origin of the Correct Interpretation of Our Sensory Impressions," in Warren and Warren, *Helmholtz on Perception*, 249–50; Hermann von Helmholtz, "The Recent Progress of the Theory of Vision," in Warren and Warren, *Helmholtz on Perception*, 128.

63. Hermann von Helmholtz, "Concerning the Perceptions in General," in Warren and Warren, *Helmholtz on Perception*, 191.

64. Helmholtz, "The Recent Progress," 130; Hermann von Helmholtz, *Treatise on Physiological Optics*, 3 vols., trans. from 3rd German edition, ed. James P. C. Southall (New York: Dover, 1962), 3: 4–5. For a full discussion, see R. Steven

Turner, "Consensus and Controversy: Helmholtz on the Visual Perception of Space," in *Hermann von Helmholtz and the Foundations of Nineteenth-Century Science*, ed. David Cahan (Berkeley: University of California, 1993), 154–204.

65. Helmholtz, "The Recent Progress," 61–81, citation from 80.

66. Helmholtz connected his research on the eye's physiology to the practice of painting in a lecture later published as "On the Relation of Optics to Painting," reprinted in Warren and Warren, *Helmholtz on Perception*, 139–68. There has been much further work on that essay and its implications, notably Lenoir, *Instituting Science*, chap. 6, and Crary, *Suspensions of Perception*, chap. 3.

67. Helmholtz, "The Recent Progress," 79.

68. Ibid., 72.

69. Helmholtz, *Treatise on Physiological Optics*, 3: 37–154.

70. Surveys of this experimentation include: Ernest Edmund Maddox, *Tests and Studies of the Ocular Muscles*, 3rd ed. rev. (Philadelphia: Keystone Publishing, 1907), and Bernice Barnes, "Eye Movements," *American Journal of Psychology* 16 (1905): 199–207.

71. Helmholtz, *Treatise on Physiological Optics*, 2: 1–5, citation 4.

72. Ibid., 228–61, citation 235.

73. Helmholtz, "Facts of Perception," 223.

74. Helmholtz, "The Recent Progress," 128 and 135.

75. Helmholtz, *Treatise on Physiological Optics*, 3: 66.

76. Ibid. 68.

77. Wilhelm Wundt was especially graphic in making the claim: "whenever we move the visual axis into a new position the eye proceeds just like a mathematician when he compensates for errors according to the rules of the probability calculus. The individual muscles behave like the individual observations, the lengthening and shortening which they experience in the transition to the new position behave like the unavoidable errors in observation, and the coefficients of resistance of the muscles behave exactly like the observational weightings." Wundt, "Über die Bewegung der Augen," cited and translated in Lenoir, "Operationalizing Kant," 193.

78. Thomas L. Hankins, "A 'Large and Graceful Sinuosity': John Herschel's Graphical Method," *Isis* 97 (2006): 605–33. Hankins places succinctly Herschel's historical situation: on one hand, he realized the importance and usefulness of mathematical reasoning; on the other, he strongly believed that graphical methods were able "to perform that which no system of calculation can possibly do, by bringing in the aid of the eye and hand to guide the judgment" (cited in ibid., 608).

79. In an undated letter usually assigned to the summer of 1850. The unsigned review by Herschel, "Quetelet on Probabilities," appeared in *The Edinburgh Review* 92 (1850). See James Clerk Maxwell, *Maxwell on Molecules and Gases*, eds. Elizabeth Garber, Stephen G. Brush, and C. W. F. Everett (Cambridge MA: MIT, 1986), 9. On Quetelet and Maxwell, see also 9–12. For further discussion of Quetelet and Maxwell, see Peter M. Harmon, *The Natural Philosophy of James Clerk Maxwell* (Cambridge UK: Cambridge University, 1998), 124–26; I. Bernard Cohen, "Scientific Revolutions, Revolutions in Science, and a Probabilistic Revolution 1800–1930," in Krüger, Daston, and Heidelberger, *The Probabilistic Revolution*, 1: 39–40. In this same collection, see Lorenz Krüger, "The Slow Rise of Probabilism: Philosophical Arguments in the Nineteenth Century," 1: 79–82.

80. Harmon, *The Natural Philosophy of James Clerk Maxwell*, 48–57. See also, David Lindley, *Boltzmann's Atom: The Great Debate That Launched a Revolution in Physics* (New York: Free Press, 2001), 69–71.

81. Letter dated 30 May, 1859. Maxwell, *Molecules and Gases*, 277–80. See also, Harmon, *The Natural Philosophy of James Clerk Maxwell*, 126–27.

82. On the chief criticism about the transfer of heat, which came from Rudolf Clausius, see Crosbie Smith, *The Science of Energy: A Cultural History of Energy Physics in Victorian Britain* (London: Athlone, 1998), 241–47; and Harmon, *The Natural Philosophy of James Clerk Maxwell*, 176–80. On viscosity and density, see Lorenz Krüger, "The Probabilistic Revolution in Physics, an Overview," in Krüger, Daston, and Heidelberger, *The Probabilistic Revolution*, 2: 375.

83. Maxwell, *Molecules and Gases*, 423 and 427. "On the Dynamical Theory of Gases" appears on 420–72.

84. Maxwell, *Molecules and Gases*, 123. "Introductory Lecture on Experimental Physics" appears on 110–25.

85. On Maxwell's reliance upon Laplace's statistical theories, see Harmon, *The Natural Philosophy of James Clerk Maxwell*, 124. See also, Maxwell, "On the Dynamical Evidence of the Molecular Constitution of Bodies," in *Molecules and Gases*, 217–37, esp. 220, where Maxwell counts Laplace among the "fathers" of dynamics.

86. Letter of 11 December 1867. *Maxwell on Heat and Statistical Mechanics: On "Avoiding All Personal Enquiries" of Molecules*, eds. Elizabeth Garber, Stephen G. Brush, and C. W. F. Everett (London: Associated University Presses, 1995), 176–78. Lord Kelvin first applied the name "daemon." For discussion of the daemon, see Smith, *The Science of Energy*, 239–67; Edward E. Daub, "Maxwell's Demon," *Studies in the History and Philosophy of Science* 1 (1970): 213–27; Stephen G. Brush, *The Kind of Motion We Call Heat: A History of the Kinetic Theory of Gases in the 19th Century*, 2 vols. (Amsterdam: North-Holland, 1976), 2: 587–98.

87. Maxwell, *Heat and Statistical Mechanics*, 220.

88. Smith, *The Science of Energy*, 251–52.

89. The relationship between Boltzmann and Maxwell is indirect and complex. See Maxwell, *Molecules and Gases*, "Introduction," esp. 18, 22–29, and 32–33. See also Lindley, *Boltzmann's Atom*, 39–41; Carlo Cercignani, *Ludwig Boltzmann: The Man Who Trusted Atoms* (Oxford: Oxford University, 1998), 198–200; Engelbert Broda, *Ludwig Boltzmann: Man, Physicist, Philosopher*, trans. Larry Gay (Woodbridge CT: Ox Bow, 1983), 68; and Brush, *The Kind of Motion We Call Heat*, 2: 432–47.

90. Ludwig Boltzmann, "Weitere Studien über das Wärmegleichgewicht unter Gasmolekülen," *Sitzungsberichte der Kaiserlichen Akademie der Wissenschaften in Wien* 66 (1872). On Quetelet, see Cohen, "Scientific Revolutions," 39.

91. Boltzmann, "Weitere Studien," cited and translated in Porter, *Rise of Statistical Thinking*, 113.

92. Cercignani, *Ludwig Boltzmann*, 88.

93. We will not discuss here the objection to the H-theorem raised in 1876 by Johann Josef Loschmidt, Boltzmann's older colleague at the University of Vienna. Loschmidt's paradox states that one cannot deduce an irreversible process from time-symmetric dynamics. Loschmidt pointed out that Boltzmann assumed molecular chaos—that velocities of colliding particles are uncorrelated and independent of position—but this surreptitiously introduced time-asymmetry into his formula.

94. Lindley, *Boltzmann's Atom*, 75, 84, and 88–93. See also, Cercignani, *Ludwig Boltzmann*, 86–102; and Broda, *Ludwig Boltzmann*, 77–93.

95. Cercignani, *Ludwig Boltzmann*, chap. 10, and Broda, *Ludwig Boltzmann*, 97–103.

96. Maxwell, *Molecules and Gases*, 47.

97. Our account is distilled from the following sources: Lindley, *Boltzmann's Atom*, 83–93; Broda, *Ludwig Boltzmann*, 79–81; Cercignani, *Ludwig Boltzmann*, 86–95; Thomas S. Kuhn, "What Are Scientific Revolutions?" in Krüger, Daston, and Heidelberger, *The Probabilistic Revolution*, 1: 15–17; Brush, *The Kind of Motion We Call Heat*, 2: 598–615.

98. Peter Guthrie Tait, "On the Foundations of the Kinetic Theory of Gases," *Philosophical Magazine* 21 (1886), cited in Bellone, *A World on Paper*, 29.

99. Bellone, *A World on Paper*, 87–98.

100. Ibid., 39.

101. William Thomson (Lord Kelvin) and Peter Guthrie Tait, *A Treatise on Natural Philosophy*, 2 vols. (Cambridge UK: Cambridge University, 1879), 1: 219.

102. William Thomson (Lord Kelvin), "The Dynamical Theory of Heat," *Transactions of the Royal Society of Edinburgh* (March 1851).

103. On Carnot's principle see A. d'Abro, *The Rise of the New Physics*, 2 vols. (New York: Dover, 1951), 1: 337–42. See also, Smith, *The Science of Energy*, 86–99; Brush, *The Kind of Motion We Call Heat*, 2: 566–83.

104. William Thomson (Lord Kelvin), "On a Universal Tendency in Nature to the Dissipation of Mechanical Energy," *Philosophical Magazine* 4 (1852), cited in Bellone, *A World on Paper*, 48.

105. For a discussion, see d'Abro, *Rise of the New Physics*, 1: 344–57.

106. Porter, *Rise of Statistical Thinking*, 126–28.

107. Ludwig Boltzmann, "The Second Law of Thermodynamics," 20, reprinted in *Theoretical Physics and Philosophical Problems*, ed. Brian McGuinness, trans. Paul Foulkes (Dordrecht: D. Reidel, 1974), 13–32.

108. Ludwig Boltzmann, "On Certain Questions of the Theory of Gases," *Nature* 51 (1895): 209, reprinted in McGuinness, *Theoretical Physics and Philosophical Problems*, 201–9.

109. Robert S. Cohen, "Ernst Mach: Physics, Perception and the Philosophy of Science," in *Ernst Mach, Physicist and Philosopher*, eds. Robert S. Cohen and Ray J. Seeger (Dordrecht: Reidel, 1970), 126–64; Brush, *The Kind of Motion We Call Heat*, 1: 274–94; John T. Blackmore, *Ernst Mach: His Work, Life, and Influence* (Berkeley: University of California, 1972), chap. 12.

110. Ludwig Boltzmann, "On the Significance of Theories," address of 16 July 1890 delivered at Graz, 35, reprinted in *Theoretical Physics and Philosophical Problems*, 33–36.

111. Witness the many pages of complex mathematical computations performed before the start of construction in Gustave Eiffel, *La Tour de Trois Cents Mètres*, 2 vols. (Paris: Société des Imprimeries Lemercier, 1900), 1: 15–71.

112. Porter, *Rise of Statistical Thinking*, 217–19. On the controversy about atomism, the decline of Boltzmann's standing in the 1890s, and his importance to quantum theory, see also Lindley, *Boltzmann's Atom*, 143–46, 174–78, 208–9.

113. The following discussion of Planck and the black-body problem is principally derived from Thomas S. Kuhn's detailed historical account, *Black-Body Theory and the Quantum Discontinuity, 1894–1912* (Oxford: Oxford University, 1978).

114. Ibid., 54, quoting Planck's letter to Leo Graetz in early 1897.

115. Ibid., 3–11 and 92–97.

116. Ibid. 28, quoting Planck's "Über irreversible Strahlungsvorgänge" from the summer of 1897.

117. Ibid., 97–98, quoting Planck's 1920 Nobel Prize lecture. On Planck's reading of Boltzmann and his use of the H-Theorem derivation, see 70–71 and 76–91.

118. Ibid., 104 and note 25.

119. Ibid., 90 and 93–96.

120. Ibid., 112. On the stages of Planck's thought in deriving his constant, see 105–9.

121. Ibid., 130, quoting Planck's *Vorlesungen über die Theorie der Wärmestrahlung* of 1906. On Planck's reticence to admit quantum discontinuities, see 114–30.

122. Ibid., quoting Planck's 1920 Nobel Prize lecture (emphasis in the original). His letter to Ehrenfest is reproduced in full on 132.

123. Niels Bohr, "Atomic Theory and Mechanics" (1925), 26, reprinted in *Atomic Theory and the Description of Nature* (New York: Macmillan, 1934), 25–51.

124. The standard historical account of Bohr's atom is John L. Heilbron and Thomas S. Kuhn, "The Genesis of the Bohr Atom," *Historical Studies in the Physical Sciences* 1 (1969): 211–90; reprinted in John L. Heilbron, *Historical Studies in the Theory of Atomic Structure* (New York: Arno, 1981), 149–228. See also, I. Bernard Cohen, *The Revolution in Science* (Cambridge MA: Harvard University, 1985), 427–30, and Kuhn, *Black-Body Theory*, 247–49.

125. Bohr, "Atomic Theory and Mechanics" (1925), 34–35. Further citations in this paragraph are from pages 47 and 51.

126. The long history of debate between mathematics and empirical research reaches back into the seventeenth century. Our point is that, at this historical juncture, those two activities intersect and the boundaries between them dissolve. Relevant discussions include Hacking, *Representing and Intervening*, esp. chap. 9; and also his article "Experimentation and Scientific Realism," chap. 13 in Richard Boyd, Philip Gasper, and J. D. Trout, eds., *The Philosophy of Science* (Cambridge MA: MIT, 1997). On the interaction between physical and theoretical evidence in physics, see Galison, *Image and Logic*, esp. chaps. 1 and 9.

127. Niels Bohr, "Development of Atomic Theory" (1927), 54; reprinted in *Atomic Theory and the Description of Nature*, 52–91.

128. Ibid., 53–57 and 62–68.

129. Ibid., 90.

130. Niels Bohr, "The Quantum of Action and the Description of Nature" (1929), reprinted in *Atomic Theory and the Description of Nature*, 92–101; "The Atomic Theory and the Fundamental Principles underlying the Description of

Nature" (1929), reprinted in *Atomic Theory and the Description of Nature*, 102–19.

131. Marmontel, "Description," *Supplément*.

132. Bohr, "Quantum of Action," 97. Further citations of this article are from pages 98, 96, and 101.

133. Jaucourt, "Description," *Encyclopédie*.

134. Bohr, "Atomic Theory and Fundamental Principles," 103. Further citations in this paragraph are from pages 107 and 109.

135. Ibid., 115. Further citations are from the same page of this article and from Foucault, *The Order of Things*, 246.

136. Bohr, "Atomic Theory and Fundamental Principles," 115.

137. Galison, *Image and Logic*. Galison's detailed material history offers a full account of the new instruments and interpretations they sparked in the first half of the twentieth century.

CHAPTER 6

1. Samuel F. B. Morse, *New York Observer* (20 April 1839), reprinted in Helmut Gernsheim and Alison Gernsheim, *L.-J.-M. Daguerre: The History of the Diorama and the Daguerreotype*, 2nd ed. (New York: Dover, 1968), 89–90. This volume is the standard history of Daguerre's invention and its dissemination.

2. Joel Snyder, "Visualization and Visibility," in *Picturing Science / Producing Art*, eds. Caroline A. Jones and Peter Galison (New York: Routledge, 1998), 390–93.

3. Ibid., 392, and Shelley Rice, *Parisian Views* (Cambridge MA: MIT, 1997), 7 and 10.

4. Much has been written on Marey. The overview presented here is indebted to Marta Braun, *Picturing Time: The Work of Étienne-Jules Marey* (Chicago: University of Chicago, 1992), esp. chap. 3; François Dagognet, *Étienne-Jules Marey: A Passion for the Trace*, trans. Robert Galeta with Jeanine Herman (New York: Zone Books, 1992), 65–128; John W. Douard, "É.-J. Marey's Visual Rhetoric and the Graphic Decomposition of the Body," *Studies in History and Philosophy of Science* 26, 2 (June 1995): 175–204; Josh Ellenbogen, "Camera and

Mind," *Representations* 101 (Winter 2008): 86–115; Snyder, "Visualization and Visibility," 387–96.

5. Cited by Snyder, "Visualization and Visibility," 380, from É.-J. Marey, *La Méthode graphique dans les sciences expérimentales et particulièrement en physiologie et en médecine* (Paris, 1878), 108.

6. Braun, *Picturing Time*, 66.

7. Ibid., 79.

8. Paul M. Laporte, "Cubism and Relativity with a Letter of Albert Einstein," *Art Journal* 25, 3 (Spring 1966): 246–48. Laporte reviews some of the writers since Sigfried Giedion first mooted the analogy between Relativity and Cubism in his Charles Eliot Norton lectures at Harvard in 1938–39. Laporte's own publications on the topic include "The Space–Time Concept in the Work of Picasso," *Magazine of Art* 41, 1 (January 1948): 26–32, and "Cubism and Science," *Journal of Aesthetics and Art Criticism* 7, 3 (March 1949): 243–56.

9. Daniel-Henry Kahnweiler, *The Rise of Cubism*, trans. Henry Aronson (New York: Wittenborn Schulz, 1949), 10. Kahnweiler's text was written in 1915 and originally published in German as *Der Weg zum Kubismus* in 1920.

10. Cited from Stéphane Mallarmé, *Dice Thrown Never Will Annul Chance*, trans. Brian Coffey (Chester Springs PA: Dufour Editions, 1967), "Preface." Mallarmé's poem was first published by the journal *Cosmopolis* in 1897, but without the facing-page layout that Mallarmé intended. Later, in 1914, the free-standing poem was published by *La Nouvelle Revue Française* with typography and layout based on Mallarmé's corrected proofs for a luxury edition that never appeared in his lifetime. Facsimiles of Mallarmé's handwritten working notes, of the *Cosmopolis* publication, and of the corrected proofs never published have recently been issued in Stéphane Mallarmé, *Un coup de Dès jamais n'abolira le Hasard*, ed. Françoise Morel (Paris: La Table Ronde, 2007). Our illustration is taken from this new facsimile edition. For the poem's history and commentary, see Stéphane Mallarmé, *Collected Poems*, trans. and ed. Henry Weinfield (Berkeley: University of California, 1994), 119–45 and 264–75.

BIBLIOGRAPHY

ELECTRONIC RESOURCES

Intuitive Surgical. Corporate website. www.intuitivesurgical
.com.

Robotic Surgery. Brown University Biomedical Engineering So-
ciety. http://biomed.brown.edu/Courses/BI108/BI108_2005
_Groups/04/neurology.html.

Stanford Encyclopedia of Philosophy. Edited by Edward N.
Zalta. http://plato.stanford.edu.

*Visualizing Knowledge: From Alberti's Window to Digital Ar-
rays.* Website and archive. http://visualization.stanford.edu.

BOOKS AND ARTICLES

d'Abro, A. *The Rise of the New Physics.* 2 vols. New York:
Dover, 1951.

Addison, Joseph. "The Pleasures of the Imagination." *The
Spectator*, Paper no. 411 (21 June 1712).

d'Alembert, Jean Le Rond. *Preliminary Discourse to the En-
cyclopedia of Diderot.* Translated by Richard N. Schwab.
Indianapolis IN: Bobbs-Merrill, 1963.

Alder, Ken. *Engineering the Revolution: Arms and Enlight-
enment in France, 1763–1815.* Princeton NJ: Princeton
University, 1997.

Alpers, Svetlana. *The Art of Describing: Dutch Art in the Sev-
enteenth Century.* Chicago: University of Chicago, 1983.

———. "Describe or Narrate?" *New Literary History: A Jour-
nal of Theory and Interpretation* 8, 1 (1976): 15–41.

Alston, David. "David et le théâtre." In *David contre David.*
Edited by Régis Michel. 2 vols. Paris: La documentation
française, 1993, 1: 165–98.

Andrews, Michelle. "A Guiding Hand." *U.S. News & World
Report* 141, 4 (31 July 2006): 59–62.

Angiviller, Charles-Claude Flahaut de la Billaderie, comte d'.
"Correspondance de M. d'Angiviller avec Pierre." Edited
by Marc Furcy-Raynaud. *Nouvelles Archives de l'Art
Français*, 1905.

Antal, Frederick. *Classicism and Romanticism with Other
Studies in Art History.* New York: Basic Books, 1966.

Apuzzo, Michael L. J. "New Dimensions of Neurosurgery in
the Realm of High Technology: Possibilities, Practicalities,
Realities." *Neurosurgery* 38, no. 4 (April 1996): 625–37.

Baker, Keith Michael. *Condorcet: From Natural Philosophy to Social Mathematics*. Chicago: University of Chicago, 1975.

———. "Épistémologie et Politique: Pourquoi l'*Encyclopédie* est-elle un dictionnaire?" In *L'Encyclopédie: Du réseau au livre et du livre au réseau*. Edited by Robert Morrissey and Philippe Roger. Paris: Honoré Champion, 2001, 51–58.

Bakhtin, Mikhail M., and Valentin N. Voloshinov. *Marxism and the Philosophy of Language*. Translated by Ladislav Matejka and I. R. Titunik. New York: Seminar, 1973.

Ballantyne, Garth H., and Fred Moll. "The da Vinci Telerobotic Surgical System: The Virtual Operative Field and Telepresence Surgery." *Surgical Clinics of North America* 83 (2003): 1293–1304.

Banfield, Ann. "Describing the Unobserved: Events Grouped around an Empty Centre." In *The Linguistics of Writing: Arguments between Language and Literature*. Edited by Nigel Fabb, Derek Attridge, Alan Durant, and Colin MacCabe. Manchester UK: Manchester University, 1987, 265–85.

———. "L'Imparfait de l'Objectif: The Imperfect of the Object Glass." *Camera Obscura* 24 (1990): 64–87.

———. *The Phantom Table: Woolf, Fry, Russell and the Epistemology of Modernism*. Cambridge UK: Cambridge University, 2000.

———. *Unspeakable Sentences: Narration and Representation in the Language of Fiction*. Boston: Routledge & Kegan Paul, 1982.

Barnes, Berenice. "Eye Movements." *American Journal of Psychology* 16 (1905): 199–207.

Barthes, Roland. *On Racine*. Translated by Richard Howard. New York: Hill & Wang, 1964.

———. "The Plates of the Encyclopedia." In *A Barthes Reader*. Edited by Susan Sontag. New York: Hill & Wang, 1986, 218–35.

Bates, David. "Cartographic Aberrations: Epistemology and Order in the Encyclopedic Map." In *Using the Encyclopédie: Ways of Knowing, Ways of Reading*. Edited by Daniel Brewer and Julie Candler Hayes. Oxford: Voltaire Foundation, 2002, 1–20.

Becq, Annie. "Continu et discontinu dans l'écriture de l'*Encyclopédie*: Le choix de l'ordre alphabétique." In *L'Encyclopédie et ses lecteurs*. Caen: Éditions de l'École normale du Calvados, 1987, 17–33.

———. "Les idées esthétiques de Marmontel." In *Jean-François Marmontel (1723–1799)*. Edited by Jean Ehrard. Clermont-Ferrand: G. de Bussac, 1970, 147–74.

Belhoste, Bruno. "École de Monge, école de Laplace: le débat autour de l'École polytechnique." In *L'Institution de la raison: La Révolution des idéologues*. Edited by François Azouvi. Paris: Vrin, 1992, 101–12.

———. "Les origines de l'École Polytechnique: Des anciennes écoles d'ingénieurs à l'École centrale des travaux publics." *L'Histoire de l'éducation* 42 (1989): 13–53.

———. "Un modèle à l'épreuve: L'École polytechnique de 1794 au Second Empire." In *La Formation polytechnicienne, 1794–1994*. Edited by Bruno Belhoste, Amy Dahan Dalmedico, and Antoine Picon. Paris: Dunod, 1994, 9–30.

Belhoste, Bruno, Antoine Picon, and Joël Sakarovitch. "Les Exercices dans les écoles d'ingénieurs sous l'Ancien Régime et la Révolution." *L'Histoire de l'éducation* 46 (1990): 53–109.

Bellone, Enrico. *A World on Paper: Studies on the Second Scientific Revolution*. Translated by Mirella and Riccardo Giacconi. Cambridge MA: MIT, 1980.

Bender, John. "Enlightenment Fiction and the Scientific Hypothesis." *Representations* 61 (1998): 6–28.

———. "Matters of Fact: Virtual Witnessing and the Public in Hogarth's Narratives." In *Hogarth: Representing Nature's Machines*. Edited by David Bindman, Frédéric Ogée, and Peter Wagner. Manchester UK: Manchester University, 2001, 49–70.

———. "The Novel as Modern Myth." In *Defoe's Footprints: Essays in Honour of Maximillian E. Novak*. Edited by Robert M. Maniquis and Carl Fisher. Toronto: University of Toronto, 2009, 223–37.

Bender, John, and Michael Marrinan, editors. *Regimes of Description: In the Archive of the Eighteenth Century*. Stanford CA: Stanford University, 2005.

Benjamin, Walter. *Illuminations*. Translated by Harry Zohn. New York: Schocken, 1969.

Bergman, Gösta M. "La grande mode des pantomimes à Paris

vers 1740 et les spectacles d'optique de Servandoni." *Theatre Research / Recherches Théâtrales* 2 (1960): 71–81.

———. *Lighting in the Theatre*. Stockholm: Almqvist & Wiksell, 1977.

Bernet, Jacques. "La *Cyclopaedia* d'Ephraïm Chambers (1728), ancêtre de l'*Encyclopédie* de Diderot et d'Alembert." In *Les sources anglaises de l'Encyclopédie*. Edited by Sylvaine Albertan-Coppola and Madeleine Descargues-Grant. Valenciennes: Presses Universitaires de Valenciennes, 2005, 25–38.

Blackmore, John T. *Ernst Mach: His Work, Life, and Influence*. Berkeley: University of California, 1972.

Bodner, Johannes, Florian Augustin, et al. "The da Vinci Robotic System for General Surgical Applications: A Critical Interim Appraisal." *Swiss Medical Weekly* (19 November 2005): 674–78.

Bohr, Niels. *Atomic Theory and the Description of Nature*. New York: Macmillan, 1934.

Boime, Albert. "Marmontel's *Bélisaire* and the Pre-Revolutionary Progressivism of David." *Art History* 3, 1 (March 1980): 91–94.

Boltzmann, Ludwig. *Theoretical Physics and Philosophical Problems*. Edited by Brian McGuinness. Translated by Paul Foulkes. Dordrecht: D. Reidel, 1974.

———. "Weitere Studien über das Wärmegleichgewicht unter Gasmolekülen." *Sitzungsberichte der Kaiserlichen Akademie der Wissenschaften in Wien* 66 (1872).

Bond, Donald F., editor. *The Spectator*. 5 vols. Oxford: Clarendon, 1965.

Booker, Peter Jeffrey. *A History of Engineering Drawing*. London: Chatto & Windus, 1963.

Boyd, Richard, Philip Gasper, and J. D. Trout, editors. *The Philosophy of Science*. Cambridge MA: MIT, 1997.

Boyer, Carl B. *A History of Mathematics*. 2nd ed. Revised by Uta C. Merzbach. New York: John Wiley, 1989.

Brann, Eva T. H. *The World of the Imagination, Sum and Substance*. Lanham, MD: Rowman & Littlefield, 1991.

Braun, Marta. *Picturing Time: The Work of Étienne-Jules Marey*. Chicago: University of Chicago, 1991.

Brewer, Daniel. *The Discourse of Enlightenment in Eighteenth-Century France*. Cambridge UK: Cambridge University, 1993.

Brewer, John. *The Pleasures of Imagination*. Chicago: University of Chicago, 1997.

Broda, Engelbert. *Ludwig Boltzmann: Man, Physicist, Philosopher*. Translated by Larry Gay. Woodbridge CT: Ox Bow, 1983.

Brown, Harold I. "Galileo on the Telescope and the Eye." *Journal of the History of Ideas* 46, 4 (1985): 487–501.

Brown, Marshall. *The Gothic Text*. Stanford CA: Stanford University, 2005.

Brush, Stephen G. *The Kind of Motion We Call Heat: A History of the Kinetic Theory of Gases in the 19th Century*. 2 vols. Amsterdam: North-Holland, 1976.

Bryson, Norman. *Tradition and Desire: From David to Delacroix*. Cambridge UK: Cambridge University, 1984.

———. *Word and Image: French Painting of the Ancien Régime*. Cambridge UK: Cambridge University, 1981.

Buffat, Marc. "L'âme contre les sens ou l'esthéthique spiritualiste des Éléments de littérature." In *Marmontel: Une rhétorique de l'apaisement*. Edited by Jacques Wagner. Louvain: Éditions Peeters, 2003, 35–49.

Buffon, Georges Louis Leclerc, comte de. "Initial Discourse." In *From Natural History to the History of Nature: Readings from Buffon and His Critics*. Edited and translated by John Lyon and Philip R. Sloan. Notre Dame IN: University of Notre Dame, 1981.

———. *La méthode des fluxions, et des suites infinies* par M. le Chevalier Newton. Paris: Chez de Bure l'Aîné, 1740.

Cardy, Michael. The *Literary Doctrines of Jean-François Marmontel*. Oxford: Voltaire Foundation, 1982.

Cercignani, Carlo. *Ludwig Boltzmann: The Man Who Trusted Atoms*. Oxford: Oxford University, 1998.

Clairon, Mlle Hippolyte. *Mémoires de Mlle Clairon*. 1822. Reprint, Geneva: Slatkine Reprints, 1968.

Cochin, Charles-Nicolas. *Lettres sur l'Opéra*. Paris, 1781.

Cohen, I. Bernard. *Revolution in Science*. Cambridge MA: Harvard University, 1985.

———. "Scientific Revolutions, Revolutions in Science, and a Probabilistic Revolution 1800–1930." In *The Probabilistic*

Revolution. Edited by Lorenz Krüger, Lorraine Daston, and Michael Heidelberger. 2 vols. Cambridge MA: MIT, 1987, 1: 23–44.

———. *The Triumph of Numbers: How Counting Shaped Modern Life*. New York: Norton, 2005.

Cohen, Robert S. "Ernst Mach: Physics, Perception and the Philosophy of Science." In *Ernst Mach, Physicist and Philosopher*. Edited by Robert S. Cohen and Ray J. Seeger. Dordrecht: Reidel, 1970, 126–64.

Cohn, Dorrit. *Transparent Minds: Narrative Modes for Presenting Consciousness in Fiction*. Princeton NJ: Princeton University, 1978.

Collé, Charles. *Journal et Mémoires*. 3 vols. Nouv. éd. Paris: Firmin-Didot, 1868.

Collison, Robert. *Encyclopaedias: Their History throughout the Ages*. 2nd ed. New York: Hafner, 1966.

Connon, Derek F. *Innovation and Renewal: A Study of the Theatrical Works of Diderot*. Oxford: Voltaire Foundation, 1989.

Crary, Jonathan. *Suspensions of Perception: Attention, Spectacle, and Modern Culture*. Cambridge MA: MIT / October Books, 1999.

———. *Techniques of the Observer: On Vision and Modernity in the Nineteenth Century*. Cambridge MA: MIT, 1990.

Crow, Thomas. *Emulation: Making Artists for Revolutionary France*. New Haven CT: Yale University, 1995.

———. *Painters and Public Life in Eighteenth-Century Paris*. New Haven CT: Yale University, 1985.

———. "Painting and Pre-Revolutionary Radicalism in France." *Art History* 1, 4 (December 1978): 424–71.

Dagognet, François. *Étienne-Jules Marey: A Passion for the Trace*. Translated by Robert Galeta with Jeanine Herman. New York: Zone Books, 1992.

Damisch, Hubert. *L'Origine de la perspective*. Paris: Flammarion, 1987.

Darnton, Robert. *Mesmerism and the End of the Enlightenment in France*. Cambridge MA: Harvard University, 1968.

Daston, Lorraine. *Classical Probability in the Enlightenment*. Princeton NJ: Princeton University, 1988.

———. "Objectivity and the Escape from Perspective." In *The Science Studies Reader*. Edited Mario Biagioli. New York: Routledge, 1999, 110–23.

———. "The Physicalist Tradition in Early Nineteenth-Century French Geometry." *Studies in History and Philosophy of Science* 17 (1986): 269–95.

Daston, Lorraine, and Peter Galison. "The Image of Objectivity." *Representations* 40 (Fall 1992): 81–128.

———. *Objectivity*. New York: Zone Books, 2007.

Daub, Edward E. "Maxwell's Demon." *Studies in the History and Philosophy of Science* 1 (1970): 213–27.

Davies, B. L., et al. "Active Compliance in Robotic Surgery—The Use of Force Control as a Dynamic Constraint." *Proceedings of the Institution of Mechanical Engineers. Part H, Journal of Engineering in Medicine* 211, 4 (1997): 285–92.

de Bolla, Peter. *The Education of the Eye: Painting, Landscape, and Architecture in Eighteenth-Century Britain*. Stanford CA: Stanford University, 2003.

Dear, Peter. *Discipline & Experience: The Mathematical Way in the Scientific Revolution*. Chicago: University of Chicago, 1995.

Delécluze, Étienne. *Louis David: Son école et son temps*. Paris: Didier, 1855.

Desrosières, Alain. *La Politique des grands nombres*. Paris: Éditions de la Découverte, 1993.

Diderot, Denis. *Correspondance*. Edited by Georges Roth. 16 vols. Paris: Éditions de Minuit, 1955–70.

———. *Œuvres*. Edited by Laurent Versini. 5 vols. Paris: Robert Laffont, 1996.

Diderot, Denis, and Jean Le Rond d'Alembert. *Encyclopédie, ou dictionnaire raisonné des sciences, des arts et des métiers*. 17 vols. Paris: Briasson et al., 1751–65. Reprint, Elmsford NY: Pergamon, 1969.

[Diderot, Denis, and Jean Le Rond d'Alembert]. *Recueil de Planches sur les Sciences, les Arts libéraux, et les Arts mécaniques, avec leur Explication*. 11 vols. Paris: Briasson, David, Le Breton, Durand, 1762–72.

Dieckmann, Herbert. "The Concept of Knowledge in the *Encyclopédie*." In *Essays in Comparative Literature*. Edited by Herbert Dieckmann, Harry Levin, and Helmut Motekat. St. Louis MO: Washington University, 1961, 73–107.

Douard, John W. "É.-J. Marey's Visual Rhetoric and the Graphic Decomposition of the Body." *Studies in History and Philosophy of Science* 26, 2 (June 1995): 175–204.

Douglas, R. S. "Robotic Surgery in Ophthalmology: Reality or Fantasy?" *British Journal of Ophthalmology* 91, 1 (January 2007): 1.

Drake, James M., et al. "Computer- and Robot-assisted Resection of Thalamic Astrocytomas in Children." *Neurosurgery* 29, 1 (1991): 27–33.

Dubos, Jean-Baptiste. *Réflexions critiques sur la Poésie et sur la Peinture.* 7th ed., 3 vols. Paris: Pissot, 1770. Reprint, Geneva: Slatkine, 1967.

Edgerton, Samuel Y., Jr. *The Renaissance Rediscovery of Linear Perspective.* New York: Harper and Row, 1975.

Ehrard, Jean. "L'arbre et le labyrinthe." In *L'Encyclopédie, Diderot, l'esthétique: Mélanges en hommage à Jacques Chouillet.* Edited by Sylvain Auroux, Dominique Bourel, and Charles Porset. Paris: Presses Universitaires de France, 1991, 233–39.

Eiffel, Gustave. *La Tour de Trois Cents Mètres.* 2 vols. Paris: Société des Imprimeries Lemercier, 1900.

Elkins, James. "Clarification, Destruction, and Negation of Pictorial Space in the Age of Neoclassicism, 1750–1840." *Zeitschrift für Kunstgeschichte* 53 (1990): 560–82.

———. *The Domain of Images.* Ithaca NY: Cornell University, 1999.

———. "Logic and Images in Art History." *Perspectives on Science* 7, 2 (Summer 1999): 151–80

———. *The Poetics of Perspective.* Ithaca NY: Cornell University, 1994.

Ellenbogen, Josh. "Camera and Mind." *Representations* 101 (Winter 2008): 86–115.

Engell, James. *The Creative Imagination, Enlightenment to Romanticism.* Cambridge MA: Harvard, 1981.

Fleury [Joseph-Abraham Bénard]. *Mémoires de Fleury de la Comédie Française, 1789–1820.* 6 vols. Paris: Ambroise Dupont, 1835–38.

Fliegelman, Jay. *Declaring Independence: Jefferson, Natural Language, and the Culture of Performance.* Stanford CA: Stanford University, 1993.

Foucault, Michel. *The Order of Things: An Archaeology of the Human Sciences.* New York: Vintage Books, 1973.

Frantz, Pierre. *L'esthétique du tableau dans le théâtre du XVIIIe siècle.* Paris: Presses Universitaires de France, 1998.

Fried, Michael. *Absorption and Theatricality: Painting and Beholder in the Age of Diderot.* Berkeley: University of California, 1980.

———. *Courbet's Realism.* Chicago: University of Chicago, 1990.

Friedman, Michael. *Kant and the Exact Sciences.* Cambridge MA: Harvard University, 1992.

Funkhouser, Howard Gray. "Historical Development of the Graphical Representation of Statistical Data." *Osiris* 3 (1938): 269–404.

Galison, Peter. *Image and Logic: A Material Culture of Microphysics.* Chicago: University of Chicago, 1997.

———. "Reflections on Image and Logic: A Material Culture of Microphysics." *Perspectives on Science* 7, 2 (1999): 255–84.

Gauss, Carl Friedrich. *Theoria Motus Corporum Coelestium in Sectionibus Conicis Solem Ambientum.* Hamburg: Perthes et Besser, 1809.

Gernsheim, Helmut, and Alison Gernsheim. *L.-J.-M. Daguerre: The History of the Diorama and the Daguerreotype.* 2nd ed. New York: Dover, 1968.

Gigerenzer, Gerd, et al. *The Empire of Chance: How Probability Changed Science and Everyday Life.* Cambridge UK: Cambridge University, 1989.

Gillispie, Charles C. *Pierre-Simon Laplace, 1749–1827: A Life in Exact Science.* Princeton NJ: Princeton University, 1997.

Gombrich, Ernst H. "Lessing (Lecture on a Master Mind)." *Proceedings of the British Academy* 43 (1957): 133–56.

———. "Moment and Movement in Art." *Journal of the Warburg and Courtauld Institutes* 27 (1964): 293–306.

Goodden, Angelica. *Actio and Persuasion: Dramatic Performance in Eighteenth-Century France.* Oxford: Clarendon, 1986.

———. "'Une Peinture Parlante': The *Tableau* and the *Drame*." *French Studies* 38, 4 (October 1984): 397–413.

Goodman, Nelson. *Languages of Art: An Approach to a Theory of Symbols*. Indianapolis IN: Hackett, 1976.

———. *Ways of Worldmaking*. Indianapolis IN: Hackett, 1978.

Grabiner, Judith V. *The Origins of Cauchy's Rigorous Calculus*. Cambridge MA: MIT, 1981.

Grattan-Guinness, Ivor. "Mathematical Physics in France, 1800–1840: Knowledge, Activity, and Historiography." In *Mathematical Perspectives: Essays on Mathematics and Its Historical Development*. Edited by Joseph W. Dauben. New York: Academic Press, 1981, 95–138.

———. *The Norton History of the Mathematical Sciences: The Rainbow of Mathematics*. New York: W. W. Norton, 1997.

Greaves, Mark. *The Philosophical Status of Diagrams*. Stanford CA: CSLI Publications, 2002.

Hacking, Ian. *Representing and Intervening: Introductory Topics in the Philosophy of Natural Science*. Cambridge UK: Cambridge University, 1983.

———. *The Taming of Chance*. Cambridge UK: Cambridge University, 1990.

Hahn, Roger. *The Anatomy of a Scientific Institution: The Paris Academy of Sciences, 1666–1803*. Berkeley: University of California, 1971.

———. "The Application of Science to Society: The Societies of Arts." *Studies on Voltaire and the Eighteenth Century* 25 (1963): 829–36.

———. *Pierre Simon Laplace 1749–1827: A Determined Scientist*. Cambridge MA: Harvard University, 2005.

———. "Le rôle de Laplace à l'École polytechnique." In *La Formation polytechnicienne, 1794–1994*. Paris: Dunod, 1994.

———. *Le système du monde: Pierre Simon Laplace, un itinéraire dans la science*. Translated by Patrick Hersant. Paris: Gallimard, 2004.

Hammer, Eric M. *Logic and Visual Information*. Stanford CA: CSLI Publications, 1995.

Hamon, Philippe. *La Description Littéraire: Anthologie de textes théoriques et critiques*. Paris: Macula, 1991.

———. *Introduction à l'analyse du descriptif*. Paris, 1981. Nouv. éd. Paris: Hachette supérieur, 1993.

Hankins, Thomas L. *Jean d'Alembert: Science and the Enlightenment*. Oxford: Clarendon, 1970.

———. "A 'Large and Graceful Sinuosity': John Herschel's Graphical Method." *Isis* 97 (2006): 605–33.

———. *Science and the Enlightenment*. Cambridge UK: Cambridge University, 1985.

Hankins, Thomas L., and Robert J. Silverman. *Instruments and the Imagination*. Princeton NJ: Princeton University, 1995.

Hardesty, Kathleen. *The Supplement to the Encyclopédie*. The Hague: Martinus Nijhoff, 1977.

Harmon, Peter M. *The Natural Philosophy of James Clerk Maxwell*. Cambridge UK: Cambridge University, 1998.

Hassfeld, S., et al. "Intraoperative Guidance in Maxillofacial and Craniofacial Surgery." *Proceedings of the Institution of Mechanical Engineers. Part H, Journal of Engineering in Medicine* 211, 4 (1997): 277–83.

Heilbron, John L., and Thomas S. Kuhn. "The Genesis of the Bohr Atom." *Historical Studies in the Physical Sciences* 1 (1969): 211–90. Reprinted in John L. Heilbron, *Historical Studies in the Theory of Atomic Structure*. New York: Arno, 1981.

Helmholtz, Hermann von. "Concerning the Perceptions in General." In *Helmholtz on Perception: Its Physiology and Development*. Edited by Richard M. Warren and Roslyn P. Warren. New York: John Wiley & Sons, 1968, 171–203.

———. "The Facts of Perception." In *Helmholtz on Perception: Its Physiology and Development*. Edited by Richard M. Warren and Roslyn P. Warren. New York: John Wiley & Sons, 1968, 207–46.

———. "On the Relation of Optics to Painting." In *Helmholtz on Perception: Its Physiology and Development*. Edited by Richard M. Warren and Roslyn P. Warren. New York: John Wiley & Sons, 1968, 139–68.

———. "The Origin of the Correct Interpretation of Our Sensory Impressions." In *Helmholtz on Perception: Its Physiology and Development*. Edited by Richard M. Warren and Roslyn P. Warren. New York: John Wiley & Sons, 1968, 247–60.

———. "The Recent Progress of the Theory of Vision." In *Helmholtz on Perception: Its Physiology and Develop-*

ment. Edited by Richard M. Warren and Roslyn P. Warren. New York: John Wiley & Sons, 1968, 59–136.

———. *Selected Writings of Hermann von Helmholtz*. Edited by Russell Kahl. Middletown CT: Wesleyan University, 1971.

———. *Treatise on Physiological Optics*. Trans. from 3rd German edition. Edited by James P. C. Southall. 3 vols. New York: Dover, 1962.

Herschel, John. "Quetelet on Probabilities." *The Edinburgh Review* 92 (1850).

Hersey, George L. *Architecture and Geometry in the Age of the Baroque*. Chicago: University of Chicago, 2000.

Holmström, Kirsten Gram. *Monodrama–Attitudes–Tableaux Vivants: Studies on Some Trends of Theatrical Fashion 1770–1815*. Stockholm: Almqvist & Wiksell, 1967.

Howell, Wilbur Samuel. *Eighteenth-Century British Logic and Rhetoric*. Princeton NJ: Princeton University, 1971.

Hume, David. *A Treatise of Human Nature*. Edited by L. A. Selby-Bigge and P. H. Nidditch. 2nd ed. Oxford: Clarendon, 1978.

Hunter, I. W., et al. "Ophthalmic Microsurgical Robot and Associated Virtual Environment." *Computers in Biology and Medicine* 25, 2 (1995): 173–82.

Ivins, William M. *On the Rationalization of Sight*. 1938. Reprint, New York: Da Capo, 1973.

Jay, Martin. *Cultural Semantics*. Amherst: University of Massachusetts, 1998.

———. *Downcast Eyes: The Denigration of Vision in Twentieth-Century French Thought*. Berkeley: University of California, 1993.

Johnson, Dorothy. "Corporality and Communication: The Gestural Revolution of Diderot, David, and *The Oath of the Horatii*." *Art Bulletin* 71 (March 1989): 92–113.

Jullien, Adolphe. *Les Spectateurs sur le Théâtre: Établissement et suppression des Bancs sur les Scènes de la Comédie-Française et de l'Opéra*. Paris: A. Detaille, 1875.

Kafker, Frank A., and Serena L. Kafker. *The Encylopedists as Individuals: A Biographical Dictionary of the Authors of the Encyclopédie*. Oxford: Voltaire Foundation, 1988.

Kahnweiler, Daniel-Henry. *The Rise of Cubism*. Translated by Henry Aronson. New York: Wittenborn Schulz, 1949.

Kaiser, David. *Drawing Theories Apart: The Dispersion of Feynman Diagrams in Postwar Physics*. Chicago: University of Chicago, 2005.

Kemp, Jonathan, editor. *Diderot, Interpreter of Nature*. Translated by Jonathan Kemp and Jean Stewart. Westport CT: Hyperion, 1979.

Kirby, Joshua. *Dr. Brook Taylor's Method of Perspective Made Easy*. Ipswich: W. Craighton, 1754.

Klein, Ursula. *Experiments, Models, Paper Tools: Cultures of Organic Chemistry in the Nineteenth Century*. Stanford CA: Stanford University, 2003.

Kline, Morris. *Mathematical Thought from Ancient to Modern Times*. New York: Oxford University, 1972.

Krüger, Lorenz. "The Probabilistic Revolution in Physics, an Overview." In *The Probabilistic Revolution*. Edited by Lorenz Krüger, Lorraine Daston, and Michael Heidelberger. 2 vols. Cambridge MA: MIT, 1987, 2: 373–78.

———. "The Slow Rise of Probabilism: Philosophical Arguments in the Nineteenth Century." In *The Probabilistic Revolution*. Edited by Lorenz Krüger, Lorraine Daston, and Michael Heidelberger. 2 vols. Cambridge MA: MIT, 1987, 1: 79–82.

Kuhn, Thomas S. *Black-Body Theory and the Quantum Discontinuity, 1894–1912*. Oxford: Oxford University, 1978.

———. "What Are Scientific Revolutions?" In *The Probabilistic Revolution*. Edited by Lorenz Krüger, Lorraine Daston, and Michael Heidelberger. 2 vols. Cambridge MA: MIT, 1987, 1: 7–22.

Langins, Janis. *La République avait besoin de savants*. Paris: Belin, 1987.

———. "Sur l'enseignement et les examens à l'École polytechnique sous le Directoire: à propos d'une lettre inédite de Laplace." *Revue d'histoire des sciences* 40 (1987): 145–77.

Lagrange, Joseph-Louis. *Œuvres de Legrange*. Edited by Joseph-Alfred Serret. 14 vols. Paris: Gauthier-Villars, 1867–92.

Laplace, Pierre-Simon. *Essai philosophique sur les probabilités*. 5th ed. Paris: Bachelier, 1825.

———. Supplément au "Mémoire sur les approximations des formules qui sont fonctions de très grands nombres et sur leur

application aux probabilities." In *Mémoires de l'Académie des sciences de Paris*, 1er série, 10 (1810): 559–65.

———. *Œuvres complètes de Laplace*. 14 vols. Paris: Gauthier-Villars, 1878–1912.

———. *Théorie analytique des probabilities*. Paris: Courcier, 1812. Reprint, Brussels: Culture et Civilisation, 1967.

Laporte, Paul M. "Cubism and Relativity with a Letter of Albert Einstein." *Art Journal* 25, 3 (Spring 1966): 246–48.

———. "Cubism and Science." *Journal of Aesthetics and Art Criticism* 7, 3 (March 1949): 243–56.

———. "The Space–Time Concept in the Work of Picasso." *Magazine of Art* 41, 1 (January 1948): 26–32.

Latour, Bruno. "Drawing Things Together." In *Representation in Scientific Practice*. Edited by Michael Lynch and Steve Woolgar. Cambridge MA: MIT, 1990, 19–68.

Lavoisier, Antoine Laurent de. "Mémoire sur la manière d'éclairer les salles de spectacles." Paris, 1781.

Le Brun, Charles. *L'expression des passions & autres conferences*. Edited by Julien Philipe. Paris: Éditions Dédale, 1994.

———. *The Passions Of The Soul: As They Are Expressed In The Human Countenance, Shewing Its Various Changes & Appearances Under The Influence Of Different Passions: Engraved In A Manner Which Represents Real Drawings Almost As Large As Life From The Celebrated Designs Of Monsieur Le Brun, With Extracts From His Discourse On The Passions, Describing Their Influence On The Features And Muscles Of The Face*. London: Robert Wilkinson, 177-?.

Lefèvre, Wolfgang, editor. *Picturing Machines 1400–1700*. Cambridge MA: MIT, 2004.

Legendre, Adrien Marie. *Nouvelles méthodes pour la détermination des orbites des comètes*. Paris: Courcier, 1805.

Lekain, Henri-Louis. *Mémoires de Lekain, précédé de réflexions sur cet acteur et sur l'art théâtral par François-Joseph Talma*. Paris: E. Ledoux, 1825.

Lenoir, Timothy. "The Eye as Mathematician: Clinical Practice, Instrumentation, and Helmholtz's Construction of an Empiricist Theory of Vision." In *Hermann von Helmholtz and the Foundations of Nineteenth-Century Science*. Edited by David Cahan. Berkeley: University of California, 1993, 109–53.

———. *Instituting Science: The Cultural Production of Scientific Disciplines*. Stanford CA: Stanford University, 1997.

———. "Operationalizing Kant: Manifolds, Models, and Mathematics in Helmholtz's Theories of Perception." In *The Kantian Legacy in Nineteenth-Century Science*. Edited by Michael Friedman and Alfred Nordmann. Cambridge MA: MIT, 2006, 141–210.

Lessing, Gotthold Ephraim. *Laocoön: An Essay on the Limits of Painting and Poetry*. Translated by Edward Allen McCormick. Baltimore MD: Johns Hopkins University, 1984.

Lévi-Strauss, Claude. *The Savage Mind*. Chicago: University of Chicago, 1966.

Lindley, David. *Boltzmann's Atom: The Great Debate That Launched a Revolution in Physics*. New York: Free Press, 2001.

Livingston, Donald W. *Hume's Philosophy of Common Life*. Chicago: University of Chicago, 1984.

Locke, John. *An Essay Concerning Human Understanding*. Edited by Peter H. Nidditch. Oxford: Clarendon, 1975.

Locquin, Jean. *La Peinture d'Histoire en France de 1747 à 1785*. Paris: 1912. Reprint, Paris: Arthena, 1978.

Lough, John. *The Encyclopédie*. New York: David McKay, 1971.

Ludwig, Bernard. "L'utilisation des renvois dans la lecture de l'*Encyclopédie*." In *L'Encyclopédie et ses lecteurs*. Caen: Éditions de l'École normale du Calvados, 1987, 35–54.

Lynch, Michael. "Discipline and the Material Form of Images: An Analysis of Scientific Visibility." *Social Studies of Science* 15 (1985): 37–63.

———. "The Externalized Retina: Selection and Mathematization in the Visual Documentation of Objects in the Life Sciences." In *Representation in Scientific Practice*. Edited by Michael Lynch and Steve Woolgar. Cambridge MA: MIT, 1990, 153–86.

———. "Science in the Age of Mechanical Reproduction: Moral and Epistemic Relations between Diagrams and Photographs." *Biology & Philosophy* 6, 2 (April 1991): 205–26.

Lynch, Michael, and Steve Woolgar, editors. *Representation in Scientific Practice*. Cambridge MA: MIT, 1990.

Lyon, John, and Phillip R. Sloan, editors and translators. *From Natural History to the History of Nature: Readings from Buffon and His Critics*. Notre Dame IN: University of Notre Dame, 1981.

Lyotard, Jean-François. *The Inhuman: Reflections on Time*. Translated by Geoffrey Bennington and Rachel Bowlby. Stanford CA: Stanford University, 1991.

Maddox, Ernest Edmund. *Tests and Studies of the Ocular Muscles*. 3rd ed. Revised. Philadelphia: Keystone Publishing, 1907.

Mahoney, Michael S. "Charting the Globe and Tracking the Heavens: Navigation and the Sciences in the Early Modern Era." In *The Heirs of Archimedes: Science and the Art of War through the Age of Enlightenment*. Edited by Brett D. Steele and Tamera Dorland. Cambridge MA: MIT, 2005, 221–30.

———. "Drawing Mechanics." In *Picturing Machines: 1400–1700*. Edited by Wolfgang Lefèvre. Cambridge MA: MIT, 2004, 281–306.

———. "Huygens and the Pendulum: From Device to Mathematical Relation." In *The Growth of Mathematical Knowledge*. Edited by Herbert Breger and Emily Grosholz. Dordrecht: Kluwer Academic Publishers, 2000, 17–39.

Mallarmé, Stéphane. *Collected Poems*. Translated and edited by Henry Weinfield. Berkeley: University of California, 1994.

———. *Un coup de Dès jamais n'abolira le Hasard*. Edited by Françoise Morel. Paris: La Table Ronde, 2007.

———. *Dice Thrown Never Will Annul Chance*. Translated by Brian Coffey. Chester Springs PA: Dufour Editions, 1967.

Marmontel, Jean-François. *Bélisaire*. Edited by Robert Granderoute. Paris: Société des Textes Français Modernes, 1994.

———. *Mémoires*. Edited by Jean-Pierre Guicciardi and Gilles Thierriat. Paris: Mercure de France, 1994.

———. *Œuvres Complètes de Marmontel*. 19 vols. Paris: Verdière, 1818–20.

Maxwell, James Clerk. *Maxwell on Heat and Statistical Mechanics: On "Avoiding All Personal Enquiries" of Molecules*. Edited by Elizabeth Garber, Stephen G. Brush, and C. W. F. Everett. London: Associated University Presses, 1995.

———. *Maxwell on Molecules and Gases*. Edited by Elizabeth Garber, Stephen G. Brush, and C. W. F. Everett. Cambridge MA: MIT, 1986.

Miller, Karol, and Kiyoyuki Chinzei. "Constitutive Modeling of Brain Tissue: Experiment and Theory." *Journal of Biomechanics* 30, 11/12 (1997): 1115–21.

Mohr, Catherine J., Geoffrey S. Nadzam, and Myriam J. Curet. "Totally Robotic Roux-en-Y Gastric Bypass." *Archives of Surgery* 140 (2005): 779–86.

Monge, Gaspard. *Géometrie descriptive: Leçons données aux écoles normales, l'an 3 de la république*. Paris: Baudouin, an VII [1799].

Netz, Reviel. *The Shaping of Deduction in Greek Mathematics: A Study in Cognitive History*. Cambridge UK: Cambridge University, 1999.

Nisbet, H. B., and Claude Rawson, editors. *The Cambridge History of Literary Criticism*. Vol. 4, *The Eighteenth Century*. Cambridge UK: Cambridge University, 1997.

Noverre, Jean-Georges. *Observations sur la construction d'une salle d'Opéra*. Paris, 1781.

Pairault, François. *Gaspard Monge: Le fondateur de Polytechnique*. Paris: Tallandier, 2000.

Panofsky, Erwin. *Perspective as Symbolic Form*. Translated by Christopher S. Wood. New York: Zone Books, 1991.

Paris, Musée du Louvre. *Jacques-Louis David 1748–1825*. Exhibition catalogue. Paris: Réunion des Musées Nationaux, 1989.

Pascal, Roy. *The Dual Voice: Free Indirect Speech and Its Functioning in the Nineteenth-Century European Novel*. Manchester UK: Manchester University, 1977.

Patte, Pierre. *Essai sur l'architecture théâtrale*. Paris, 1782.

Paulson, Ronald. *Hogarth*. 3 vols. New Brunswick NJ: Rutgers University, 1993.

———. *Popular and Polite Art in the Age of Hogarth and Fielding*. Notre Dame IN: University of Notre Dame, 1979.

Péron, Alexandre. *Examen du tableau du serment des Horaces peint par David*. Paris: Impr. de Ducessois, 1839.

Pinault, Madeleine. "Diderot et les illustrateurs de l'*Encyclopédie*." *Revue de l'Art* 66 (1984): 17–38.

Poggenpohl, Sharon Helmer, and Dietmar R. Winkler. "Diagrams as Tools for Worldmaking." *Visible Language* 26, 3/4 (Summer/Autumn 1992): 252–69.

Porter, Theodore M. *The Rise of Statistical Thinking, 1820–1900* Princeton NJ: Princeton University, 1986.

Priestly, Joseph. *The Theological and Miscellaneous Works of Joseph Priestly*. Edited by John Towill Rutt. 25 vols. London: G. Smallfield, 1817–31. Reprint, New York: Kraus Reprint, 1972.

Putnam, Hilary. *Realism and Reason*. Cambridge UK: Cambridge University, 1983.

———. *Representation and Reality*. Cambridge MA: MIT, 1988.

Puttfarken, Thomas. *The Discovery of Pictorial Composition: Theories of Visual Order in Painting, 1400–1800*. New Haven CT: Yale University, 2000.

Quetelet, Adolphe. "Recherches sur la population, les naissances, les décès, les prisons, les dépots de mendicité, etc., dans le royaume des Pays-Bas." *Nouveaux mémoires de l'Académie Royale des Sciences et Belles-Lettres de Bruxelles* 4 (1827): 117–92 with two plates.

———. *Sur l'homme et le développement de ses facultés, ou Essai de physique sociale*. 2 vols. Paris: Bachelier, 1835. Reprint, Paris: Librairie Arthème-Fayard, 1991.

Regnault-Warin, Jean-Joseph. *Mémoires historiques et critiques sur F.-J. Talma et sur l'art théâtral*. Paris: A. Henry, 1827.

Renwick, John. "Marmontel, Voltaire, and the *Bélisaire* Affair." *Studies in Voltaire and the Eighteenth Century* 121 (1975): 155–305.

Reynaud, Denis. "Pour une Théorie de la Description au 18e siècle." *Dix-Huitième Siècle* 22 (1990): 347–66.

Rice, Shelley. *Parisian Views*. Cambridge MA: MIT, 1997.

Ridley, Matt. *Francis Crick: Discoverer of the Genetic Code*. New York: HarperCollins, 2006.

Roger, Jacques. *Buffon: A Life in Natural History*. Edited by L. Pearce Williams. Translated by Sarah Lucille Bonnefoi. Ithaca NY: Cornell University, 1997.

———. *The Life Sciences in Eighteenth-Century French Thought*. Edited by Keith R. Benson. Translated by Robert Ellrich. Stanford CA: Stanford University, 1997.

Rosenberg, Pierre, and Udolpho van de Sandt. *Pierre Peyron, 1744–1814*. Paris: Arthena, 1983.

Rosenberg, Pierre, and Louis-Antoine Prat. *Jacques-Louis David, 1748–1825: Catalogue raisonné des dessins*. 2 vols. Milan: Mondadori Electa, 2002.

Rosenblum, Robert. "Gavin Hamilton's *Brutus* and Its Aftermath." *Burlington Magazine* 103 (January 1961): 8–16.

———. *Transformations in Late Eighteenth-Century Art*. Princeton NJ: Princeton University, 1967.

Rosenfeld, Jeffrey V. "Minimally Invasive Neurosurgery." *Australian and New Zealand Journal of Surgery* 66 (1996): 553–59.

Rotman, Brian. "Thinking Dia-Grams: Mathematics, Writing, and Virtual Reality." In *Mathematics, Science, and Postclassical Theory*. Edited by Barbara Herrnstein Smith and Arkady Plotnitsky. Durham NC: Duke University, 1997, 17–39.

Sakarovitch, Joël. *Épures d'architecture: De la coupe des pierres à la géométrie descriptive XVIᵉ–XIXᵉ siècles*. Basel: Birkäuser Verlag, 1998.

Sawaya, Raymond, et al. "Advances in Surgery for Brain Tumors." *Neurologic Clinics* 13, 4 (November 1995): 757–71.

Schaffer Simon. "'The charter'd Thames': Naval Architecture and Experimental Spaces in Georgian Britain." In *The Mindful Hand: Inquiry and Invention from the Late Renaissance to Early Industrialisation*. Edited by Lissa Roberts, Simon Schaffer, and Peter Dear. Amsterdam: Royal Netherlands Academy of Arts and Sciences, 2007, 279–305.

Sewell, William H. "Visions of Labor: Illustrations of the Mechanical Arts before, in, and after Diderot's *Encyclopédie*." In *Work in France: Representations, Meaning, Organization, and Practice*. Edited by Steven L. Kaplan and Cynthia Koepp. Ithaca NY: Cornell University, 1986, 258–86.

Shapin, Steven. *A Social History of Truth: Civility and Science in Seventeenth-Century England*. Chicago: University of Chicago, 1994.

Shapin, Steven, and Simon Schaffer. *Leviathan and the*

Air-Pump: Hobbes, Boyle, and the Experimental Life. Princeton NJ: Princeton University, 1985.

Sheridan, Thomas. *A Course of Lectures on Elocution. . . .* London: A. Millar et al., 1762. Reprint, Menson UK: Scolar, 1968.

Shin, Sun-Joo. *The Logical Status of Diagrams.* Cambridge UK: Cambridge University, 1994.

Shin, Sun-Joo, and Oliver Lemon. "Diagrams." *Stanford Encyclopedia of Philosophy.* Edited by Edward N. Zalta. http://plato.stanford.edu/entries/diagrams/.

Smith, Crosbie. *The Science of Energy: A Cultural History of Energy Physics in Victorian Britain.* London: Athlone, 1998.

Snyder, Joel. "Visualization and Visibility." In *Picturing Science / Producing Art.* Edited by Caroline A. Jones and Peter Galison. New York: Routledge, 1998, 379–97.

Sobchak, Vivian. "The Scene of the Screen." In *Materialities of Communication.* Edited by Hans Ulrich Gumbrecht and K. Ludwig Pfeiffer. Stanford CA: Stanford University, 1994, 83–106.

Stafford, Barbara Maria. *Artful Science: Enlightenment, Entertainment, and the Eclipse of Visual Education.* Cambridge MA: MIT, 1994.

———. *Body Criticism: Imaging the Unseen in Enlightenment Art and Medicine.* Cambridge MA: MIT, 1991.

———. *Good Looking: Essays on the Virtue of Images.* Cambridge MA: MIT, 1996.

Stalnaker, Joanna. "In Visible Words: Epistemology and Poetics of Description in Enlightenment France." Ph.D. Diss., New York University, 2002. Ann Arbor MI: UMI, 2002.

———. *The Unfinished Enlightenment: Description in the Age of the Encyclopedia.* Ithaca NY: Cornell University, forthcoming 2010.

Starobinski, Jean. "Remarques sur l'*Encyclopédie.*" *Revue de Métaphysique et de Morale* 75, 3 (1970): 284–91.

Steele, Brett D. "Muskets and Pendulums: Benjamin Robins, Leonhard, Euler, and the Ballistics Revolution." *Technology and Culture* 35, 2 (1994): 348–82.

Stewart, Andrew. "David's *Oath of the Horatii* and the *Tyrannicides.*" *Burlington Magazine* 143 (April 2001): 212–19.

Stewart, Larry. *The Rise of Public Science: Rhetoric, Technology, and Natural Philosophy in Newtonian Britain, 1660–1750.* Cambridge UK: Cambridge University, 1992.

Stewart, Philip. "Illustrations encyclopédiques: de la *Cyclopaedia* à l'*Encyclopédie.*" *Recherches sur Diderot et sur l'Encyclopédie* 12 (1992): 70–98.

Stigler, Stephen M. *The History of Statistics: The Measurement of Uncertainty before 1900.* Cambridge MA: Belknap Press of Harvard University, 1986.

Swijtink, Zeno G. "The Objectification of Observation: Measurement and Statistical Methods in the Nineteenth Century." In *The Probabilistic Revolution.* Edited by Lorenz Krüger, Lorraine J. Daston, and Michael Heidelberger. 2 vols. Cambridge MA: MIT, 1990, 1: 261–85.

Supplément à l'Encyclopédie, ou Dictionnaire raisonné des Sciences, des Arts et des Métiers par une Société de gens de lettres. Edited by Jean-Baptiste Robinet. 4 vols. Amsterdam: M. M. Rey, 1776–77.

Thomson, William (Lord Kelvin). "The Dynamical Theory of Heat." *Transactions of the Royal Society of Edinburgh* (March 1851).

Thomson, William (Lord Kelvin), and Peter Guthrie Tait. *A Treatise on Natural Philosophy.* 2 vols. Cambridge UK: Cambridge University, 1879.

Tischbein, Johann Heinrich Wilhelm. "Briefe aus Rom, über neue Kunstwerke jetzlebenden Künstler." *Der Teutscher Merkur* (February 1786). In *The Triumph of Art for the Public, 1785–1848: The Emerging Role of Exhibitions and Critics.* Edited by Elizabeth Gilmore Holt. New York: Anchor Books, 1979, 12–24.

Tsirbas, A., C. Mango, and E. Dutson. "Robotic Ocular Surgery." *British Journal of Ophthalmology* 91 (2007): 18–21.

Turner, R. Steven. "Consensus and Controversy: Helmholtz on the Visual Perception of Space." In *Hermann von Helmholtz and the Foundations of Nineteenth-Century Science.* Edited by David Cahan. Berkeley: University of California, 1993, 154–204.

Universal Magazine of Knowledge and Pleasure. 113 vols. London: J. Hinton, 1747–1803.

"The Use and Principles on which the Hydrostatic Balance

acts. . . ." *Universal Magazine of Knowledge and Pleasure* 4 (1749): 310–17.

Vasarius, H., et al. "Man-Machine Interfaces in Computer Assisted Surgery." *Computer Aided Surgery* 2, 2 (1997): 102–7.

Vasna, T. R. K., et al. "Use of the NeuroMate Stereotactic Robot in Frameless Mode for Movement Disorder Surgery." *Stereotactic and Functional Neurosurgery* 80 (2003): 132–35.

Voltaire. *Théâtre complet de M. Voltaire.* 9 vols. Caen: G. Le Roy, 1788.

Wall, Cynthia. *The Prose of Things: Transformations of Description in the Eighteenth Century.* Chicago: University of Chicago, 2006.

Wellbery, David E. *Lessing's Laocoon: Semiotics and Aesthetics in the Age of Reason.* Cambridge UK: Cambridge University, 1984.

Werner, Stephen. *Blueprint: A Study of Diderot and the Encyclopédie Plates.* Birmingham AL: Summa Publications, 1993.

Wildenstein, Daniel, and Guy Wildenstein. *Documents complémentaires au Catalogue de l'œuvre de Louis David.* Paris: Fondation Wildenstein, 1973.

Wind, Edgar. "The Sources of David's *Horaces.*" *Journal of the Warburg and Courtauld Institutes* 4 (1940–41): 124–38.

Yeo, Richard. *Encyclopaedic Visions: Scientific Dictionaries and Enlightenment Culture.* Cambridge UK: Cambridge University, 2001.

INDEX

Body: commonsense conception of, 5; correlation and, 29; movement of, 203–4, 204; perception and, 173–77, 199, 220n18; privileging of, 199; scales of representation and, 75; virtual surgery and, 5–6, 13. *See also* Gesture

Bohr, Niels, 191–97, 199, 205, 209

Boileau, Nicolas, 84–85

Bolla, Peter de, 14

Boltzmann, Ludwig, 169, 180–91, 195, 196, 199, 205, 234n93; Boltzmann's law, 183–84

Bonaparte, Napoleon, 159

Borghese *Gladiator*, 144

Botany, 93

Bourgeois drama, 137–38

Boyle, Robert, 218n3

Brain, 99–100, 106

Braque, Georges, 205

Braun, Marta, 202–3

Bricolage, 10, 215n20

British Association, 162

Brooklyn Bridge, 186

Brownian motion, 191

Buffon, Georges-Louis, 56, 74–76, 78–80, 95; *Histoire Naturelle*, 74, 104

Bundled sheaf metaphor of perception, 99, 106

Burney, Frances, 150

Calculus: computational descriptions, 16; and curves, 16, 56, 77–78; philosophical issues concerning, 223n53; photography and, 202; and probability, 95, 160, 177, 181, 187–88; and spatial representation, 171; uses of, 77–79, 153, 160, 197; as working object, 199

Cameraman, 3, 5

Camera obscura: atlases and, 33; understanding and, 13, 60–61; vision and, 170, 174, 220n18

Cameras, surgical use of, 3, 5. *See also* Photography

Caravaggio, 136, 228n116

Carnot, Sadi, 184

Catalogues, visual. *See* Visual catalogues

CAT scanners, 5

Causal Law, 172–73

Causation: eighteenth-century debate over, 88; modern physics and rupture in, 194–96; in Newtonian world view, 17

Celestial mechanics, 79, 160, 168, 199. *See also* Astronomy

Cells, as heuristic device in physics, 183–84, 187, 189

Census data, 164

Central limit theorem, 162–63

Certitude: probability and, 56, 95, 181; sense perception and, 78. *See also* Truth

Chambers, Ephraim, *Cyclopedia*, 10–11

Chardin, Jean-Baptiste-Siméon, 72, 82; *The Copper Fountain*, plate 4, 24, 24–25, 33, 55, 147

"Chasse, Venerie," 42, 43–45, 46

Chiaroscuro. *See* Light and shade

Chronophotographs, 202

Cinema, 61

Circulatory system, 201

Clairon, Hippolyte, 104, 140

Classical paradigm, 82–83

Cochin, Charles-Nicholas, *Lettre sur l'opera*, 124

Cognition: correlation and, 29; diagrams and, 23; *Encyclopedia* and, 12; photography and, 204; in virtual surgery, 13

Collage, 147

Collé, Charles, 98

Collections, 93

Color, 24

Comédie-Française, 97–98, 103, 114–15, *116*, 117, 128, 139

Comedy, 96, 107, 110, 137

Comets, 161

Commedia dell'arte, 100

Communication: description and, 81–82; diagrams and, 46; of emotions, 85–86; gestural, 100–101

Computer assisted displays, 156

Computer simulation, 6–7

Concepts: perception and, 173; working objects in relation to, 33

Condorcet, Marie-Jean-Nicolas de Caritat, marquis de, 95, 158, 160

Connon, Derek F., 226n53